Adobe Photoshop 5.0 for Photographers

For Margaret and my mother, Marjorie

Adobe Photoshop 5.0 for Photographers

An illustrated guide to image editing and manipulation in Photoshop

Martin Evening

The Library
University of Saint Francis
2701 Spring Street
Fort Wayne, Indiana 46808

OXFORD • AUCKLAND • BOSTON • JOHANNESBURG • MELBOURNE • NEW DELHI

Focal Press

An imprint of Butterworth-Heinemann Linacre House, Jordan Hill, Oxford OX2 8DP 225 Wildwood Avenue, Woburn, MA 01801-2041 A division of Reed Educational and Professional Publishing Ltd

A member of the Reed Elsevier plc group

First published 1998 Reprinted 1999 (three times)

© Martin Evening 1998

All rights reserved. No part of this publication may be reproduced in any material form (including photocopying or storing in any medium by electronic means and whether or not transiently or incidentally to some other use of this publication) without the written permission of the copyright holder except in accordance with the provisions of the Copyright, Designs and Patents Act 1988 or under the terms of a licence issued by the Copyright Licensing Agency Ltd, 90 Tottenham Court Road, London, England WTP 9HE. Applications for the copyright holder's written permission to reproduce any part of this publication should be addressed to the publishers

British Library Cataloguing in Publication Data

A catalogue record for this book is available from the British Library

Library of Congress Cataloguing in Publication Data

A catalogue record for this book is available from the Library of Congress

ISBN 0 240 51519 6

Printed and bound in Italy by Printer Trento s.r.l.

Contents

Introduction	
Section One Photoshop Fur	ndamentals
Chapter One Digital Capture	
Scanners	
Resolution	
Dynamic range	
Bit depth	
Scanning speed	
Visual assessment	
Kodak Photo CD	
Image quality	
Archive storage	
The Image Pac	
Optimum Photo CDs	
Precision Transforms	
Opening a Photo CD image	
Digital cameras	
Scanning backs	I
CCD chip cameras	۱
Dicomed Bigshot	2
Low-end cameras	
Chapter Two Resolution	
Terminology	2
Repro considerations	2
Altering image size	2
Practical conclusions	
Chapter Three RGB and CMYK Color	
•	3
The 'all CMYK' route	ک د
The versatility of RGB	3
Photoshop conversions	3
CMYK and monitor display	
Photoshop 5.0 color management	
Color management systems	د
Manual (Built-in) color conversion options	د
Color conversions using ICC profiles	3
Chapter Four File Formats	
TIFF (Tagged Image File Format)	4
PICT	4
EPS	4
DCS	4
IDEC	1

Adobe Photoshop 5.0 for Photographers

Other file formats for the Internet	
GIF	
PDF	49
Importing Multipage PDF files	
FlashPix	
IVUE	
Portable Network Graphics (PNG)	51
Chapter Five Print Output and Proofing	
RGB output devices	52
CMYK proofing and fine art printing	53
PostScript printing	
Desktop proofing	56
Printers for all	56
Quantity printing	
Storing digital files	57
Image database management	58
Bureau checklist	
Image protection	60
Chapter Six Configuring Photoshop	
Buying a system	
Monitor display	
Retailers	
Improving Photoshop performance	
Chip speed	66
RAM memory & scratch disks	67
Clearing the clipboard memory	
Configuring the RAM memory settings (Macintosh)	
Configuring the RAM memory settings (Windows)	71
PCI cards	
Video display	
System software	
Efficient work routines	
The History feature	
Multiple undos	74
History brush and Snapshot	75
Quick Edit	75
Monitor calibration	
Photoshop color management	
Photoshop color management history	
Photoshop 5.0 color management	
Handling legacy files	
Problems to be avoided when exchanging RGB files	
File opening routines	
Sample file opening tables	87
Opening CMYK and Lab files	
CMYK setup	
CMYK model	
Ink options	
Separation options	95
Information palette	
Closed color loops	96

Chapter Seven The Work Space

Photoshop Preferences	98
Saving files	98
Display & Cursors	99
Transparency & Gamut	99
Units & Rulers/Guides & Grids	100
Plug-ins and scratch disk/Memory & Image Cache	100
Image Window	101
Rulers, Guides & Grids	103
The toolbox	
Selection and move tools	
Modifier keys	
Lasso: Freehand/Polygon/Magnetic	
Move tool	H
Crop tool	112
The Paint tools	
Airbrush	
Paint Brush	
Rubber Stamp/Pattern Stamp	
History brush and History palette	114
History and memory usage	
Non-linear History	
Eraser	
Pencil	
Line	
Focus: Blur/Sharpen/Smudge	
Toning: Dodge/Burn/Sponge	
Pen and Path drawing	121
Type/Type Mask (horizontal & vertical)	121
Type/Type Mask (norizontal & vertical)	121
Gradient	
Paint Bucket	
Eyedropper/Color sampler	
Navigation tools – Hand and Zoom	124
Foreground/Background colors	125
Selection Mode/Quick Mask	123
The Photoshop Palettes	
Navigator	
Info	
Options	
Color	
Swatches	
Brushes	
Actions	
Layers	
Channels	
Paths	130

Section Two Basic Image Corrections

Chapter Eight Image Adjustment

Cropping	
Orientation and canvas	
Image analysis	
Tonal adjustments	
Assigning shadow and highlight points	
Color balance and contrast	
Curves adjustments	
Image size	
Unsharp masking	
Amount	
Radius and Threshold	143
Chapter Nine Color Adjustments	
Hue/Saturation	145
Multiple adjustment layers	150
16-bits per channel support	150
Replace Color	
Adjustment Layer benefits	154
Selective Color	155
Color Range	155
Chapter Ten Repairing an Image	
Basic cloning methods	158
Retouching a color negative	
Alternative spotting technique using the History brush	
Cloning selections	
Restoring a faded image	
Keyboard shortcuts	166
Chapter Eleven Montage Techniques	
Selections and channels	167
Summary of channels and selections	169
Selections	169
Quick Mask mode	169
Alpha channels	169
Paths	169
Modifying selections	
Smoothing and enlarging a selection	
Anti-aliasing and feathering	172
Layers	174
Blending modes	175
Layer masks	
Adding a Layer Mask based on a selection	
Viewing a Layer Mask in Mask or rubylith mode	
Applying and removing Layer Masks	
Working with multiple layers	
Preserve Transparency	
Transform commands	181

Layer rotation and flips	182
Numeric Transforms	183
Repeat Transform	183
Transforming selections and paths	183
Drawing paths with the pen tool	184
Guidelines for drawing pen paths	185
Montages	189
Clipping groups	192
Exporting Clipping Paths	194
Chapter Twelve Retouching	
Brush blending modes	198
Retouching with the paintbrush	199
Softening the focus	200
Rescuing shadow detail	201
Scanning halftone images	203
Dodge and Burn	205
Section Three Advanced Tec Chapter Thirteen Shortcuts	•
Contextual menus	
Selections	
Moving and cloning selections	214
Navigator, Info and Options Palette	215
Working with Actions	216
Troubleshooting Actions	218
Automation plug-ins	
Batch processing	220
Conditional Mode Change	220
Contact Sheet	
Fit Image	221
Multi-Page PDF to PSD	221
Export Transparent Image and Resize Image	221
Layers and Channels	223
Chapter Fourteen Black and White Effects	221
Duotone mode	
Full color toning	235
Solarization	
Black and white from color	
Chapter Fifteen Coloring Effects	
Color overlays	245
Retouching with overlays	246
Hand coloring a B/W photo	248

Chapter Sixteen Layer Effects

Layer Effects controls	25
Drop Shadow	
Inner Shadow	
Outer Glow & Inner Glow	
Bevel & Emboss	
Painting effects	
Transforms and alignment	
Type layers	
Spot color channels	
Chapter Seventeen Filters	
Blur filters	
Fade filter	
Smart Blur	
Noise filters	
Filters for alpha channel effects	
Creative filtering	
Distort filters	
Pushing the envelope	
Displacements	
Chapter Eighteen Lighting and Render	ing
Clouds and Difference Clouds	
Lens flare	
Lighting Effects and Texture Fill	27-
3D Transform	
Halo effect	
Chapter Nineteen Synthesis	
Disco Inferno	
Paris Metro by Ed Horwich	
Red Dwarf Radio Times cover by Ian McKinnell	
Coloring in Lab color mode and using History	
Anatomy of a layered image	
Appendix	
List of Photographer contributors	
Glosary of terms	
World Wide Web contacts list	
Index	
Index list	30

Introduction

think the Adobe Photoshop program will rank as one of the most important photographic product developments from the latter part of this century, alongside Polaroid instant film and electronic automated cameras. By no means was Photoshop the first professional image editing program. High-end digital image editing has been in use since the mid eighties. But, and this is a significant distinction, Photoshop is now the leading image editing program as used by designers, repro houses and now photographers all around the world. The advent of Photoshop made professional quality image manipulation and other pre-press tasks available in a desktop computer environment. As desktop computer systems have got faster in terms of speed and capacity, the gap between high-end and desktop has narrowed. The accessibility and affordability of Photoshop has been the key to its success. More people than ever before can now get involved with image editing, including those who would never normally have been able to afford high-end bureau services. From a creative point of view, this empowerment has to be a good thing even if the output from certain self-styled digital artists is, how can I put it, not everyone's cup of tea.

From a technical standpoint, dipping one's toes in the digital stream embodies taking on much more responsibility for the production process. For that reason this book is not solely about Photoshop but also delves into the technical implications surrounding the program's use and working in the digital domain. You are about to venture into new territory. Those colleagues who helped in the research and advised on this project have like myself all come from a photographic based background and learned how to use the new technology from scratch. So in planning this book I considered carefully what could be packed into 250 pages or so that would be relevant to some-

one wanting to use Photoshop as a digital darkroom tool. Texture designs for web sites and special type effects have consciously been omitted – there are plenty of other books to service that need. Instead, here is a packed guide to the Photoshop features you'll really want to use and become familiar with. One special feature is the inclusion of tutorial movies on the CD-ROM. From my own experience, I found movie examples a helpful way to learn, so some of the book tutorials are also featured on the CD disc. If you want to dive in and learn the Photoshop basics, I suggest bypassing the first section and begin by reading Chapter Six on 'Configuring Photoshop'. The practical steps introduce all the basic image correction controls and as you progress through the book show you how to incorporate some of Photoshop's more powerful features and sophisticated techniques.

I use an Apple Macintosh system to run Photoshop, but have included keyboard equivalents for PC users and special instructions throughout. If you are running the Windows 95 operating system or later, the translation between Mac and PC is not too dissimilar. My advice to anyone is use the computer system you feel most comfortable with. I find it a sign of maturity when one can mention the words Macintosh and PC in a sentence without claiming superiority one way or the other. Platform wars and speed comparisons prove very little. When analyzing these differences on top of the range kit, Photoshop performance hinges more on the skill and speed of the operator than on the hardware or computer system they use.

Being British born I use UK English spelling in the normal course of my writing. However, Adobe are a US company and the international, English language Photoshop interface uses US spelling. As this book is being distributed throughout many English speaking countries, we settled on the US English spelling conventions throughout. In addition, I believe it is important for everyone that all the interface terms and definitions are used precisely. There are many confusing and incorrect terms in use – like the Photoshop user who on an Internet mailing list described an action called 'Pretzel clicking'. In Germany apparently, the Apple Command key is also known as the Pretzel key.

Acknowledgments

I must first thank Andrea Bruno of Adobe Europe for her suggestion that I write a book about Photoshop aimed at photographers. I would also like to thank Reuel Golden of the *British Journal of Photography* and Stuart Price at *MacUser*, who before that first commissioned me to write about digital imaging. I would like to give a special mention to my publishing editors Jennifer Welham and Margaret Riley for all their help in getting this book launched. Also thanks to Adam Woolfitt and Mike Laye who helped form the Digital Imaging Group (DIG) forum for UK digital

photographers and all the other DIG and Association of Photographers members, in particular: Laurie Evans, Jon Gibson-Skinner, Peter Hince, Ed Horwich, Alex Howe, Bob Marchant, Ian McKinnell, David Wood (who compiled and authored the CD-ROM), and Rod Wynne-Powell, who reviewed the final manuscript and provided much useful guidance; also Andrew Wood Mitchell for organizing the sound recording and music on the CD.

The following clients, companies and individuals should also be mentioned for the help they gave me: Adobe, Chris Bishop, Bookings, Rex Boyd, Russell Brown, Clippers, Clipso, Chris Cox, Elite models, John Field, Bruce Fraser, Gucci, Nick Haddon, Mark Hamburg, Hair UK, Leon Herbert, Ritchard Istace, Brian Marshall, M&P, Models One, Nevs, Robert Palmer, Marc Pawliger, Tim Piazza, Profile, Clair Rawlings, Red or Dead Ltd, Jeff Schewe, Schwarzkopf Ltd, Michael Smiley, John Smith, Paul Smith, Martin Soan, Storm, Tapestry, Carl Volk and Jim Williams. Hello to everyone who belongs to the Photoshop discussion e-mail list and special mention to the list owners: Michelle Eason, John Puffer, Cindy Stone and Peter C.S. Adams. And lastly, thanks to friends and family, in particular: Gareth Pryce who helped check the copy at the draft stage, my mother for her love and encouragement and Sara too for all her support and patience.

There is a web site set up to promote this book where you can find active links mentioned in the book and any late breaking news on Photoshop 5.0.

http://www.bh.com/focalpress/evening

Chapter One

Digital Capture

reckon it is fair to say probably every photographer I know now involved with digital imaging came from the position of being a one time digital skeptic. The conversion has in some cases been dramatic which was no doubt linked to the speed of changes which took place in our industry during the eighties and nineties. One colleague commented that in the early days he used to tease his retouching bureau that you could see the pixel structure of a digital image. 'When they started working with 200–300 MB images and you saw the grain structure of the film before the pixels – I finally conceded my argument!'

The point is that digital imaging has successfully been employed by the printing industry for over ten years now and if you are photographing anything for print media, one can say with certainty an image will at some stage be digitized. At what point in the production process that digitization takes place is up for grabs. Before, it was the sole responsibility of the scanner operator working at the printers or highend bureau. The worldwide sales success of Photoshop is evidence that pre-press scanning and image editing now takes place more commonly at the desktop level.

So this book commences with the digital capture or digitization of a photographic image. It is self-evident that the quality of your final output can only be as good as the quality of the original. Taking the digitization process out of the hands of the repro house and closer to the point of origination is quite a major task. Before, your responsibility ended with the supply of film or prints to the client. Issues such as image resolution and CMYK color conversion were not your problem, whereas now they can be.

It is worth bearing in mind the end product we are discussing here: digital files which have been optimized for reproduction on the printed page. The media by which those images are processed are irrelevant to the person viewing the final product. Those beautiful transparencies are only ever appreciated by a small audience – you, the art director and the client. Pretty as they might be, transparencies are just a means to an end and it is odd that clients still insist on digital files being 'proofed' as transparency outputs when a 4 color wet proof or Iris would give a better impression of how the job will look in print. I am not knocking film – I myself mostly use transparency film to capture my images and then have these scanned. A roll of film has the potential to record and store gigabytes of data at high quality, quickly and for a very reasonable cost. The majority of my work involves shooting live action and in my opinion, digital cameras have some way to go before they will be able to rival the versatility of conventional film and satisfy my needs, though I am sure it will happen one day.

Scans can be made from all types of photographic images: transparencies, B/W negatives, color negatives or prints. Each of these media are primarily optimized for the photographic process and not digital. The tonal range of a negative, for example, is very narrow compared to a transparency, but that is because a negative's tonal range is optimized to match the sensitometric curve of printing papers. Therefore the task of creating a standardized digital result from all these different types of sources is dependent on the quality of the scanning hardware and software used and their ability to translate different photographic media to a standard digital form.

Structure of a digital image

A digital image is a long string of binary code (like the digital code recorded on your music CDs, which is translated into an audio signal). It contains large amounts of information which when read by the computer's software displays or outputs as a full tone image. A digital image is a high-fidelity original; any digital copy of the file will be an exact replica.

Each picture element or 'pixel' is part of a mosaic of many thousands or millions of pixels and each individual pixel's brightness, hue and saturation is defined numerically. To understand how this works, it is best to begin with a grayscale image where there are no color values, just luminosity. Grayscale images are made up of 256 shades of gray – this is what is known as an 8-bit image. A 1-bit or bitmapped image contains black or white colored pixels only. A 2-bit image contains 4 levels (2²), 3-bit 8 levels (2³) and so on, up to 8-bit (28) with 256 levels of gray. An RGB color image is made up of 3 color channels. Each channel has 8-bit grayscale information defin-

ing the opacity of each color component of the full color image. The overlaid color channels mean a single pixel of an RGB color image contains 24-bit color information or up to 16.7 million colors.

Confusion arises when the color bit depth of monitors is discussed. The principles are the same but it is the display capabilities of the monitor that are being referred to here and not the color depth of the image viewed on it. A basic computer with a monitor may only display at 8-bit or 256 colors, but with additional video memory installed, higher bit depth display becomes possible. So an RGB image in Photoshop can only be viewed in as many colors as are available on the monitor but the digital image itself will still be in 24-bit color. Likewise with scanners – the specification for a particular model may state that it captures color at 30-bit or 36-bit color. As will become apparent later, this is a good thing, but the imported image will still be no more than 24-bit in Photoshop, though now Photoshop also supports 16-bits per pixel for each channel, it may become possible to export a 48-bit RGB image.

Scanners

A scanner does two things: it reads information from a photographic original – print, negative or transparency - and converts this to digital information in the preferred color space and output size, ready for image editing. High-end drum scanners as used by professional bureaux produce the best quality. The optical recording sensors and mechanics are superior as is the software and of course you are paying a skilled operator who will be able to adjust the settings to get the finest digital results from your original. Desktop drum scanners are available at a slightly more affordable price, but hot on the heels of these are the top of the range flatbeds, in particular the Agfa, Umax and Linotype-Hell models. The reason for this improved performance is largely due to the quality of the professional scanning software now bundled (i.e. Linotype and Binuscan). In fact it has been rumored these flatbed scanners have for quite a while been capable of improved output. They were hindered from achieving their full potential by software limitations which maintained a division in the market between these and the more pricey desktop drum scanners. It rather reminds me (and I am told this is a true story) of an electrical goods manufacturer in the process of testing their latest budget 'all in one' phono/tuner/cassette and CD player prototype. The sound quality from the CD was no better than phono or cassette, so the MD suggested adding a few extra components to distort the output from everything but the CD player, after that the CD always sounded superior.

With a drum scanner, the image is placed either on the surface of a Perspex drum, or as in the case of the Kodak Premier system, held in a perfect arc not touching any surface. The image on the drum is rotated at high speed and a light source travels across the width of the film in unison with a probe containing a photomultiplier which records the image color densities digitally at very fine detail.

Flatbed scanners work a bit like a photocopying machine. The better models record all the color densities in a single pass and have a transparency hood for transparency scanning. One or two high-end flatbeds use a method of three pass scanning, which provides better color accuracy. The third type of scanner is a CCD (Charge Coupled Device). Polaroid, Nikon and Kodak make good models for scanning from 35 mm formats up to 5×4 sheet film. In addition it is worth checking out the Imacon CCD scanner which has a very high optical scanning resolution and good dynamic range. Basically these devices record the image information onto the CCD chip, which is like an electronic film plate.

If you are going to buy a scanner for repro quality output, then purchase the very best you can afford. The Linotype Saphir Ultra flatbed, for example, has a true optical resolution of 1000×2000 pixels per inch. The quality is excellent and for scanning in 5×4 transparencies this would yield files of 4000×5000 pixels at 1000 ppi scanning resolution. In a still life studio, this would be a useful device for scanning images to reproduce at A3 size. Or you should just get a basic flatbed. There are two reasons for this – Adobe Photoshop software has in the past been bundled with scanners, including the cheap models (though in some cases the bundle may only include Photoshop LE, which is a cut down version, but can be upgraded). The deals offered are so good, that for the price of the Photoshop software, the scanner almost comes free! I find the Umax Vista S-8 I bought a few years back is perfect for lots of little jobs, even though it is far from being a repro quality scanner. I can scan in Polaroids and e-mail them to the client as an attachment, or scan in prints at a good enough quality for web design work. Even for high-end retouching, it is sometimes satisfactory when I require to scan in a simple element or texture.

What to look out for

The only way to truly evaluate a scanner is to try it out for yourself with a sample scan and to test the advanced models properly, a certain amount of experience using the software helps in order to obtain the very best results. The manufacturer's technical specifications can guide you to a certain extent when whittling down your selection. Here is what to look for:

Resolution

Specified as pixels per inch, this indicates how fine the scanner can resolve an image. It is the optical resolution that counts and not the interpolated figures which may claim scanning resolutions of up to 9600 ppi. Photoshop is capable of interpolating (resampling an image to make it bigger than the original) and probably with better results in most cases. The low-end flatbed machines begin with resolutions of 300×600 ppi, rising to 1000×2000 for the high-end models, 2700 ppi from CCD scanners like the Nikon Coolscan, and higher resolutions still with the drum scanners. Flatbed resolutions are expressed by the horizontal resolution – the number of linear scanner recording sensors – and vertical resolution – the mechanical accuracy of the scanner. My advice when using a flatbed is to set the scanning resolution no higher than halfway between the vertical and horizontal optical resolutions and interpolate up if you must in Photoshop. For critical jobs – scanning detailed line art, for example – it may be worth rotating the page 90 degrees and comparing the quality of the two scans.

Dynamic range

This critical benchmark of scanner quality is usually left out of the specifications list of lower priced machines, because they are mostly not very good! A photographic print has a reflectance range of about 2.2 which is beyond the capabilities of a standard scanner and when it comes to scanning transparencies the ludicrous density ranges of modern E-6 emulsions are way beyond the scope of these poor electronic eyes (Ektachrome transparencies have a typical dynamic range of 2.85). The tell-tale signs are lost highlight detail – no matter how much you tweak the scanner settings or play around in Photoshop, there is nothing there on the scan except pure white (255, 255, 255) or black (0, 0, 0). A scanner capable of capturing a higher dynamic range is essential for repro work. Look for a dynamic range of 3.0 or above.

Bit depth

If you are scanning from negatives, then dynamic range won't be a problem, but capturing enough detail within that narrow range and expanding it to produce a smooth continuous tone positive is. An increased scanning bit depth expands the range of tones captured in a scan. A 36-bit scanner records 12 bits per channel, which amounts to 4096 levels compared with 256 levels per 8-bit channel. 24-bit Photoshop files need 256 levels per channel, so even if your original has a compressed range of tones to scan from, a 36-bit scanner will be able to discern enough subtle tonal gradation in

order to produce a full tone 24-bit image. If the original is scanned on just a 24-bit scanner, you may lose lots of information when setting the levels – the resulting histogram will reveal gaps and instead of smooth tones you will see posterization or ugly color banding. If the scanner you are buying boasts a high bit depth, fine, but do also check about the dynamic range.

Scanning speed

Scanning in a large file can take a very long time so check the reviews for comparative times as buying a slow scanner could really stall your workflow.

Visual assessment

All scanners are RGB devices. CCD chips are arrayed in a 2×2 mosaic with one red, two green and one blue sensor (the extra green is there to match the sensitivity of the CCD to that of the human eye). When evaluating the quality of a scan, check each individual channel but pay special attention to the blue channel because this is al-

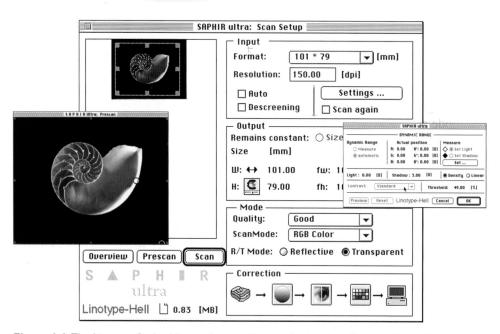

Figure 1.1 The Linotype Saphir Ultra software offers professional quality scanning with an easy to operate interface.

Photograph: Adam Woolfitt

ways the weakest. Look for excess noise and streaking. The noise will not always be noticeable with every subject scanned, but if you had lots of underwater pictures to process, this failure would soon become apparent.

Scans from B/W negatives or prints are a good test for any scanner. These are the hardest originals of all to record and low-end models are just not up to the task. When you scan a color image, the result is usually quite pleasing to the eye even though on closer inspection there may be much wrong in one or more of the channels. The illusion that everything is all right is due to the overlapping of these three channels which creates maybe not millions, but enough shades of color to appear continuous toned. If this image were then converted to a grayscale or desaturated (Image > Adjust > Desaturate) in RGB mode, the resulting grayscale would be all right too. On the other hand, if the original information to be scanned is monochromatic, then the problem stems from a lack of differentiation between the color channel sensors and consequently the weakness is easier to spot. Whether you scan in RGB or grayscale mode, the scan will only be as good as the weakest channel. The tell-tale signs are posterized tonal information and gaps in the Levels histogram display. There is nothing really you can do to correct this other than having the image rescanned using a better quality scanner – you cannot create information which was not there in the first place. If you use a flatbed to scan in prints, one way round the problem is to make the print match the recordable density range of your scanner. For example, if the device you are using is unable to record the full tonal range of a standard bromide print, then select a soft grade of printing paper, increase the print density for the highlights and reduce the D-max for the shadows. Print several versions and find which scans best with your equipment. Or as was just mentioned, make the grayscale images using scans from color originals. Try also converting to Lab mode and using the grayscale information in the Lightness channel.

Kodak Photo CD

Kodak launched Photo CD in 1992 as a platform-independent storage medium of digitized images for use with desktop computers and for display on TV monitors via a CD player. The initial expectations were that Photo CD would become popular with the amateur market. There was, however, soon considerable interest among the professional photographers and DTP industry, who were eager to adopt Photo CD as an alternative to expensive drum scans or the purchase of a desktop scanner. The product development has of late been directed towards improving quality and to continue satisfying this professional market. The main advantages of Photo CD are:

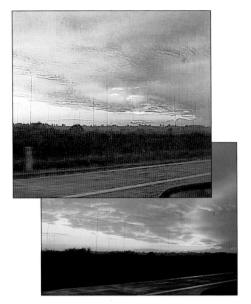

Low cost digital cameras achieve low file storage sizes through hefty compression. This is particularly evident in the blue channel. Note the checkered pattern - a typical sign of excessive compression.

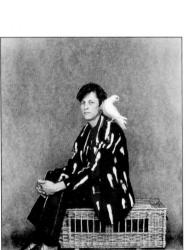

Without a wide dynamic range, shadow and highlight detail will be clipped. Faint highlights fail to be picked up and appear burnt out.

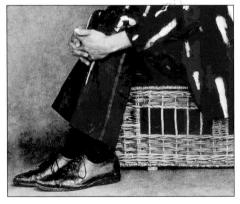

Figure 1.2 Close inspection and examination of the individual color channels reveals the shortcomings of a poor quality scan.

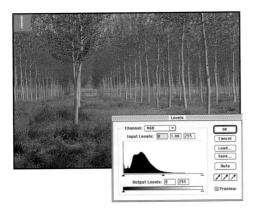

I The above Photo CD image, opened using the Adobe Photoshop RGB transform, reveals a problem of clipping in the shadow areas. The histogram bars are all shifted across to the left.

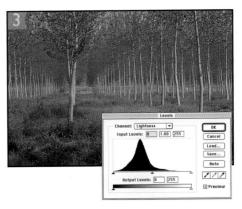

3 This example shows the same Photo CD image this time opened using the CIELAB transform. The picture is slightly darker, but note the more even distribution of tonal values.

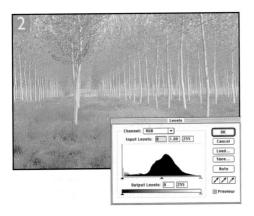

2 Compare the difference when the gamma level is set to an extreme value of 2.3. As the RGB image is lightened, the picture loses a lot of color, becoming desaturated. The Levels dialog box shows levels after adjustment.

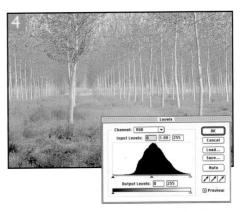

4 Apply the same Levels adjustment to the CIELAB transform. Because the image is in Lab color mode, only the lightness values change and not the color values, retaining more color detail. The image was converted to RGB and the resulting Levels are shown for comparison.

Figure 1.4 The above examples show the benefits of opening a Photo CD with the CIELAB transform, compared with 'Adobe Photoshop RGB'. When opening a Photo CD image click on the 'Destination' button and choose the appropriate transform from the pop-up menu. Carry out the Levels adjustments in Lab color mode, then convert to either RGB or CMYK mode if you wish. As you can see, opening in LAB color preserves more of the color detail after adjusting Levels.

For more information about Photo CD scans, visit the YCC Digital Imaging web site at http://www.webster.sk.ca/ycc

The Acquire module plug-in (version 3.0) for Photo CD is now available for free download from the Kodak site: http://www.kodak.com/dialhome/techInfo/. After installing, reboot the computer for the necessary plug-ins and extensions to become available. Instead of opening the PCD disc, head down the File menu to Import and choose Acquire Photo CD 3.0. Again, choose the file you wish to open the same way as before, though this time there are two check boxes – by checking 'Show all image files', you get to see a preview image of the file highlighted. Click Open to proceed to the Acquire module dialog box. Some of these options are identical to those in the previous dialogue box. Additional features include:

Crop tool Drag within the preview image to select the desired crop area.

<u>Resolution</u> As before choose from the usual selection of resolutions. In addition set a predetermined dpi resolution and physical image dimensions.

<u>Image adjustments</u> Options available for sharpening and tonal adjustment. Leave set to None, as these can be more effectively carried out in Photoshop.

<u>Preview</u> Select this option to preview the image. If image adjustments are used, the effects of these will be shown.

Note that only the later version of the Acquire plug-in module contains Precision Transforms. The earlier version 2.0, while still available for free download, is regarded as inferior because it does not use PTs. The Acquire module provides more options, but the process of opening a PCD image is more lengthy and the extra options you get (like cropping) are all available in Photoshop anyway. The final image quality will not be any better than opening directly in Photoshop.

In conclusion

Photo CD is a well established service for the digitizing and storage of photographs. When weighing up the cost of buying a decent scanner, it is worth calculating the comparative cost of Photo CD scans, taking into account the costs of archiving all the data likely to be accumulated. On the downside, the Kodak profiles are in my opinion not really precise enough. Some intervention will nearly always be required to get a perfect color match and the new interface Kodak introduced for version 5.0 of Photoshop is far from user friendly (see Figure 1.3). The Kodak web site contains lots of useful extra information (see above). One of the new developments introduced by Kodak includes a 30 MB CMYK TIFF scan output either to a general standard or to your custom printer specifications. This service is supplied at specialist bureaux only and is costed at the same price as a Pro Photo CD scan.

Digital cameras

These are exciting early days, when high resolution digital image capture becomes a reality. Granted, there are still obstacles to overcome before digital cameras come remotely close to matching the versatility of film cameras, but for certain professional setups digital cameras are able to fulfil a useful role in the studio and on location. Digital cameras have arrived at a time when digital press technology is well and truly established. Digital camera development has therefore been designed very much with the needs of press output in mind. Film scanners have had to be designed to cope with the uneasy task of converting continuous tone film originals of different types to a standard digital output. Digital camera design has been invented from the ground up to meet the specific needs of repro.

A Nikon rep was once asked how many customers in Europe had bought their very expensive 8 mm fisheye lens? Apparently they had sold just one, and that was to a rich businessman who had had it converted into a novelty desk lamp (I suppose the aperture ring was used as a dimmer control). Unless you have just won the Lottery or got money to burn, the currently available high-end digital cameras are beyond the reach of individual photographers. All high-end digital camera systems come with a premium price tag and that's before taking into account the purchase of major peripherals such as special lighting, image editing work station and a proof printer. To evaluate the effectiveness of purchasing an all digital system, one could begin by calculating the savings made in film and processing, but this factor on its own is not enough. A really important benefit of running a digital studio is increased productivity. It is possible for the client to attend a shoot, approve the screen image after seeing corrections, then the picture can be transmitted by ISDN to the printer (or wherever) and the whole shoot be 'signed off' the same day. In all probability clients will look for the material savings to be passed on to them. As photographic studios are getting involved in the repro process at the point of origination, there is no reason why they should not consider selling and providing an extra menu of services associated with digital capture, like CMYK conversions, print proofing and image archiving.

At present, digital cameras used in product shot or catalog studios are a very efficient substitute for shooting with film. Digital makes sense where the photography is happening every day, using the same type of lighting equipment and the size of output and printing quality are known in advance. Going digital is not suited to a studio which shoots different types of subject matter and varying lighting techniques. With advertising clients, the digital output size is usually not known till the end of a production schedule. Without this vital information being made available beforehand, the only answer is to record the image at very high resolution, which is a limitation

on most digital camera backs. There are individual cameras to suit these different ways of working with the exception of the Dicomed Bigshot, none that can do all. Even so, the Bigshot is an imperfect solution for rapidly capturing live action.

Doubtless, some time in the future there will be a digital camera capable of capturing images under different working conditions, with rapid shooting, that is also lightweight and economical to buy. We have such a system now of course and it's called 'film' – it is extremely versatile and costs around £5.00 per gigabyte in storage after processing.

Digital capture is all too often being promoted as an easy solution, and it is interesting to note that of all UK digital camera sales, the majority have been to repro houses looking to save on external photography costs and provide an all-in-one service to their clients. This has lead to a drop in standards, because the people using these cameras are not trained photographers. Unfortunately there are end clients who view the advantages of digital purely on the basis of cost savings: increased productivity, fast turnaround and never mind the creativity. In the long run it is likely that photographers with professional lighting skills will be brought in to work as employees (this is happening already) or that digital studios of the future will be collectives of freelance photographers sharing the equipment between them. Far from making life easier, the future of digital is going to involve major financial investment that will have to be recouped within a maximum time span of two to three years.

Scanning backs

These record a scene similar to the way a flatbed scanner reads an image placed on the glass platen. A row of light sensitive elements travels in a single continuous sweep across the image plane, recording the digital image. The digital backs are designed to work with large format 5×4 cameras, though the scanning area is slightly smaller than the 5×4 format.

Because of their design, a daylight balanced continuous light source must be used. HMI lighting is recommended for the exposure, because this produces the necessary daylight balanced output and lighting power. Some manufacturers of flash equipment like the Swiss firm Broncolor now make HMI lighting units which are identical in design to the standard flash heads and accept all the usual Broncolor lighting adaptors and accessories. In reality, I notice some photographers are actually using Blonde tungsten lights filtered for daylight. The only thing to be careful of here is that lower light levels may require setting a higher ASA capture setting, leading to increased blue shadow noise. Bright highlights and metallic surfaces can sometimes

cause streaking known as 'blooming' to occur. It is best avoided, but such artifacts can at least be retouched out if necessary. Some devices contain anti-blooming circuitry in the hardware.

The exposure time depends on the size of final image output. It can take anything from under a minute for a preview scan up to 10 minutes to record a 100 MB+ image. Everything has to remain perfectly still during exposure, which limits the subject matter that can be photographed. You can use a scanning back on location, but sometimes you get unusual effects similar to the distortions achieved with high speed focal plane shutters. A colleague photographing a scene on the River Thames with a scanning back had to retouch out the stretched boat passing through the frame during exposure! Not an ideal tool for such location work, especially in fluctuating sunlight conditions.

CCD chip cameras

If scanning backs follow the principles of a flatbed scanner, CCD chip cameras are analogous to the CCD scanners I described earlier. A small wafer containing an array of millions of light sensitive elements are the electronic film which records the image exposure. You find this mechanism adopted in custom digital backs for medium format roll film cameras as well as built into 35 mm camera bodies of Canon and Nikon cameras.

The image is recorded instantaneously; therefore flash, daylight and tungsten light sources can all be used. The standard CCD chip is monochrome though, so to record a color image, there have to be three sequential exposures made through a red, then a green and lastly a blue filter. As a live action camera, it can only record in monochrome. The filtering process is achieved with a large rotating disc of colored filters in front of the camera lens. It is a bit cumbersome in appearance, but works automatically. Where flash is used to illuminate the subject, the flash output must be consistent with each exposure, otherwise you will get a color cast. With some flash systems, it is advisable to fire the flash off once just prior to the series of color exposures.

The output files are not so large as those produced by the scanning back. The CCD chip in the Leaf DCB camera produces a 4 MB sized rectangular scanned image. An RGB composite is therefore 12 MB. This does not sound very impressive, but with digital cameras you have to think differently about the meaning of megabyte sizes or more specifically pixel dimensions and the relationship with print output file size.

Digitally captured images are pure digital input, while a high-end scanned image recorded from an intermediate film image is not. Good as drum scans may be, the latter are always going to contain some electronic or physical impurity, be it the surface of the film, the drum or grain in the film image. The recommended resolution for scanned images prepared for print output is double the printing screen frequency or sometimes 1.5:1 is recommended as the optimum ratio. In either case the film image must be scanned at the correct predetermined pixel resolution to print satisfactorily. If a small scanned image file is blown up, the scanning artifacts will also be magnified as well. Because digital files are so pure and free of artifacts, it is possible to enlarge the digital data by 200% or more and match the quality of a similar sized drum scan.

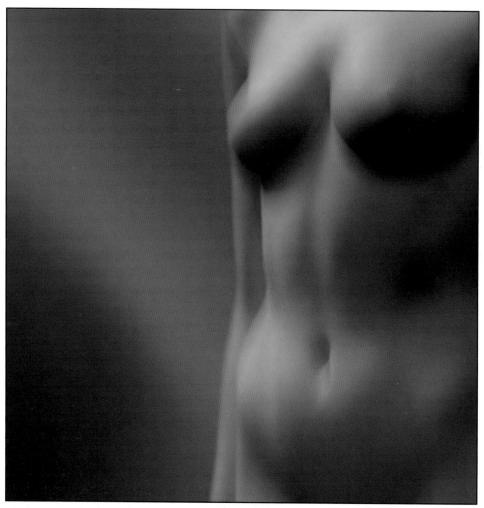

Figure 1.5 The above picture was taken by Jon Gibson-Skinner using the Leaf Digital camera back. The subject is actually a mannequin photographed showing movement and using natural daylight.

It's hard to take on board at first, I know. It came as a shock to me too when I was first shown a digital picture: an A3 print blowup from a 4 MB grayscale file! Not only that, but digital images compress more efficiently compared to noisy film scans. The full-frame Leaf 12 MB image will compress losslessly to around a few megabytes (less with high quality JPEG) and transmit really quickly by ISDN or fast modem. Catalogue and product shot studios prefer to have the Leaf back attached to something like the Fuji GX68 camera, because it has a full range of movements in the lens plane and can reasonably handle the same type of photography tasks as monorail plate cameras.

Striped chips

Full RGB color capture is possible with variations on the CCD chip design. The light sensitive elements are arranged in a mosaic pattern of color sensitive elements, recording all the color information in a single exposure. The most familiar examples are those bulkily designed 35 mm cameras based on the Kodak/Nikon F90 (N90 in the US) and Canon EOS-1 body designs. The early models recorded small 4.5 MB RGB images on a chip equivalent to about half the 35 mm frame area. This meant an effective doubling of the 35 mm lens focal lengths in terms of the angle of view. On such cameras, a 50 mm standard lens effectively became a 100 mm equivalent telephoto and the wide angle 24 mm was equivalent to a standard lens. These models are still available, but attention is now focused on the latest Kodak DCS 520 and EOS.DCS 1 cameras by Nikon and Canon respectively. With a 6 million pixel 15 MB chip covering nearly all of the 35 mm frame area and the angle of lens coverage close to what one is used to with a conventional 35 mm film camera. The immediacy of capture is a bonus to the reportage photographer, who is then able to transmit the data by modem to the newspaper or press agency.

A 15 MB RGB image is perfectly suited to full page high quality reproduction and the comments made in the last section about digital image purity do not apply to striped chips, because there is a discernible mosaic structure to the image when viewed closeup. Even so, such a camera could happily be used for magazine fashion and portraiture work. Images are stored in the hard drive of the camera body and downloaded to the computer, so it can be used remotely on location, maybe downloading periodically to a laptop computer to clear the hard drive in order to shoot more fresh images. Can you spot a drawback? How many 15 MB exposures would it take to fill up your computer's hard disk? Seventy two frames (2 rolls of film) would occupy about a gigabyte. If you are still inclined to get carried away shooting lots of frames, where are you going to save all your images to and how are you going to archive them? Forty exposures could be fitted onto a recordable CD, but think how long it

would take to transfer and record all that data? Clearly digital capture photography is going to alter the way we work. So maybe it won't be necessary to shoot so many exposures once we have the approved image 'in the bag' so to speak.

Dicomed Bigshot

Dicomed, who make scanning backs and the Imaginator software for high-end image editing, released the Bigshot in 1996, a striped CCD chip camera back designed to fit on the back of a Hasselblad 553 ELX camera. The Japanese Itochu Corporation provided the major investment, securing a five year exclusive supply of the Loral Fairchild 6×6 cm 16 megapixel CCD. The striped version records a 48 MB interpolated RGB image file instantaneously. This is in a square format, so realistically a typical rectangularly cropped image would be around 36 MB. The Dicomed distributor I spoke to claimed the quality of digital output is equivalent to a 5×4 film scan. The UK Digital Imaging Group approached photographer Barry Lategan, who kindly agreed to test out the Dicomed Bigshot and shoot a cover for *Image* magazine. The Bigshot results were impressive and there was certainly a lot of detail captured in the image. If you zoomed in very close, you could just make out the mosaic structure of the striped chip.

At £38 000, the Bigshot is one of the most expensive digital backs on the market and that is before adding in the cost of purchasing the Hasselblad, lenses and computer work station. The main drawback is the slowness of operation. It currently takes around 40 seconds to see the preview displayed on screen and up to a further four minutes to process the full resolution image. Barry Lategan's impressions were that this long wait between shots suited his fashion photography style, but would have been no good at all when photographing the Prime Minister the previous week.

There is an alternative version of the Bigshot, which like the Leaf DCB has a monochrome CCD and built-in LCD filters for sequential shooting. This delivers a purer image and larger sized file for still life photography only. A further promised development is a Bigshot with rapid changing filters, producing high resolution one shot images in 1/400 of a second.

Low-end cameras

Not to be dismissed as toys, there are many professional uses for a simple digital camera. The basic design is based around the chip used in the latest digital video cameras like the Sony DVC. These still cameras are all available for under £1000

and some produce 'high' resolution images which would fill a 17 inch monitor screen, in some cases larger, plus they can capture low resolution images when you want to shoot and store a larger number of shots on the camera's card.

I first came across the Canon 60 when Pat Scovell, art buyer at Bates Dorland agency in London, raved about how useful it was to them. Pat proudly related the agency's digital adventures: early experiments included an Australia shoot for Compaq computers with photographer Tony May. The art director Paul Ogden had received a day's training using the Canon 600 Sureshot and Compaq laptop computer hooked up to a GSM phone. Once out there, he was able to transmit images back to the agency showing choices of location and wardrobe. These were approved internally then e-mailed to the client for final approval. Working in such a remote area as the Australian Outback, where there are no telephones, this 'highly prized' simple setup saved much time and worry.

One can think of many business uses – for model castings, location hunting etc. especially when linked to e-mail. The images may not be up to repro quality, but for web use they are ideal. People can and do use such cameras to record visual Internet diaries. You don't even have to hook up to a computer to play back the images, most models have a small LCD screen/viewfinder for playback. This can be a drawback, because the small screen consumes a lot of battery power and unlike the video cameras which are supplied with rechargeable battery packs, the digital still cameras are supposed to rely on disposable batteries which have a rather short life. It is worth checking the press reviews before committing to a purchase and find out how long it takes to download the images from the camera to the hard disk. Anyway, enough eulogizing, after all the weighty considerations over high-end kit, here at least is one digital camera every business can afford to buy and make good use of.

There are now a few digital cameras on the market which capture 'million pixel plus' images, yielding a digital file of around 3.5 MB, or large enough to fill the screen of a high resolution monitor. The quality of the first models on the market are quite good and almost of respectable quality. There still remains a wide gulf between these and the true professional quality cameras. These too have had many teething problems. Photographers are having to adapt to solving all sorts of new problems. Without doubt there is much to be learned and many of these quality issues will be addressed over the next few years. I predict digital and film capture will feature side by side for many years to come. Photographers should use whichever medium they feel most comfortable with though without doubt, looking at the mass market of photography, the pressure to go digital is going to be driven foremost by clients and market need.

Chapter Two

Resolution

his chapter deals with the issues of digital file resolution, and two of the first questions everyone wants answered – how do you define it and just how big a file do you really need? When we talk about resolution in photographic terms, we normally refer to the sharpness of the lens or fineness of the emulsion grain. In the digital world, resolution relates to the way an image is output. Digital images are made up of picture elements called 'pixels' and every digital image contains a finite number of these blocks of tonal information. The more pixels in an image, the finer its resolving capacity. If you took a frame of 120 roll film 6 cm \times 6 cm and wanted to preserve all the detail digitally, including the emulsion grain, a scan producing a 5700 \times 5700 pixel image or 92 MB of RGB data, should do the trick. With a digital image that size, there would be enough pixel information to reproduce a photographic quality print of 50×50 cm – one which would withstand minute inspection.

The pixel dimensions of a digital image are an absolute value: a 3000×2400 pixel image would reproduce at high quality in a magazine at 10×8 " at 300 pixels per inch and the file size would be around 18 MB RGB or 24 MB CMYK. An A4 or full bleed magazine page would be around 3500×2500 pixels and roughly 23 MB RGB (30 MB CMYK) in size using the same number of pixels per inch. Pixel dimensions are the surest way of defining what you mean when quoting digital file size. Megabyte sizes are a less reliable way of describing things because document file sizes are also affected by the number of layers and alpha channels present and whether the file has been compressed or not. Nevertheless, referring to image sizes in megabytes has become a convenient shorthand when describing a standard uncompressed TIFF file.

The digital resolution therefore refers to the fineness of the output – the number of pixels per inch or centimeter used to construct the final print. So if we have a digital image with a dimension of 3000 pixels, the same image can be output either 10 inches at a resolution of 300 pixels per inch or 12 inches at a resolution of 250 pixels per inch. This can be expressed clearly in the following formula: pixel size = physical dimension \times (ppi) resolution. In other words, there is a reciprocal relationship between pixel size, the physical dimensions and resolution.

Terminology

Before proceeding further let me help clarify a few of the confusing terms used when describing resolution and their correct usage.

ppi: pixels per inch. Describes the digital resolution of an image. The term dpi is often used to describe digital resolution as well. Scanners, for example, are sometimes advertised with scanning resolution expressed in dpi. Monitor resolution is also specified in ppi: Macintosh monitors commonly have a resolution of 72 ppi, whereas PC monitors are usually 96 ppi. One of the benefits of the Macintosh default resolution of 72 ppi (which dates back to the era of the first Apple Macs) is that it helps graphic designers get a better feel for the weight of their fonts when laying out a page.

lpi: lines per inch. The number of halftone lines or 'cells' in an inch, also described as the screen ruling. The origins of this term go back way before the days of digital desktop publishing. To produce a halftone plate, the film exposure was made through a finely etched crisscross screen of evenly spaced lines on a glass plate. When a continuous tone photographic image was exposed this way, dark areas formed heavy halftone dots and the light areas, smaller dots, giving the impression of a continuous tone image when printed on the page and viewed from a normal distance.

dpi: dots per inch. Refers to the printing device used. Output printing devices are specified as printing to resolutions of 600, 1200 or 2400 dpi, for example. This tells you the number of printing dots it can print and not the number of halftone cells. The density of each halftone dot is constructed of smaller print dots. There is an optimum relationship between the printer dpi and the screen frequency (lpi) chosen. Generally speaking only the high resolution image setters (2400 dpi) are able to construct a fine resolution line screen frequency *and* with a good range of tonal gradation.

At the very least what you need to understand is that an image displayed on the screen at 100% does not represent the actual physical size of the image, unless of course your final picture is designed for screen use only, such as for the web or CD-ROM display.

Repro considerations

You can see from the above description, where the term 'lines per inch' originated. In today's digital world of image setters, the definition is somewhat archaic. You may here people refer to print output as spi: samples per inch, where the samples are a conglomerate of fine dots making a cell or rosette. The distribution pattern being repeated so many times per inch.

The structure of the final print output appearance bears no relationship to the pixel structure of a digital image. A pixel in a digital image does not equal a cell of halftone dots on the page. To explain this, if we analyse a CMYK cell or rosette, each color plate prints the screen of dots at a slightly different angle, typically: Yellow at 0 or 90 degrees, Black: 45 degrees, Cyan: 105 degrees and Magenta: 75 degrees. If the Black screen is at a 45 degree angle (which is normally the case), the (narrowest) horizontal width of the black dot is 1.41 (square root of 2) times shorter than the width of the Yellow screen (widest). If we extend out the width of the data creating the halftone cell, then multiplying the pixel sample by a factor of 1.41 would mean that there was at least a 1 pixel width of information with which to generate the black plate. The spacing of the pixels in relation to the spacing of the 45 degree rotated black plate is thereby more synchronized.

For this reason, you will find that the image output resolution asked for by printers is usually at least 1.4 times the halftone screen frequency used, i.e. multiples of $\times 1.4$, $\times 1.5$ or $\times 2$. Which is best? Ask the printer what they prefer you to supply. Some will say that the 1.4:1 or 1.5:1 ratio produces crisper detail than the higher ratio of 2:1. There are also other factors which they may have to take into account such as the screening method used. Stochastic or FM screening, it is claimed, permits a more flexible choice of ratios ranging from 1:1 to 2:1. If you want the very best results, then trust your printer's advice.

Image size is therefore determined by the final output requirements and at the beginning of a digital job, the most important information you need to know is:

- How large will the picture appear on the page, poster etc.?
- What is the screen frequency being used by the printer how many lpi?
- What is the preferred ratio used to determine the output resolution?

This information needs to be known ideally before the image is scanned (or captured with a digital camera). When shooting film, potentially high resolution images are captured without any extra cost penalty in storage or time, even though only 10 MB worth of RGB data will actually be used. If the specification is not available, then the only alternative is to scan or shoot at the highest practical resolution and resample the image later. The downside of this is that large image files consume extra disk space and take longer to process on the computer. If a particular project job requires none of the images to be larger than 10 MB, then you'll want to know this in advance rather than waste time and space working on unnecessarily large files.

Altering image size

If the image pixel dimensions are not quite right, it is no big deal to trim the size up or down to the exact pixel. This process is known as resampling. Image data can be enlarged or reduced by an interpolation method which approximates the missing pixels – creating new ones, guessing their correct tonal values. With an image open in Photoshop, choose Image > Image Size. The dialog box shows all the information relating to file size: the pixel dimensions, physical dimensions and resolution. Any of these values can be changed. Of the three interpolation methods available, Bicubic provides the best quality for resampling continuous tone images.

I consider 'interpolating up' an image in Photoshop to be preferable to relying on the interpolation found in basic scanner software. On the other hand, there are better solutions like Resolut and ColorShop which are used to good effect when interpolating digital capture files. Interpolation works most effectively on a raw scan – one that has not already been sharpened. Unsharp masking should always be applied last as the file is being prepared for repro. Interpolating after sharpening will enlarge the image artifacts introduced by the sharpening process. Another tip for getting the best results out of Photoshop interpolation is to do it in stages, increasing or decreasing the resolution by 50 ppi at a time. Start with an image at 300 ppi (or make it 300 ppi in the Image Size dialog box) and reduce to 250 ppi, 200 ppi, till the pixel dimensions get close to the desired number.

I was speaking to a photographer who works in an all digital studio using the Leaf DCB system. He claimed a 12 MB sized original had successfully been blown up to 70 MB using ColorShop. This was pushing interpolation to its limits, but the output was still just about acceptable.

There are no definitive answers to the question how large does a file have to be to print at 'X' size? High-end bureaux process their images for advertising at around 7000×5000 pixels (approx. 100 MB in RGB) or larger and supply proofs to the

client on 10×8 film interpolated up to 200–300 MB. Working from the master file, they can create the color separations to reproduce the advert in either a quarter page newspaper or on a bus shelter poster site using different conversion specifications. For them, working with large file sizes is the only way to guarantee being able to meet clients' constantly changing demands. The resolution required to illustrate a glossy magazine double page full-bleed spread is around 60 MB RGB or 80 MB CMYK. Some advertising posters actually require smaller files than this, because the print screen is that much coarser. Once an image has been scanned at a particular resolution and manipulated there is no going back. A digital file prepared for advertising usages may never be used to produce anything bigger than a 35 MB CMYK separation, but you never know – that is why it is safer to err on the side of caution – better to sample down than have to interpolate up. It also depends on the manipulation work being done – some styles of retouching work for advertising are best done at a magnified size and then reduced.

At the beginning of the chapter I said that a 96 MB file reproduced 50×50 cm would match the quality of a photographic print from a 120 format negative. That gave an indication of the resolving power of film. In the real world of publishing, whether the original is film or digital, it is still going to end up as a digital file for repro. However you work, even assuming every picture you take is always super sharp, most of the photographic detail is never seen by anyone except the photographer and client examining the original with a magnifying Lupe.

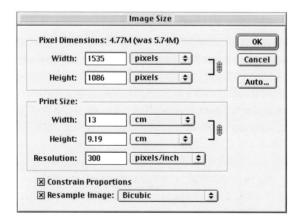

Figure 2.1 To change the image output resolution without altering the physical size, check the 'resample image' box and enter a new resolution. To change image output dimensions without altering the resolution, leave the 'resample' box unchecked.

I have surprised myself by just how large a small file can be successfully blown up using continuous tone processes. In theory the larger a picture is printed, the further away it is meant to be viewed and the resolution does not have to alter in order to achieve the same perception of sharpness. For example, an RGB file of just 13 MB can reproduce at A1 size and look great at a normal viewing distance. Similar sized digital files have reputedly filled the sides of hoardings. These are the limits though, and one is treading a fine line here, below which the quality will never be sharp enough at normal viewing distance (except at the smallest of print sizes). It also depends on the image subject matter – anything containing a lot of mechanical detail will need a greater number of pixels to capture the subject successfully, but the same rule would not apply for a picture of clouds.

Practical conclusions

Amidst all the conflicting opinions on how large a digital file should be, I find the guidelines given by some of the photographic picture libraries instructive. Photographers who submit digital work are asked to supply digital files of around 40–50 MB RGB and certainly no less than 25 MB. The thinking is that for the vast majority of picture purchases, these file sizes will be ample and in fact the vast majority of pictures purchased are probably printed using 20 MB of RGB data or less.

The Photoshop software is highly regarded by the professional retouching industry for its rich features and wide range of plug-in filters. The only thing really holding the program back is the hardware on which it is operated. Faster, multiprocessor computers equipped with large amounts of RAM memory are starting to snap at the heels of more costly setups. In theory, Mac and Windows super systems will be the way forward for economical, professional quality image editing. If you consider some of the system changes implemented in Photoshop 5.0 like scratch disk support extended to up to four scratch disks of 2 gigabytes each, that RAM memory is getting faster and there is the option to install a gigabyte of memory in some desktop systems you can see why competing image editing systems are beginning to feel the pinch.

One can be sure of this though, that in any magazine publication you care to look at, the screen resolution used to print all the images therein is mostly consistent throughout, yet there is probably just as wide a variety in original digital file sizes used as with the formats of film with which the photographs were taken. At the end of the day, all these pictures – however generated and tweaked – have to be resampled to suit the resolution and color space of the magazine print press and to be judged on equal merit. In the past I have had lengthy discussions with both photographers and

clients who insist nothing less than a 10×8 sheet of film will provide good enough quality for advertising work. I do believe an overobsession with 'pixel correctness' gets in the way of appreciating just how good the technical output quality can be from smaller format cameras or what can be created on a modest computer desktop setup in the hands of a talented artist. And this obsession with numbers and achieving the highest technical excellence sometimes misses the point of why people want to use Photoshop. Not everything must be judged against the highest benchmarks, otherwise we would all still be using plate cameras to shoot everything and photography using 120 and 35 mm cameras would never have happened.

To go back to the above example of a glossy magazine, I have seen close-up original art proofs destined for these publications: on the one hand a large format transparency output for a global fashion business advert which could have come from a 100–200 MB file and on the other hand a series of Pictrograph RGB prints for a fashion spread, which would have been printed from no more than 28 MB of RGB data. To my eyes both looked equally superb when printed in *Bazaar* magazine. Leaving aside the fact that you can't reproduce all that sharp detail in even the best magazines, isn't the visual and creative impact what counts most of all?

So if we analyse all the printed images in a single publication, we can see many different production routes being taken to reach the same end result. One photographer shoots color negative film, has a C-type print made and this is scanned as final art. Another supplies a transparency to scan from and in both cases the scan is made direct to CMYK at near enough the exact resolution required. Someone else might be shooting digitally and sending images direct by ISDN and if shot on something like the Leaf DCB, interpolated up to fit the page (if not done so already). An advertising agency will commission their bureau to produce separation films which match the exact requirements of the magazine printing press and the files produced will originate from a very large RGB file, but lots of data will have to be ditched in the process. The list could go on to itemize the other types of scanning processes used, not to mention the formats the images were originated on – all these factors have some bearing on the printed results and if it looks good, who is to say which is the right or wrong method?

An enormous industry was based around photographers supplying films to clients, who made positional scans for layout purposes, who in turn then sent the film for repro scanning at the bureau/printer, making separations and producing the final print. Along comes a photographer armed with his or her desktop computer and Photoshop, offering to cut out a large chunk of the repro process, supplying repro quality digital files themselves. Tread on somebody's toes once and they won't like you very much. Stamp all over them and they begin to squeal (loudly), especially if

they believe you don't have a clue what you are talking about. This has been the problem lately: photographers and others jumping in at the deep end, getting involved in the repro process and finding themselves in confrontation with the established repro and bureau service companies who are not happy at losing their scanning/retouching business.

Output use	Resolution	Pixel size	MB (RGB)
35 mm transparency	2400 ppi	3400 × 2270	22
6 x 6 cm transparency	1200 ppi	2650 × 2650	20
5 x 4" transparency	1000 ppi	5000 × 4000	57
10 x 8" transparency	1000 ppi	10000 × 8000	230
A5 Postcard print	267 ррі	1560 x 1100	5
10 x 8" print	267 ррі	2670 x 2140	16
A4 Pictrograph print	267 ррі	3120 × 2210	20
A3 Pictrograph print	267 ppi	4420 × 3120	40

Figure 2.2 How large does a digital file need to be? Above examples indicate the RGB megabyte size and pixel resolution for various film transparency and Pictrograph print output uses.

Output use	Output resolution	Screen ruling	MB (RGB)	MB (CMYK)
Screen resolution display	72 ppi		900 K	
Newspaper single page	170 ppi	85 ррі	22	30
Magazine single page	300 ррі	150 lpi	25	33
Magazine double page	300 ррі	150 lpi	50	66
6 sheet poster	75 ppi	150 lpi	30	40
48 sheet poster	75 ppi	150 lpi	75	100

Figure 2.3 When it comes to reproducing digital files for printed use here is a rough guide to the sort of file sizes required. Notice that the 48 sheet poster does not require that much more data than a full-bleed, double page glossy magazine spread. These are approximate figures and apply to RGB files (for comparison with the above table).

Now, obviously, repro specialists know best when it comes to getting the best printed results, but remember they have a vested interest too in keeping the likes of you out of the equation. This leads to occasional 'secondhand car salesman' type tactics, designed to make you look foolish in front of the end client, but I reckon companies with attitudes like these are dying out now. The smart businesses recognize the digital revolution will continue apace with or without them and they have to continually adapt to the pace of modern technology and all its implications. Besides, repro companies are getting into digital photography themselves. The boundaries between our industries are constantly blurring. Learn as much as you can about the reprographic process, know your limitations and seek the advice of your bureau with regards to preparing your files and achieving the best results in print. The good companies will be cooperative. If you think you're being given the runaround, find someone else who will help you. In London, a few of the major color laboratories have expanded to provide a wide range of digital bureau services including the supply of custom film separations. I find they understand both the repro business and photographers' needs. It is an important backup service to have at one's disposal. I for one am not interested in rocking the boat any more than necessary. However, whenever I encounter a problem with a printer concerning my supplying digital files, the bureau I use can be relied upon to step in and do the job instead: from separations to print finishing, and to the client's total satisfaction.

Chapter Three

RGB and CMYK Color

his is a challenging subject to be discussing so early in the book, principally because among the photographic community, there is no clear consensus on working in RGB or CMYK color. Every time the subject is brought up, you can guarantee a wide ranging discussion comparing the merits of working exclusively in either color mode, when the conversion takes place and should you the photographer be responsible for this?

First, what are the RGB and CMYK color modes? You will be familiar with RGB color, because if you take color photographs, your transparencies and prints are made up of yellow, magenta and cyan dyes which absorb light from the blue green and red portions of the spectrum. The film therefore records in red, green and blue colors. The RGB color space is very large and includes many of the colors within the visual spectrum and few outside it. A large format, beautifully exposed transparency of a landscape will look great masked off on a lightbox, but when it comes to reproducing that same image in print it needs first be converted to CMYK (Cyan, Magenta, Yellow and black or Key color). This is where the disappointment often sets in, because compared with the millions of colors that exist in RGB, a far more restrictive palette is available in CMYK. Some colors are particularly difficult to reproduce accurately, so some subject areas in this landscape picture example, like green grass and blue sky, may well be hard if not impossible to match exactly to the transparency original.

Color photographers have always worked in RGB, supplying RGB originals as final art work and the difficulties concerning CMYK conversion were always someone else's problem. Except now, by getting involved closer to the point where the files

are prepared for printing, that is no longer the case. If you are handling digital images, CMYK conversion should be very much at the front of your mind. You might argue: Everything originates in RGB color – transparencies, prints, scanned images and digital cameras even – why don't I stick to working in RGB mode and make the conversion later, or let the printer do this? I believe we are seeing a shift towards this way of working for reasons that shall be explained later. In the meantime we have a situation where the expensive high-end scanners used at the printers both scan the image and create a good CMYK conversion, or rather the skilled scanner operator oversees the conversion using sophisticated, expensive kit. Printers have never before worked digitally in RGB color mode because there has never been any reason why they should – hence a reluctance to work from RGB files and sort out what is seen as *your* problem.

In essence the printers are reasonably enough covering themselves from the responsibility of converting your digital images to match the standard of CMYK output obtained with their own high-end equipment. If you are going to supply images digitally, your production route will overlap with the services provided by a professional repro company. If the digital files you submit do not fit in with that production process, you'll suffer the humiliation of work being thrown back at you as unusable. As yet, converting an RGB file to CMYK is not a generally recognized bureau service option, unless you were to write a transparency from the digital file and supply this as an RGB original for the printer to scan from again, for them to carry out the conversion. This of course will incur extra delays and costs to the final client, so is not always a sensible route. The basic problem is if you supply an RGB file, what are you converting those colors to?

The advent of digital cameras is forcing a rethink. If you the photographer shoot film, get it scanned and supply a digital file, the printer might argue that they need the original film to scan from themselves. If digital capture takes off, that option will no longer exist, so one way or another the RGB to CMYK issue will have to be resolved. The early adopters of digital camera systems were repro houses and they are therefore having to investigate ways and means of handling RGB files and the use of independent hardware/software solutions to carry out the conversion to CMYK. If professional quality digital cameras become more widely used (as is expected), either we photographers will all be (a) making transparencies from our digital files and sending these to be scanned again at the printer or (b) supplying digital files direct. As I see it, the only issue really is whether the files will be converted by the originator or the printer to CMYK. So how do photographers currently address these issues? To illustrate the above points I have outlined a few scenarios.

The 'all CMYK' route

Ian McKinnell is an editorial photographer and experienced Macintosh Photoshop user (one of the first UK Lisa Mac owners in fact). Most of his work is destined for one time usage in magazines. He shoots all his pictures, whether people or still life, using 5 × 4" transparency film and has the chosen pictures drum scanned at his bureau (with transparency originals this size, there is no discernible grain in the digital image) to produce approximately a 35–40 MB CMYK file. The CMYK scan is made specifically for the requirements of the publication's printer settings. Ian does all his retouching and manipulation in CMYK and supplies the magazine with a digital output without ever producing a hard (printed) proof. As Ian says, why work with colors that will never print? The CMYK conversion takes place right at the beginning of production and this avoids difficulties of RGB to CMYK conversion and problem colors. He has a good rapport with the bureau who supply the scans. If as in the early days, a client's printers get funny about handling his digital files, he can even (via the bureau) go one stage further and supply his own repro ready CMYK films.

This working method does have an elegant simplicity to it. The CMYK conversions are all carried out by the same company and the photographer can build a good working relationship with the scanner operator. Color consistency is more reliable too. The drawbacks are the lack of Photoshop features available when working exclusively in CMYK and the 25% increase in file size you get with four channel CMYK as opposed to three channel RGB. For many production jobs this is the best way to proceed. The speed penalty incurred by working in CMYK should not be too much of a problem provided you boost the amount of RAM memory. One of the bureaux I use even provide a CMYK scan on Photo CD to your precise printer settings in addition to the standard Image Pac for the same cost as a high resolution scan. You can see an example of Ian's work, showing how he constructed the Red Dwarf *Radio Times* cover, in Chapter Nineteen.

The versatility of RGB

A major advantage of working in RGB is that you can access all the bells and whistles of Photoshop which would otherwise be hidden or grayed out in CMYK mode. Mixed final usage also needs to be taken into account – by this I mean jobs where the final picture may be used in a variety of ways and multiple CMYK separations made to suit several publications, each requiring a slightly different CMYK conversion because CMYK is not a 'one size fits all' color space. High-end retouching for advertising usage is usually done in RGB mode and a large format transparency output produced. That transparency can be used as an original to be scanned again and

converted to CMYK but the usual practice is just to use the transparency output for client approval and produce CMYK conversions and film separations direct from the digital file to suit the various media publications. When you think about it, a transparency proof for all its glory is actually quite useless considering the end product is to be printed on paper. The ideal proof should be a CMYK output printed on the same stock as that used for the final publication.

There is life beyond CMYK, I should not forget to mention Hexachrome printing: a six-color ink printing process which extends the range of color depth attainable beyond conventional CMYK limitations. This advanced process is currently available through specialist print shops and suitable for high quality design print jobs. Millions have been invested in the presses currently used to print magazines and brochures, so expect four-color printing to still be around for a long time to come, but six-color Hexachrome will open the way for improved reproduction from RGB originals. Photoshop supports six-color channel output conversions from RGB, but you will need to buy a separate plug-in utility like HexWrench to do this. Spot color channels can be added and previewed on screen – spot color files can be saved in DCS 2.0 or TIFF format. How about screen based publishing – Multimedia CD-ROMs and the Internet? Viewers who have monitors displaying more than the basic 256 colors will appreciate the color depth of a fuller RGB color range. Again, if you are working in these areas or are producing images for mixed media, there is no reason why you should always be limited exclusively to CMYK.

Photoshop conversions

You may have been told that Photoshop does a bad job of converting from RGB to CMYK. Well, I would suggest that one of the most important breakthroughs Adobe achieved with Photoshop 5.0 was to address precisely this issue – that of color management and improving color conversions. Even prior to version 5.0 you could say that the problems people experienced converting to CMYK lay in the difficulty of converting out of gamut colors and a lack of understanding configuring CMYK separation setup settings properly. Photoshop now does a very good job of managing color, provided you understand how to calibrate your system and monitor correctly. For advice on calibration and the color settings, refer to Chapter Six.

If the original RGB colors are way out of gamut, i.e. outside the CMYK color space, you can check this: choose View > Gamut Warning. Pixels which fall outside the CMYK color space are displayed with the chosen gamut warning color (see preferences: Transparency & Gamut). To continue working in RGB but at the same time view the image in CMYK, choose View > CMYK Preview. With the preview switched on, you can access all the commands and filters which would otherwise be unavail-

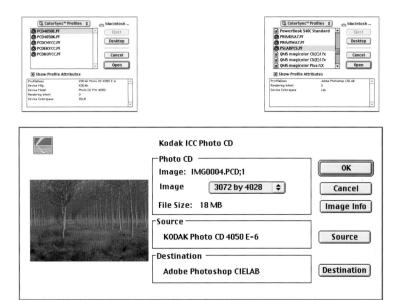

Figure 1.3 The Kodak designed Open PhotoCD interface for Adobe Photoshop 5.0. The top left dialog shows the 4050 E-6 source profile being selected. Top right, the Adobe Photoshop CIELab destination transform. Unfortunately, it is now more difficult to identify the correct transforms, without clicking on each one in turn and reading the description from the window below.

The dialog box which now appears offers several choices. First, choose the resolution size for output, i.e. Base 16, 18 MB. Click on Source to choose the film type of the original (if unsure, click Info – original film type and scanner information will be displayed). You can choose between Universal Ektachrome, Kodachrome or Color negative. Choose the latest version numbers, or if you know the Pro Photo CD scan was made using a 4220 work station, select one of the 4050 transforms. Next select Destination and choose between Adobe Photoshop RGB or Adobe Photoshop CIELAB color spaces. Remember, the Kodak YCC color mode is based on the CIELAB color model. Selecting CIELAB color will ensure transfer of the fullest range of tonal detail possible. The CIELAB gamut can handle shadow and highlight detail which might otherwise be lost. Opening a PCD file with the 'Adobe Photoshop CIELAB' transform, followed by making basic Levels adjustments and then converting to RGB mode is better than simply opening directly with the Adobe Photoshop RGB transform. The latter is prone to clipping of image shadow detail. Opening via the CIELAB transform, making Levels/Curves adjustments and converting to RGB is the best route for the majority of cases, except where there are lots of blues in the image. The CIELAB transforms are a bit on the red/magenta side. I like to adjust the color balance slightly afterwards and selectively desaturate the red and magenta using Hue/ Saturation.

Precision Transforms

Precision Transforms or PTs are fundamental to the Photo CD concept of 'device independence'. All types of film format are scanned with the aim of near enough mapping the digitized information to fill a standard color space. When opening a PCD file, select the Precision Transform which most closely matches the film original. The very latest transforms are the Pro format 4050 E-6 and 4050 K-41 for E-6 transparency and Kodachrome films respectively. Selecting either of these will improve the quality of the imported image, particularly in the shadow detail of reversal films.

Opening a Photo CD image

I don't know why, but in the past Kodak were not particularly helpful directing their customers as to the correct way of opening a PCD image. You would think it was fairly straightforward. In response to consumer demand, many bureaux took it upon themselves to produce their own leaflets explaining how this should be done. The main things to be aware of are: first, not to go near the PHOTOS folder (see below), and second seek a supplier with the very latest PIW (4220 work station) and make sure you have the above Precision Transforms installed. However, Kodak are going to be supplying better customer guidelines in the future. But in the meantime...

The standard Photoshop installation will install all the necessary plug-ins necessary to open an image from a PCD disc, but you may find the extensions have been temporarily switched off or disabled. First, go to the extensions manager (Mac system) and check to see that all the KODAK PRECISION and CD-ROM extensions are switched on. If not, do so now and reboot the computer.

NB: The easiest mistake Macintosh users can make is to go direct to the folder marked 'PHOTOS' either direct from the CD or opening within Photoshop. These PICT format images (for TV monitor display) are not suited for Reprographic output as the highlight tones tend to be clipped.

- Insert the Photo CD disc into the CD-ROM drive.
- With Photoshop loaded, open the image required via the File > Open menu.
- Click to select desktop and open the PCD icon.
- Go to the 'Photo CD' folder. Open the folder marked 'IMAGES'.
- Check the indexed print on your CD for the image number and click 'Open'.

of the Image Pac structure is that you can easily access the appropriate resolution required for any usage without having to open the very largest sized file and resample down. The Kodak software enhancements for opening Photo CD images also optimize the image detail for whichever resolution you choose.

Photo CD is device and platform independent. The Photo CD Imaging Work station (PIW) operated by the bureau, scans transparencies, B/W and color negatives and matches the data output for all these different input sources ready to be accessed by a computer running either the PC or Macintosh system.

The images are scanned at the bureau on the PIW and converted to Kodak's Photo CD YCC storage format. This format stores color information using a method based on the CIE or L*A*B color model (see Chapter Three). Almost all the image detail is recorded in the Y (luminance) channel. The two chroma (CC) channels record the color information – these contain little image detail and can be compressed to a smaller size. Finally a hierarchy of resolutions is created which forms the image Pac.

Optimum Photo CDs

The scanner operator working on the PIW has limited control over the making of PCD scans. Included with every work station is a Scene Balance Algorithm (SBA) control, which will automatically read an image and make adjustments for incorrect camera exposure or variations in color temperature (just like the automated devices used in optical printers at photo finishing labs). The operator can override or reduce the SBA to taste. Or as is more likely, in the case of handling professionally shot reversal films, stick to using the 'Universal Film Terms'. This will retain the original appearance of the image as it appears on film. To explain this more clearly, the PIW records the information from the film on the basis that it is correctly exposed and has the correct lighting color balance, retaining the original film's unique characteristics.

The aspect ratio of the scanning area is 2:3. Therefore 35 mm or 6×9 cm film formats make best use of the available area. The PIW mask holders will accept any other format up to 5×4 but bear in mind that with 6×4.5 cm or 6×6 cm transparencies where you want to crop to a portrait or landscape format, you will make use of only half the total scanning area. A 35 mm full framed image scanned at standard resolution will yield a maximum image size of 18 MB, while with a 6×4.5 cm image you only get 9 MB of usable data. For these film formats you will certainly only want to have high-res 72 MB Pro Photo CD scans done, which will provide a 36 MB image (less if you want to crop within the full frame).

Cost

Labs/bureaux offering the Kodak Photo CD service can supply the processing of a roll of film, transparency or negative plus transfer of all the images to a Master CD disc as an inclusive package. Depending on where you go, it can work out at less than a pound per scan including the film processing, though in addition you will have to purchase the CD disc. A Master disc can store up to 100 standard resolution (18 MB) 35 mm scans, while the Pro disc can store 25 individual high resolution (72 MB max) scans from either 35 mm, 120 or 5 × 4 films. Pro Photo CD scans cost around £20 each plus £20 for the Pro Photo CD disc. These charges compare with £40–£100 for high-end drum scans.

Image quality

Is it any good? Kodak have worked closely with professional bureaux with the aim of constantly improving the quality. Leading bureaux are prepared to offer Pro Photo CD scans as a cheaper alternative to drum scans. At Tapestry in Soho, London, I was shown examples of CMYK Cromalin proof outputs from both a Hell Color scanner and Kodak Pro Photo CD. There is a perceptible difference between the two when they are compared side by side, but it is hard to fault the Photo CD scans when the printed results are viewed in isolation. Quality is dependent too on the operator who is preparing your scans, but I'll come to this later.

Archive storage

Digitized images are written to disc in a lossless (compressed without loss of detail) format, making Photo CD an efficient and cheap storage medium for archiving images. Scanned images consume precious disk space, which adds to production costs, especially if you are having to store both original and manipulated versions. With the cost of process + scan package deals being as cheap as they are, one can easily build an archive library of skies, elements and textures etc.

The Image Pac

The Photo CD format contains a pyramid structure of 5 resolutions from Base/16 (used to create the thumbnail index card images), up to 16 Base (18 MB) for output as a 10×8 photographic quality print. The Pro Photo CD disc can also store 64 Base (72 MB) images scanned from any film format up to 5×4 sheet film. The advantage

able in CMYK mode and see how the results would look after a conversion. RGB colors with no equivalent CMYK value have to be modified somehow to fit within the CMYK color space. When colors in your RGB image fall far outside the CMYK color space, the conversion process may cause clipping to occur – saturated colors block out, just as lost highlight detail results in washed-out image highlights. Other 'illegal' colors appear almost gray in comparison to their original RGB form. Once a conversion has been made, then all this detail may become lost. That is why working with the Gamut Warning or CMYK Preview switched on while still in RGB allows the opportunity to make corrections before the conversion (see Chapter Nine on advanced color adjustments for more information as to how to modify an RGB image before converting to CMYK).

CMYK and monitor display

When evaluating a digital image in CMYK mode, you are doing so by viewing a light transmitting RGB device. In theory the contrast of this compared with light reflecting CMYK inks on paper could not be greater – true CMYK only exists with the proof or final print output. On the whole, once a monitor screen has been calibrated, it is possible to 'soft proof' something on screen and get near enough the same perception of color as will appear in print, but under certain circumstances the margins of error are quite noticeable. One must be clear as to whether this is due to the CMYK color conversion or the monitor display. You won't always notice something is amiss, except when working with a range of colors that are hard to reproduce on a monitor, like yellows, for example. The only sure way to tell is to run a proof.

This tells you that the Photoshop CMYK monitor display is not real CMYK color and to make matters even more complicated, nor is RGB a standard color space either. Both color modes are described as being 'device dependent'. Just as CMYK color spaces differ depending on the color gamut of the print process, so all RGB devices vary in color performance. RGB devices include scanners, monitors and digital cameras. Look at a display of television sets in a shop and you'll notice each one produces a different looking picture, even though all are tuned to the same broadcast source. Computer monitors for graphics work are built to higher tolerance specifications and some allow more user control over the display – which is one reason why you pay a lot of money for them. Some makes of monitor will display the RGB spectrum more effectively than others. To soft proof from the monitor screen requires a certain familiarity – a feel for how colors will reproduce in print, plus paying attention to details, like maintaining consistent lighting conditions and regularly calibrating your RGB devices.

What was really needed was a universal color mode, a frame of reference which could describe all the colors of the visual spectrum. This was a task set way back in 1931 before the advent of digital imaging, by the Commission Internationale de l'Eclairage. The three dimensional CIE color space describes color in terms of values mapped on a three dimensional axis. One axis describes the luminance value and the other two the color or chroma values. Using this model, all perceptible colors within the visible color spectrum can be specified and the CIE color gamut is consequently larger than either the CMYK or RGB color spaces. Colors specified using the CIE model encompass the spectrum of all RGB and CMYK color gamuts and for that reason is ideal as a 'device independent' color space used for translating color values between RGB and CMYK. The Adobe Photoshop CIELAB and Kodak Photo CD YCC formats are both based on the CIE model, using three channels: one to define luminance, one to describe the transition of color values from magenta to green and the third from yellow to blue. You will note in the first chapter I advocated opening PCD images to the Adobe Photoshop CIE Lab color space. The image is still displayed in RGB, but the Lab color mode is capable of containing a color space (and color information) which extends beyond the display limitations of your monitor. The conversion to CMYK can also usefully take place direct from Lab.

Photoshop 5.0 color management

I'll be referring to Adobe color management again in more detail later on, but what Adobe have done is to make the RGB color space independent of the monitor RGB space and therefore the RGB 'workspace' is now 'device independent'. Lab still plays a part in converting CMYK values from RGB, but by making the RGB space separate to the monitor, we can potentially work in a standardized RGB color space, share image files more easily between systems and across computer platforms, maintaining color consistency, because the RGB space can be specified as one of several recognized industry standards.

Imagine a scene where you have a group of mixed language speaking people gathered together. All of them are multilingual and able to communicate fluently in different languages, but they have a problem when it comes to using obscure words which have no direct equivalent in the other listener's native tongue. However, because the English language has the wider vocabulary, they resolve these problems by translating to the English and then use the other person's English dictionary translation to discover the nearest equivalent. That basically is what happens when a color management system converts digital information from one RGB device to another or prepares an RGB/Lab image to go to a CMYK output destination. It recognizes the unique characteristics of all known scanners, cameras, monitors and output devices and takes control of maintaining an accurate transition from one device to

another. Successful employers of color management boast of being able to work entirely in a digital medium: scanning from a variety of scanner sources, soft proofing on the monitor screen and writing CMYK outputs to a dozen or more different presses. By selecting the appropriate input and output color profile at every stage, the color should remain consistent throughout. So if one were to scan an original transparency on two separate systems and output to different printers, the colors should look very similar (given that the print characteristics would vary slightly).

That is the theory and what can and does happen in practice, but to get there, all the pieces of the color management jigsaw must first be in place, so let's start with calibrating the system. In the studio, photographers use daylight color corrected lightboxes to preview their transparencies and in the larger design organizations, work will be checked in a viewing room under specially calibrated lighting conditions, while in all likelihood, the client holds the transparency up to an angle poise lamp or fluorescent strip light to check the quality. A similar thing applies to calibrating viewing monitors. If Photoshop users are working with a decent quality monitor and follow the calibration setup guidelines (again it is very important you read through the section in Chapter Six on calibration) there will be a similarity between the viewing appearance of the image from one system to another. At the high-end level, only the most expensive monitors which incorporate automatic calibration checking routines will guarantee the fine degree of color consistency demanded when trying to match exact shades of color from original to print. As for the client, I guess it does not really matter how they choose to view the pictures, so long as they don't then complain the colors look wrong!

So the first thing you should do is follow the Adobe Photoshop manual instructions and optimize the display which will include at the operating system level selecting the appropriate Monitor ICC profile or generating one of your own using the Adobe Gamma control panel. Remember that cathode ray tube monitors take about half an hour or more to fully warm up. Another thing to bear in mind is that monitor brightness and color balance will change over a period of time and fluctuate slightly on a daily basis. If the room lighting conditions alter during the day, that too will affect the perceived monitor performance. The daily fluctuations may be very slight but to perfectionists, for whom color accuracy is essential, spectrophotometer type hardware devices can be used to accurately measure the screen color output and regulate the display within fine tolerance limits. If this is the sort of thing you think you will need, then Barco, Hitachi, Light Source Colortron and Radius Precision View have the kind of kit you should investigate further. It never ceases to amaze me that there continues to be such variance in monitor displays, even in professional environments like bureaux, where I've seen displays looking at least one stop brighter than the print output.

Color management systems

In 1993, Apple introduced ColorSync and incorporated it into the Macintosh operating system. Apple, as members of the International Color Consortium (ICC) helped develop platform-independent profiles for pre-press devices. ICC ColorSync profiles are now available for most known devices. Selecting the appropriate profile that matches your monitor and output device will help maintain color consistency throughout a project. High quality scanner and digital camera systems should have the necessary software drivers to automatically embed an ICC profile in the files, which Photoshop 5.0 will read upon opening (assuming the preferences are configured properly).

PC computers running on Windows 95 or later operating systems incorporate Kodak CMS color management. Kodak CMS you will remember is at the heart of Kodak Photo CD, which uses what are called Precision Transforms to define the Source (i.e. emulsion type) and Destination (color space or print output). Kodak profiles are not in such plentiful supply and some may have to be purchased separately. Photoshop, however, utilizes its own built-in color management system, based on ICC profiles. The color management system incorporated in Photoshop 5.0 is now designed to work identically for both modern Macintosh and PC systems. The ICC ColorSync profiles are based on a factory standard, which may not be accurate enough for everyone's taste. For absolute precision, use a calibration device or there are cheapish software packages now available which enable you to generate your own custom profiles of pre-press devices. Barco monitors have an internal self-checking system which monitors the screen performance throughout the day and compensates accordingly.

Manual (Built-in) color conversion options

Photoshop needs to know what sort of settings the printer requires to print on a particular paper stock. The CMYK separation settings must be input first before the conversion is carried out as these will determine the outcome of the conversion. The manual separation setup provides complete control, whereby you can enter the separation method and inks to be used as directed by the printer. This still gets us no nearer to working out what to do about converting awkward pictures containing RGB colors that are way out of gamut, so if you use the manual CMYK setup, the advantage (or disadvantage maybe) is that you tweak the RGB image in Photoshop beforehand using the CMYK preview (View > Preview > CMYK Preview) to see the impact after a conversion to CMYK.

If you have an image destined to be used in more than one type of print publication the answer is to carry out a separate CMYK conversion from the RGB master for each publication, changing the settings beforehand each time. Try to imagine the problem: you have an image with a full range of tones in RGB and it is to be printed on high quality paper in a glossy magazine. At this standard of printing, the dot gain (spread of ink on the paper surface) should be low. Enter the Separation settings and correct dot gain before converting to CMYK and the final file should print to match your screen. Suppose the same picture was then to be reproduced in a newspaper. This time you would convert the RGB image to CMYK but using different settings. The dot gain would be higher and the amount of ink density allowable, would be less to achieve a good result. In both examples the CMYK print outputs should ideally match according to the monitor view but the two sets of CMYK files are markedly different in appearance, yet they display the same on your computer. Many Photoshop users happily get by without worrying too much about CMYK, until that is they are faced with their first print job. Imagine the nightmare scenario where all the color gets drained out of an image after the conversion and they realize they have then got a big problem on their hands, because the printers are unwilling or, more likely, unable to help them out.

Color conversions using ICC profiles

An alternative to the manual method is to do a CMYK conversion using an ICC profile. At the top of the CMYK Setup dialog there are three buttons; if you click on ICC, the dialog box changes and in the pop-up menu you can select an ICC profile to match your print output. This can be a standard profile like 3M Matchprint Euroscale to match your output or a custom profile supplied by the printer. You have a choice of engines: for the best results I always recommend the Adobe Built-in engine (not to be confused with the Built-in manual conversion setup). For photographs and other images, use 'Perceptual' for the rendering intent. The conversion process will then map the out of gamut colors to the CMYK gamut and compress the other colors for you. Black Point Compensation should be left switched on if you wish to map the darkest neutral color of the source image to the darkest neutral color of the destination space, rather than to black.

This book dwells a lot on these color management issues because color should be of the utmost importance to photographers. Despite all you might have read or heard in the past about ColorSync and ICC profiles, this is a new, fresh approach to color management and deserves to be judged on its own merits. There have been a lot of converts to ICC based color management in the upper echelons of the repro industry, because it now works and the Adobe Photoshop Built-in ICC engine in particular provides a superior professional quality conversion.

My own first tests converting from RGB to CMYK using the Adobe ICC Built-in engine were extremely impressive. A brand new monitor had arrived that morning – I waited for it to warm up and all I had to do then was calibrate it using the Adobe Gamma control panel, select the right profile in CMYK setup and change the color mode in my test image from RGB to CMYK. The first Cromalin proof was to my mind 100% spot on. Photoshop 5.0's new color management system has the means to fit in with a device independent RGB workflow to produce high quality CMYK separations. The vast majority of print output may be done to CMYK, but with screen publishing to multimedia and the Internet, hexachrome printing and new technological developments such as the one just mentioned, RGB is anything but a redundant color space.

Chapter Four

File Formats

hotoshop supports an incredibly wide range of image file formats and can handle almost anything you care to throw at it – all the tools are there to open incoming files. Choosing which format to output your images with can be narrowed down to a handful of professionally recognized formats. Where and when you use these is explained in this chapter. While an image is open, it is effectively always in the native Photoshop format. The picture can be manipulated using any of the Photoshop features, some of which like layers and adjustment layers are only savable to the native format. If you open a PICT file image, you can make as many layers as you want, but to save back as a PICT, you will have to flatten the image first or otherwise overwrite in the Photoshop format. The first time you save (File > Save... or File > Save As...), some file formats may be dimmed (Macintosh) or not present (Windows). The image will need to be flattened or the color mode changed before being able to save in the desired format. If it is necessary to save an image with all the layers etc. intact, then choose to save as a Photoshop file. Saving is speedier this way and the file size is usually kept quite compact compared with the other formats. The File > Save a Copy... option is useful if you want to preserve the original file in its current format without renaming. A summary of format features can be found in Figure 4.4 at the end of this chapter.

TIFF (Tagged Image File Format)

This is one of the most common formats used when saving images. TIFFs support Photoshop channels and paths, so are quite flexible. Bureaux generally request that you save your output image as a TIFF, as this can be read by most other imaging computer systems. The bureaux I go to always request the picture is flattened and saved with all alpha channels removed. An uncompressed TIFF is about the same size as shown in the Image Size dialog box. The LZW compression (which appears in the Save dialog box) is a lossless compression option. Data is compacted and the file size reduced without any image detail being lost. Saving and opening will take longer when LZW is utilized. Therefore, bureaux request you do not use LZW compression. The byte order is chosen to match the computer system platform the file is being read on. Most software programs these days are aware of the difference, so the selection of byte order is now less relevant. TIFF files can readily be placed in Quark or PageMaker documents.

PICT

The PICT format is sometimes handy for archiving images which feature areas of contiguous colors (i.e. subjects against plain color backgrounds). The PICT format compresses the data very effectively without any image degradation, though files can additionally be compressed using various levels of JPEG compression. I would add though that there is nothing about PICT which the native Photoshop file format cannot do better and there are some size limitations with PICT.

EPS

Figure 4.1 The EPS Save dialog box.

For desktop publishing work, EPS (Encapsulated PostScript) files are the preferred format for placing images within page layout documents. The PostScript language is used by a printer to build the output on a PostScript device. EPS files can be either RGB or CMYK. The saving options include saving paths as a Clipping Path and Preview display. A clipping path can be specified if you have one saved in the paths palette or perhaps one generated by the Extensis Mask Pro plug-in. These act as an outline mask when placing your file into a page layout program.

Preview: the choice is between a TIFF preview which is supported on both platforms, or PICT (Mac only). A low resolution preview is created for viewing in the page layout.

Encoding: the choice is between ASCII or Binary encoding. ASCII is the more generic and suited to Windows platforms only, but generates larger sized files. Binary is faster. JPEG coding produces the smallest sized, compressed files. Use JPEG only if you are sending the job to a Level 2 PostScript printer. Bear in mind that image quality will become significantly degraded when you select lower quality JPEG compression settings.

Halftone Screen and Transfer Functions: for certain subjects, images will print better if you are able to override the default screen used on a print job. Transfer functions are similar to setting Curves. They do not alter the screen appearance of the image and are adjusted to accommodate dot gain output. The screen and transfer functions are defined in Photoshop. Check these boxes if you want information entered to override the default printer settings. If printing the same file to two different printers, you may wish to save one file for the final print job as it is and save another version for the proof printer specifying the use of preset transfer functions to compensate for the different printing characteristics.

DCS

Quark XPress uses a version of the EPS format known as DCS (Desktop Color Separations). This format enables Quark to read EPS files and create the color separations, generating five separate files: one preview composite and four color separation files. Photoshop 5.0 supports DCS as a separate file format to EPS: the old DCS 1.0 and the newer DCS 2.0 format, which combines all the separations and preview in a single file and supports more than four color channels, i.e. spot colors and HiFi color.

JPEG

The most dramatic way of compressing large files is with JPEG (Joint Photographic Experts Group) compression. For example, an $18 \, \text{MB}$, 10×8 " file at 300 dpi resolution can be reduced in size small enough to fit on a standard floppy disk and do so without causing too much degradation to the image. JPEG uses what is known as a 'lossy' compression method. The heavier the compression, the more the image becomes irreversibly degraded. If you open a JPEG file and examine the structure of the image at 200%, you will see what I mean – the picture contains a discernible

checkered pattern of 8×8 pixel squares, which when using the heaviest JPEG setting will easily be visible at 100% viewing. Compression is more effective if the image contains soft tonal gradations. Busy, detailed images do not compress so efficiently and the JPEG destruction becomes more apparent. Real time JPEG conversion is available with some programs, whereby the image is previewed showing the expected image degradation. This is only an approximation and so therefore has not been included as a feature in any version of Photoshop.

Once an image has been JPEGed, it is not a good idea to compress it a second time because this compounds the damage done to the image structure. Having said that, provided the image pixel size remains identical, the destruction caused by successive overwriting is slight (except in those areas of the picture which have been altered). This of course is not a good practice to follow. The idea with JPEG is that you can reduce an image one time only to occupy a much smaller space than the original file and do this for efficient archiving purposes, faster electronic distribution, or saving a large file to a restricted disk space. Still you will hear people claim that where professional quality counts, JPEG compression should not be used under any circumstances. All my digital pictures are archived using non-lossy formats, but I do not share this purist belief when it comes to getting quality images distributed via a modem or ISDN. Wildlife photographer Steve Bloom once showed me two Pictrograph print outputs. One of these was a 24 MB uncompressed original and the other a 2 MB JPEG version. Could I or any imaging expert tell which was which? Answer: no.

Saving with JPEG compression is how web designers make continuous tone photographic images small enough to download quickly on the Internet. Image quality is less of an issue here, so high compression is best. I use a Photoshop JPEG compression setting of 2–4 (1 if things get really desperate). The trade-off between sacrificing image quality in order to save on download times is definitely a price worth paying. When an image is properly sized and ready to be saved for the web, I choose File > Save As... > JPEG. I position the slider or enter a compression setting of 3 and click OK. Then I check the saved file size. If it is too big, I repeat the process, this time choosing a higher compression of 2 and check to see how much lower the size is. There is no quality problem repeating JPEG saves this way – while the image is open, all data is held in Photoshop memory. Only the actual saved file on the disk is successively degraded. Photoshop provides improved JPEG formatting including Progressive JPEG. The Netscape 4.0 browser supports this format enhancement, whereby JPEGs may download progressively the way interlaced GIFs do.

Preparing a JPEG for web use

I The image we start with is at least two or three times the destination web page size. It is preferable to make adjustments at this scale (but not too big) and reduce later. The monitors used to view the picture will all be of different brightness. One way to ensure your picture will look all right is to check the histogram display (Image > Histogram). An even spread of bars indicates that the picture can be read at various levels of brightness. Macintosh users may want to open the Gamma Control Panel (see Chapter Three) and select a gamma of 2.2 to simulate the screen brightness of a typical UNIX/PC monitor.

2 The blue channel, as is often the case, contains more grain than the others. To improve the image quality and later compression, soften the detail. The new Smart Blur filter or a small amount of the Median filter can be applied to smooth out the noise. Use the Fade Filter command if necessary to restore some of the original sharpness.

3 When it comes to reducing the image size, check the Resample Image box and set the new image size measurements in pixel units and make the image resolution 72 pixels per inch. You can judge how to sharpen the picture visibly on the screen. The trick is not to sharpen as much as you might do normally, keep in mind that UNIX and some PC monitors have a finer screen resolution (96 dpi), so the image will appear smaller anyway. Pictures with more detail and sharper edges do not lend themselves well to efficient IPEG compression. You may not be able to do anything about this, but if you can, selectively soften sharp edges in the areas that are not of central interest with the blur tool. Note that for screen display images, a resolution setting of 72 dpi, while having no impact on the pixel dimensions, is critical as far as some multimedia applications are concerned. They may otherwise scale your image to 72 dpi.

Client: Clipso. Model: Gillian at Bookings.

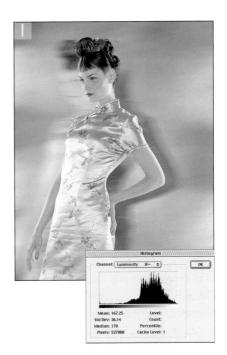

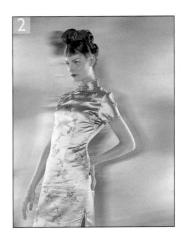

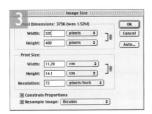

4 Finally save as a JPEG, choosing a low quality compression.

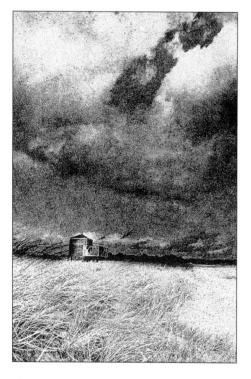

5 Check the final web image, it is not 34k, but actually uses just 31.8k of space. Mac files contain Macintosh specific resource information that is stripped out when uploaded as a Raw Binary image to the web server. This file then actually only measures 21k. Another version 1 prepared which was saved as a straightforward JPEG without the above tweaking, was 3K larger in size, almost 15% bigger. Small savings accumulate on a big site leading to swifter access download times.

Figure 4.2 Exception to the rule 1: this high contrast landscape image contains very few tones. As a 350 pixel tall JPEG the smallest I could make it was around 33 kilobytes. Not bad, but as a 6 color GIF it only occupied 18 kilobytes and with little comparative loss in quality.

Photograph: Davis Cairns.

Other file formats for the Internet

As far as publishing images on the web are concerned, only one thing matters and that is keeping the total file size of your pages small. In nearly every circumstance JPEG is the most effective way of achieving file reduction for continuous tone images. Graphics which contain fewer and distinct blocks of color are best saved using the GIF format. Occasionally one comes across a photograph to be prepared for a

Figure 4.3 Exception to the rule 2: the Index page graphic for the Association of Photographers web site would normally have been saved as a GIF (at around 20 kilobytes). The problem here was that the subtle gray tones looked terrible when dithered to the 216 color Web Palette. I therefore saved as a JPEG retaining the subtlety, making the size now 30 kilobytes, still keeping the total page size within a tolerable limit.

web page that would save more efficiently as a GIF (see Figure 4.2) and vice versa – some graphics which benefit from being saved as a JPEG (see Figure 4.3). Photoshop 5.0 includes expanded saving options, allowing you to omit saving non-image data, plus permit the use of lower case file extensions. The latter addresses an unfortunate oversight, many web servers are case sensitive and would not recognize capitalized file names.

GIF

GIF (Graphics Interchange Format) is normally used for publishing graphics and small thumbnail photographs on a web page (there are limits as to how much you can reduce a JPEG). To prepare an image as a GIF, the color mode must be adjusted to Indexed Color. This you will remember is an 8-bit color display mode where specific colors are 'indexed' to each of the 256 or fewer numeric values. So you choose a palette of indexed colors which are saved with the file and then save as Compuserve GIF or export to the GIF89a format (File > Export > Gif89a). The file is then ready to be placed in a web page and viewed by web browsers on all computer platforms. That is the basic concept of how GIFs are produced. Photoshop 5.0 contains special features to help web designers improve the quality of their GIF outputs. One such advance has been the ability to preview Indexed mode colors while in the Index Color mode change dialog box and an option to keep matching colors non-dithered. This feature will help improve the appearance of GIF images and reduce banding or posterization. When Preview is switched on, it will take a while for the display to reflect the image mode changes unless you are working on a screen sized image, which you should be anyway. Note that when designing GIF graphics, designs with horizontal detail compress better than those with vertical detail.

I The illustration here was prepared for a science web article and is in RGB color. The first step is to convert to Indexed Color mode. In the Indexed Color mode dialog box, select the Web Palette. This is a 216 color palette containing just those colors common to both Macintosh and Windows computer systems. For all web and CD design work this is the one to choose. You will find on the CD-ROM a websafe palette to add to your Swatches (in the Swatch palette submenu, select Load Colors... and sample these colors for use in all your web graphic designs).

2 Back to the Indexed Color mode dialog box, choose Diffusion Dither. This dithers the colors in the limited spectrum creating an illusion of greater color depth. If the Preserve Actual colors option is checked, this will prevent these colors from becoming dithered. Not all 216 colors are used in the display, a small saving in file size can be made by trimming the GIF file to contain an exact palette within the 216 color range.

Return the image mode back to RGB. The result of this action is an image in RGB color still built of 216 indexed websafe colors or less (but no more). The image looks the same as the previous 216 color indexed image, but is an essential step to reduce file size.

3 Return a second time to Indexed Color mode. The dialog box shows by default that you are now using a custom palette made up of 'x' number of colors. These are the exact number of indexed colors which make up the indexed image and are all websafe. Rather than choose File > Save, go File > Export > GIF89a. The dialog box displays the custom palette of indexed colors with a low resolution preview of the image in the box above. You can choose to interlace the GIF you are about to make and select one or more of the colors shown in the palette to be transparent (click on the color swatch, shift click to add colors). The suffix '.gif' is appended to the file name. Click OK to export.

PDF

Acrobat is an Adobe PDF electronic publishing format. Every time you install an Adobe software product using Easy Install the latest version of Acrobat Reader will automatically be updated to your hard disk. This freeware program is available for both Macs and PCs and readily available to install from consumer magazine CDs. Presentations on CD (like the Adobe Photoshop Tutorial CD) use Acrobat to display electronically published documents. Web sites too are using Adobe Acrobat to reproduce pages designed in PageMaker or Illustrator and which can be viewed almost exactly the way they were created. Best of all, Acrobat documents are small in size and can be printed at high resolution. The beauty of the PDF (Portable Document Format) is its independence of computer operating system and the fonts installed on the client's computer. I can create a document in PageMaker and export as an Acrobat PDF using the Acrobat Distiller program (this utility is available to be purchased separately). Anyone with the Acrobat Reader program can then open my document and see the layout just as I constructed it with the pictures plus text in the font I chose. An Acrobat file download link on a website will download the PDF document to the hard disk and automatically open the reader program for viewing while the visitor is connected on-line.

Importing multipage PDF files

Three new Photoshop parser plug-ins enable any Adobe Illustrator, EPS or single/multipage PDF file to be imported. Complete PDF documents can now be rasterized and batch processed to be saved as a series of page image files. The Import dialog box contains settings to determine the desired image resolution and color mode.

FlashPix

The FlashPix format is being jointly developed and backed by Eastman Kodak, Live Picture, Microsoft and Hewlett-Packard. It is based on the Live Picture IVUE pyramid structure format. High resolution images are viewed by a browser connected to a modem. To view the full sized image on the screen, a screen resolution preview

only is downloaded. If you zoom in to a small section, just the detail information in that area of the picture is downloaded to the browser. The viewer can inspect an image at full view and select any area in close-up quickly without at any time having to download the entire image.

When saving in the FlashPix format there are options for compression (with a choice of strengths) or no compression. As a Flashpix image is opened in Photoshop, a choice of image resolutions is offered - this is similar to the choice of Image PAC resolutions you get with Photo CD.

File Format	RGB	CMYK	Indexed Color	Grayscale	Layers	Alpha Channels	Paths
Adobe Photoshop	•	•	•	•	•	•	•
Adobe Photoshop 2.0	•	•					
Compuserve GIF			•				
FlashPix	•			•			ogq .
GIF89a (Export)			•				
JPEG	•	•		•			VIII.Eve.
Photoshop EPS	•	•	•	•			
(DCS 1.0)		•					r Kobi
(DCS 2.0)				•		redic	•
Photoshop PDF	•		•				
PICT			•	•			•
PNG	•		•				
Scitex CT	•			•			
TIFF			•			• CARE	•

Figure 4.4 File format saving options showing compatibility with the different color modes and Photoshop features active. While you may notice other saving options linked to channels and color modes are available in the Save As... dialog box, this does not mean the saved file will actually retain them when opened again.

IVUE

The IVUE format (on which FlashPix is based) is used by the Live Picture program for display and image processing in Live Picture. Files are converted from Photo CD or a TIFF file to the IVUE pyramid structure format using Live Picture software before they can be opened in Live Picture. Photoshop and Live Picture complement each other and for that reason you can import IVUE files into Photoshop, for modification. The IVUE Import plug-in (which comes with Live Picture) must first be installed in the Photoshop plug-ins folder.

Portable Network Graphics (PNG)

This is a new format for the display and distribution of RGB color files on-line. PNG features improved image compression and enables alpha mask channels to be saved with the image for creating transparency. Other advantages over JPEG and GIF are higher color bit depths supported up to 32-bit images and built-in gamma correction, so you can view an image at the Gamma setting intended for your monitor. Updated versions of Netscape Navigator and Microsoft Internet Explorer web browsers will be supporting the PNG format.

Future of electronic publishing

Digital imaging was first regarded as a modern, faster alternative solution to the conventional repro and photographic retouching process. Much attention has been focused on the narrowing gap between high-end and desktop machine capabilities with the prediction that in the future we will be handling ever larger file sizes. When Photoshop was first introduced it was only just possible to manipulate large files on the hardware then available, though I know a photographer who at that time retouched an 80 MB CMYK on his IICi Macintosh with just 16 MB of RAM!

One can argue the opposite though – that the growth of multimedia, screen based publishing (including the Internet) does not require large file sizes. Most images you see on screen are reduced versions from much bigger files, but as more work is commissioned for direct use in multimedia only, there will be less need to capture or work at a resolution higher than whatever is needed to fill a screen display.

Chapter Five

Print Output and Proofing

he standard of output available from digital continuous tone printers has improved enormously over recent years. Many people find they in fact prefer the print quality produced by the high-end bureau machines over conventional color silver prints. I see two reasons for this: the ability to finely control the color output yourself on the computer using Photoshop and the wider range of paper bases available, compared to the choice between plastic matt or plastic glossy. Broadly speaking, there are three types of print output that as a Photoshop user you might wish to consider: proof printers, high quality RGB and CMYK repro proof printers (which are also used for high quality final art outputs). I am mainly concerned here with the practical needs of a Photoshop user, producing original art work on their system and who wants a means of proofing – from visual rough to art print quality (some of the print output methods discussed in this chapter are suited to proofing page layouts). The emphasis is very much on how to produce a professional proof output ready to supply the printer without going into the details of four-color printing and platemaking.

RGB output devices

Following on from the discussions about RGB to CMYK conversions, you will remember me saying that some people prefer to work throughout in RGB and supply an RGB output as the final art, the same way as one would supply a transparency or print. Writing to transparency film is quite a slow and expensive process, but is the usual means used by high-end bureaux when presenting work to a client and money is no object. Such an output can either be scanned again or used as a reference for the

printer to work from the digital file. A CMYK proof is regarded as a better reference in these situations, but nevertheless the transparency output is one with which some photographers may feel more at home.

Transparency writers use a scanning laser beam to expose the light sensitive silver emulsion. The same technology is employed to make RGB photographic prints, particularly large blowups for exhibition display with print writers such as the Durst Lambda, CSI Light Jet 5000 and HK printers: Sphera PW30 and PW50. As with the transparency writers, these machines are intended to be installed in lab/bureaux, replacing the enlarger darkroom. After scanning in a negative or transparency, a printer occupying space in a single room is capable of outputting from any film format to any size of photographic print (up to 48 inches wide with the Lambda service).

A personal favorite of mine is the Fujix Pictrography process, which produces a true photographic print finish. A single pass exposure (as opposed to the three or four passes involved with dye-sublimation) is made with a thermal laser diode onto silver halide donor paper, followed by a thermal development transfer to the receiving print. This Fuji claim has all the permanence of a conventional color photograph. Admirers of the New York based photographer Raymond Meier, may be interested to know that he has his own Pictrography machine and supplies editorial clients with Pictrographs as finished artwork. Fashion photographers in particular like using Pictrograph outputs, maybe because of the current popularity of supplying C-type prints made from color negatives. The latest 4000 machine prints at two resolutions: 267 or 400 dpi in sizes ranging from A6 to A3. The results are very crisp and the smooth glossy surface will cause no problem when scanned from again and the only chemical solution required is purified water!

CMYK proofing and fine art printing

If the two minute print time, A3 output size and sub £20 000 price tag sound appealing then the Pictrograph might be an affordable proposition for a small studio business. However, this is still an RGB printer using cyan, magenta and yellow colored dyes. Pictrographs are beautiful as portfolio prints or final art proofs, but do not help when communicating with a printer who has the job of making CMYK separations from a digital RGB file. What they want you to supply ideally is a proof printed using CMYK inks showing near enough how you see the colors reproducing. Dye-sublimation printers use CMY or CMYK dyes, which are 'sublimated' (transferred) to the receiving print. These are available as relatively inexpensive desktop machines (around £5000 for an A4 printer). The material costs are fairly high and a bureau service dye-sub will cost you about £10 to £15 per A4. Dye-sub prints cannot match the archival

permanence of a conventional color print and are not known for their stability. The print dyes react when they come in contact with soft plastics such as transparent portfolio sleeves or are heat sealed. Kodak have addressed this problem by introducing on the Kodak XLS 8600 a special 'Extra-Life' printer ribbon which will coat the print surface with a transparent protective layer.

Dye-subs are just a means to an end. If you are looking for a fail-safe method of supplying digital files for repro, then follow the advice which I have seen posted on the Internet: convert your RGB file to CMYK and save it as a TIFF or EPS file and make a CMYK print proof to your satisfaction from the CMYK. Supply the CMYK print proof plus TIFF/EPS file on the disk *and* the original RGB file version, but save the RGB file in the native Photoshop format. The designer will have a CMYK file ready to place in a page layout and a CMYK color proof to supply the printer. If the printer was helpful and had supplied you with full printing inks and other specifications for the conversion, they should be happy to work from this. If not, they can always convert the original RGB themselves to match the CMYK proof. The reason for saving the RGB file as a Photoshop document is to remove the risk of the designer placing the RGB file in the layout by mistake. An additional benefit of saving in the Photoshop format is that it would be smaller than an equivalent TIFF due to run-length encoding compression.

The biggest buzz of late has been the rising quality of inkjet printers. These use CMYK liquid inks which are finely sprayed onto the paper surface at resolutions of 300 dpi or higher. The best of these has to be the Scitex Iris inkjet where the paper is mounted on a drum which revolves at high speed and the print head passes across the surface in a linear fashion (like a drum scanner in reverse). Iris prints made on the standard paper are ideal as repro proofs, but that's not all. There are no limitations to the type of paper which can be used. You can load up paper stock to match that used on the print job. I know of an advertising photographer who owns his own Iris printer and keeps a wide range of paper stocks, so he can proof to any surface required. The very best results are obtained on archival fine art paper – I was quite stunned by the beauty of the first prints I saw produced this way. Iris proofing on art paper has taken off in the US as a medium for exhibiting and selling art photography – whether manipulated or not. In the UK renowned photographer printers such as Max Ferguson have switched from the darkroom to an all digital setup, supplying clients with Iris art prints. The standard Iris service is comparable in price to other forms of proofing. The inks used are sensitive to sunlight and not guaranteed to last more than a few years. UV protected inks are available for archival printing, but the colors are quite different to the normal inks. Switching from one ink to the other requires flushing out the system and calibrating the printer again. Bureaux will offer one type of service or the other: standard or fine art output, but not both unless running at least two machines.

Poster inkjet plotters are also capable of printing up to A0 size. These outputs are suitable for all commercial purposes – printing either Photoshop files or Vector based artwork. The latest inks are more colorfast and can be guaranteed to last longer than was the case before. Even so, the prints produced are only intended for economical short-term sales display on a gloss or matt paper surface.

PostScript printing

When your computer is instructed to print a document, graphic or photograph, the data has to be converted into a digital language the printer can understand. RGB image files can successfully be output on their own using Apple's proprietary Quickdraw – the same language which describes how documents appear on the monitor screen. To print out a page which combines text and images together, Quickdraw will only print the way the data appears on the screen. If you print from a page layout program, it reproduces the screen image only. The text will be nice and crisp but placed EPS images will print using the pixelated preview. PostScript is a page description language developed by Adobe. When proofing a page layout, the image and layout data are processed separately by a server (either on the same machine or a remote computer) and once the data has been fully read and processed sent to print in one smooth operation. This process is known as Raster Image Processing (RIP). For example, you'll notice many proofing printers come supplied with PostScript (level 2 or later). Normally a prepared CMYK image is embedded in the PostScript file of a page layout program and then converted in the RIP (Raster Image Processor). The RIP takes the PostScript information and creates the pixelmap line of dots for each separation to be output to film or plate. The Photoshop image data is likely to be in either TIFF or encapsulated PostScript (EPS) form in the file created by the page layout program and it is this which is passed along with the original vector images and fonts to be rasterised. Printing speed is dependent on the type of print driver software the printer uses and the amount of RAM memory installed in the server machine. Too little memory and either the document will take ages to process or won't print at all.

There are many desktop PostScript printers to choose from for less than £10 000 – which one you should go for depends on the type of color work you do. Laser printers are useful to graphic designers where the low cost of consumables such as paper and toners is a major consideration. A setup including a laser printer and dedicated RIP server is ideal for low cost proofing and short run color laser printing. I am thinking here of the Efi Fiery RIP server linked to a color laser printer such as a Canon copier.

Desktop proofing

To summarize then, when purchasing a printer which is ideal for image proofing purposes, you would be looking at something within a reasonable price range – maybe a Fujix Pictrograph for RGB final art outputs, an A4 or A3 PostScript dye-sublimation printer for quality CMYK proofing, or a PostScript laser printer for economical layout proofing and short run printing. There are, however, a lot more lower cost options appearing on the market which feature improved inkjet technology. The Epson range of Stylus color printers are excellent value. UK prices begin at under £300 for the Epson 800 A4 printer rising to around £1500 for the A2 model. The results are superb and almost of photographic quality with a choice of several types of paper surfaces. Although these are CMYK printers, they only work properly when fed RGB data. The best results are obtained when printing directly from Photoshop RGB files, especially if you are working in a larger pre-press RGB space like Adobe RGB (1998).

As with the Iris, you can experiment using other art papers as well. PostScript software is available, so one can RIP a page layout on the same computer and send it to the printer. The processing time will be dependent on how the server software is configured. Although slightly slower than using a remote server, it has to be borne in mind that even the fastest inkjets are a lot slower than a laser printer, plus the ink cartridge consumables are quite expensive in the long run. Nevertheless, despite their slowness, inkjets are now very much desired by Photoshop users as a versatile and affordable solution for desktop proofing and producing portfolio quality outputs.

Fuji continued developing their own original print technologies and a while back introduced the Thermal Autochrome process, aimed at competing within the mid range dye-sub market. This is still an RGB print device. Its selling points are – competitive pricing and security printing – no negative or peel-off backing is associated with the making of the print and it can be connected directly to a digital camera, producing a print image without needing to store it digitally.

Printers for all

There is a rapidly growing market for digital photography at the consumer level. Here one sees prices of low-end digital cameras dropping significantly and interest in these toys has been raised since the introduction of low cost postcard size printers. Fargo got there first with the cutely named FotoFun, which is basically a miniature dye-sub printer producing very acceptable looking color prints.

The only snag is the price per sheet of FotoFun paper, roughly about the cost of a Polaroid Instant print. Other products have swiftly arrived on the market, most use the 'Taxan' designed print engine and produce slightly smaller prints but at half the cost of the Fargo. The economic arguments are such that if one only wants to save and print about six out of say 36 exposures, digital photography is less costly than buying and processing a roll of film via the high street lab.

Quantity printing

When faced with a large print order, it is not so easy to attain the levels of discount normally associated with large run color photographic printing. One option might be to have a color transparency output made and use this as the master to print from in the normal way. Alternatively there is an image processor designed by the photographic company Marrutt, which can produce low cost C-type prints in large quantities and at a reasonable cost. The aforementioned laser light writers such as the Lambda process are always going to be that bit more expensive. Beyond that, one should look at repro type solutions. The technologies to watch are Computer to Plate (CTP) or direct digital printing: Chromapress, Xericon and Indigo. These are geared for fast, repro quality printing from page layout documents, containing images and text. They make short print runs an economic possibility.

Storing digital files

Having outlined the range of printing methods to choose from, which then is the best removable drive media for archiving and transporting your digital files? Magneto Optical are highly rated for their reliability and because they are cheap to buy. Iomega ZIP drives are also very popular now. The older Syquest 44 MB and 88 MB media are still catered for, though the drives have long been discontinued. Of all the other types of removable media on the market, one should find that any busy bureau will make a point of trying to cater for all needs, but don't bank on it. Always check before bringing a job in that your disk or tape can be read.

The one standard that is universal is CD-ROM. Every computer is sold with a CD-ROM player these days. The CD drives which can read and record to CDR discs are not that expensive to buy and the media costs have tumbled to ridiculously low prices. The only problem with a CD is that if it gets damaged you lose everything and that might be a hefty chunk of valuable data. A sensible precaution is to make an extra backup copy of important data and archive this separately. New on the market are rerecordable CD media and in the future DVD which will compact even more data on

a single disc. Jaz disks store 1 Gb of data and the read/write access times are comparable to a standard internal hard disk. Jaz is useful for handling large amounts of data quickly as a temporary storage medium before archiving to CD or tape.

Image database management

A seasoned travel photographer once tried to calculate how many rolls of 35 mm film he had shot in his lifetime. If you placed each strip of film end to end, how far would they reach? A trip across the capital city maybe? However much film professionals get through, archiving and storing all those negatives and slides is still quite a task. Film, as I said in the first chapter, is such an efficient method of capturing image information that it will take a radical development in digital technology before it is ever completely superseded. If I get a commission to shoot for an advertising agency, PR company or magazine, I mostly photograph with either a 35 mm or 120 roll film camera and the pictures taken have been reproduced at anything from a thumbnail sized image on an editorial page up to a film poster in Leicester Square, covering a five storey building. The compactness and versatility of film are a tough benchmark for digital cameras to beat. Archiving film may be time consuming, but archiving digital files is going to be just as, if not more costly time wise. If done properly though, it will save time and you'll reap the rewards in the future.

From your own experience you will appreciate the importance of keeping track of all your office work files by saving things to their correct folders just as you would keep everything tidy inside the filing cabinet. The task is made slightly easier on the computer in as much as it is possible to contain all your word processing documents on the one drive (and a single backup drive). Digital files are by comparison too large to store on a single disk and need to be archived on many separate disks or tapes. One disk looks pretty much like another and without diligent marking and storing, fast forward a year or so and it will take you forever trying to trace a particular picture. I only have to look at my collection of video tapes to appreciate the wisdom of indexing – I know there are movie masterpieces in there somewhere, but am damned if I can find them.

The Apple Macintosh operating system features alias making. From any file or application an alias can be created and stored in a separate location. The alias is a tiny sized file – double clicking the alias will launch the program it was created in and open the original. If that original is stored on a drive not currently loaded, a dialog box appears informing you by name which disk to load (good idea to number

your disks). My current method of archiving images relies on this method. I keep an alias of each image file in a single folder on the main computer hard disk. I refer to the icon which helps me locate the exact disk the image is stored on.

That's fine for Mac owners but if your operating system does not have this feature or you would like a more sophisticated archival retrieval system then consider a software utility such as Image AXS or Kodak's Shoebox (some demos of these types of program are available on the CD-ROM) a good image cataloging program will do more than provide a contact sheet of images, which are obviously better than icon previews, but also allow indexing with field entries to aid searching. Basically these are database programs designed for efficient image retrieval.

You can of course append your own image information within the Photoshop program itself. The File > File Info... dialog box provides a comprehensive list of options for annotating an image to meet with agreed professional picture library requirements.

Bureau checklist

Before you send that disk, to avoid delays and disappointment, make sure you have everything fully prepared. Some bureaux supply their customers with guidelines, others assume you know enough about digital imaging to understand the basic requirements. First, be specific about the media you intend to supply. Asking do you take Magneto Opticals? is not precise enough, they may only be equipped to accept 128 MB 3.5 inch disks but not 230 MB 3.5 inch disks or larger 1.3 gigabyte and 2.6 gigabyte disks. Identify the disk and jewel case with your name and telephone number and don't forget to clearly identify which file on the disk is to be output. Maybe scale the window so only that folder is visible when the window is opened and label it 'Output folder'. Certain types of removable media are renowned for their instability or sensitivity to strong magnetic fields. In fact nothing is ever 100% foolproof. Be sure to have a backup copy of the file stored separately, so in case of disk failure another copy can be supplied. Neither is ISDN file transfer completely reliable, but at least one can ring to confirm everything has been transmitted successfully.

The preferred image file format is usually a TIFF, uncompressed and saved using Mac byte order. If the bureau is running PC or UNIX systems, they may request you save using PC byte order (which can also be read by Macs). It is even remotely possible that a bureau may be running a machine with version 2.0 of Photoshop. A layered Photoshop image created in version 3.0 or later will be unreadable unless you left the 'version 2.0 compatible' file option checked in preferences. I advise you

switch this option off, because it wastes time and disk space when saving a Photoshop file. It is best to stick with the TIFF format for simplicity's sake. Bureaux also prefer you to remove any masking channels and paths from the final output file. Removing unwanted alpha channels from a TIFF will economize on the stored file size. Only leave paths when saving a clipping path with an EPS file.

What output size and resolution should the image be? Check first the required or suggested resolution for the print process and adjust the image dimensions to match this setting and always take into account the non-printing margin space. There are limits as to how much one can 'interpolate up' a digital image. Apply unsharp masking as necessary – Photo CD files always need sharpening, high quality drum scans or digitally captured images should only be sharpened locally to selected areas like the eyes. Preparing a file for repro is another story. A lot of sharpness gets lost in the process and therefore a little more unsharp masking than looks correct on the monitor screen will be the right amount to use.

Use the correct color mode – either RGB or CMYK. Some service providers, like the people who produce the Iris art prints, may use their own color conversion hardware to work from your RGB files. Lastly, consider how you are going to calibrate the image on your monitor to the print. Guidelines are provided in the following chapter. If the bureau making the print also supplied the scan you can safely assume that by maintaining a 'closed loop', as long as you have not altered the color balance, the output color balance will match those of the original. If you substantially change the colors, then maybe include a small scaled down version off the edge of the main picture as a reference sample. Trim away or mask out later.

Image protection

Anyone who fully understands the implications of images being sold and transferred in digital form will appreciate the increased risks posed by piracy and copyright infringement. The music industry has for a long time battled against pirates duplicating original disks, stealing music and video sales. Digital music recordings on CD made this problem even more difficult to control when it became possible to replicate the original flawlessly. The issue of piracy is not new to photographers and image makers, but the current scale of exposure to this risk is. It includes not just us Photoshop geeks, who are going to be affected, but includes anyone who has their work published or is interested in the picture library market.

To combat this problem, the first line of defence had been to limit the usefulness of images disseminated electronically by (a) making them too small in size to be of use other than viewing on a screen and (b) including a visible watermark which both

identified the copyright owner and made it very difficult to steal and not worth the bother of retouching out. The combination of this two pronged attack is certainly effective but has not been widely adopted. The World Wide Web contains millions of screen sized images few of which are protected to this level. The argument goes that these pictures are so small and degraded due to heavy JPEG compression, what possible good are they for print publishing? One could get a better pirated copy by scanning an image from a magazine on a cheap flatbed scanner. Shopping is now replacing sex as the main focus of interest on the Internet, so screen sized web images therefore do now have an important commercial value in their own right. Furthermore, the future success of digital imaging and marketing will be linked to the ability to transmit image data. The technology already exists for us to send large image files across the world at speeds faster than ISDN. Once implemented, people will want to send ever larger files by telecommunications. The issue of security will then be of the utmost importance.

In recognition of this market need, software solutions are being developed to provide better data protection and security, providing suppliers of electronic data with the means to warn, identify and trace the usage of their intellectual property. From a users point of view, the requirements are, to produce an invisible 'fingerprint' or encrypted code, which does not spoil the appearance of the image but can be read by the detection software. The code must be robust enough to work at all usage sizes – screen size to high resolution. They must withstand resizing, image adjustments and cropping. A warning message should be displayed whenever an image is opened up alerting the viewer to the fact that this picture is the property of the artist and a readable code embedded from which to trace the artist and negotiate a purchase.

Two companies have produced such encryption/detection systems – SureSign by Signum Technology and Digimarc by the Digimarc Corporation. Both work as plugins for Photoshop. They will detect any encrypted images you open in Photoshop and display a copyright detection symbol in the status bar alongside the file name. The Digimarc plug-in is included free with Photoshop 4.0. To use Digimarc to encrypt your own work, you have to pay an annual usage fee to Digimarc to register your individual ID (check to see if free trial period offers are in operation). Anyone wishing to trace you as the author, using the Photoshop Digimarc reader plug-in, will contact their web site, input the code and from there read off your name and contact number. Here is the main difference between the two systems – the Digimarc code is unique to each author/subscriber while SureSign provide a unique author code plus transaction number. In my opinion, the latter is a more adaptable system. Anyone contacting me with regard to image usage can quote the transaction number which would relate to a specific image. As for pricing methods, with Digimarc the software is free but you

have to pay an annual fee to register your code. SureSign at the time of writing,, sell the software with a fixed number of transactions and additional fees are charged to buy another batch of numbers.

Both systems work effectively on digital originals (you can compare them for yourself, a Signum Technology demo is available on the CD-ROM). There is no guarantee that a fingerprint will remain intact when scanned from a halftone printed image, yet Signum report one client was able to detect the SureSign code from a scanned newspaper page! These programs herald an important step forward for the secure distribution of copyright protected data. The future will see many improvements and new possibilities. Digital images will one day be sent for appraisal sealed in an image degrading 'digilope'. The quality will be good enough to judge if the shot is right or not, but unsuitable for publication. To access the image in its full glory, the client would contact the supplier for a unique code. This code would represent a single transaction indicating who had bought the licence and what specific usage rights had been bought. Now if by chance the customer buying the picture were dishonest and passed the opened version on to someone else or used the picture for extra unnegotiated usages, a discovered infringement would always be traceable to the original purchaser. Schemes such as these will help enforce responsible business practice and discourage piracy. There is even an opportunity for people buying pictures to make themselves some extra money. If a client reseals the digilope and passes the image around to other interested buyers and if as a result they buy the image from you again, you can trace the first purchaser or purchasers and offer a commission as a thank you incentive.

The detection business is very important if fingerprint type encryption is to become trusted as a valuable method of copyright protection. Detection software will also help people searching for a particular image, whether encrypted or not. New Mexico Software are talking of a search engine which, for want of a better description, has 'eyes' and can catalogue every image it comes across on the Internet. Don't ask me how it will do this, but the theory is that you can show an image to the search engine and ask it to find others that match - just as you would conduct a normal word search. This can be used as another method of controlling piracy – identifying duplicate images on the web and also helping picture researchers locate a specific type of picture. Show it a picture of an elephant drinking from a watering hole and it will suggest a list of web pages featuring pictures that match this criteria. For some reason various international police authorities are interested in acquiring this tool. New Mexico and Signum Technologies recently joined forces with C.E. Heath and Beazley a Lloyd's insurance syndicate, who are providing an insurance cover plan to enforce copyright protection and recover damages where ownership can be proved using the encryption detecting software.

Chapter Six

Configuring Photoshop

n order to get the best Photoshop performance from your computer, you need first to ensure that everything is configured correctly. First item on the agenda – which operating system to recommend, PC or Macintosh? Or how about Windows NT and the Silicon Graphics O2/UNIX systems? I guess that for most of you, the decision of which system to adopt has already been taken. Your allegiance is solid and who am I to direct you otherwise? As you will realize by now, I use Macintosh computers and have done so for many years. I like the simple clear design of the graphical user interface. Throughout my computerized career, it's what I have grown up with and it feels like home. The same arguments apply if you're a Windows PC user and apart from anything else, once you have bought a bunch of programs, you are locked into that particular system. If you switch it means facing the prospect of buying your favorite software packages all over again. If the CHRP (Common Hardware Reference Platform) machines had ever been made, it would have been possible to buy one hardware system and choose either operating system to install on it, but the likelihood of CHRP being resurrected is nil.

The Internet is overladen with futile battles of the operating systems. You know the sort of thing: my Pentium is better than your Mac 604e and similar playground squabbles. The only certainty is that a Pentium II is faster than a 486 and a Power PC G3 is faster than a Power PC 601. Comparing like for like between the two systems will reveal marginal speed benefits of a few seconds one way or the other.

Buying a system

Later in this chapter I shall go into more detail about RAM and scratch disks etc. Let me start off though by outlining the basic list of features to look for in a setup designed to run Photoshop.

Only the other day a young photographer came up to me after a presentation, seeking advice on what sort of system to buy. He had been told by someone working at a bureau he would need to spend at least £7 000 buying the fastest desktop computer with lots of RAM and always have drum scans (their bureau drum scans of course) to input his work. If you work in a bureau and your job is to process digital images as efficiently as possible to a top professional standard, of course you want to use the best equipment, anything else would be false economy. For an ex-student looking to get started on the Photoshop learning curve this was most definitely inappropriate advice to offer. If you are new to image editing and looking for a machine to get started with, then it makes sense to put a ceiling limit on how much you wish to spend. You never know if you are going to have the patience or time to commit learning the intricacies of Photoshop and building a serious digital setup. So with that in mind, don't overdo it. If image editing turns out not to be your kind of thing, at least you won't have wasted your money and will still have a powerful computer capable of doing all the office work, linking to the Internet or shooting down rogue asteroids.

The most important feature is expansibility. For this reason, most (but not all) entry level computers are unsuitable. I suggest starting with at least 24 or 32 MB of RAM (random access memory) – 16 MB fitted memory + an extra 16 MB module, but you will definitely want to plan for further upgrades in the near future. Look for a machine with at least 3 RAM memory module slots. In the above example, you start with 32 MB of RAM and your first upgrade could be to add a 64 MB module boosting the total RAM to a respectable 96 MB.

Monitor display

The monitor is the most important part of your kit. For Photoshop work, a multiscan Trinitron or Diamondtron tube is best. There are plenty of affordable 17" monitors of this type on the market. You get what you pay for of course and it is worthwhile checking the computer press for recent product test reports before deciding which model to buy. Try not to get anything smaller than a multiscan 17" screen. Remember that extra Video RAM (VRAM) is always going to be needed to display anything more than hundreds of colors on even a small sized display. The minimum require-

ment is usually 2 MB of VRAM, which is enough to display 32000 colors at a pixel resolution of 832 × 624. All modern computers seem to be fitted with 1 MB of VRAM as standard, but not all can be expanded to accommodate more VRAM. To display millions of colors on a large screen, you will need a computer with either spare VRAM slots (to add extra VRAM modules) or at least one PCI expansion card slot, which will accept a video accelerating PCI card.

Extras

An internal $12 \times$ or faster CD-ROM drive is standard issue these days and will enable you to access Kodak Photo CD scans. The Adobe Photoshop software program varies in price enormously. Some people prefer to buy Photoshop bundled with a flatbed scanner, the price of the two together is sometimes as much as the program on its own.

Other things to buy would include a second hard disk plus a removable media storage device such as the Iomega Zip drive or a Magneto Optical system. You need these to back up your main hard disk and store all your image documents (the hard disk should be kept as empty as possible) and for transferring documents to a bureau for printing. Bureaux will be able to satisfactorily read PC format files. NB. If you use a Windows PC, SCSI devices such as scanners and external drives necessitate the installation of a SCSI card.

A digitizing pad or graphics tablet is highly recommended. It replaces the mouse as an input device, is easier to draw with and pressure responsive. Big is not necessarily best. Some people use the A4 sized tablets, others find it easier to work with an A5 or A6 tablet like the Wacom Ultrapad and Wacom Artpad. You don't have to move the pen around so much with smaller pads and therefore these will be easier for painting and drawing.

Retailers

Mail order companies (commonly referred to as 'box shifters', which says it all really) are hard to beat on price, though in my experience service ranges from excellent to appalling. Always try to find out if anyone else has had a bad experience with a particular dealer before parting with your cash. Under UK consumer law, any claim on your warranty will require you take up the matter via the company which sold the equipment to you. Legally your consumer rights are protected. In practice, suppliers make small margins on cut-price equipment sold from a warehouse and the

procedure for handling complaints can be very lax. If you do have a problem, ensure your complaint is dealt with swiftly. Always be persistent but firmly polite, otherwise tempers flare or your complaint may easily get ignored. Computer trade shows are a good place to find special offers, but again check who you are dealing with. Remember prices are always dropping – the system you buy today could be selling for half that price next year, assuming it is still manufactured! Your capital investment is not going to hold its value.

Businesses which rely on their equipment to be working every day of the week will choose to buy from a specialist dealer – someone who will provide professional advice and equipment tailored to their exact needs and, most important of all, instant backup in case things go disastrously wrong.

Improving Photoshop performance

Keep the imaging work station free of unnecessary clutter – the more applications and files you load up, the more the machine will slow down. It is best to have a separate computer to run all the office software Internet/modem connections and games etc. Switch off nonessential extensions, this will reduce start up times and improve overall operating speed. Make sure you understand what you are doing and can correctly identify what each extension does (you'll need to refer to a system book). Some extensions are essential to run software and external drives but most you don't really need. Photoshop can run without any extensions at all, but you will probably want to have things like the Kodak Color Management System extensions, Gamma, CD-ROM control panels and High Sierra access etc.

Chip speed

Microchip processing speed is expressed in megahertz, but performance speed also depends on the chip type. A 240 MHz 603 Power PC is not as fast as a 240 MHz 604e Power PC chip. Speed comparisons in terms of the number of megahertz are only valid between chips of the same series. It all became so confusing that Apple proceeded to ditch the emphasis on clock speed measurement with the launch of their G3 processor Macs, believing that the number of integer units on a processor were more important. Apple and Umax make multiprocessor or multiprocessor expandable computers. Daystar used to make multiprocessor computers – the Genesis was a prime example, with four Power PC 604 150 MHz processors. Some of the latest

Pentium desktops have twin processing. To take full advantage of multiprocessing, the user must run enabled software. Adobe make Photoshop, Premier and After Effects available to run on multiprocessor computers.

Another factor is bus speed. No, this has nothing to do with action packed movies about runaway vehicles. It refers to the speed of data transfer from RAM memory to the CPU (the central processing unit, i.e. the chip). High performance computers have faster bus speeds and therefore are faster at graphics work like Photoshop, where large chunks of data are being processed. CPU performance is mostly restricted by slower bus speeds of around 40–50 MHz. For instance, the Power Computing Tower clone series saw off competition from faster Power PC chips because of the extra fast internal bus speed of 60 MHz.

Chip acceleration

Mid to top of the range Macintoshes starting with the Power PC 7500 allow a full processor upgrade while some older LC, Centris and Quadra Macs can be upgraded to Power PC. Another option (if a slot is provided) is to soup up the performance of your processor chip by adding a level 2 cache, which will add a 10–30% speed increase. A 256k cache is provided with many machines already. If you have lots of RAM memory installed (over 50 MB) then its worth getting a 512k level 2 cache. Cache memory stores frequently used system commands and thereby takes the strain away from the processor chip allowing faster performance on application tasks. Level 2 cache is really a minimum requirement.

RAM memory & scratch disks

When it comes to image editing, the amount of RAM memory you have installed is a key factor – a minimum of 24 MB application memory is recommended for Photoshop. As I mentioned earlier, when buying a computer, you want something that may be upgraded with more RAM at a later date. Newer machines can be upgraded one module at a time, with others you have to install SIMMs in pairs. SIMMs (Single In-line Memory Modules) are fitted in older computers. Power Macs and modern PCs use DIMMs (Dual inline Memory Modules). Lastly there are EDO RAM modules – primarily PC modules but which are also increasingly used in Macintosh clone computers. The new EDO DIMMs are faster.

The general rule used to be that Photoshop requires available RAM memory of 3–5 times the image file size to work in real time. That will still hold true for 5.0 except under certain circumstances where the History options are set to allow a great many

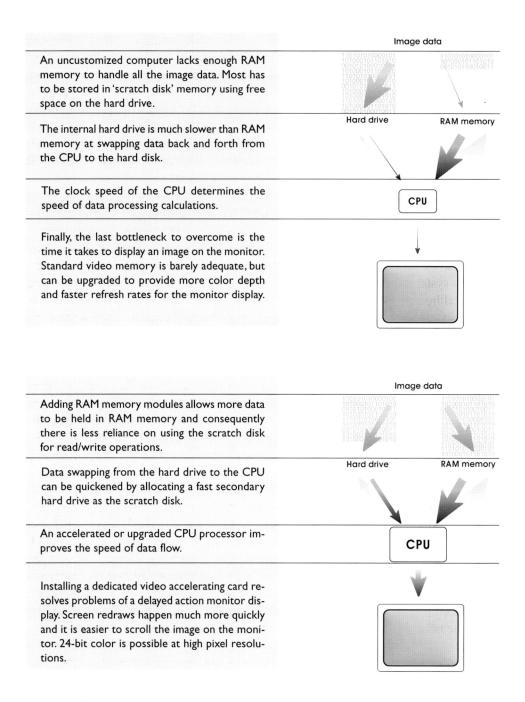

Figure 6.1 Above illustration compares the performance of a standard issue desktop computer before and after optimizing for Photoshop use.

multiple undos and you are performing global changes, with each operation affecting the entire image (like applying a filter). If you do that the memory requirements will soon escalate to many times the document file size. Let's say you have just 32 MB of RAM memory fitted, of which 24 MB is allocated to Photoshop. The program eats up another 12 MB and that leaves you with only 12 MB, or in theory just enough RAM to work on a 2–4 MB file in real time. To get round this memory devouring problem, Photoshop utilizes free hard disk space as an extension of RAM memory. It uses all the available free hard disk as 'virtual memory' or, in Photoshop terms, it creates a 'scratch disk'.

The Apple Macintosh operating system pulls off a similar trick with its own memory management system. The RAM doubler extension does the same kind of thing as well. But the important thing to note here is that when it comes to running Photoshop, Photoshop's own virtual memory management system is best and having two virtual memory systems working at the same time will lead to reduced performance and more likelihood of system crashes. That is why the Adobe Photoshop manual recommends you switch off Macintosh virtual memory and not use other virtual memory utilities with Photoshop.

The free hard disk space must be at least equivalent to the amount of RAM allocated for Photoshop. If you have 60 MB of RAM allocated to Photoshop and 30 MB of free disk space, the program will use only 30 MB of the RAM. For optimal image editing, at least 400 MB of free hard disk space is recommended. Under these conditions, Photoshop will use all the RAM for real time calculations (mirroring the actual RAM on the scratch disk) and when it runs out, use the extra space on the scratch disk as a source of virtual memory, up to 400 MB.

Photoshop is designed always to make the most efficient use of real RAM memory. There are slight differences between the way this works on Windows PC and Macintosh systems respectively, but essentially the program tries to keep as much RAM as possible free for memory intensive calculations. Low level data like the 'last saved' version of the image are stored in the scratch disk memory giving priority to the current version and last undo versions being held in RAM memory. Photoshop continually looks for ways to economize the use of RAM memory, writing to the hard disk in the background, whenever there are periods of inactivity.

With all this scratch disk activity going on, the hard disk performance plays an important part in enhancing Photoshop speed. A fast internal hard disk is adequate for getting started. For best results, install a secondary hard drive, dedicated as the scratch disk (assign this as the primary scratch disk in Photoshop preferences). AV (audio visual) designated drives are regarded as fairly fast. You can either connect

one of these externally via the SCSI port or on some models internally, if space permits. Internal drives in some cases can be faster than an equivalent external drive. This is because the external SCSI port is usually of a SCSI 1 standard, suited for connecting all types of SCSI devices. Internal SCSI connections are often SCSI 2, which provides a quicker data transfer standard (data transfer not data access time is the measure of disk speed to look out for). For fastest data transfer, a wide array system is used – a combination of RAID hard drives, and wide SCSI 3 connection plus a special PCI card. Hard disks can be partitioned – a 400–500 MB partition for the primary scratch disk should be ample on a new 2 gigabyte SCSI drive. Have one partition for the primary scratch disk, with the remaining space as a secondary scratch disk, is a more efficient way of working than allocating the whole of the drive. There is provision in Photoshop for as many as four × 2 gigabyte scratch disks. So if you installed a 2 gig internal drive, you could divide the partitions in four and as the scratch disk memory requirements went beyond the limits of the first 500 MB, the scratch disk usage would spill over to the next partition and so on. This makes for more efficient and faster disk usage.

Allocate all the RAM available to Photoshop (see below) and run the application on its own. If you need to swap a file with Quark or PageMaker say, save the file, close Photoshop and then open in the other program. This may at first seem long winded, when you could have both programs open simultaneously. Unless you are working with small screen sized images, Photoshop is going to need all the memory it can get. In the long run you will always save time by running Photoshop in isolation this way.

Clearing the clipboard memory

Whenever you perform a Photoshop task that uses up a lot of scratch disk memory, you can see this in the file information box in the lower left window display. Photoshop stores the undo version in clipboard memory on the scratch disk. Copying a large selection to the clipboard also occupies a lot of memory. From time to time, if you are happy with the way your image is looking, purge the clipboard of data to minimize the loss in performance. In version 3.0 I used to make a small selection with a marquee tool, copy once, then copy again and deselect. This double copying operation cleared the undo from the memory. In version 5.0, you simply choose Edit > Purge > Undo, Clipboard, Pattern, Histories or All.

Configuring the RAM memory settings (Macintosh)

In the Finder desktop, go to the Apple menu and choose 'About this Macintosh'. The dialog box will show you how much RAM is used by the system and how much application RAM remains – see Largest Unused Block. Next, find the unopened application icon and choose File > Get Info from the desktop menu. Change the Preferred Size setting to the largest unused block figure minus 2000 kilobytes.

Configuring the RAM memory settings (Windows)

When you first install Adobe Photoshop 5.0, 75% of all available system RAM is automatically allocated for Photoshop use. You cannot improve upon this memory allocation but can make sure there is an adequate amount of memory allocated to the permanent swap file. This should be as large as the amount of RAM memory installed or 10 MB, whichever is bigger. If you want to run other programs simultaneously with Photoshop, lower the percentage of RAM allocated to Photoshop via Memory and Image Cache Preferences.

PCI cards

If Photoshop is accused of being slow, that's not the fault of the software, but rather the architecture of the computer running it. Desktop computers are designed to perform all types of tasks. This jack of all trades compromise is one thing that separates the desktop computer from dedicated high-end systems. Would you believe that the world's first parallel processing computer, used towards the end of World War II to crack the German Enigma code, was a faster calculator than a Pentium PC trying to emulate the same task? The Colossus computer contained over 2500 valves. What would have taken the later Bombe machine 15 minutes to accomplish, takes around 18 hours on a Pentium! Apparently Winston Churchill ordered the machines and blueprints to be destroyed after the war. Surviving documents were only recently declassified and a working replica of the Colossus is now on display at Bletchley Park, England. Further information can be found at: www.cranfield.ac.uk/ccc/BPark/.

Despite modern desktop computers being utilitarian do-it-all machines, the ability to install Nubus or PCI expansion cards (circuit boards) in slots on the motherboard means you can add from a whole range of components to the basic computer, converting it to a customized work station for broadcast video editing, 3-D modelling or professional image editing. Radius make accelerating boards like Photoengine, which

is dedicated to boosting Photoshop performance. Powershop (from Adaptive Solutions) is another dedicated Photoshop board, and can add a 300% speed boost to the Apple 9500, given enough RAM.

Video display

Displaying a digital image on the monitor is another bottleneck to overcome. This can be solved either by installing more video RAM or preferably fitting a video graphics Nubus/PCI card. Doing this will both accelerate display redraw times and increase the color depth to millions of colors and at finer resolutions. There is a lot to be said for graphics quality 17" monitors. The screen size is adequate and if you upgrade the video graphics as suggested, you can run at the highest resolution allowable in millions of colors. It is a big leap between that and purchasing a 20" or 21" monitor. Many of these large monitors have noticeably curved screens – they are fine for business use, but not graphics work. They also require a lot more video memory. That is why fast video acceleration is essential. With accelerated 24-bit video boards now starting at less than £300, they are no longer such an expensive option. The 8 MB IxMicro Twin Turbo 128 and the Formac ProFormance 80 PCI cards are recommended good buys.

Screen display in Photoshop is faster than it used to be, but you'll still appreciate working with a decent sized screen. Add an extra monitor if your system allows and use the smaller screen to display the palette windows. Monitors must be carefully calibrated, but I'll come on to that later in this chapter.

System software

A computer that is in daily use will after a month noticeably slow down without some housekeeping. You should regularly rebuild the desktop file by holding down the Command and option keys (Macintosh) simultaneously at startup. This maintenance operation makes it easier for the computer to locate files (just as when you tidy up your own desk). Norton Utilities are a suite of programs that add functionality: Norton's Speed disk has to be run from a separate start up disc (one built on a floppy for example). Image files continually read and write data to the hard disk, which leads to the disc fragmentation. Norton will defragment files on the main hard disk or any other drive. This is essential on the drives you allocate as the scratch disks in Photoshop. If you're experiencing bugs or operating glitches and want to diagnose the problem, run Norton's Disk Doctor. This will hunt out disk problems and fix them on the spot.

On the subject of Norton, Rod Wynne-Powell has this extra advice to offer: I have never read it in print or in Norton's literature, but an essential procedure for running Norton is that you run it more than once, if you find that it reports any error at the end. On the second or subsequent runs you may ignore the search for bad blocks, as if they occur you have more than a simple glitch, but in this way you find out whether any 'fixed' item has caused any other anomalies. If you are unlucky enough to have 'bad blocks' do not assume that their reallocation has solved the problem; it may well have reassigned the faulty block, but it could be that the data present in that area is now invalid, and could be a vital system component, which will now start to corrupt more of your disk. The advice is simple, and not welcome; the hard disk must be reformatted, and the System and Applications all reloaded. If bad blocks recur the drive needs replacement.

Reduce the disk cache in the memory controls panel to around 32–64k. If you mostly intend running one software program at a time (like Photoshop), there is less need for the disk cache. Note that altering the cache has nothing to do with Photoshop performance as such, it just economizes on the amount of RAM used by the system. If you're a Power PC user, then you'll benefit from installing the latest system update. The earlier System 7.5 relied on old code being run under emulation. The current update runs more of the system software on native Power PC native code. System 8.0 at last offers multi-tasking and an all native Power PC working environment.

Now Utilities system enhancements enable you to quickly navigate through nested folders. When you mouse down on any folder icon, a sub-menu of folders or documents appear drag to any folder there and you can see the contents of each. A similar trick can be achieved by placing an alias of the hard disk in the Apple Menu items folder. Again, Rod Wynne-Powell comments: Sadly with the arrival of OS/8, the hitherto invaluable Now Utilities suite of System enhancements has become unusable, but with the takeover of Now Software by QualComm (publisher of equally memorable Eudora), the new owners have now announced they do plan an update. It had so many productivity enhancements, that were either poorly implemented in OS/8 or still not available that it would be sad to see them disappear. I thought some were part of the System, I had got so used to them. In particular, knowing memory usage was vital to the avoidance of memory restrictions, and the ability to use the desktop windows to force a jump in the Open/Save dialogue boxes was so elegant! These are vital productivity enhancements all photographers need.

Efficient work routines

Think ahead, don't just dash in and start manipulating. Work out what you want to do and plan the session in logical stages. If the file to be created is going to put a strain on your computer because of either slow chip speed or lack of RAM memory, then do a low resolution test first, noting down the settings used as you go along. Even better, record an action of what you do and save these settings automatically. Of course many of the filter settings will then need to be adjusted for a larger sized document – leave a pause in the recording and set accordingly.

The History feature

For as long as I can remember, the number one request has always been for Photoshop to include a multiple undo function, which allowed users to revert back through more than a single undo. I usually argued that Photoshop always had had multiple undo features in the form of using the snapshot commands, magic eraser plus image and adjustment layers. Those who were familiar with these Photoshop features knew how to construct their workflow so that revisions of more than one undo were possible. The History amalgamates these features into a single Photoshop feature. It replaces the use of the snapshot and in a hidden fashion very cleverly makes use of the image tiling to limit the drain on memory usage. One can look at the History as a multiple undo feature whereby you can reverse up to 100 separate Photoshop actions, but History is actually a far more sophisticated and powerful tool than that.

Multiple undos

Each stage in Photoshop is recorded as a separate undoable state. The number of undos is set in the History Options which can be found in the History palette submenu. Global image changes require the whole image to be stored in that state. Wherever local changes take place, only the image data in that sector of the frame is recorded. You can test this by setting the status window to show scratch disk size and note how the memory usage increases with every stage added to a Photoshop session. Interestingly enough, the first adjustment layer bumps up the memory usage rather more compared to a plain old Image adjustment. However, any subsequent adjustment layers will only add a negligible amount to the memory usage. Some people will find too many Histories irksomely slow when it comes to editing large files with loads of global changes. Skilled users with an awareness of what is happening in the program will find combining adjustment layers with a moderate number of histories the preferred way of working.

In the context of this chapter, I would recommend visiting the History Options submenu and changing the number of undos to suit the job you are working on. If the picture you are working with is big and to have more than one undo is both wasteful and unnecessary, then restrict the number. On the other hand if multiple undos are well within your system limits or the Photoshop actions are not a string of global changes then make the most of it. Clearly it is a matter of judging each case on its merits. After all, History is not just there as a mistake correcting tool, it has great potential for mixing composites from previous image states.

History brush and Snapshot

History addresses the various usage of snapshot, magic eraser, define pattern/clone from pattern techniques, by combining the functionality all in one section of the program and doing so in a way that is much easier for the user to understand and access. Taking a snapshot is easy – click the Snapshot button at the bottom of the palette. This stores the image in its current state for future retrieval and prevents this version being overwritten. Neither is there a constraint of only having a single snapshot stored at one time.

The history brush can be used in the same way you might have used the magic eraser to paint back in a previous saved (snapshot or state) version of the image – very versatile indeed. This saves you from having to duplicate a portion of the image to another layer, retouching this layer and merging back down to the underlying layer again. Non-linear history enables you to branch off in different directions and recombine effects without the need for layers. In this respect, History should be judged not as a drain on system resources, but as a tool to enhance productivity.

Adjustment layers allow you to change your mind at a later date, so you can undo Levels, Curves, Color Balance etc. adjustments. You can even have more than one adjustment layer. For example, you could have a file saved with four different Hue/Saturation settings. The Hue/Saturation adjustment layers would only add a few kilobytes each to the overall image file size. You could quickly demonstrate to a client several color variations in succession, without having to open four separate files.

Quick Edit

This feature was added in version 3.0. Essentially it resolves the problem of having a huge file open occupying lots of precious RAM memory, when you actually only need to work on a small portion of the image. In the example shown here, one can open just a portion of a large sized file and carry out alterations more efficiently. The

saving space one thing you must watch out for is working up to the edges of a Quick Edit selection. If you were to filter the whole of a Quick Edit image area, the boundaries would jump out after exporting back to the main image. Define the Quick Edit selection to be slightly larger than is actually needed. If Quick Edit does not appear in the File menu Import/Export options, don't worry, it is still there, it has been relegated to the Goodies/plug-ins folder on the Adobe Photoshop CD-ROM. Install it in the Import/Export plug-ins folder.

3 You can now manipulate on the opened portion of the image. The Quick Edit image can be saved separately if the session has to be interrupted before completion. If you use layers, though, these must be flattened before exporting: File > Export > Quick Edit Save. The edited image is merged with the original file.

I The file to open has to be in Photoshop 2.0, Scitex CT or uncompressed TIFF file format. Choose File > Import > Quick Edit.A dialog window displays a low resolution preview of the image. Drag within the preview to select the area to be opened. The file size is shown in the dialog window. To enlarge the selection overall by one pixel (in the preview window), press '=' (+) on the keyboard. To decrease, press '-'. Use the arrow keys on the keyboard to move the selection around.

2 Click on Grid to split the image up into tiled sections. Click in the plus or minus box to alter the grid. Click on the tile area to select, press 'F' to jump to the first tile and 'N' to proceed to the next. Use the arrow keys on the keyboard to move up or down the grid. Press Command/Ctrl-A to select the whole of the image. When finished, click OK to open the Quick Edit window.

Monitor calibration

The monitor screen is your most important piece of kit. Image adjustments are based on how the color is represented on the screen and how you interpret the monitor image. Back in Chapter Three on RGB and CMYK color, I discussed some of these problems. To recap briefly, each RGB color device has its own unique gamut, the dynamic range or brightness range of a monitor is not the same as the printed page and lastly we need to think in terms of outputting to CMYK color which is not the same as looking at transmissive RGB color.

Central to all these considerations is the appearance of the image on the monitor and how we read and understand that information. So the first step is to get the monitor calibrated and make sure the display will be in sync with the output.

An Ektachrome transparency has a dynamic range in the region of 2.7 and a printed image a dynamic range of around 2.3. A typical computer monitor has a dynamic range of only 1.4–1.6. The range of colors which can accurately be displayed is rather limited compared to the full tonal range of the final print. To get round this problem, the display of digital information has to be compressed to fit within the brightness range of the monitor, so the whitest portions of the image appear as the brightest values on the screen and the blackest parts of the image are represented by the darkest values on the screen. A linear compression of the tones displayed on the monitor would be one answer, but not the most practical. The solution used is nonlinear compression. Least compression is applied to the tones where image information matters most and more compression where it doesn't. In practice this means there is usually slight compression of the highlight tones and most compression takes place in the shadow tones, with the mid to highlight tone separation displayed most accurately of all.

The very best monitors such as the Barco Calibrator and Radius Precision View come with their own calibration software and hardware. Otherwise closely follow the instructions in the Photoshop manual on monitor calibration. Use one or the other, but not both. The objective of calibration is to neutralize the screen display color and optimize the way the tonal range is displayed within the constraints of the Cathode Ray Tube (CRT).

Before following the calibration procedures pay attention to how your computer is physically sited and the lighting. Dim lighting helps conditions improve the contrast of your monitor by reducing flare on the screen, which is fine as long as doing so does not impede others working around you. Think about the color of the walls and color temperature of the light sources. I suggest neutral color painted walls. If you have daylight coming in, fix up some shuttered blinds to regulate the amount of light coming in and using daylight colored bulbs for working after dark. Even reflections

My Charles charl

off the clothes you wear may have some impact on the screen color. Make sure your monitor has been left switched on for at least half an hour so it has had a chance to stabilize itself. After the manual brightness and contrast controls have been set, ensure these are not touched again as to do so will upset the whole calibration process and, lastly, get rid of any colored desktop patterns. Choose a neutral gray instead.

I The Adobe Gamma Control Panel and calibration procedure now operates identically for both Macintosh and Windows PC systems. The Adobe Gamma Control Panel is located in the Application > Goodies > Calibration folder. Install a copy in your system folder, i.e. on a Macintosh, inside the Control panel folder. When opened you have a choice between using the Control panel method of operation or the Wizard.

2 In Control Panel mode the interface option settings will be familiar to Photoshop users who knew the Thomas Knoll Gamma Control Panel. You can load existing ICC profiles or make your own custom profile and save as an ICC profile.

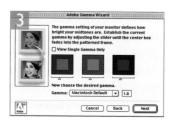

3 The Wizard option will guide new users through all the steps necessary to adjust the physical monitor settings for brightness and contrast and then fine tune the Gamma to optimize your monitor display if not listed as an ICC profile.

Photoshop color management

We now come to what I believe to be one of the most important aspects of Photoshop 5.0 – the new color management system. It may not matter so much to everyone, but this is something which should be of paramount importance to photographers and anyone concerned with seeing accurate color and CMYK color conversions. The choice you face is either to leave everything exactly as it is or you can choose to override the default setup to take full advantage of Photoshop's implementation of ICC based color management. That being the case, you can adjust the settings in order to adopt the most suitable RGB color work space as your standard. If you do so then it is essential that you understand exactly what is going on in Photoshop and the implications for sharing your files with other Photoshop users and opening legacy Photoshop files. If you don't want to concern yourself with this then leave every-

thing as it is. The current default RGB color space is sRGB, described as a new emerging RGB standard agreed between Hewlett-Packard, Microsoft, Pantone, Corel and others. sRGB was originally chosen as the default because most users would be advised not to tamper with the RGB settings and sRGB was felt to be most compatible with the consumer RGB devices being developed over the next few years. But consider this, sRGB has been developed as a standard to suit the low-end business and consumer market. In my opinion it falls a long way short of satisfying the needs of high-end color users or anybody who is producing work for repro. For the majority of PC users it will make the transition to Photoshop 5.0 color management a smoother one, but whether you are a Mac or PC user, you'll be working in what I regard as a less than perfect color space.

The way Photoshop manages color and mode conversions has been changed completely. Photoshop can now compete head to head with other advanced color management and high-end image editing systems. The only problem is that despite the simplicity of the new system, it is going to be hard for some folks to adjust to this new way of working. And I include here experienced professionals who may face much initial head scratching trying to make sense of it all. It is a transitional problem really, because for as long as Photoshop 5.0 and older versions of Photoshop continue to be used side by side, users will have to contend with thinking in terms of both 'old' and 'new'. There may be a lot of frustration and difficulties in the early stages, but once a good number of users have settled down to the routine of working exclusively in version 5.0 and have their systems calibrated properly, color management should be effortless. I am mostly concerned that the bureaux we use all equip themselves with version 5.0 as soon as possible, because without them adopting the Photoshop 5.0 system of color management, some of these new working benefits will be negated.

Photoshop color management history

I don't want to muddy the waters any more than necessary, but since many people did not necessarily understand the workings of previous Photoshop color management, it is worth reiterating to see what was happening before and how legacy (pre- version 5.0) files should be handled when opening them up in Photoshop 5.0. Like other color management systems, Photoshop used to rely on the device independent Lab color space for translating color between RGB and CMYK. Lab was the go-between, the all seeing, all knowing color space. Crucially, the RGB color space was defined by the color space of your particular monitor profile, which would not necessarily be the same RGB color space of another user's monitor. To proof CMYK colors on the screen, a translation was made from CMYK via Lab to the monitor RGB color. The way these colors were displayed on screen was determined by the monitor profile and the set-

tings entered in the Printing inks and CMYK separation setup. The settings had to be entered before making the CMYK conversion, as the display was determined by a combination of all these factors.

This mostly worked satisfactorily, except for the odd occasion where one would see image banding when displaying a CMYK file in RGB. In that case, you could change the composite display preferences from faster to smoother, which would adjust the display on the fly but consequently slow down the screen redraw. CMYK color display accuracy was therefore a problem, as was the limitation of having varying, RGB device dependent, color spaces used in the color management process. The monitor gamma setup procedure differed between PC and Macintosh owners. The Macintosh Gamma Control Panel affected the global monitor display, while on a PC the Gamma correction was applied at the application level only. This was a system issue which the Adobe engineers did their best to address. Now that Microsoft are supporting ICC profiles in their operating system using ICM 2.0, PC computers have the potential to manage color the same way Macs do.

Photoshop 5.0 color management

Figure 6.2 The RGB setup. Choose here your RGB workspace. Enter the ColorSync profile for your monitor in the operating system – this will be identified in the RGB setup dialog. You can override the RGB Color setup and enter your own custom color space settings (see text below).

What Adobe have done now is to settle on a standardized approach by making the *RGB work space* independent of the system or monitor you are using. So the Photoshop 5.0 RGB work space is therefore device independent, just like Lab color is. The monitor profile is now important as a means of interpreting how the RGB data is displayed, while the actual RGB values can conform to a universally recognized standard. All people have to do is calibrate their monitors and generate or select the appropriate profile. The RGB color you view on your screen should be the same for someone looking at the image on another monitor regardless of the operating system they are using or make of monitor, provided that is, they too have followed the correct calibration procedure. To picture what is happening, you have to imagine that all Photoshop operations take place in the RGB color space which can be one of several recognized standards. This is what is called the 'work space' it is the color space

which Photoshop does all its calculations in. Activities surrounding the Photoshop RGB work space, like the importing of images, the display of RGB data on screen and CMYK conversions, are moderated by ICC profiles to maintain color consistency throughout the workflow. Therefore, if you import an image which has an ICC profile embedded in it, this is recognized upon opening and if the profile does not match the current setup the image data can be adjusted accordingly (or not, if you wish). The ICC profile of your monitor is taken into account and the RGB display values are calculated on the basis of the work space primaries plus monitor profile. The CMYK conversion can be specified too with an ICC profile (see Color Settings > CMYK setup) or manually by entering in the custom separation setup information.

We are looking towards a color management system in which the user only has to calibrate their monitor and everything else fits into place. Afterwards it should not be necessary to manually tweak your gamma control settings to match your output devices - the device ICC profile will take care of the translation. If everyone chose to adopt this approach to color management, it would not have to be a complicated issue. And, oh yes, wouldn't it be nice if clients all paid their bills on time? In reality bureaux will be sticking to their own closed color loop systems and whatever you supply them with for output will have to match in with that. There is nothing to prevent you basing your own studio/office system loop on ICC profiles and it is highly recommended you do so, but don't assume everyone else will. What about bureaux running outputs from your files, who do not have version 5.0, or are not bothering to calibrate their systems properly and also, which RGB color space will we all be using? Among Photoshop 5.0 users it matters less individually which RGB color space you choose in the RGB setup, as long as you stick to using the same space for all your work. Photoshop 5.0 can safely convert between RGB spaces with minimal loss of data, but the space you plump for does matter. Once chosen you should not change it. Whichever work space you select in RGB setup, you will have to be conscious of how your Photoshop 5.0 RGB files may appear on a non-Photoshop 5.0 system. Below is a guide to the listed RGB choices.

Apple RGB is the old Apple 13" monitor standard while the sRGB space is the choice for Windows PC users and is based on the high definition TV color standard (for broadcast). sRGB might be the color space to use for web design projects but is not well suited for repro quality work. The sRGB space clips the CMYK gamut and you will never get more than 85% cyan ink in your CMYK separations. The CIE RGB space is based on the CIE color model which Lab color is also based on. The greens tend to be a bit yellow and the space is too close to Lab to be of any real advantage. Wide Gamut RGB is there as a very large space which will encompass all the RGB primaries at their extremes and you can include a huge range of RGB colors. Although there may be larger gaps in color tone information between one bit and the next, when used with care you can obtain richly saturated RGB transparency outputs,

without as had been predicted, the risk of banding. The NTSC and PAL/SECAM are old TV video standards. ColorMatch RGB is an open standard monitor RGB space used by Radius, which was around for a while. SMPTE-C (Society of Motion Picture and Television Engineers) is the current standard for television in the US. The space formerly known as SMPTE-240M was based on a color gamut proposed for HDTV production. As it happens, the coordinates Adobe went ahead with did not exactly match the actual SMPTE-240M standard. Nevertheless, it proved such an ideal space for pre-press editing, that it has officially been adopted as the Adobe standard space for repro work and is now known as Adobe RGB (1998). I originally adopted SMPTE-240M as the RGB default, because it was a large enough space to accommodate both CMYK print and RGB transparency output. Despite now being renamed Adobe RGB (1998) the coordinates are nevertheless identical to the former space.

Fellow beta tester Bruce Fraser, came up with his own RGB space specification which was intended to provide a better RGB space than SMPTE-240M. His space includes most of the CMYK gamut and makes less of an excursion into the greens. If you want to test this alternative space for yourself, it is fairly easy to enter your own custom RGB space settings in the RGB setup dialog. These are: White point: D65. Gamma: 2.2. Red x: 0.6400 y: 0.3300 Green x: 0.2800 y: 0.6500 Blue x: 0.1500 y: 0.0600. You can name it Bruce RGB if you like — a loadable Bruce RGB profile can be found in the Samples folder on the CD-ROM.

Figure 6.4 To look at this another way, imagine the RGB viewing color space of your monitor is defined as a triangle. The RGB setup offers the choice of several different RGB color space standards, which all vary in size. To choose which RGB space you should work in, you want a space which is as large as or slightly larger than the monitor RGB space. Wide gamut RGB will encompass nearly all the RGB spectrum, but the ideal space is one wider than the monitor RGB, but not too wide, yet includes the CMYK gamuts.

Figure 6.3 Just because a monitor is an RGB device does not mean that it is displaying the entire RGB spectrum. Every RGB device has its own individual 'profile' which can be accurately defined and taken into account when displaying color that belongs to a wider color space which is outside the limits of the monitor's RGB display capabilities. With Photoshop, a monitor can operate in an RGB color space which is larger than its actual display limits.

Figure 6.3 illustrates the concept behind choosing an ideal work space. It is not a technically accurate drawing, but gets across the idea that the work space can be larger than the actual RGB monitor. I could have overlaid a CMYK gamut space as well to show that we are choosing an RGB work space which accommodates the limits of the CMYK gamut, but it would have made the illustration look rather messy. The accompanying diagram (Figure 6.4) examines the same issue from a different perspective, by imagining the monitor RGB space as a triangular shape. If you select a work space which is smaller than the monitor space, you are not using the monitor to its full potential and more importantly you are probably clipping parts of the CMYK gamut. Select too wide a space and you are stretching the work space gamut unnecessarily beyond the normal working requirements. Imagine the top shape being stretched or shrunk to match the shape of the selected RGB work space on the layer below.

Figure 6.5 This example illustrates an RGB image which was acquired and edited in RGB using Bruce Fraser's recommended coordinates. A CMYK conversion was carried out using the same tables as used for all the other images printed in this book.

Figure 6.6 The image was assembled with a gradient chosen to highlight the deficiencies of sRGB. The master RGB file was then converted to fit the sRGB color space. A CMYK conversion was made using the same CMYK setup as in figure 6.5. sRGB is weaker at handling cyans and greens. There is also a slight boost in warmth to the skin tones.

CMYK Info	Α	В	С
Cyan	88	73	94
Magenta	10	5	- 1
Yellow	82	2	3
BlacK	2	0	0

CMYK Info	Α	В	С
Cyan	84	73	84
Magenta	15	5	6
Yellow	76	2	3
BlacK	4	0	0

As I mentioned earlier, if you alter the RGB settings to adopt a new RGB work space you have to take into account that this will potentially cause confusion when exchanging RGB files between your machine running Photoshop 5.0 and someone who is running Photoshop 4.0 where the RGB they use is based on the monitor space. Figures 6.7 and 6.8 are actual screenshot examples of how an RGB file will be displayed on the monitor if this change in working procedure is not correctly recognized. If you are sending an RGB file to someone else for them to view then one of four things should happen.

- (1) They open the file in Photoshop 5.0 with the RGB Color Mismatch Settings set to the default of Convert Colors on Opening.
- (2) They open the file in Photoshop 5.0 with the RGB Color Mismatch Settings changed to Ask on Opening and they click Convert Colors.
- (3) You convert RGB image to Lab mode in Photoshop 5.0. This does not lose you any image data and is a common color mode to both programs.
- (4) You convert the RGB image in Photoshop 5.0 from the work space RGB to match the RGB profile of the other user before saving. Go Image > Mode > Profile to Profile... and select the destination RGB space from the extensive pop-up list. This could be something like Apple Multiscan 15".

The last two examples take into account the limitations of Photoshop 4.0 (or an earlier version) not being able to understand and read a Photoshop 5.0 RGB file in anything other than the monitor RGB color space. If you are sharing files and you want to preserve all the color information, but don't know what system is going to be used to read them, the safest and surest thing to do is save a copy in Lab mode. If you are designing images for universal screen display – web design, for example – then either convert your images to the sRGB profile in the Image > Mode menu or temporarily change the RGB work space to sRGB. The reverse situation – opening a legacy file in Photoshop 5.0 – has potential pitfalls too, but these will only happen if you incorrectly specify your color settings and you choose to ignore all Photoshop's attempts to warn you that the RGB profile settings are different and the colors need to be converted.

File opening routines

The file opening procedure is really quite straightforward, but until you get a grasp of how Photoshop 5.0 works it is still easy to get tied in knots trying to work out why deviating from the recommended setup produces such anomalies on the screen.

Problems to be avoided when exchanging RGB files

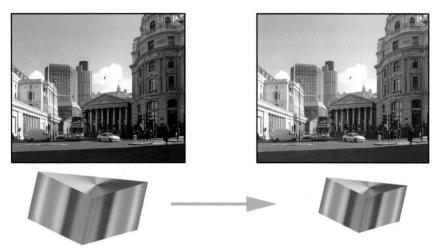

Figure 6.7 Photoshop 5.0 image opened in Photoshop 4.0. If the RGB work space selected in Photoshop 5.0 is going to be wider than the basic monitor RGB work space used in Photoshop 4.0, then the latter will interpret a Photoshop 5.0 file as being like any other 4.0 legacy file. The RGB colors will appear much compressed and consequently desaturated in version 4.0. The only way round this is to either convert the version 5.0 RGB in Image > Mode > Profile to Profile to the smaller RGB color space used in Photoshop 4.0, or convert the image from RGB to Lab mode in 5.0. Lab mode is always going to be common to both versions of Photoshop.

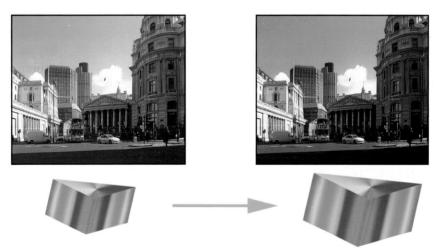

Figure 6.8 Photoshop 4.0 image opened in Photoshop 5.0. Again, if the RGB work space selected in Photoshop 5.0 is going to be wider than the basic monitor RGB work space used in Photoshop 4.0, then Photoshop 5.0 will expand the RGB color space as shown here, *unless* you have the Profile mismatch settings set correctly either to Convert RGB Colors or Ask When Opening and you click Convert. In both these examples, if you alter the RGB setup from the default work space, you must be aware of how these files might be interpreted when viewed in a different RGB work space.

When you open a file in Photoshop 5.0, the first thing Photoshop looks for is an ICC profile. The profile contains specific information regarding the color gamut of the file. If an ICC profile tag is present and it matches the current Photoshop setup (in either the RGB or CMYK setup), all is well and the file is automatically opened in the respective color space. The characteristics of the monitor used to view the screen image will vary from system to system so the variance of the monitor is taken into account when calculating the display colors and you do this by letting Photoshop know which monitor ICC profile to use. This is specified either in the ColorSync system profile, ICM control panel or with the Adobe Gamma control panel. The application level Monitor setup is no more. The monitor settings and the RGB work space are two entirely different things. If two users are sharing the same RGB work space setting, but using two different makes of monitor, the Monitor ICC profile interprets the image data so that it appears identical on the two screens. Ultimately you want the monitor to reflect an accurate impression of what the print output shall look like. When it comes to printing, you select an ICC profile which matches the output device and this too will interpret the image data, taking into account the known characteristics of the output device. When ICC color management is used correctly and all devices are calibrated, the monitor preview should match the colors and lightness of the output.

If for some reason the colors do not match up and the shift is identical from device to device then this would suggest that the monitor calibration is at fault. If the mismatch occurs with a specific device, the wrong device profile may have been selected or else the profile for that device is no longer accurate due to physical changes in the output device. This is not necessarily a problem. Custom ICC profiles can easily be made for any output device using inexpensive software. The other possibility is that the Photoshop settings are awry, as was shown in Figure 6.8.

When you save a Photoshop 5.0 file, the profile tagging options (see Profile setup in Color preferences) must be switched on. So where it says Embed profiles, ensure all these boxes are checked. Without this no record of the Photoshop color space set-

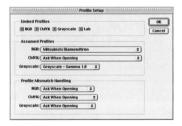

Figure 6.9 The Profile Setup preferences. Follow the guidelines in the text for configuring these preferences. Basically you want to have all the Embed profile boxes checked on and the Assumed profile for RGB set to match the monitor profile. This will take care of legacy files created on the same system. Not all legacy files will be your own, so for this reason it is maybe best to keep the mismatch handling for RGB files left as Ask When Opening.

tings will be recorded. When Photoshop 5.0 interrogates a file on opening, the ICC profile may be different, in which case it will want to convert the image data to match the current system setup. When you save that file, tagging will be employed, identifying the new setup and when you open that file again, the tag will be recognized as compatible and open without having to convert the colors again.

If no ICC profile is present, this will be spotted and at this point you can either instruct Photoshop to ignore the lack of a tag (see Figure 6.8 again to remind yourself of the horrors that can lead to) or you can allow Photoshop to convert the colors to the current color space (RGB or CMYK), using the best guess of the file's provenance. This is where the Assumed Profile business comes in. If you go to the Profile Setup preferences, below Embed Profiles you can specify the assumed profile in absence of an ICC profile tag. None of your legacy files are likely to contain an ICC tag, so the best thing to do here is to select the monitor profile tag from the pop-up menu as your assumed RGB profile and the most commonly used CMYK setup as your assumed CMYK profile. Or you can leave both set to Ask When Opening and enter the mismatch handling there when the dialog box opens half way through the file opening.

Sample file opening tables

Information on the CMYK setup will follow next, but first I have prepared a series of tables covering the points just discussed relating to file opening from Photoshop 5.0 and legacy files in the three color modes: RGB, CMYK and Lab. Each table starts with the file being opened at the top and showing the progress of a file opening down to saving and proofing at the bottom. The aim is to show the opening procedures Photoshop uses in order to determine whether a file's image data needs converting or not.

The opening routine is automatic. Photoshop asks all the questions and makes decisions as to how the image's data is treated based on the way you have configured your program settings. In the central column are reminders where you the user should specify settings which will inform Photoshop of the device profiles and color space you intend using. At the bottom I have linked the monitor display and image output together, because after all, if the system has been properly calibrated, this is where you will be comparing the output with the monitor display and expecting both to match up.

Open RGB legacy image

Open RGB legacy image

Is a source ICC profile present?

No

Is a source ICC profile present?

No

Use assumed color space profile to Convert colors from 'assumed' RGB space to current work space

Set profile mismatching in Color preferences

Convert colors from **known** RGB space to current work space

Save Save

Current RGB Color space profile embedded

Current RGB Color space profile embedded

Open/Acquire RGB image

Open/Acquire RGB image

Is a source ICC profile present?

Is a source ICC profile present?

Yes

Yes

Does file's ICC profile match current RGB work space?

Does file's ICC profile match current RGB work space?

Yes

No

Convert colors from known RGB space to current work space

Save Save

Current RGB Color space profile embedded

Current RGB Color space profile embedded

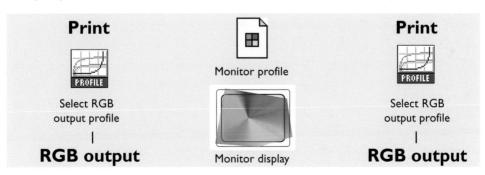

Open CMYK image

Is a source ICC profile present?

Yes

Does ICC profile match current CMYK setup?

No

Open CMYK image

Is a source ICC profile present?

Yes

Does ICC profile match current CMYK setup?

Yes

Convert CMYK colors from known CMYK space to match current CMYK setup via Lab Color space

Save Save

Current CMYK profile embedded

CMYK Source profile embedded

Open CMYK image

Is a source ICC profile present?

No

Use assumed CMYK color space profile

Set profile mismatching in Color preferences

Convert CMYK colors from 'assumed' CMYK space to match current CMYK setup via Lab Color space

Save

Current CMYK profile embedded

Open Lab mode image

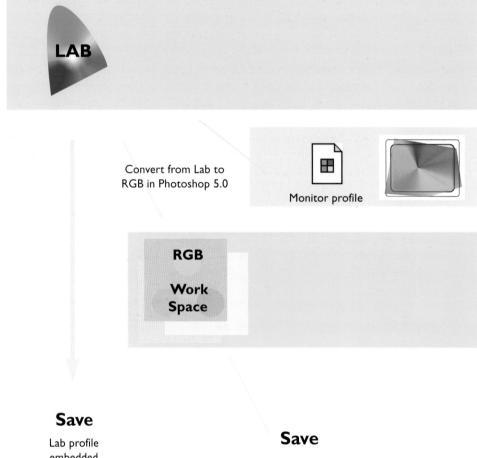

Opening CMYK and Lab files

Files created in Photoshop 5.0 and saved in Lab or CMYK should be embedded with an ICC profile. In the case of Lab, it is a universally understood color space. In the absence of an ICC tag the file will open without interruption and saving in Lab mode is one sure way of surmounting RGB color space mismatch worries. The received wisdom regarding CMYK files is that these should not be converted back and forth to RGB. I always prefer to keep an RGB master and convert to CMYK using a custom conversion to suit each press requirement, but always refer to the same RGB master file. Converting from one CMYK space to another is not normally recommended but in the absence of an RGB master, this will be the only option available. Photoshop 5.0 makes the process of CMYK to CMYK conversion easier to accomplish. You specify the known or assumed CMYK profile in the Profile mismatch handling dialog box. When you choose Convert Colors, the CMYK image data is mapped from the known or assumed CMYK profile to the one currently specified in the CMYK setup.

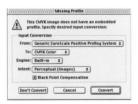

Figure 6.10 If on opening a CMYK file, no embedded profile found, you can convert the file to the CMYK setup currently specified in Color settings. The dialog shown here has the Euroscale Positive proofing system as a default. If the provenance of the file is known, then change this to match the setup used. If you do not want to modify the CMYK file's colors in any way, choose Don't Convert.

CMYK setup

All the CMYK setup specifications are entered in the one CMYK Setup Color preference. Previously, you had four Color settings preferences: Monitor setup; Printing inks; Separation setup; Separation tables. Information entered in the above preferences were used to determine the way Photoshop converted from RGB to CMYK, in terms of how the actual image data was converted and how the information was displayed on the screen. The Macintosh method was to change the screen display when viewing the CMYK file to reflect dot gain, while the PC method was to alter the screen display of Photoshop in RGB mode to reflect the impact of dot gain. Two conflicting approaches which worked well enough for each system but created confusion when PC and Mac users compared notes on setup procedures.

The color management in version 5.0 has unified things across the two platforms and brought with it the benefit of improved CMYK conversions from RGB, because the RGB gamut is now independent of the monitor space and depending on the RGB work space you select, there is less chance of clipping the CMYK gamut. Second,

Adobe's built-in ICC color management engine is superior and, lastly, if you change a file to 16 bits per channel before converting you will reduce the amount of data which could potentially get lost in the conversion.

Monitor Setup is no longer there because Photoshop 5 now gets this information from the system (ColorSync or ICM) or the Adobe Gamma control panel. In RGB Setup, Photoshop shows you the name of the currently active monitor profile, but only allows you to enable or disable the monitor compensation. You choose a monitor profile at the System level or generate your own custom monitor profile using the Adobe Gamma control panel. All other CMYK preferences are set in the one dialog.

CMYK model

Of the three options, it is recommended that you either use an ICC profile (as discussed in Chapter Three) or select the built-in CMYK model and use the following options to establish a precise custom CMYK separation setup.

Ink options

Where it says Ink Colors, choose the setting recommended by your press and enter the suggested Dot Gain below. If you cannot find the press type listed in Ink Colors, select Custom from the menu. This will open the Custom Ink Colors dialog box. Check with the printer as to the custom values to be entered here or Load... a presupplied Ink Colors profile.

The Dot Gain value affects the brightness of the image display on the monitor screen only and simulates the impact dot gain will have on the printed file. The higher the dot gain the darker the CMYK image display. Dot gain refers to the spread of ink on the paper after it is applied. A CMYK image has to be lightened to compensate for this factor which is dependent very much on the type of press and paper stock being used. The Use Dot Gain For Grayscale option is now a separate preference and avail-

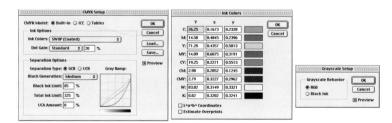

Figure 6.11 The CMYK setup, the Custom Ink Colors and the Grayscale setup dialogs.

able to both Macintosh and Windows. There are two choices for the display of Grayscale information. Grayscale behavior can be set to display the image in RGB, which means no compensation is applied or set using Black Ink. When using the latter, do so before converting an image to grayscale. The conversion process will take into account the current dot gain values specified in CMYK setup, to display on screen exactly how the image will print from the black plate. There should be no visual change in brightness, the image tonal values will be lighter. Dot Gain Curves are a welcome addition. In the preparation of this book I was provided with precise dot gain information for the 40% and 80% ink values. If you select the Dot Gain Curves option, you can enter custom settings for the composite or individual color plates.

Separation options

This controls what type of separation will be used and the total ink limits permitted. The default Photoshop setting is GCR, Black Generation: Medium, Black Ink Limit 100%, Total Ink Limit 300%, UCA Amount 0%. To know what should be entered here, ask the printer. Unfortunately it is not always that simple. In my experience, I am nearly always told to use the default Photoshop settings. So that being the case, I have asked around various printers here in the UK and abroad what default settings would they suggest? For European printing I am told use UCR, a black ink limit of 85% and set the Total Ink Limit to 320%.

UCR is the preferred separation method in use today and commercial printers will recommend this as the separation method they use on their systems. The UCR setting is also favored as a means of keeping the total ink percentage down on high speed presses, although is not necessarily suited for every job. Low key subjects and high quality print jobs are more suited to the use of GCR with UCA. However, in the case of Photoshop conversions, you are better off sticking with the default GCR with 0% UCA. This produces a longer black curve and better image contrast. I asked Tim Piazza of TAGS studio for his advice on settings. Here is what he recommends:

If it is commercial printing (sheetfed, short run web): GCR Medium, 85% Black Ink Limit, 325% Total Ink coverage.

If it's going to a publication as an advertisement: GCR Medium, 85% Black Ink Limit, 287% Total Ink coverage (unless there's a great deal of black).

If there's a great deal of black and going to publication: GCR Medium, 80% Black Ink Limit, 280% Total Ink coverage.

If it's going to a packaging printer, silk screen, or gravure, talk to the printer.

Information palette

Given the deficiencies of display on a monitor – its limited dynamic range and inability to reproduce colors like pure yellow on the screen – professionals rely on the numeric information to assess an image. Certainly when it comes to the correct output of neutral tones, it is possible to predict with greater accuracy the neutrality of a gray tone by measuring the color values with the eyedropper tool. If the RGB numbers are all even, it is unquestionably gray. The CMYK values are different. When printing a neutral gray, the color is not made up of an even cyan, yellow and magenta. If you compare the color readout values between the RGB and CMYK Info palette readouts, there will always tend to be more cyan ink used in the neutral tones, compared with the yellow and magenta inks. If the CMY values were even, you would see a color cast.

Closed color loops

Given that not everyone you work with will be using ICC profiles in their color management, you will find bureaux who have their own closed color loop established. Anything that they scan and output will reproduce reliably on their system with the same colors as the original providing you don't tamper with the color balance of the image data. So if you visit your favorite lab/bureau, they supply you with a scan, you retouch it and pass it back for output, the colors are guaranteed to be faithful to the original as if they had retouched it themselves. If the color loop they utilize does not match your system, the answer is to modify your display monitor profile to match their output. You don't want to mess up your carefully calibrated settings either, so the answer is to use the Adobe Gamma control panel to make a new custom monitor profile which matches the bureau color loop output. Load this monitor profile at the system level, whenever you are working with their supplied files. Any color changes you do happen to make will be relative to the original.

The procedure (known as iteration) starts with you comparing the bureau output with the digital file on screen and using the Adobe Gamma control to change the screen appearance to match what you see in the output. Once you are satisfied that the two look close enough, then save the modified monitor profile using a different name and that's it. Load this custom ColorSync system profile whenever you want to get in sync with their color loop. Remember though to revert to the standard monitor profile afterwards. If you have the relatively simple task of creating color consistency from your own desktop scanning setup, the scanner software should provide you the means to run a test strip through the scanner. Check the monitor display with the original and fine tune the ICC profile settings in the scanner software to maintain a consistent device profile.

Chapter Seven

The Work Space

efore moving on to the practical Photoshop techniques, let's first look at the Photoshop interface. The tools and palette layouts underwent some minor revisions between the version 3.0 and version 4.0 upgrades. The aim then was to unify the interface and keyboard key commands in line with other Adobe graphics software products, so if you were switching between current versions of Photoshop, Illustrator and PageMaker programs, the interface and keyboard commands would remain fairly consistent. For example, the keyboard zoom shortcut in all these programs is: hold down the Command/Ctrl key+Spacebar. The hand tool, used to scroll the document window, can temporarily be accessed in Photoshop by holding down the Spacebar, but in PageMaker you hold down the Option/Alt key. The reason for this difference is that in PageMaker you are working mostly with text and holding down the Spacebar would add a string of spaces into the text unless you had deselected the text object first. In Photoshop the Option/Alt key is an important and often used modifier key. Apart from these slight discrepancies the transition between all Adobe graphics programs is relatively seamless. With version 5.0 the interface has had much added to it, but undergone fewer alterations to the legacy features. The toolbox layout has changed quite a bit, the layer palette opacity sliders revised and improvements made to some of the dialogs. Only a couple of the old shortcuts have been abandoned or the key combinations reallocated to perform some other function. There are a lot more new shortcuts to learn though (see Chapter Thirteen), but overall the period of adjustment to using the program features that you are familiar with is very smooth. The following pages give an account of the basic Photoshop work space and introduces the new tools. Use this chapter as a reference as you work through the remainder of the book.

Photoshop Preferences

Located in the File menu, preferences govern various Photoshop functions. Before getting started, open the preferences dialog box – File > Preferences > General (Command/Ctrl-K). To tidy the screen layout, click on the Reset Palette Locations to Default button. If you would like Photoshop to always open with the palettes positioned this way, uncheck the Save Palette Locations box. As for the other settings in this first dialog, I would recommend leaving them as they are, except you can check the Beep When Done box if you want Photoshop to signal a sound alert when tasks are complete. Unchecking the Export Clipboard box saves time when exiting Photoshop to launch another program. Unless you are wanting to paste clipboard contents to another program, then leave it off. Bicubic interpolation is the best quality option. Leave this set as the default. If you need to override this setting then you can do so in the Image > File size dialog. Click the Next button to proceed.

Saving files

Do you need image previews? For the most part, I would assume yes. In the normal course of your work, it is very useful indeed to have picture document icons and thumbnail previews in the Open dialog boxes when searching for a file. There are times when you don't want previews, such as web graphic files which you want to upload as small as possible without platform specific header information. I usually upload files to my server in a Raw Binary format, which strips out all this and other Mac resource information anyway. For general cross platform access you can choose to save a Windows and Macintosh thumbnail with your file.

Appending a file with a file extension is handy for keeping tabs on which format a document was saved in – there is no other way of telling until you actually open the file. It is very necessary for saving JPEG and GIF web graphics. Early versions of Photoshop 4.0 capitalized the file extension, which was no good for servers that were case sensitive. Version 5.0 allows the file to be appended with lower case letters. The version 2.5 compatibility might as well be left switched off, unless you need to share your files with someone who only has a very old copy of Photoshop. This early version of the program did not support layers, so an extra flattened version of the image is stored when saving. Switching it off saves on disk space not to mention time when saving the file. Overall I prefer to set the preferences to 'Ask When Saving'. This is because of the mixed work I do and the need to switch some of these options on or off.

Display & Cursors

Video LUT Animation speeds up the display of colors on 24-bit monitors. Leave this option switched on unless the video card you are using suggests otherwise. Computers not able to display 16-bit or higher color have to rely on 8-bit color display (256 colors). The default display for this color depth produces a not very pretty grid pattern of dots. If you are limited in this way to a mere 256 colors, you can choose the Diffusion Dither option, which approximates the in-between colors to a better, if not completely accurate, display. It certainly looks nicer.

The color channels are by default set to display in shades of gray. There is an option for displaying in color. This does not make it easy to see what is going on when editing individual channels, therefore keep the Color Channels in Color option switched off. Normally the cursor changes to display the icon of the tool in current use. This is fine when starting to learn Photoshop but for precision work I suggest changing the brush cursor to Brush Size and the other cursors to Precise. The Brush Size cursor displays an outline of the brush shape at actual size in relation to the image magnification.

Figure 7.1 The Preferences dialog boxes for General controls and Saving files.

Transparency & Gamut

The transparency settings simply modify the transparency display in layers – if you view a layer on its own, with the background layer icon switched off, the transparent areas of a layer are displayed with a checker board pattern. Edit the display preferences here if you so wish. The Gamut display comes into effect when working in RGB or Lab mode and you choose View > Gamut Warning. Colors that fall outside the CMYK gamut are displayed as a solid color which is set here.

Units & Rulers/Guides & Grids

These preferences control how all the above features are displayed. Ruler units can also be changed via the Info palette sub-menu. Guides & Grids were new to Photoshop 4.0 and one more example of the unification between Photoshop and the other Adobe graphics suite of programs. Use of Guides & Grids is discussed in the following section on Photoshop Windows.

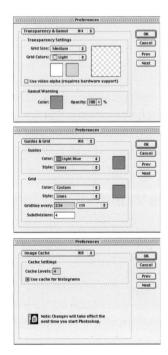

Figure 7.2 The remaining Preferences dialog boxes: Display & Cursors, Transparency & Gamut, Units & Rulers, Guides & Grids, Plug-ins & Scratch Disk plus Memory & Image Cache.

Plug-ins and Scratch Disk/ Memory & Image Cache

Choose the folder to be sourced as the Plug-ins folder (they may be shared with another application). Select the Plug-ins folder via the Preferences menu (hit Select, don't open it). Choose the Primary and spill over scratch disks. As was explained in the last chapter, the primary scratch disk should ideally be one that is separate to the disk running Photoshop and the system and be kept free of other data. The primary scratch disk choice will only take effect after you restart Photoshop. However, if you hold down the Command/Ctrl+Option/Alt keys at the beginning of the startup cycle, you can choose the location of the Plug-ins folder first then hold down the same key combination again and then choose the scratch disks. Up to four scratch disks can now be specified.

The image cache settings affect the speed of screen redraws. When working with high-resolution images, Photoshop uses lower resolution versions to update the screen display when compositing or making layer or Image adjustments. Settings can be between 1 and 8. A higher setting provides faster screen redraw, sacrificing the quality of the preview.

Windows memory management is different from Macintosh. Memory allocation is set as a percentage of the total RAM available. The default used by Photoshop is 75%. If more applications are required to run simultaneously, the percentage can be lowered, though this will degrade Photoshop's potential performance on your system.

You thought the web was slow? Underpowered computers will spend a lot of time in wristwatch or egg timer land while waiting for commands to execute. The Progress bar on a Macintosh features a Cancel button. Hitting the 'Esc' key or Command/ Ctrl-period (.) will also cancel an operation.

Image Window

The document window looks like any other system window. Extra information is displayed in the two boxes located in the bottom left corner of the image window. The leftmost displays the zoom scaling percentage, showing the current zoom factor. You can type in a new percentage of any value you like from 0.2% to1600% up to two decimal places and hit Return. Next to this is the Preview box. Holding down the mouse over the Preview box, displays a preview showing a placement of the image on the currently selected paper size. The preview reflects the image dimensions at the current resolution set. This can be checked by holding down the Option/Alt key while holding down the mouse – the display shows the dimensions and image resolution. Command/Ctrl and mousing down shows the image tiling information.

The Preview box displays updated file information. The display preferences can be changed by mousing down over the arrow next to the box:

<u>Document Size</u> displays the current document size. The first figure is the file size of a flattened version of the image. The second, the size if saved including all the layers.

Scratch Disk Size displays first the amount of RAM memory used. The second figure is the total RAM memory after the system overhead, available to Photoshop. The latter figure remains constant and only changes if you close Photoshop and reconfigure the memory partition. During a Photoshop session, the first figure will increase dramatically when performing certain operations that consume a large amount of RAM/Scratch Disk memory.

<u>Efficiency</u> summarizes the current performance capability of Photoshop. Basically it provides a simplified report on the amount of Scratch Disk usage. Low percentages warn that it may be advisable to purge the clipboard or undo memory (Edit > Purge > Clipboard/Undo).

<u>Timing</u> times Photoshop operations. It records the time taken to filter an image or the accumulated timing of a series of brush strokes. Every time you change tools or execute a new operation, the timer resets itself.

<u>Tool selection</u> is new to Photoshop 5.0 and displays the name of the tool you have currently selected. This is a useful aide memoire for users who like to work with all the palettes hidden.

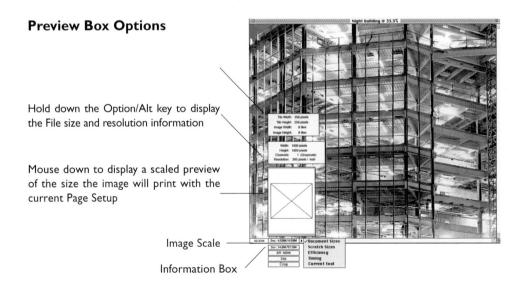

Figure 7.3 The Window layout of a Photoshop document.

Figure 7.4 To open a second window view of a Photoshop document, choose View > New View. Changes applied to the close-up view are automatically updated in the full-frame view.

Opening a Second Window

You can create a second window view of the image you are working on by choosing View > New View. The image is duplicated in another window. The advantage of doing this is you can have one window with the image open at Fit to Screen scale and the other zoomed in close-up on a detail within. Any changes you make can be viewed simultaneously at both scales, avoiding the need to zoom in and out and saving you time.

Rulers, Guides & Grids

At the beginning of this chapter I mentioned the unification of standards and tools between Adobe graphics programs. Not least of which is the inclusion of Guides & Grids. Those of you who have worked with DTP layout programs will be familiar with these as a means of aligning page layout elements.

Guides can be introduced at any time, provided the Rulers are displayed (View > Show Rulers). Drag from the ruler bar across the image and release the mouse wherever you want the guideline to go. If you are not happy with the positioning, select the move tool and drag the guideline into the exact required position. From the View

Figure 7.5 Displays showing grids (back) and guides. Use Command/Ctrl—semicolon (;) — to toggle between showing and hiding guides. To position a guide, drag from either the horizontal or vertical ruler. Hold down the Shift key as you drag to make the guide snap to a ruler tick mark.

menu there are a series of options for the guides. They can be shown or hidden, you can select Snap to Guides and objects on layers will snap to position when placed within close proximity of a guide edge. Furthermore you can Lock Guides and Clear Guides. If the ruler units need changing, double click anywhere on a ruler to call up the Ruler Units preferences dialog box. If the rulers are visible but the guides are hidden, dragging out a new guide will make the others reappear.

Guides can be positioned anywhere in the image according to your specifications and, as was shown, be rearranged using the move tool. The last option in the View menu – Show Grid – reveals an evenly spaced grid. The grid acts just like the guides and you can choose the option Snap to Grid to make objects align to the grid structure. To alter the grid, go to the preferences and select Guides & Grids. To see a practical example of using guides in a project that involves a PageMaker layout created partly in Photoshop, see the tutorial at the end of Chapter Eleven about preparing a flyer design for Ocean Images, swapping between PageMaker and Photoshop.

The toolbox

Just like every other program you have been used to working with, the usual editing conventions still apply. Pixels can be cut, copied and pasted just as you would do with text in a word processing document. Mistakes can be undone with a single Edit > Undo command. The other File and Window menu options will be familiar and self-explanatory. The rest is somewhat daunting, though the toolbox icons do give a

Figure 7.6 The Toolbox palette with keyboard shortcuts shown in brackets.

clue as to tool functions. Tool options are located in the Options palette (Window > Show Options). Double clicking any tool will automatically display the Options palette, or if a tool is selected, press Enter. One important interface change in version 5.0 has been to remedy the problem of accidentally cycling through the tool options with the keyboard shortcut. The key shortcut for accessing the rubber stamp (clone aligned) tool is 'S'. As of old, pressing 'S' a second time, selected the next option which was the clone nonaligned mode and after that a further five tool options before returning to clone aligned mode. That could get very frustrating if you had forgotten the rubber stamp was already selected. What Adobe have done now is default the single key stroke to call up the last used tool in a particular category. If you wish to select another tool sharing the same single keystroke command, you can only access them by holding down the shift key plus the key shortcut as shown in Figure 7.6. If selecting a particular tool is an illegal command, you now see a warning sign on screen – as if you are trying to paint on an image in 48-bit color. Double clicking in the image window will call up a dialog explaining why you cannot access that tool. If you click at the very top of the toolbox, this will now open the Adobe On-line... dialog (also available in the File menu). Any late breaking information plus access to on-line help and professional tips are all easily accessible within Photoshop.

Selection and move tools

The four tools are grouped together at the top of the toolbox (the type tool has a selection mode of operation, but more of that later). They include: marquee, lasso, magic wand and move tools. Selection tools are used to define image areas that you want to modify separately, float as a layer or copy and paste. The move tool is not actually a selection tool as such, but is sensibly grouped with the other three because you use it to move selection contents plus perform other drag and drop functions.

Within the basic toolbox are extra tool options. These become visible when you hold down the mouse over the main icon. Therefore, the marquee tool has options for either rectangular, elliptical or single row/single column selections. The lasso tool is used to draw freehand selection outlines and has two other modes – the polygon lasso tool, which can draw straight line and freehand selections and the new magnetic lasso tool. The magic wand tool selects pixels on the basis of their color values. If you have a picture of a red London bus (yes, there are still a few left in London) click on the bus with the magic wand tool and 'hey presto' the red color is selected! That's what most people expect the magic wand tool to do, in reality it does not perform that reliable a job. I find it works satisfactorily on low resolution images (such as those prepared for screen sized display). There are ways of modifying the wand – for example, the Tolerance setting and smoothing options in the Select menu. If you are going to create complex selections this way then really you are often better off choosing the Select > Color Range option. This menu command provides everything the magic wand tool has on offer but with much more control.

The Tolerance setting governs the sensitivity of the magic wand selection. When you click on an area in the image, Photoshop selects all the adjacent pixels whose numeric color values are within the specified tolerance either side of the pixel value. If the pixels clicked on have a mean value of 120 and the Tolerance setting is set at the default of 32, Photoshop will select pixels with a color value between 88 and 152.

Personally, I rarely ever use the magic wand when defining critical outlines, but do find it quite useful when I want to make a rough selection area based on color. In short, don't dismiss the wand completely but don't put too much faith in its capabilities for professional mask making either. There are better ways of going about doing this, as shall be explained later.

Modifier keys

Macintosh and Windows keyboards have slightly different key arrangements, hence the double sets of instructions throughout the book reminding you that the Command key on the Macintosh is equivalent to the Control (Ctrl) key on a Windows keyboard (because Windows PC computers don't have a Command key) and the Macintosh Option key is equivalent to the Alt key in Windows. In actual fact, on the Macintosh compatible keyboards I use, the Option key is labelled as Alt. Macintoshes do have a Control key too. On the Mac its function is to access Contextual menus (more of which later). Windows users will find their equivalent is to click with the right mouse button. Finally, the Shift key operates the same on both Mac and PC.

NB. Throughout this book I will keep reminding you of the keyboard equivalents for both platforms.

Figure 7.7 The Modifier keys on a Macintosh keyboard and their Windows PC equivalents.

These keys are 'modifier' keys because they modify tool behavior. Modifier keys do other things too – hold down the Option/Alt key and click on the marquee tool in the toolbox. Notice that the tool displayed cycles through the options available. Drag down from the system or Apple menu to select About Photoshop... The splash screen reopens and after about 5 seconds the text starts to scroll telling you lots of stuff about the Adobe team who wrote the program etc. Hold down the Option/Alt key and the text scrolls faster. If you want to see an Easter egg, go to the layers palette, hold down the Option/Alt key and choose Palette Options from the palette sub-menu. For the most part, modifier keys are used in conjunction with the selection tools and as you get more proficient you should be able to reach the appropriate key instinctively without your eyes having to leave the screen.

The Shift and Option/Alt keys affect the shape and drawing behavior of the marquee tools: holding down the Shift key when drawing a marquee selection constrains the selection to a square or circle; holding down the Option/Alt key when drawing a marquee selection, centers the selection around the point you clicked on the image.

Holding down the Shift+Option/Alt keys when drawing a marquee selection constrains the selection to a square or circle and centers the selection around the point where you first clicked. Here is another useful tip: after drawing the selection, do not release the mouse button yet – hold down the Spacebar. This allows you to reposition the placement of the selection. Release the Spacebar and you can continue to modify the shape as before.

After the first stage of drawing a selection, whether by marquee, lasso, magic wand or a selection has been loaded from a saved alpha channel with subsequent selection tool adjustments, the modifying keys now behave differently.

Holding down the Shift key as you drag with the marquee or lasso tool adds to the selection. Holding down the Shift key and clicking with the magic wand tool also adds to the existing selection.

Holding down the Option/Alt key as you drag with the marquee or lasso tool, subtracts from the selection. Holding down the Option/Alt key and clicking with the magic wand tool also subtracts from the existing selection.

A combination of holding down the Shift+Option/Alt keys together whilst dragging with a selection tool (or clicking with the magic wand) creates an intersection of the two selections.

To summarize: The Shift key adds to a selection, the Option/Alt key subtracts from a selection and the Shift+Option/Alt keys intersect a selection. To find out more about practical techniques requiring you to modify selection contents, refer to Chapter Eleven on Montage Techniques.

P | P | P | Lasso: Freehand/Polygon/Magnetic

Everything that has been written above about working with the marquee tools applies to the lasso tool. The default freehand mode needs little explanation, just drag around the area to be selected holding down the mouse as you draw. When you release the mouse, the selection joins up from the last point drawn with the starting point.

In polygon mode, you can click to start the selection, release the mouse and position the cursor to draw a straight line, click to draw another line and so on. To revert temporarily to freehand operation, hold down the Option/Alt key and drag with the mouse. Release the Option/Alt key and the tool reverts to polygon mode. To complete the polygon lasso tool selection position the cursor directly above the starting point (a small circle icon appears next to the cursor) and click.

The magnetic lasso is new, as is the magnetic pen tool. Both use the same code and therefore are basically the same in operation, except one draws a selection and the other a pen path. The magnetic lasso has a sensing area (set in the options palette). When you brush along an image edge, where an outline is detectable, the magnetic lasso intelligently prepares to create a selection edge. You continue to brush along the edges until completing the outline and then close the selection.

This innovation is bound to appeal to newcomers and anyone who has problems learning to draw paths with the pen tool, but I reckon this is quite a powerful Photoshop feature and should not be dismissed lightly as an 'idiot's pen tool'. Used in conjunction with a graphics tablet, you can broaden or narrow the area of focus by varying the stylus pressure. Without such a tablet, you have basic mouse plus keyboard control, using the bracket keys ([and]) to determine the size of the tool focus area.

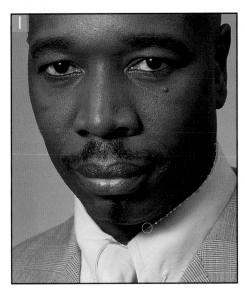

I Where there is a high contrast edge, the magnetic lasso has little problem following the suggested path roughly drawn by dragging along the shirt collar. Anchor points are automatically added along the path.

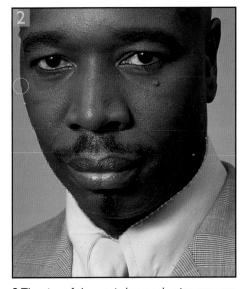

2 The size of the magic lasso selection area can be enlarged by lessening the pressure if using a graphic tablet input device. This makes drawing an outline much quicker. For precise edge definition, add more pressure to narrow down the tool's field of view.

3 In a situation like this there is quite a lot of room for latitude. As you draw the tool away from the edge, it does not add another point until it senses a continuation of the edge. You can watch the tool laying down a path like a magnet sticking to an edge. To scroll the screen across as you work, hold down the Spacebar – this temporarily accesses the hand tool without disturbing the operational flow of the selection tool.

4&5 If you veer too far off course, reverse the path of the tool and hit the delete key to erase the previous point (there are no limits to this type of undo). To complete the selection, hit the Enter key or double click. The end points will join up and if there is a gap, attempt to follow and continue the image outline.

The only way to truly evaluate the performance of the magnetic tools is to take them for a spin and learn how to use them in combination with the relevant keyboard keys. In operation, the magnetic lasso and magnetic pen tool operate alike: the magnetic lasso draws a pseudo path, laying down anchor points along the way – the distance apart of the points can be set in the Options palette as a frequency value, while the edge contrast specifies the minimum contrast of an edge before the tool is attracted. As you brush along an edge, an outline follows the edge of greatest contrast within the brush width area and sticks to it like a magnet.

To reverse a magnetic outline, drag back over the outline so far drawn. Where you meet an anchor point, you can either proceed forward from that position or hit the delete key to reverse your tracks even further to the anchor point before that and so on... A single mouse click allows you to add an anchor point.

While defining an outline, a combination of mousing down with the Option/Alt key changes the tool back to the regular lasso to manually draw round an edge. Holding down the Option/Alt with the mouse up changes the tool to the polygon lasso (or

freeform pen tool if using the magnetic pen). Other selection modifier key behavior comes into play before you start to drag with the tool – hold down the Shift key then drag to add to an existing selection.

To complete a selection, click on the start point. Double click or hit Enter to close with a line determined by the magnetic tool. Photoshop will intelligently follow the line you are currently on and close the loop wherever there is good edge contrast for the tool to follow. Option/Alt double click closes the path with a straight line segment.

h...

Move tool

You can select the move tool from the tools palette. Just as you can access the Hand tool at any time by holding down the Spacebar, the move tool is activated by holding down the Command/Ctrl key. The Command/Ctrl key in this respect is not a modifier key but is actually the move tool. The Option/Alt key modifies move tool behavior. Holding down the Option/Alt key plus the Command/Ctrl (move tool shortcut) as you drag a selection makes a copy of the selection.

You use the move tool to:

- Drag and drop layers and selections from one image window to another.
- Move selections or whole images from Photoshop to another application.
- Move selection contents or layer contents within a layer.
- Copy and move a selection (hold down Option/Alt key).

When one of the selection tools is selected, dragging within a selection does not move the selection contents, but moves the selection outline only. When the move tool is selected, the cursor does not have to be centered on the object or selection, it can be anywhere in the image window. There are just two options for the move tool in the Options palette. Pixel Doubling is checked by default. When a layer or selection is moved, the screen redraw resolution is temporarily halved making the operation much smoother, avoiding screen display delays. The other is Auto Layer. When this is switched on, the move tool auto selects the uppermost layer containing the most opaque image data below the cursor. This is fine and useful for some layered images. Where many layers overlap, the use of the Ctrl/Right mouse click to access the contextual layer menu is the more precise (if slower) method. If you have the move tool selected in the toolbox and the Auto Layer option unchecked, holding down the Command/Ctrl key temporarily inverts the state of the move tool to Auto Layer mode.

女 Crop tool

The crop tool has changed slightly, adding a movable center point. You use the Enter key to OK the crop and the Escape (esc) key to cancel and exit from cropping. On both Macintosh and PC keyboards, these keys should be diagonally positioned, with the 'esc' key at the top left and Enter key at bottom right. Drag the crop tool across the image to marquee the estimated crop. Refine the position of the crop by directly dragging one of the eight crop handles. Constrain the proportions of the crop by holding down the Shift key as you drag. Reposition the crop without altering the crop size by dragging within the crop area. To rotate the angle of the crop, move the cursor anywhere just slightly outside the crop window. When you place the cursor and drag above the center point the central axis can be repositioned.

The paint tools

Situated below the selection and move tools are the tools for painting and pixel modification. The common options available to these tools are choices of different blending modes and opacity. Mouse only users can set the opacity or intensity of the tool action from 1 to 100%. If you have a graphic tablet as your input device (highly recommended) the pressure sensitivity options are activated in Photoshop and offer fine control over tool behavior. Opacities can also be set from the keyboard: 1=10%, 9=90% and 0=100%. The Photoshop paint tools are more than adequate for painting and retouching work. Combine the basic tool functions with different blending modes, brush shapes, fade and other options (like Wet Edges for the paint brush tool) and Photoshop can become a sophisticated artist's painting program. For example, you can design your own custom brush shapes or load some from the Brushes folder. The only problem as I see it is the lack of an intuitive interface for this type of work. You need to spend some time familiarizing yourself with all the variables to really feel at home like an artist with his or her favorite paint tools. Fractal Design's Painter program is regarded as one of the best bitmapped paint programs because it provides a very wide range of brushes and the interface is well thought out for the needs of digital paint artists. Here though is a run down of the Photoshop paint tools.

Mimics the effect of a real airbrush, producing a spray of paint. As you click with the mouse or press down with the stylus, the airbrush paint will continue to spread out if you stop moving the cursor, just as in real life.

Crop Tool cursor icons

- Cursor placed on mid
 point box changes crop
 size in one direction
- Cursor inside bounding box – moves whole cropping area
- Cursor positioned anywhere outside box rotates the cropping area

Figure 7.8 The crop tool bounding box. The cursor positioned on the corner box changes the crop dimensions both horizontally and diagonally. In Photoshop 5.0 the center point can be repositioned to set the central axis point.

8

Paint Brush

The standard paint tool for retouching work. This can be used like the airbrush with a range of brush sizes from a single hard edged pixel up to a 100 pixel wide soft edged brush (you can create your own larger brush if you desire). Optional extras include Wet Edge painting, which builds extra density around the edge of the brush stroke and a Fade control.

Rubber Stamp/Pattern Stamp

An essential tool for retouching work such as spotting (discussed later in Chapter Ten) and general repairing of images. The rubber stamp tool is mostly used in one of the clone modes to sample pixels from one part of the image to paint in another. In clone (aligned) mode, hold down the Option/Alt key and click where you want to sample from. Release the key and click in the area you want to clone to. This action defines a relationship between sample and painting positions. Once set, any subsequent clicking or dragging will spot or paint the image always using the same coordinates. The sample point can also be from a separate image. This is useful for combining elements or textures from other pictures. The rubber stamp normally samples from a single layer only. The Sample Merged option permits the clone sample to be taken from merged layer pixel information. The pattern stamp tool replaces the pattern option in the old style rubber stamp Options palette menu.

Mistory brush and History palette

The History palette and history brush combine the roles of the Snapshot and magic eraser in this star billing, multiple undo feature. The History palette displays the sequence of Photoshop states as you progress through a Photoshop session (as shown in Figure 7.9). To reverse to a previous state, you can either click on it or drag the arrow slider back up the list. The number of histories allowed is chosen in the History palette pop-up menu. When the maximum number of histories is reached, the earliest history state at the top of the list is discarded. Similarly, the same thing happens if you alter the number of histories permitted.

At the very top, above the divider, image Snapshots can be stored. The default operating mode stores a Snapshot of the opening image state. You can choose not to store an opening image this way if you prefer and take more snapshots at any time to add to the list. This feature is useful if you have an image state which you wish to temporarily store and not lose as you progress rapidly through further image changes – like just before a rapid sequence of rubber stamp cloning. To create a snapshot, click on the Snapshot button at the bottom of the palette. Alternatively, if you wish instead to duplicate the image state, then click the duplicate image button and save the duplicate file. The history brush then will enable you to pick a state from the list, click on the space just to the left where you will see an icon become visible and you can then paint information in from a previous history state or from one of the Snapshots.

The History palette and brush answer the request for multiple undos by allowing you to reverse your tracks and recover a version of the image after more than one Photoshop action has taken place (up to 100 histories are permitted) and also let you selectively paint back in the previously held image information as desired. That is a simple way of looking at the history brush and it is easy to understand how it now replaces the role of the magic eraser, but of course it is actually providing a lot more than that. Take, for example, the alternative spotting technique explained later in Chapter Ten. A lengthy procedure which before involved duplicating the background layer, applying the Dust & Scratches filter, defining as a pattern, deleting the layer and cloning the information back in as a pattern with the rubber stamp tool. That is no longer necessary – now you just apply the filter, reverse one step (the keyboard shortcut for stepping back is Command/Ctrl+Option/Alt-Z) and clone in the information from that particular state using the history brush.

The History feature does not really take on the role of a repeat Edit > Undo command and nor should it. There are several actions which will remain only undoable with the Undo command, like intermediate changes when setting shadow and highlights in the levels dialog. Furthermore there are things which can be undone with Edit > Undo that have nothing to do with the History. If you delete an Action or a

History stages	Scratch disk
Open file	61.2
Levels adjustment layer	138.9
Curves adjustment layer	139.9
Rubber Stamp	158.3
Rubber Stamp	159.1
Rubber Stamp	160.1
Rectangular marquee	139.7
Feather 100 pixels	149.9
Inverse selection	162.6
Levels adjustment layer	175.3
Flatten image	233.5
Unsharp mask filter	291.7
Close	

Figure 7.9 The accompanying table shows how the scratch disk memory will fluctuate during a typical Photoshop session. The opened image was 38.7 MB in size and 250 MB of memory was allocated to Photoshop. Notice how minor local changes to the image do not increase the amount of memory used compared with the global changes. As with previous versions of Photoshop, memory usage may even sometimes go down during a session as extra steps are added.

History, these are only recoverable using Edit > Undo. So although the History feature is described as a multiple undo, it is important not to confuse History with the role of the Undo command. The Undo command is toggled and this is because the majority of Photoshop users like to switch quickly back and forth to see a before and after version of the image. The system arrived at by Adobe of combining Undo and History has been carefully planned to provide the most flexible and logical approach – History is not just an oh I messed up. Let's go back a few stages feature, which is the way Adobe Illustrator works, it is a tool designed to ease the workflow and allow you more creative options in Photoshop.

History and memory usage

Conventional wisdom suggested that any multiple undo feature would require vast amounts of memory to be tied up storing all the previous image states. Testing Photoshop 5.0 will tell you this is not necessarily so. It is true that a combination of global Photoshop actions will cause the scratch disk memory to soar, but localized

Figure 7.10 The non-linear history tree. This graphic representation of non-linear history in action shows an image at four different stages in the history palette all of which branch off from one common ancestor. To show how these states are linked, I have highlighted the groups of history states. Client: Schwarzkopf. Model: Louise Anne at Elite.

changes will not. You can observe this for yourself – set the image window bottom left corner status display to show Scratch Disk usage and monitor the readout over a number of stages. The right hand value is the total amount of scratch disk memory currently available – this will remain constant, watch the left hand figure only. Every Photoshop image is made up of tiled sections. When a large image is in the process of redrawing you see these tiles rendering across the screen. With History, Photoshop memorizes changes to the image at the tile level. If a brush stroke takes place across two image tiles, only the changes taking place in those tiles are updated and therefore on a larger image the more economical the memory usage will be. When a global change takes place such as a filter effect, then the whole of the image area is updated and the memory usage will rise accordingly.

A savvy Photoshop user will want to customize the History feature to record a reasonable number of histories, while at the same time being aware of the need to change this setting if the history usage is likely to place too heavy a burden on the scratch disk memory. The example in Figure 7.9 shows that successive histories need not consume an escalating amount of scratch disk memory. After the first adjustment layer, successive adjustment layers have little impact on the memory usage (only the screen preview is being changed). Rubber stamp tool cloning and brush work affect changes in small tiled sections. Only the Flatten Image and Unsharp Mask filter at the end add a significant amount to the scratch disk usage. You will find the Purge History command added in the Edit > Purge menu provides a useful method of keeping the amount of scratch disk memory used under control.

Non-linear History

Non-linear history is not any easy concept for beginners to grasp. If the Photoshop interface were radically different it might be possible to make it more user friendly but that would spoil the current design and a complete nonstarter. The best way to think about non-linear history, is to imagine each history state having more than one 'linear' progression, allowing the user to branch off in different directions instead of as one linear chain of events. Figure 7.10 shows more clearly the concept of non-linear history and how now in Photoshop you can take an image down several different routes, while working on the same file in a single Photoshop session. Without non-linear history, recent states are erased if you progress back up the list and alter the image.

Snapshots of history branches can be taken and painted in with other history branches without the need to save and duplicate files. Non-linear history requires a little more thinking on your part in order to monitor and recall image states, but ultimately makes for more efficient use of the available memory.

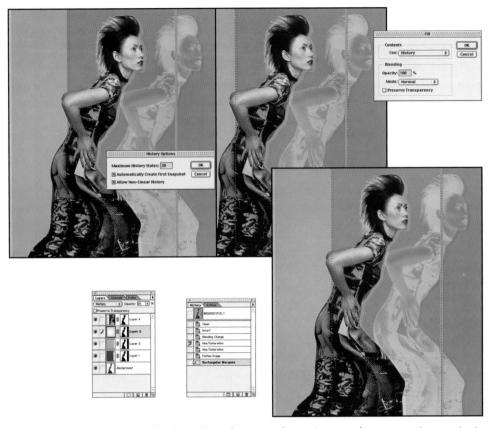

Figure 7.11 An essential benefit of non-linear history is that it gives you the opportunity to paint in or fill not just from previous but alternative future histories. While it might be argued that such things are already available with layers, history offers an infinitely more flexible and adaptable approach. When you stop to consider the nature of history, it is just as much an extension of layers as it is a multiple undo. Here I changed the Hue/Saturation of a layer, kept that layer active and returned to the original state. In the History palette the adjusted color state was selected. I marqueed a portion of the image and filled from History. Client: Clipso. Model: Melanie at Storm.

Eraser

Choose from any one of the above brush modes for the eraser tool plus the block option. The eraser removes pixels from an image replacing them with the current background color. There are four brush modes: paintbrush, airbrush, pencil and block. The magic eraser option survives in a refined form as the Erase to History option: the Option/Alt-drag keyboard shortcut erases to the currently selected History. Also a Wet Edges option which will match the behavior of the similarly named paint brush feature. These features have been included for artistic effects. Some graphic tablets feature an eraser mode when you turn the stylus upside down. This is recognized in Photoshop without having to select the eraser tool.

0

Pencil

Produces hard edged, anti-aliased, pencil-like drawing lines. When the computers running Photoshop were a lot slower than they are today, brush response times were noticeably slow (there is still sometimes a slight delay on modern fast computers when working with large files). The pencil tool provided a fast response sketching tool. The 'Auto Erase' option converted the tool from painting with the foreground to the background color. The Auto Erase feature can also be accessed by holding down the Option/Alt key.

Toning tool options	
Dodge tool	Function
Option+Shift+W	Set Dodge to Shadows
Option+Shift+V	Set Dodge to Midtones
Option+Shift+Z	Set Dodge to Highlights
Option/Alt key	Toggle to Burn tool
Burn tool	Function
Option+Shift+W	Set Burn to Shadows
Option+Shift+X	Set Burn to Midtones
Option+Shift+Z	Set Burn to Highlights
Option/Alt key	Toggle to Dodge tool
Sponge tool	Function
Option+Shift+J	Set Sponge to Desaturate
Option+Shift+A	Set Sponge to Saturate

Line

This is now sharing position with the pencil tool on the fly-out menu. Single pixel or wider lines can be drawn with this tool. To constrain the drawing angle in 45 degree increments, hold down the Shift key (this applies to all the painting tools as well). Arrow heads can be added to the line either at the start or finish of the line. Click the Shape... button in line tool Options to customize the appearance of the arrowhead

oportions. The line tool could be used for measuring if it was set to zero pixels and the distance read in the Info palette (Window > Show Info). That was before the introduction of the measure tool.

O | ∆ | № Focus: Blur/Sharpen/Smudge

If your aim is to soften an image edge, do not use the smudge tool, but rather the blur option from the focus tool options. In blur mode, the blur tool is just like painting with one of the blurring filters. I use it a lot to soften portions of image outlines after compositing or locally modifying alpha channel masks. I recommend you use the converse option – sharpen – sparingly. Excessive tool sharpening creates nasty image artifacts. The results are too crude for my liking, it is much better to make a feather edged selection of the area to be sharpened and apply the Unsharp Mask filter instead.

The smudge tool selects the color of the pixels where you first click and smears pixels in whichever direction you drag the brush. For best results I recommend using a pressure sensitive graphics tablet. The Finger Painting option uses the current foreground color for the start of the smudge. It is best to think of this as an artist's tool like a palette knife used in oil painting.

● © **Solution** Toning: Dodge/Burn/Sponge

Dodging and burning should be familiar concepts. Photoshop provides a nice element of control over the tool effect: you can choose to apply the toning effect selectively to either the Highlights, Midtones or Shadows. Thus if you want to darken or burn the shadow portion of an image without affecting the adjacent highlights, choosing the burn tool in Shadows mode will enable you to do this. As an alternative to the rubber stamp tool, the dodge tool is excellent for removing wrinkles and facial lines without altering the underlying texture if applied in very low percentages. The third option is the sponge tool which has two modes: Saturate increases the color saturation, Desaturate lowers the color saturation. Handy shortcuts have been added in 5.0 which permit quick access to the tonal range application settings.

0 00 0 0+ 0- R N

Pen & Path drawing

Photoshop provides a suite of vector path drawing tools. These work in the same way as those found in programs like Illustrator and Freehand. For detailed instructions on drawing paths and working with the pen tool, refer to Chapter Eleven on Montage Techniques. The magnetic pen tool behavior is more or less identical to the magnetic lasso. The freeform pen is like the same tool in Illustrator – a free drawing pen tool, which operates like the lasso.

Type/Type Mask (horizontal & vertical)

The type tool underwent a major refit for version 5.0. Whereas type was once instantly converted to a bitmapped image or a selection mask, it now is placed as either vector art or a selection outline still, with the options of horizontal or vertical alignment. Type for publishing is normally set in a layout program, where it can be combined with imported images. Although you can create advanced text effects with plug-ins like Vector Effects from Metatools, other special text effects can only be achieved in Photoshop.

Adobe have now made it possible for type to remain as vector art longer, before being converted to bitmapped, pixel information. When a type tool is selected, if you click anywhere in the image, there will be a short delay before the type edit dialog box appears on the screen. In here, you can enter and edit type – specifying the fonts, leading, spacing and size etc. When you OK the type that's been entered, it will appear as a new layer (type mode) or a selection (type mask mode). The selection outline is like any other selection, which you can use as the basis for image adjustments or for floating image areas.

The real interest though is in the performance and opportunities given by the new type tool. Because the type is in vector art form, it remains fully editable. You can double click the type layer and reset the type at any time – changing the fonts, mixing them or entering new text. An extra feature new to Photoshop 5.0 is Layer Effects. These will work on both type layers and image layers, automating the process of adding grouped layers to provide effects such as drop shadows with live feedback.

This is a book about Photoshop and photography. A rich variety of text effects can be achieved in Photoshop and many designers who work in print and multimedia mostly use the program for this purpose. There are plenty of other Photoshop books devoted mainly to the needs of graphic designers, but contain little about information about

image manipulation. I am going to concentrate on the needs of image makers first here – you will therefore find only a limited amount of information on the type tools in Chapter Sixteen.

E

Measure

This is a new Photoshop feature and provides an easy means of measuring distances and angles, which are displayed in the Info palette. Previously you would have used the line tool set to 0 pixels width to do this same job. To use the tool, have the Info palette open, then click and drag to make a measurement in the image window. The measure tool also has a protractor mode – after dragging and releasing the mouse, Option/Alt click on the end point and drag out a second arm. As you drag out and rotate this arm, the angle measurements are updated in the Info palette. The measure tool will always remain visible whenever you click again on the toolbox icon. The measure tool can be constantly updated by clicking and dragging either of the end or protractor angle points. As with other tools the measure tool obeys snap to grid or guide behavior.

Gradient

The gradient tool is used to draw linear or radial gradients. A simple gradient is drawn by selecting the Foreground to Background color option and dragging across the image area. An evenly stepped gradient is created between the two points. You will find that Adobe have now expanded the range of gradient options to include

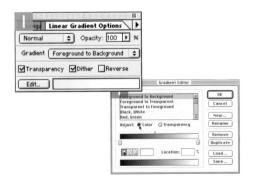

I To create a custom gradient, double click the gradient tool to open the Gradient Options palette and click on Edit... to reveal the Edit dialog box. Make sure the Adjust: Color radio button is selected

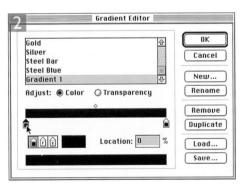

2 Click New, to create a new gradient. Click on the left most slider, the arrow above turns black. In the palette color window below, click here to call up the Color picker. Select a new color from the picker.

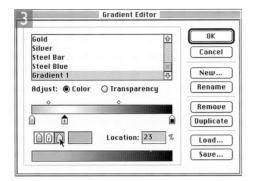

4 I added a few more gradient points and finally adjusted one of the gradient midpoint settings by moving the diamond shaped midpoint slider over to the left.

3 The left hand side of the gradient bar fades from the selected gray to black. Add a new gradient point by clicking just below the gradient editing bar. This time click on the background selection box (marked with a 'B'). Clicking on the Foreground color box would select that color instead.

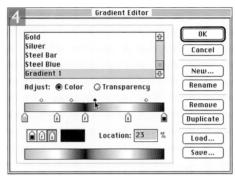

Angular, Diamond and Reflected. The gradient edit and blending mode options make this a very sophisticated tool. The KPT Gradient designer plug-in still has the edge when it comes to gradient creation, but the Photoshop gradient tool has almost as much potential readily available in the tools palette. A problem associated with gradients in the past was that of gradient banding – check the Dither box to add fine noise to the gradient.

Many more options are located in the Edit dialog box – click on the Edit... button. A number of preset gradients are readily available from the menu. You can easily edit and create your own gradient pattern. See the accompanying tutorial showing how to create and customize a gradient.

Paint Bucket

The action of this tool is in effect nothing more than 'make a magic wand selection based on the Tolerance setting in the Options palette and fill the selection with the current foreground color or predefined pattern'. There is none of the flexibility associated with making a magic wand or Color Range selection and modifying it before filling. I had never found a good use for this tool until it was pointed out that you could use the Bucket to quickly fill the inside areas of a Mask or Quick Mask outline.

Eyedropper/Color sampler

The eyedropper samples pixel color values from any open image window and makes that the Foreground color. The sample area can be set to: Point, 3×3 Average, 5×5 Average. The middle option is the best one to select normally. If you hold down the Option/Alt key, the sample becomes the Background color. When working with any of the following tools – airbrush, brush, pencil, type, line, gradient or bucket – holding down the Option/Alt key creates a new Foreground color. The sampler tool is another new addition and provides persistent pixel value readouts from up to four points in the image. Like the measure tool the sample points remain active all the time and can be recalled at any time by clicking on the color sampler icon. The great value of the sampler is the ability to monitor pixel color values at fixed points in an image. To see what I mean, take a look at the tutorial in Chapter Eight, which demonstrates how the combination of placing color samplers and precise curves point positioning means that you now have even more fine color control with valuable numeric feedback in Photoshop 5.0. Sample points can be deleted by dragging outside the image window or Option/Alt clicking on them.

শ্ৰে Navigation tools – Hand & Zoom

To navigate around an image, select the hand tool and drag to scroll. To zoom in on an image, either click with the zoom tool to magnify, or drag with the zoom tool, marqueeing the area to magnify. This combines a zoom and scrolling function. In normal mode, a plus icon appears inside the magnifying glass icon. To zoom out, hold down the Option/Alt key and click (the plus sign is replaced with a minus sign). A useful shortcut well worth memorizing, is that at any time, holding down the Spacebar accesses the hand tool. Holding down the Spacebar+Command/Ctrl key calls up the zoom tool. Holding down the Spacebar+Option/Alt calls up the zoom tool in zoom out mode. An image can be viewed anywhere between 0.2% and 1600%. Another zoom shortcut is Command/Ctrl-plus (Shift click the '=' key) to zoom in and Command/Ctrl-minus (next to '=') to zoom out. The hand and zoom tools also have another navigational function. Double click the Hand tool to make the image fit to screen. Double click the zoom tool to magnify the image to 100%. Navigation can also be controlled from the Navigation palette, the View menu and the lower left box of the image window.

Foreground/Background colors

As mentioned earlier when discussing use of the eyedropper tool, the default setting is with black as the Foreground color and white as the Background. To reset the default colors, either click on the black/white Foreground/Background mini icon or simply click 'D'. Next to the main icon is a switch symbol. Clicking on this exchanges the colors, so the Foreground becomes the Background. The alternative shortcut is to click 'X'.

Selection Mode/Quick Mask

The left icon is the standard for Selection mode display. The right icon converts a selection to display as a semitransparent colored 'Quick Mask'. Double click either icon to change the default overlay mask color.

Screen display

The standard mode displays images in the familiar separate windows. More than one document can be opened at a time and it is easy to select individual images by clicking on their windows. The middle display option changes the background display to an even medium gray color and centers the image in the window with none of the distracting system window border. All remaining open documents are hidden from view (but can be accessed via the Window menu). Full Screen mode displays the image against a black background and hides the menu bar. The toolbox and other palettes can be hidden too by pressing the Tab key. To show all the palettes, press the Tab key again. To toggle between these three viewing modes, press the 'F' key. And here's another tip: if you are fond of working in Full Screen mode with a totally black border, but miss not having access to the menu bar, in the two full screen modes you can toggle the display of the menu bar with the Shift-F keyboard command. This is new to Photoshop 5.0. There was an old Photoshop 4.0 trick which achieved similar ends, where you selected black (or any other color) as the foreground color and Shift clicked with the Bucket tool in the gray pasteboard area.

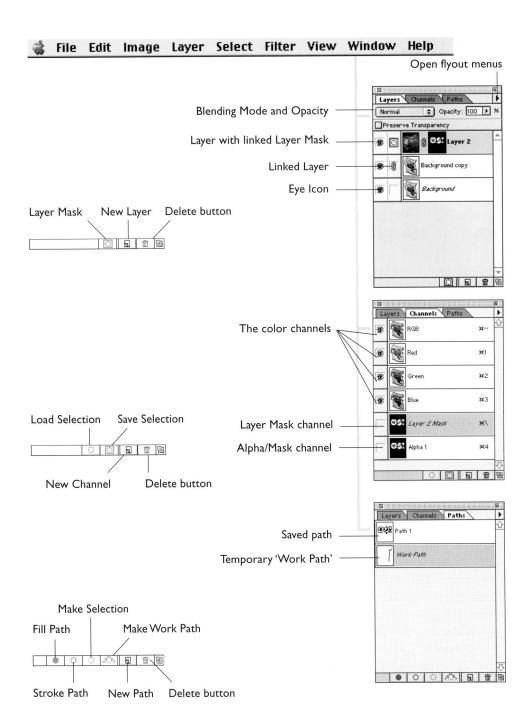

Figure 7.12 The Photoshop Layers/Channels/Paths palettes.

The Photoshop Palettes

The toolbox and palettes can be shunted around the screen like any other window. Mouse down on the title bar and drag to a new position. Apart from Actions, the palettes are grouped together in threes in the default layout. Where palettes are grouped, they are like folders in a filing cabinet. Click on a tab to bring a palette to the front of the group. Double clicking on any of the tabs collapses the palette. If an uncollapsed palette is positioned on the bottom of the screen display, the palette collapses downwards. Change the height of a palette by dragging the size box at the bottom. To return to the default size, click the zoom box at the top (Macintosh) or click the minimize/maximize box (Windows). One click will resize; a second click collapses the palette.

There is no reason why you can't modify the palette layout to suit your needs. If you have a second monitor display, you can arrange for all the palettes to be displayed nestled on the second screen, leaving the main monitor clear to display the whole image. Palettes can be moved about between palette groups or isolated. Choose any palette and drag the tab away from the palette window – a separate palette is formed. Drag from one palette window to another. When palettes are closed or not visible on the monitor, go to the Window menu – this controls the display of all palette windows.

If at any time you wish to restore the palette positions, go to File > Preferences > General and click on Restore Palette Positions. In the preferences menu, there is also a choice between opening Photoshop with palettes in the standard default layout or as they were when Photoshop was last used.

Navigator

A new feature introduced in Photoshop 4.0 that provides an alternative method of scrolling through an image. Instead of scrolling with the hand tool, the Navigator Palette displays a low resolution version of the whole picture and a colored border within, which shows the area currently displayed in relation to the remainder of the image. Drag this border around to scroll the image. Use the slider control underneath to quickly zoom in and out of the picture or hold down the Command/Ctrl key to marquee zoom in the Navigator window. The color of the viewbox border can be changed in the Navigator palette sub-menu.

Adobe Photoshop 5.0 for Photographers

Info

This palette reports information relating to the position of the cursor in the image window, namely pixel color values and coordinate position. When you drag with a tool, the coordinates update and in the case of crop, marquee, line and zoom tools, reports back the size of a dragging movement. The sub-menu leads to Palette Options... Here you can change the preferences for the ruler units and color readouts. The default color display shows pixel values for the current selected color mode plus the CMYK equivalents. When working in RGB, illegal colors which fall outside the CMYK gamut are expressed with an exclamation mark against the CMYK value.

Options

The previous section mentioned all the Options available for each tool. The palette sub-menu offers a choice between resetting the current or all tools.

Color

Used to adjust new colors in the Foreground and Background color boxes. You can choose several color modes for the color sliders from the sub-menu. Out of CMYK gamut colors are flagged by a warning symbol in the palette box.

Swatches

New colors can be saved in the Swatches palette. Scroll down to the bottom of the palette. Click in an empty square to add a new color to the palette. Hold down the Shift key to substitute a swatch color with a new foreground color. Hold down the Command/Ctrl key to erase an existing color. New sets of color swatches can be loaded via the palette sub-menu.

Brushes

The default brushes range from a single pixel wide, hard edged brush to a 100 pixel wide, soft edged brush. To select a new brush, choose one from the palette. Like the swatches, brushes can be replaced or appended via the sub-menu, which also includes options to edit or create new brush shapes. To create a new brush, drag down the palette sub-menu and select New Brush... The Diameter obviously controls the size of the brush, the upper limit is 999×999 pixels; Hardness, whether there is any

softening to the edge of the brush; Spacing – the default is 25%, higher spacing creates a stepped effect in the brush strokes. Angle and Roundness can be adjusted by dragging the cursor around in the preview box or entering numeric values in the boxes. The bottom right preview indicates the shape of the final brush.

Actions

Actions are recordable Photoshop scripts. They replaced the Commands palette which existed in version 3.0. Actions can be as simple as the old style commands: go to the Image Size dialog box, or much more complex, playing back a list of Photoshop operations with provision to pause at certain stages so that in playback you can tweak some of the settings according to the nature of the image or effect you are making. Photoshop 5.0 features improved Actions with more extensive scriptability, making this truly a most useful Photoshop feature. Chapter Thirteen explains these in more detail and lists many other useful Photoshop shortcuts.

I am often made aware that newcomers have great difficulty understanding the difference between layers and channels, especially when they see tutorials advocating channel operation techniques which look very similar to layering methods. Photoshop layers are akin to layers of acetate overlying a background image. Each layer can contain a duplicate of the background image, an imported element, be that another photographic image or bitmapped text, or it can be artwork painted in Photoshop. You can have anything up to 99 layers in a single document. A new class of layer was added in Photoshop 4.0: adjustment layers. They are not image layers, but can best be described as 'image instruction' layers. A basic adjustment layer located above one or more layers contains toning instructions for the layer(s) below. These add very little to the file size (but can slow down screen redraw times). It is not a completed command and can be opened and reset at any time before fixing an image. Some of the sub-menu options for layers are duplicated in the Layers main menu.

Channels

A Photoshop Grayscale mode image is comprised of a single 8-bit channel of image information, with a maximum of 256 levels. RGB images are comprised of three channels: Channel 1-Red, Channel 2-Green and Channel 3-Blue (RGB). CMYK images, four channels: Channel 1-Cyan, Channel 2-Magenta, Channel 3-Yellow and Channel 4-blacK. The Photoshop channels palette displays the color channels in this order, with a composite channel (Channel ~) listed at the top. Use the Command/Ctrl key + the channel number or tilde key in the case of the composite channel as a shortcut for viewing.

The extra channels which may get added to the channels palette in the course of a Photoshop session are usually referred to as alpha channels. When saving a selection (Select > Save Selection), this action always generates a new alpha channel which appears labelled as such at the bottom of the list in the Channels palette. For specialist types of printing, alpha channels can be used to store print color information, like varnish overlays or fifth/sixth color printing of special inks. Photoshop has a spot channel feature enabling spot color channels to have a color specified and previewed on screen in color. You can use the palette sub-menu to delete, duplicate or create a new channel. The button controls at the bottom of the Layers and Channels palettes provide handier shortcuts for these operations (see accompanying figure on palette buttons).

Paths

A freshly drawn path is displayed as a Work Path in the palette window. Work Paths must be saved (drag down to the New Path button or double click the path image icon) – just like selections these will easily become lost forever.

Summary

That was a reasonably detailed account of the Photoshop interface. I have highlighted the Photoshop features which I believe are most important for photographic retouching. The tools and palettes mentioned here will be cropping up again over the following chapters. So if you don't fully understand yet what everything does, hopefully the later tutorials will help reinforce the message. As an aid to familiarizing yourself with the Photoshop tools and Palette functions, help dialog boxes pop-up after a few seconds whenever you leave a cursor hovering over any one of the Photoshop buttons or tool icons. A brief description is included in the box and tools have their keyboard shortcuts written in brackets.

Chapter Eight

Image Adjustment

he following steps in this section aim to introduce everything you need to know about opening up a picture and carrying out basic image corrections. That is all most people ever want to know, but one can become distracted and confused by the many image controls available in Photoshop. The procedures outlined here show some of the methods used to prepare my own images. Of course, all the image adjustment commands are useful in one way or another – not even the simple Brightness/Contrast command should be regarded as totally redundant! I don't use the Variations command much myself, but other people like the ability to carry out one step multiple image adjustments and means to save these settings for future use or incorporate a Variations adjustment into a single undoable action. What I have done here is provide a guide to the image corrections which professionals would use. I suggest these techniques provide the greatest scope for correcting and fine tuning your images and are a good solid base on which to build your retouching skills.

Cropping

Open a file as you would any document, choosing File > Open... If scanning the image, make sure the scanner software and Import plug-in filters are installed correctly, then choose File > Import > (select scanner module). To zoom in on the image as you make the crop, you will want to use the zoom tool shortcut: Command/Ctrl+Spacebar and marquee drag area to magnify. To zoom out, here is a handy tip: use Command/Ctrl+0, which is the shortcut for View > Fit To Window. Then zoom back in again to magnify another portion of the image to adjust the crop handles.

2 You can also crop with the rectangular marquee tool. Define a selection and choose Image > Crop. The constraining options available in the Marquee Options include Constrain Aspect Ratio and Fixed Size.

3 Back to the crop tool...you can check the Fixed Target Size box and enter the desired image dimensions and resolution in the boxes below. To match the dimensions and resolution of an existing picture, make the target image active, check Fixed Target Size and click Front Image (this automatically sets the fixed target size to match the image size). Activate the other image and apply the crop tool. The image will be cropped to match the resolution and size of the former image.

I First crop the picture – this is normally done with the crop tool. In default mode, drag the tool across the image to roughly define the cropping area. As explained in the last chapter, the cursor can be placed above any of the eight handles in the bounding rectangle to reposition the crop. Placing the cursor inside the crop area moves the whole crop. In the Crop Options palette, use the Fixed Target Size to control the physical dimensions and resolution of the crop.

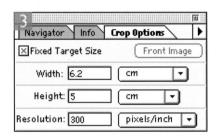

4 If the cursor is dragged outside the crop area with the crop tool, mousing down and dragging rotates the crop. You do this to realign an image which has been scanned slightly at an angle. Should there not be enough canvas size available, don't worry, Photoshop 5.0 will add the curent Background color as extra canvas after cropping. The crop bounding box center point (see image 1) can be repositioned to alter the central rotating axis.

Orientation and canvas

Use the Image > Rotate controls as necessary to orientate your image the correct way up. If you alter the canvas size, the image pixels remain unaltered and only the surrounding dimensions change. The Image > Canvas size lets you enlarge the image canvas area, extending in whatever direction is set in the dialog box. The new background will be filled with the current background color. This is useful if you want to extend the image dimensions, in order to place new elements. With Photoshop 5.0 you will find that it is now possible to resize the crop boundaries beyond the pasteboard area, without having to add to the canvas size beforehand.

Image analysis

Before making any changes, take time to examine the image in close-up. It is not essential to do this every time – mainly for critical work or where you believe there to be a problem with the quality of a scan. Start by checking the individual color channels. Do they look all right? Do any portions of a channel look clipped or posterized? If that is the case, a rescan will be the only solution. Does the composite screen image look properly registered? This is something I have only come across with low-end scanners and can be corrected by nudging the offending channel using the keyboard arrow keys, with the move tool selected.

The histogram display (Image > Histogram) provides a thorough analysis of the image, with more useful numeric feedback than shown in the Levels dialog box display. The Info palette displays the pixel values in either RGB, CMYK or both color modes. These two inspection tools will tell you a lot of what you need to know about a digital image.

Tonal adjustments

The next step is to set the shadow and highlight points, plus adjust the overall brightness of the picture. Either adjust the shadow and highlight sliders in the dialog box so that they just clip the ends of the histogram bars or manually set selected shadow and highlight image pixels to an assigned value.

The first adjustment method is quick and easy to perform. If you want to reset the settings in any of the Image adjustment dialog boxes, hold down the Option/Alt key – the Cancel button changes to Reset. The Auto button speeds up the process of tonal adjustment, but is really a bit too basic for professional use. It is important to get the adjustments right from the start and it need not take too long to accomplish. The

I The Levels dialog box displays the tonal range as a histogram. The tonal range of a scanned image usually needs to be expanded. This is done by dragging the highlight and the shadow Input sliders to just inside the histogram limits. When the Preview box is checked these tonal changes can be seen taking place in the image window area only.

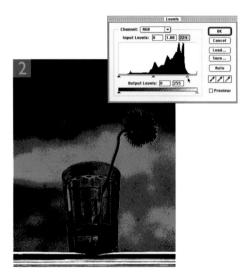

3 Check the Preview box to switch it back on and adjust the gamma slider – this adjusts the overall brightness of the image. If you prefer, enter numeric values for the Input Levels in the boxes above the histogram display.

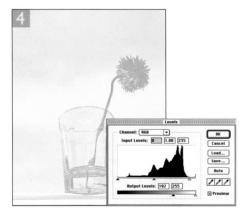

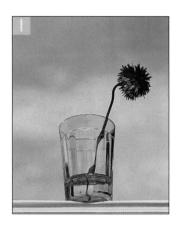

2 A better method of deciding where to set the Input sliders is to uncheck the Preview box and hold down the Option/Alt key as you drag the slider. While the Option/Alt key is held down the whole screen is displayed in 'Threshold' mode (provided the Video LUT animation is switched on in Preferences). The shadow and highlight limits are easily discernible (this only works in RGB Mode and on *most* Windows PC machines, only when the monitor is set to 256 colors).

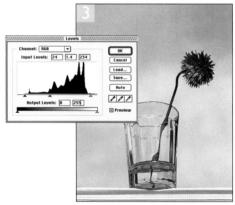

4 That should be enough to fully correct most images. Click OK if you are satisfied with the previewed results, to apply the adjustment to the image. The Output Levels sliders control (as you would expect) the output tonal range. Use these sliders to soften the contrast of a picture. To create a faded background image, for example, slide the shadow output slider across to the right.

Assigning shadow and highlight points

I Double click the highlight eyedropper icon in the dialog box and set the highlight target value, a Brightness setting of 96% (as shown here) is ideal for most printing situations. Study the image. Look for the shadow and highlight points — the previously described Threshold mode technique is a good way of finding out where these are. Zoom in on the image and click on the pixel you want to assign as the highlight target point. This should be a subject highlight, not a specular highlight such as a reflection or glare.

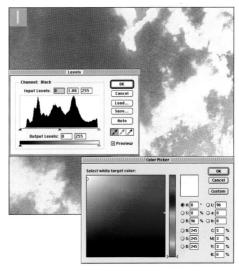

2 Now set the shadow point – double click the shadow eyedropper icon and set a brightness setting of 4% in the text box as the target brightness. After that, with the shadow eyedropper still selected, zoom in on the image to identify and click on the darkest shadow point (use the Threshold mode again to help identify). The gamma slider can be adjusted the same way as in the last example to correct for the midtone contrast or brightness.

Figure 8.1 The Info palette can be used to read color information which helps determine whether the colors are neutral or not regardless of any monitor inaccuracies. Even RGB values equal a neutral gray tone.

second, more precise method involves assigning specific parts of the image to represent the shadow and the highlight points. The process takes a little longer, but is a more precise way of setting the tonal range, producing neutral shadows, highlights and midtone values. Repro and color experts rely mainly on the numerical pixel values as a guide to judging color balance. Before making the tonal adjustment, go to the Eyedropper Options and set the Sample Size to 3×3 Average.

Color balance and contrast

While the Levels dialog box is open, you can at the same time correct for color casts by adjusting the gamma in the individual color channels. You see the pop-up menu next to the channel at the top? Mouse down and choose an individual color channel to edit. Decreasing the gamma in the magenta channel will make the image appear more magenta (CMYK mode). In RGB mode, the opposite is true – increasing the gamma setting in the green channel will make it go more green. To neutralize midtones, in the Levels or Curves dialog box, select the gray eyedropper and click on an area in the image that should be a neutral gray. The levels will automatically adjust the color balance to remove the cast.

The Levels dialog box may be enough to correct the image, but does not offer any degree of fine control. The best tool to use for color correction is Curves. This is because you can change the color balance and contrast at the same time with precision, which you cannot do so effectively with adjustment controls like Color Balance and Variations. The first thing to stress here is that the color data in an image can easily become lost through repeated image adjustments. It is a bit like trying to carry a round of drinks from the bar – the less steady your hand, the more drink that gets spilt. The glasses will only get emptier, never fuller. Pixel color information is gradually lost through successive adjustments as pixel values are rounded off. Though a Levels followed by a normal Curves adjustment hardly harms the image at all. The adjustment layers feature in Photoshop is a bonus because combinations of adjustments can be previewed (affecting a single layer or the whole image) before actually applying them. You can have several adjustment layers in a file and choose to readjust the settings several times, but the pixel values are only ever physically altered in one adjustment. This results in better image output integrity. It is recommended that you carry out spotting with the rubber stamp tool after making tonal adjustments sometimes the cloning you thought was successful is emphasized after adjusting the image levels. Adjustment layers help you to avoid this too. One snag, though, is that the Levels Threshold mode is not enabled in adjustment layers. To get round this, perform the Levels adjustment as before and click the Save... button to save the adjustment made before cancelling. Then make an adjustment layer, choose Levels and Load... the recently saved setting.

Curves adjustments

This first example shows how simple it is to use Curves to correct an RGB image. CMYK curves are by default displayed differently. Just as I mentioned reversing the Levels gamma adjustment for a CMYK file, so you reshape the CMYK curve in an opposite direction. However, if you click on the gray ramp underneath the graph, you can invert the graph representation of the curve to suit whatever way you are most familiar with.

I The photograph (shown here after applying a Levels adjustment) lacks detail in the shadows. The information is there but in its current state will print too dark. We don't want to lighten the picture overall, otherwise the highlights will then become clipped. Choose Image > Adjust > Curves. The dialog box contains a line on a graph on which you can re-map the image tones. Identify which portion of the curve needs adjustment by placing the cursor in the image area and watch where the circle appears on the curve.

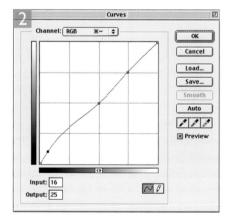

2This first stage helps determine where to place your first point. Click on the grid to make a point and drag (in this case upwards to lighten). The line bends to form a smooth curve. The shadows are more visible, but the highlights will certainly burn out. Precise positioning of the curve anchor point is achieved by using either the keyboard arrow keys or entering numeric values in the Curves dialog.

3 Pin down the highlights by inserting a point roughly on the middle of the curve and dragging to the center. Add another point further up the curve, with the aim of keeping the highlight portion of the curve as it was originally. Readjust the shadow point and click OK to accept.

The next example shows how you adjust the curve to both improve image contrast and correct the color balance at the same time. If we assume the monitor has been correctly calibrated, this can satisfactorily be done by eye on the screen.

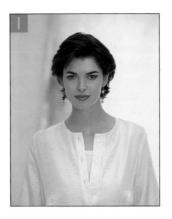

I The highlight and shadow points have been set to expand the tonal range, but still it looks too flat and lacks bite, plus there is also a slight warm cast present.

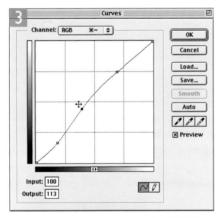

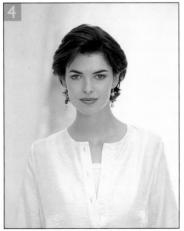

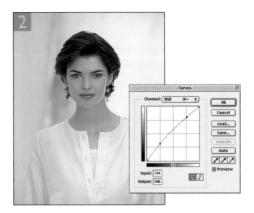

2 Apply a Curves correction. Change the channel selection from RGB to Blue. Drag the cursor over the image areas which look like they need color correction. Note the position of the circle which appears along the curve as you do this. Select this point on the curve and raise it slightly as shown. This will begin to remove the yellow cast, making the image midtones appear more blue.

3 Return to RGB mode and add control points to the curve at the shadow and highlight ends. Drag these points to form an 'S' shape like the one shown here. Drawing an 'S' shape the other way round achieves the opposite effect and softens the contrast. If you are not happy about the position of a curve point, it is very easy to move it around and change the shape. When a control point is selected, to select the next point, use Command/Ctrl+Tab.To select the previous control point, use Command/Ctrl+Shift+Tab. To get rid of a point altogether, drag it to the outer edge of the graph or Command/Ctrl click on the point in the grid.

4 As with Levels, selecting individual channels from the pop-up channels menu enables you to selectively (and with subtlety) alter color values at any position on the tonal curve.

Client: Schwarzkopf Ltd. Model: Erin at Models One.

Previous page. Client: Schwarzkopf Ltd. Model: Maria at M&P. Hair by Cobella.

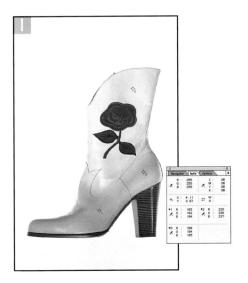

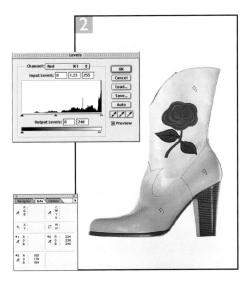

I If a color cast is present in an image like this — a white object photographed against a white background, this is always going to be very noticeable. First of all select the color sampler tool and click on the image in up to four places to monitor the color imbalance at different regions of the tonal range.

3 The color sampler points can be repositioned as necessary by dragging with the color sampler tool (you can access the tool while in a dialog, by holding down Shift). Remember that it is the RGB values we are looking at to determine neutrality. Go to Curves and adjust each color channel curve as required. The first RGB readout figure in the Info palette tells you exactly where to position the point on the curve (see the Input numeric box). Now either manually drag the point or use the keyboard arrows (Shift+arrow key moves the control points in multiples of 10) to balance the output value to match those of the other two channels. Just like Robinson Crusoe's table, what you adjust at one point on the curve will affect the shape and consequently the color at another portion. This is why it is advisable to monitor the color values across the range of tones from light to dark. Remember that you can shift select image samples to add points

to the curve.

2 Set the highlight and shadow points in the image using the eyedropper samplers (see earlier example in the chapter). This already improves the picture and removes most of the cyan cast.

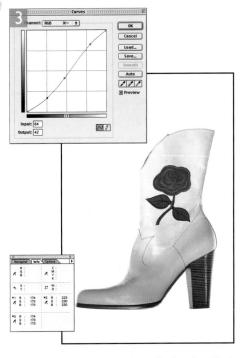

Photograph: Davis Cairns. Client: Red or Dead Ltd.

There is now a more precise way of correcting the color balance. If you exploit the fine tuning capabilities built into the new Curves dialog combined with the use of the sampler tool, you can correct with absolute precision. Remember, repro professionals rely more on the numeric readouts to judge what the color in a digital image actually is. The next tutorial featuring the white boot presents a classic situation where using the Info palette readouts to determine the neutrality of the image tones is the ultimate guarantee of perfect color correction. Match up the RGB values: when R = G = B, the resulting color is always a neutral gray, whereas C = M = Y does not (see Chapter Six on color calibration).

To add a new color value as a point on the curve, Command/Ctrl click in the image area and to add extra points, Shift+Command/Ctrl click. To select multiple points, shift click them in the grid – move one and they all move in unison. To deselect all the points, use Command/Ctrl-D. When a single point is selected you can select the next point using Command/Ctrl+Tab and the previous point using Command/Ctrl+Shift+Tab. An image like the one shown here might be prepared as a cutout against a white background. Not even the best reprographic press can reproduce the faint highlight tones between 247 and 255 on the tonal scale. Where a border of a white object fades to a white cutout, this subtle detail is not going to print. I usually set the output levels to a maximum white of 247 or 249 as shown in the earlier Levels tutorial and the highlights are assigned a pixel value which is less than pure white RGB (255, 255, 255). If you set the whitest white to 255, the first tone to register as a highlight ink dot on the page will be at around 249 or less. Anything above will be clipped and burnt out.

As a final word on Curves, click on the Arbitrary Map option to change the Curves adjustment mode. You can sketch away with the pencil cursor anywhere in the graph to map any shape of curve you could imagine. The results are likely to be quite repulsive, but wait – click on the smooth button once, twice or more, to see the curve become less jagged and the tonal transitions in the picture more gentle. Curves are featured again in later chapters.

Image size

If still confused about images size and resolution, then I suggest a rereading of Chapter Two on Resolution. To recap, a digital image contains a finite number of pixels and the resolution of an image can be specified as any number of pixels per inch. The relationship between output dimension and resolution is reciprocal. In other words, Number of pixels = Resolution \times Image dimension. Resizing an image can be carried out at any stage. If your image does not need to be used as large as the size you

opened, it is better to save on retouching time and reduce the size early in the session (save a copy to work on and keep the original preserved). Similarly, if the image needs to be resampled or interpolated up to a larger size, do this last.

Unsharp masking

The only sharpening filter you really need is the Unsharp Mask (Filter > Sharpen > Unsharp Mask). How, you ask, does unsharpening make a picture sharper? The term relates to the reprographic film process whereby a light, soft unsharp negative version of the image is sandwiched next to the original positive during exposure. This technique increases the edge sharpness on the resulting plate. The Unsharp Mask (USM) filter reproduces the effect digitally and you have a lot of control over the amount of sharpening and the manner in which it is to be applied. Sharpen and Sharpen More are preset filters which sharpen edges but feature none of the flexibility associated with USM.

Next question – do all pictures need to be sharpened and could they not have been scanned sharper in the first place? It depends on the scanner – all scans require varying degrees of USM before repro printing. The Kodak Photo CD system relies on the

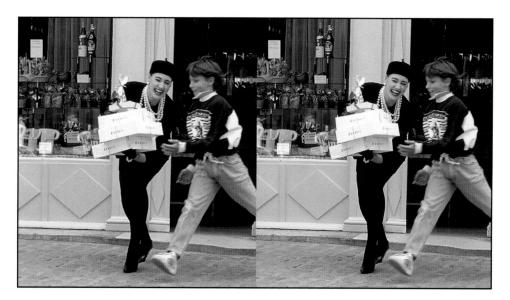

Figure 8.4 Pre-press professionals recommend you do not sharpen in RGB, only in CMYK after the conversion, but you can choose to convert to Lab color mode and sharpen the Lightness channel before converting to CMYK. The above pictures show on the left: sharpened at 200% and on the right sharpened four times at 50% in Lab mode on the Lightness channel only before converting to CMYK.

Photograph: Peter Hince.

Deciding which settings to use

Figure 8.2 When presented with an image or portion of an image that needs 'bringing in to focus', a higher Radius setting will help create the illusion of better definition. The above pictures are all sharpened with an amount of 150% and Threshold setting of 1. From left to right: No sharpening, Radius 1, Radius 2.

Figure 8.3 Incremental sharpening: if you check through the individual color channels, blue is usually the one featuring the most scanning noise. Shift select the red and green channels before applying USM. Use this tip to sharpen up Photo CD scans for RGB output. USM may be applied in stages. Test an image by entering settings in the dialog box and checking the image preview. Divide the amount by a factor of 4 and apply the filter four times.

Client: Robert John. Model: Jo at M&P.

softness of the scanned image to enable the Image PAC files to compress more easily on to the CD disc and produce equally good quality results at any of the chosen resolutions. Photo CD images therefore always need some slight sharpening, including preparation for RGB output. Unsharp Masking is normally best done last of all at the end of a Photoshop session and after conversion to CMYK. If not, some filters and other Photoshop actions may cause artifacts (similar to scanner noise) to appear on pre-sharpened images.

Amount

The amount of sharpening depends on the output usage. Images for on-line use can be successfully evaluated on screen. Output for print demands higher amounts of sharpening. With the Radius and Threshold set at their defaults, an amount of 50% may be enough to sharpen up an image for screen based publishing. In the case of print reproduction that figure would need to be increased to around 120%–200% (these are just general figures to illustrate the comparison). Experience will help you make the right judgment on screen as to what the correct amount to use should be.

Radius and Threshold

These settings both control the distribution of the sharpening effect. The Threshold controls the number of pixels the sharpening is applied to based on the brightness difference of neighboring pixels. Higher Threshold settings apply the filter only to neighboring pixels which are markedly different in tonal brightness, i.e. edge outlines. At lower settings more or all pixels are sharpened including areas of smooth continuous tone. If you can imagine the Threshold acting a bit like a Color Range selection, the Radius setting determines the feathering of the selection. The default is '1'. At higher Radius settings you will notice the edges become more contrasty (if you remember your photographic chemistry lessons, the action is similar to an acutance developer technique). The recommended setting is between 1 and 2, anything higher than 2 greatly exaggerates the edge contrast.

Most anti-aliased text and other graphic artwork is usually fine left as it is and does not benefit from sharpening. Therefore, I find text, imported vector artwork and non-anti-aliased angular shapes drawn in Photoshop are best kept on separate layers. Select the bitmapped image data only, before applying the filter.

Other adjustment tools

So far I have just covered the use of Levels and Curves image adjustments. What of the other adjustment menu options? Curves afford the most precise control over the brightness/color balance at any point on the tonal scale. The Color Balance adjustment falls somewhere between Levels and Curves. Like levels, the individual channels can be altered to change the midtone color balance, but you can also change the toe and shoulder portions of the curve – this is more flexible than Levels but not as sophisticated as Curves. Nevertheless, Color Balance is a quick and easy method for changing the color tones in an image. Brightness/Contrast fits into the category of quick and dirty image adjustment. There is nothing you can do with this that can't be achieved in the Levels dialog box. For instance, to reduce image contrast, drag the Output sliders closer together. Yet it would be a shame to see this option jettisoned – there are occasions when it is nice to have a simple control like this around. The Variations adjustment offers an impressive and easy to use dialog box. It is identical to Color Balance in that you can choose to make an image more green or more cyan in the shadows, midtones or highlights plus you can select darker, lighter, more or less saturated options too. The increments of adjustment can be fine or coarse and warnings of channel clipping are displayed in the preview boxes. Variations is not bad as a starting tool for beginners, because it combines a wide range of basic image adjustment tools in a single interface and warning is given when the limits of adjustment have been reached. I advise that you start as you mean to go on and stick to the following formula: crop and resize the image to the final destination size (later if much larger than the original), then adjust the Levels to set the highlights and shadows. Apply Curves to adjust the contrast and correct for color casts followed by a conversion to CMYK and finally apply unsharp masking.

Chapter Nine

Color Adjustments

he image adjustment controls discussed in the preceding chapter take care of the regular image enhancements. So now we shall get to grips with the fine tuning aspects of the Photoshop image adjustment controls, not to mention some of the fun things which can be done while playing around with color. The Curves, Color Balance and Variations image adjustments allow some separation of what happens to the color in either the shadows, highlights or midtones. Yet there are times when you want to narrow down the adjustments further and just work on a particular range of colors only, without affecting the remaining image components.

Hue/Saturation

First we will start with the Hue/Saturation command. The dialog controls are based around the HSB (Hue, Saturation, Brightness) color model, which is basically an intuitive form of the Lab color mode. When you select the Hue/Saturation image adjustment you can alter these components of the image globally or apply to a narrow range of colors selectively. When the Colorize option is switched on, the hue component of the image is replaced with red (retaining luminosity and saturation) as the default starting point and adjusting the Hue slider control will take you around the hue color circle plus or minus 180 degrees in either direction. Some people recommend this as a method of obtaining a colored monochrome image. Yes it works, but frankly I would suggest you follow the steps outlined later in Chapter Fourteen on black and white effects. Adjustment layers are so useful and important to Photoshop, because one can make an image adjustment, click OK, create a second adjustment

I In the following example, we have a composite image where gold body paint makeup was applied to the skin, but the film recorded it much redder than was desired.

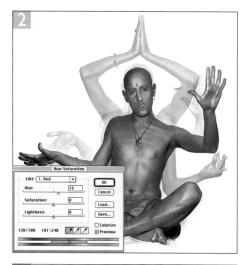

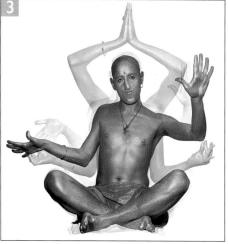

Michael Smiley - Edinburgh Fringe poster.

2 In the Hue/Saturation dialog box, you will notice a column of radio buttons representing the subtractive and additive primary colors. These narrow the color control to these color ranges only. So, by clicking on the red radio button, we can enhance or subdue the saturation of the red color component of the image and shift the red colors so that they become more yellow and less magenta.

3 After that, click on the yellow radio button and similarly tweak the settings – this time to adjust the yellow component only and in this case enhance the color saturation.

layer, but then be able to return to the previous adjustment layer (double click it), readjust the settings and so forth. They share the same ability as image layers, in as much as you can mask the adjustment layer contents and layer options. Strictly speaking, adjustment layers are mask channels, i.e. grayscale channels that happen to be within the layer palette domain. Here is a tip you might like to try: create an adjustment layer, any will do, change the blending mode and observe how the image can interact with itself.

Hue/Saturation dialog

The Hue/Saturation interface underwent a major revamp in version 5.0. Its functionality has been extended and the new interface provides a clearer feedback of what is going on. Gone is the sample color box and instead there are two color spectrum ramps and the new slider controls.

The hue values are based as before on a 360 degree spectrum, but you will find the numbering order has been changed. Red used to be centered at 0 degrees. It is now assigned a value of 180. All other colors have the same numeric values in relation to this. Colors can be sampled from the image window once one is outside the Master edit mode. Click on any of the individual colors from the pop-up menu and click in

I In the default mode, changes made will affect the image globally. As you adjust the Hue slider, the upper color ramp always remains as it is and you will see the lower color ramp shift accordingly.

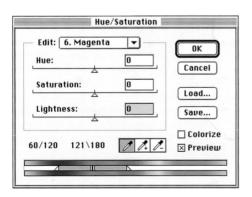

2 If you click on the Colorize button, the default setting is a primary red color (180 degrees) at 25% Saturation and 0% Lightness. Notice that the pop-up menu is dimmed and that lower color ramp reflects the color value as defined above.

3 The pop-up menu is used to specify a narrow range of colors. This feature was to be found in the old style Hue/Saturation dialog box. The difference is that now you can be more specific as to which colors are to be altered. Here you see the magenta range of colors have been selected from the menu. The dark narrow strip in the middle of the sliders represents the chosen color to modify and the lighter gray spaces represent the threshold dropoff either side of the color selection.

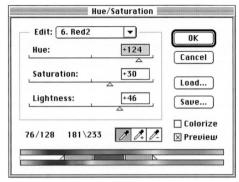

4 Now watch what happens when the Hue, Saturation and Lightness sliders are adjusted and extra colors moving towards the red end of the spectrum are shift added with the eyedropper. See how the lower color ramp colors reflect the cast introduced in the shot.

the image to select a precise color value on which to base the adjustment Shift click in the image to add to the color selection and Option/Alt click to subtract colors. Remember that the new Hue/Saturation design is like a brand new image adjustment – a Hue/Saturation adjustment layer from version 5.0 will not be recognized as such in version 4.0 of Photoshop.

I This is the before image in 24-bit RGB color mode without any image alteration with the colors as they appeared on the film.

2 The layer palette shows all of the adjustment layers which were applied to the picture, but here only the effects of the curves adjustment are shown.

Client: Schwarzkopf Ltd. Model: Emma at Boss.

3 Now with all the adjustment layers active... the Channel Mixer effect added a cyan cast, which I chose to fade off to the center by adding a layer mask to one of the adjustment layers. At this stage the background layer retains all the original pixel information. When the layers are flattened, a single pixel transformation only takes place.

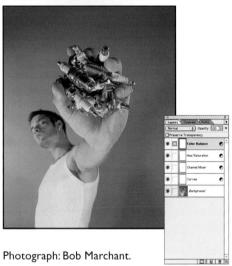

Figure 9.1 There are definite benefits to be gained by carrying out color manipulation in 16 bits per channel. The image on the left shows a picture after a series of adjustment layers have been added to the base background layer. This was carried out in 24-bit RGB color mode. The same image was then temporarily converted to 48-bit RGB color (16 bits per channel) and the same color adjustments applied in sequence. (Adjustment layers are not supported). There is a quantifiable difference between the two versions. This is hard to demonstrate with a small print but the histograms displayed below, compare the differences between the channel levels. The top row is color manipulation carried out in 16 bits per channel and converted back to 8 bit and the row underneath where 8 bits per channel were used throughout.

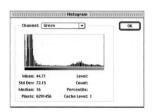

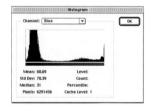

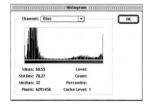

Multiple adjustment layers

Rather than apply a series of image adjustments in sequence, adjustment layers offer more flexibility because you can return to each adjustment layer at any time and revise the settings or discard them altogether.

16 bits per channel support

As explained, multiple adjustment layers do less damage to the pixel information because the combined adjustment is then a single operation. True, but for ultra critical color adjustment and color conversions, I would recommend converting the image data to 16 bits per channel. This has the effect of doubling the file size, but need only be a temporary step. 16 bit per channel support has been extended to allow color adjustments, cropping, rotating and use of the clone tool. This is still a major step forward though. Figure 9.1 shows a comparison of histogram displays between 16 bit per channel and 8 bit per channel operation. You may not feel the need to use 16 bits per channel all the time for every job, but I would say that for critical jobs where you don't want to lose an ounce of detail, the short-term file size increase is a price worth paying. The various tests I conducted all showed that under mild to extreme color adjustments the 16 bit per channel image after conversion back to 8 bit, retained all the image detail present in the original, whereas the all 8 bit route image would be slightly degraded. More obvious benefits from the use of 16 bit per channel image adjustment can be seen when applying Curves adjustments containing strong kinks in the curve or use of the arbitrary map function. The following examples of color adjustments came about through discussions I had with still life photographer Laurie Evans about how Photoshop could meet certain challenges like 'How can I match or get close digitally to the colors I saw on the Polaroid instant film?'

I promised there was fun to be had here and once you discover the Hue/Saturation command, you will keep coming back again and again to discover just how useful it is as a user friendly correcting and coloring tool. For instance, I was working with a photographer on a lengthy project, selecting different colored backgrounds. She found it preferable to select a color (any color that was near enough), fill the area and later tweak it using Hue/Saturation. Or, as was inevitably the case, dive off in a completely different direction by cycling around the Hue color wheel. The HSB color model is easy to understand – someone working in HSB can say 'I like that color (hue), but want to see it looking more saturated and a little darker.' When working with the other color models, you would have to adjust more than one color component at a time to achieve the same type of results. The problem of getting too carried away with any coloring effect, whether in RGB, Lab or HSB, is that colors may easily go out of gamut – i.e. slip over the edge of the color space and 'block out'

Figure 9.1 The top left image is the master, the remaining five on this page are variations achieved by adjusting the Hue slider only. (Colorize was not selected). Photograph: Laurie Evans.

2 First make a Curves adjustment layer. You can do this via the Layers palette sub-menu or Command/Ctrl click the New Layer button. Either way, a dialog box will appear — choose Curves from the pop-up menu. Quite subtle changes were made to the composite channel, but mostly I adjusted the green channel, adding more green to remove some of the magenta. When you are happy with everything, click OK. An adjustment layer can be redone or removed at any time — double click the layer to reopen the dialog box.

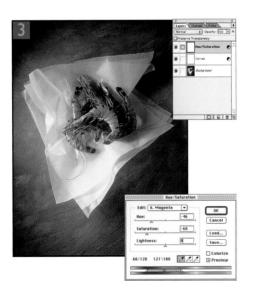

I We start with a brightly colored picture. This photograph was shot using 10×8 color transparency. Large format film, when perfectly exposed and processed, contains a slightly wider dynamic range than smaller format transparencies. It looks superb on the lightbox, but will need a high quality scan to capture all the detail and do justice to the image.

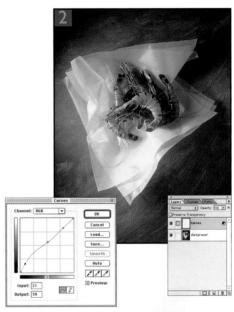

3 Make a new adjustment layer, this time for Hue/Saturation. Provided the eyeball icon was left switched on for Curves, the display will be the accumulation of the two adjustments. I selectively adjusted the color components, clicking on the individual radio buttons, I boosted the saturation of the red and yellow slightly and decreased the saturation in the magenta. Adjustment layers only become permanent once you merge the layers down or flatten the image. Leaving them as layers adds very little to the total file size, but video display performance will be slowed down for as long as the eyeball icons are switched on.

Photograph: Laurie Evans.

when converted to CMYK. Taking a tour around the hue variations in Hue/Saturation will alter the color makeup of an image in a way that was only obtainable before with color infra red film perhaps. This second shot of Laurie's (Figure 9.1) was lit with color filtered lights. As an abstract image it lends itself well to variations on a theme.

Replace Color

Hue/Saturation crops up again in the Replace Color command, which is really like a combination of the Select > Color Range and Hue/Saturation command combined in one. With Replace Color, you can select a color or range of colors, adjust the fuzziness of your selection and apply the Hue/Saturation adjustments to those selected pixels only. Alas, the selection made this way is not savable. For ultra critical situations you will want to make a Color Range type selection first and while the selection is active, choose New Adjustment Layer... > Hue/Saturation from the Layers palette. This two step process is longer but affords more editability.

2 Choose Image > Adjust > Replace Color. To make the selection, first click with the eyedropper either on the image or in the dialog box mask preview window. Click again with the 'add eyedropper' icon to add to the selection. Click with the 'minus eyedropper' to remove colors. Use the Fuzziness control slider to determine how much tolerance you want to apply to the selection area (see magic wand tool). Now change the Hue/Saturation values. As you can see here, the biggest change took place with the Hue, making the background go green instead of purple. Small saturation and lightness adjustments were also necessary.

I This is the before image and using the Replace Color adjustment command we can quickly take the image information in the purple backdrop and alter the Hue, Saturation and Lightness values. This image adjustment command is not available as an adjustment layer, because the single command is a combined two stage process which involves making a pixel selection. Photograph: Laurie Evans.

Replace Color

Selection | Image | Transform | Inc. | Transform | Transfo

3 After performing the Replace Color operation, there was a little spill over on to the blue plate. All you have to do is erase the offending areas and for this we use the history brush. First make a circular selection with the elliptical marquee tool. Does this sound difficult? Remember the marquee actions can be modified when you hold down the Option/Alt key to draw out from the center and constrained to a circle when you hold down the Shift key. If at any time you also hold down the Spacebar, you can drag and reposition the selection. If you release the Spacebar (but have still held down the Option/Alt+Shift keys), carry on expanding or contracting. Now feather the selection and select the Open image state as the History source and restore the original unaltered image.

Adjustment Layer benefits

Remember, adjustment layers and the Image > Adjust commands are identical. Adjustment layers just offer the facility for revision and to undo later. That is a pretty useful facility to have compared with the old business of duplicating an image layer, applying the adjustment and adding a layer mask. Better still, one can afford to have more than one adjustment layer saved in a document, each providing a different color change. In any single image one could have saved a series of image adjustment color variations and reload these from within an adjustment layer dialog. So when a client comes to view the work it is quick and easy to display a series of variations, working from the one file. The old method would have meant saving individual images and having to wait for each one to open up. Also, consider this: the additional adjustment layers only occupy a few kilobytes of disk space. Whichever way you look at it, that is a huge saying in time and storage. The adjustment layers are another aspect of deferred pixel processing in Photoshop. The trend began with Layers in Photoshop 3.0 and continued when this feature was added in version 4.0. Now, the combination of image layers and adjustment layers is a very powerful combination of features to have at your disposal. Used in conjunction with History they give Photoshop a three dimensional work space of not just multiple, but limitless, undos in fact. Photoshop allows you to work in layers, to delay the image adjustments by processing the preview image only and skip back to a previous state or go back and brush in image data from a later history state. And they said time travel was impossible! The drawback to adjustment layers is the way they slow down the monitor display. This slowness is not a RAM memory issue, but to do with the extra calculations required to redraw the pixels on the screen. The slowdown is just like having lots of extra complicated layers in Illustrator or other vector drawing programs.

Selective Color

The ultimate in precision color control is the Selective Color command. This allows you to selectively fine tune the color balance in the additive and subtractive primaries and also in the blacks, neutrals and whites. The controls in that respect are fairly similar to the Hue/Saturation command, except here you can adjust the cyan, magenta, yellow and black component of the chosen color range. The Selective Color command is therefore a tool for correcting to/and in the CMYK color space. The color control available with Selective Color is a bit like fine tuning the sound on a music system with a sophisticated graphics equalizer. Subtle or quite strong changes can be made with ease to the desired band of color tones. The Selective Color command is an obvious tool for getting RGB colors to fit the CMYK color space as shown here.

As a final note on the above technique – there is bound to be a noticeable color shift and more than just the green colors will benefit from adjustment. Since the initial green did not exist in CMYK it had to be converted to something else. What that something else is, well that's the art of preparing images for four-color printing. The trick is to convert the existing colors in a way that the color values obviously change but the final perception looks right to the eye. Blue skies are a good example – bright deep blues do not convert well to CMYK, and fall outside the CMYK gamut, but adjusting the Selective Color values of maybe the blue, cyan and black will produce another type of blue using a different combination of inks other than the default conversion that does work convincingly to the eye. Where the color matching is critical, Selective Color may help to correct an imbalance and improve the output color, provided the output color to be targeted is within the CMYK gamut. When this is not so, special techniques must be adopted – adding an extra printing plate using a custom color, for example.

Returning now to the last tutorial, you may like to explore other refinements to the technique. For instance the CMYK Preview window could also have the Gamut Warning switched on too. As corrections are made using Selective Color, you can see whether the colors are changing to your satisfaction and falling inside the CMYK gamut.

Color Range

The Color Range option is like a super magic wand tool which resides in the Select menu. It seems appropriate to introduce at this point to highlight an extra feature in the dialog pull down menu: you can use the Color Range command to make a selecI Not an easy one to show this, because we are starting with an 'RGB' image that is printed in CMYK. But imagine the situation – you are looking at an RGB scan which is fine on screen, but not all the colors fall within the CMYK gamut. The Photoshop Image > Mode conversion will automatically compensate and translate the out of gamut RGB colors to their nearest CMYK equivalent.

3 The result of the previous image adjustment is a picture where the RGB colors have been adjusted so that when the conversion takes place all the RGB colors have a direct CMYK equivalent. You can just as easily use the Hue/Saturation command to do this job. I used Selective Color because it is a fine tuning color adjustment tool and one based around the destination CMYK color model. A relative percentage change will proportionally add or subtract from the current value. So if the cyan value is currently 40% adding a Relative 10% will equal 44%. Adding an Absolute 10% will make the new value 50%.

Photograph: Laurie Evans.

2 If there are just a few out of gamut RGB colors to start with, there will be little change to the image appearance after converting. To check if this is the case, you can select View > CMYK Preview (highlight the view option to switch on. Highlight again to switch off) and choose View > Gamut Warning. The latter will display out of gamut RGB colors with a predefined block color (set in preferences as neutral gray by default). If the Gamut Warning shows out of gamut pixels, use the Image > Adjust commands to compensate and bring them within the CMYK gamut. Here I used the Image > Adjust > Selective Color command to selectively shift the yellow, red and black inks of the red component color.

tion based on out of gamut colors. In relation to the subject under discussion, this means you can use Color range to make a selection of all those 'illegal' RGB colors and apply corrections to these pixels only. This task is made easier if you feather the selection slightly and hide the selection edges (View > Hide Edges). Then choose View > Gamut Warning. The adjustments can be made using the Selective Color or Hue/Saturation commands as before and local areas can maybe also be corrected with the sponge tool set to Desaturate.

Chapter Ten

Repairing an Image

he simple tricks are always the best and the rubber stamp tool never fails to impress clients. So I'll start with cloning and then go on to introduce the other creative techniques for cleaning up and repairing damaged pictures. Cloning is a popular retouching technique and once mastered, most users use the rubber stamp all the time to repair their images, but remember there are other retouching techniques which will serve you better in certain situations.

Basic cloning methods

The rubber stamp tool is used to clone parts of an image and takes just a little while to get the hang of. Some keyboard/mouse coordination is required. In Clone mode, you first select an area to sample from – hold down the Option/Alt key and click. Release the Option/Alt key and click or hold down the mouse to paint over the area you want to clone to. When the Aligned option is checked, the area sampled retains the same angle and distance in relation to where you paint with the rubber stamp tool. When the Aligned option is not selected, the sampled point always remains fixed. It is ideal when the area to sample from is very small, as you can keep a tight control over the area you are sampling from. The Aligned mode is the most appropriate option to select for everyday spotting of scans. Select the Use All Layers option to sample from merged layers.

As with all the other brush tools, you can change brush size, shape and opacity to suit your needs. While you may find it useful working with different combination settings for paint work, the same does not apply to the rubber stamp tool. Typically you

want to avoid the hard edged brushes and stick to using the fine to medium soft edged brushes (just as you would always choose a fine paint brush for spotting bromide prints), though too soft a brush edge presents problems as well. Spotting used to be such a laborious and tricky process. I am reminded of an old story about a commercial photographer who rather than use a scalpel knife to remove a black speck in the sky, would paint in a couple of wings and turn it into a seagull. Thankfully with Photoshop anyone can learn to quickly spot a picture now.

I mostly always leave the opacity set to 100%. Cloning at less than full opacity usually leads to tell-tale evidence of cloning. Where the film grain of the photograph is visible, this leads to a feint overlapping grain structure, making the retouched area look slightly blurred or misregistered. When smoothing out skin tone shadows or blemishes, I will occasionally switch to an opacity of 50% or less. Retouching light soft detailed areas means I can get away with this. Otherwise stick to 100%. Lines and wrinkles can be removed effectively with the dodge tool or with the brush tool set to Lighten mode. Areas of smooth tone transition demand you be really careful when cloning. You may not even be aware of the tonal gradation present, but make sure the area you sample from is of the exact same hue, lightness and saturation or else the brush work will stand out a mile. For this reason, I have included alternative repairing techniques to handle these situations.

Retouching a color negative

Not until Photoshop 4.0 introduced adjustment layers was it possible to retouch a masked color negative and output again as such. In the example shown here, a color negative is displayed on the screen as a positive image by introducing an extra layer and three adjustment layers, one to neutralize the mask, one to invert the image and the others to expand the levels and increase the color saturation. One can then spot and retouch the active background layer without actually altering the color or masking of the color negative original.

In the past sequential image adjustments caused the image to be degraded slightly each time. Another problem was you could do all your spotting and after carrying out a Levels or Curves adjustment, the remapped image would reveal where you had worked on it with the rubber stamp tool.

The following example uses a color negative photograph of Luton Town Hall, taken by David Whiting which was digitized as a negative to include the orange color mask and output to film as a color negative again. This is a refined version of a technique which was devised by Rod Wynne-Powell of Solutions Photographic.

I The scanned negative requires spotting prior to being output as a negative again. It would be hard to retouch the negative as it is because the colors are inverted with an orange colored mask and the tonal range is too narrow to see properly what is going on. The following steps are intended for viewing a positive version of the image and the extra layers can later be discarded.

2 The first stage is to counterbalance the orange mask – sample from the rebate using the eyedropper tool set to a 3×3 pixel radius (see Eyedropper Options). Make a new layer, fill with the sample color (Option/Alt+Delete) and invert: Image > Adjust > Invert. Now change the opacity to 50% and the blending mode to Color. This as you can see, neutralizes the orange mask.

3 Next make an adjustment layer with which to convert the image to a positive. Go to the Layers palette sub-menu, select New Adjustment Layer and choose Invert. This operation inverts the tonal values exactly, rendering a pale positive from the negative, which still remains intact.

4To boost the contrast, make a second adjustment layer. Select Levels and in the Levels dialog, click on the Auto Levels button. Finally add a Hue/Saturation layer and bring up the saturation a little more. We now have an approximate image preview of the negative as a positive. To carry out any spotting or retouching, the base layer must be active. Any further changes made to the image pixels should be carried out on the negative only. When you are satisfied with your retouching, discard the adjustment layers and output to transparency. Provided you are operating within a closed loop with the bureau who supplied the scan, the output will near enough exactly match the original.

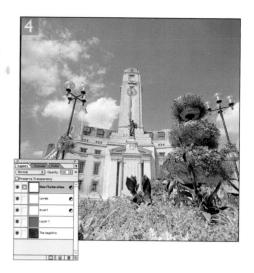

Alternative spotting technique using the History brush

Credit for the origins of this method goes to Russell Brown, Senior Creative Director of the Adobe Photoshop team. He makes use of the Noise and Scratches filter in the Filter > Noise sub-menu. This filter made its debut in version 3.0 but never really caught on with image purists, who saw the degradation of image quality a price not worth paying for the sake of automating the removal of scanner debris. To be fair, on the version 3.0 tutorial CD-ROM, the demonstration showed that it was intended you apply the filter to a feathered selection area only and not to the whole image.

The method recommended here has the advantage of applying the filtered information precisely to fill in the gaps without the risk of destroying tonal values in the rest of the image.

I There are a number of hair and scratch marks visible on this picture. Most are on the backdrop and just a few are on the subject. This spotting technique makes good use of the history brush facility. Check the History settings in the palette flyout menu. Here, Non-linear history has been allowed.

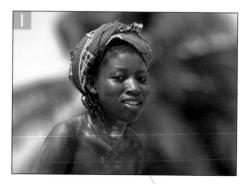

Photograph: Peter Hince.

2 Apply Filter > Noise > Remove Noise and Scratches to the image. Check the preview and adjust the Amount setting till the marks appear to be removed in the preview sample area and apply the filter.

- 3 Afterwards, activate the previous unfiltered image state, but set the History brush to paint from the filtered version. Before cloning, change the History brush blending mode to Darken and begin removing light scratch and dust marks.
- 4 So, to use the history brush for spotting, change the tool blending mode from Normal to either Lighten or Darken. If you are removing light spots, use Darken mode. If you are removing dark spots, use Lighten.

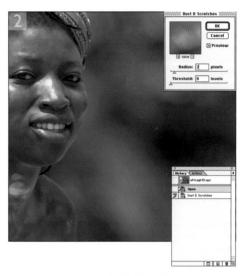

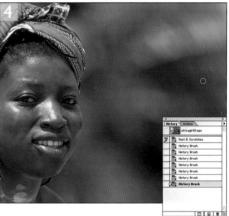

Cloning selections

Cloning with the rubber stamp tool requires skill. To hide the retouching effectively, you need to keep changing the source point you are cloning from. If you don't, you may find parallel tram line patterns betray signs of your retouching. You may notice that Photoshop 5.0 has introduced an important change in the rubber stamp tool behavior – the rubber stamp tool always clones from the previous image state. It does not resample the 'clone added' image areas as was the case in previous versions of Photoshop. It is not practical to reconstruct large areas of an image simply with the rubber stamp tool. The above techniques are suitable for most spotting treatments, but where there are larger areas to repair, another method of cloning is required. The next example demonstrates how to replace an area to be repaired with a cloned selection from another part of the same image.

I Zoom in on the creased section of the globe (select the zoom tool and draw a marquee around the area to magnify). Select the lasso tool and draw a rough outline of the area to be replaced.

Client: Schwarzkopf Ltd. Model: Charlotte at Models One.

2 In Photoshop, dragging with the marquee, lasso or type mask selection tools inside the selection enables you to move the selection border (shown by those marching ants — moving the selection outline only and not the pixels selected). In this step you just move the selection outline to another part of the image.

3 This area should be suitable. First soften the selection outline by choosing Select > Feather and enter a pixel radius of 5.0 or more as necessary.

The selection is now feathered and as can be

Feather Selection

pixels

OK

Feather Radius: 8

4 The selection is now feathered and as can be seen here – switching from Selection to Quick Mask display modes, the selection border is indeed softened.

5 Now move a copy of the selected area. – remember the keyboard shortcut of holding down the Command/Ctrl key to access the move tool. The move tool on its own will just move the selected area, leaving a whole in the image. So hold down both the Command/Ctrl+Option/Alt keys. This enables you to move a copy of the selection. You will see the cursor change to a double arrow icon, just as it does in Illustrator and PageMaker.

6 Step five is a quick and easy method for copying and moving a selection. Deselecting the selection will drop it in place. Alternatively, convert the selection into a new layer by choosing (Layer > New > Layer Via Copy) or use the keyboard shortcut: Command/Ctrl-J. Move the new layer into place and apply a free transform (Edit > Free Transform) to finely adjust the positioning, i.e. rotate the layer slightly.

7 Where there remains some minor correcting to be done, add a layer mask to the layer – Layer > Add Layer Mask > Reveal All. Set the brushes to the default Foreground/Background colors (press 'D') and with the paint brush tool, paint away unwanted parts of the cloned layer.

Restoring a faded image

Here is a common problem – restoring parts of a photograph which have faded. The basic principle is to copy the background, making it a new layer, darken the copy and selectively merge (using a layer mask) as necessary with the underlying background. Well, there is no need to go to such lengths now. Adjustment layers provide a quick and easy route to solving this problem without eating up too much memory.

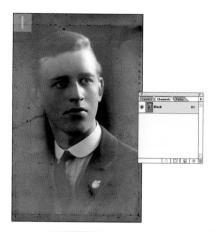

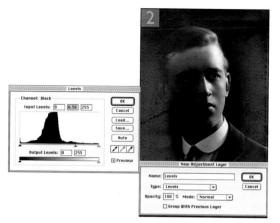

I With the image to be restored open and the Layers palette visible on the screen, choose from the palette sub-menu New Adjustment layer. Select Levels from the pull down menu.

2 The familiar Levels dialog box opens. The adjustment layer is used to darken the image, so drag the gamma Input slider to the right. The amount of darkening is not critical. Remember that adjustment layers do not permanently affect the image until after you flatten or merge down the adjustment layer.

3 With the adjustment layer active, painting anywhere in the image area is just like painting on a layer mask linked to an image layer. To remove the faded portion at the top of the picture, drag with the radial gradient tool from the center outwards, using the default Foreground/Background colors, and the gradient painting from Foreground to Background.

4 Readjust the Levels adjustment layer to balance the fade – double click the adjustment layer to open the Levels dialog box, or reduce the blending opacity setting. On this final version, I duplicated the adjustment layer and painted a bit extra with a brush on both of the layer masks.

Keyboard shortcuts

You will notice in this chapter that I introduced a few keyboard shortcuts for the menu and toolbox commands. Newcomers to Photoshop will no doubt prefer sticking to the longer routine of selecting tools by clicking on them in the toolbox and navigating through the menus and sub-menus. After a month or so, try to absorb the keyboard shortcuts, learning a few at a time.

Here are a few examples of the essential keyboard shortcuts: you can quickly select the move tool by pressing 'V' on the keyboard. Rather than keep switching between the current tool and the move tool, it is much easier to temporarily access it by holding down the Command/Ctrl key (except when the pen or hand tool are selected), then instead of using the mouse, you can also control movement via the keyboard arrow keys, nudging the layer or selection in 1 pixel (10 pixels with the Shift key also held down) increments.

Hold down the Spacebar to temporarily access the hand tool and hold down Command/Ctrl+Spacebar to zoom (magnify). To zoom out, hold down the Option/Alt+Spacebar keys. If the hand tool is already selected, then holding down either the Command/Ctrl or Option/Alt keys will have the same effect. Double clicking the zoom tool will set the view to actual pixel size (100%) as does the keyboard combination of Command/Ctrl+Option/Alt-0. Double clicking the hand tool will set the view to the fullest screen size and the alternative keyboard shortcut is Command/Ctrl-0.

These are both very useful time saving features and it is also worth mentioning that these actions are governed by whether the palette and toolbox windows are currently displayed or not. Pressing the Tab key will toggle hiding and displaying the toolbox and all palettes (except when a palette settings box is selected). The Shift+Tab keys will keep the toolbox in view and toggle hiding/displaying the palettes only. When the palettes are not displayed the image window will resize to fill more of the screen area. This can make quite a big difference if you are using a smaller sized monitor. These and other shortcuts are all listed in menu and palette order in Chapter Thirteen.

Chapter Eleven

Montage Techniques

onfusion arises early on when trying to understand the relationship between alpha channels, masks, Quick Mask mode and selections. Let me help ease the learning curve by saying they are interrelated and essentially all part of the same thing. That is to say, a selection can be viewed as a Quick Mask or saved as an alpha channel (also referred to as a mask channel). An alpha channel can be converted to make a selection, which in turn can be viewed in Quick Mask mode. Also discussed later in this chapter is the use of layer masks on Layers and how to draw paths with the pen tool and convert these to selections. So when you read somewhere about masks, mask channels, layer mask channels, alpha channels, Quick Masks and saved selections, the writer is basically describing the same thing: either an active, semipermanent or permanently saved selection.

Selections and channels

We will begin with defining selections. There are several tools from the toolbox you can use to do this – the marquee, lasso, magic wand and type tools. The marquee comes in four flavors: rectangular, oval, single pixel horizontal row and vertical column. The lasso has three modes – one for freehand, another for polygon (point by point) drawing and now a magnetic lasso tool. To start with, use the rectangular marquee to define an area within an image (see Figure 11.1). You will notice selections are defined by a border of marching ants. Selections are only temporary. If you make a selection and accidentally click outside the selected area with the selection tool, they will disappear – although you can restore them with Edit > Undo (Command/Ctrl-Z).

During a typical Photoshop session, I will draw selections to define areas of the image where I want to carry out image adjustments and afterwards deselect them. If I were interested in defining the exact outline of a main subject, I would spend quite a bit of time defining it using a variety of methods and want to store my saved work as an alpha channel (also referred to as a mask channel). To do this, choose Save Selection from the Select menu. The dialog box asks if you want to save as a new selection? Doing so creates a brand new alpha channel. If you check the Channels palette, you will notice the selection appears labelled as an alpha channel (#4 in RGB mode, #5 if in CMYK mode). To reactivate this saved selection, choose Load Selection from the Select menu and select the appropriate channel number from the sub-menu.

You don't have to use the selection tools at all. You can create a new alpha channel and paint away with the brush tool using the default white or black colors to generate a mask channel which can then be converted into a selection. In between masks and selections we have what is known as a Quick Mask. To see how a selection looks as a mask, switch to Quick Mask mode (click on the right hand icon second up from the bottom in the toolbox). Now you see the selection areas as a transparent colored overlay mask. If the mask color is too similar to the subject image, double click the Quick Mask icon and choose another color from the Color Picker in the opened dialog box. In Quick Mask mode (or working directly on the alpha channel) you can use any combination of Photoshop paint tools, Image adjust commands or filters to modify the channel mask content.

To revert back from a Quick Mask to a selection, click the selection icon in the toolbox (a quick tip is to press 'Q' to toggle between the two modes). To reload a selection from the saved mask channel, go Select > Load selection. Command/Ctrl clicking a channel is one shortcut to loading selection and by extension, combining Option/Alt+Command/Ctrl-channel # (where # equals the channel number) does the same thing. Alternatively you can also drag the channel icon down to the Make Selection button in the Channels palette.

Figure 11.1 The right half of the image shows a feathered selection (feathering is discussed later in this chapter) and the left half the Quick Mask mode equivalent display.

Summary of channels and selections

Selections

In marching ants mode, a selection is active and available for use. Any image adjustments will be effected within the selected area only. Selections are temporary and can be deselected by clicking outside the selection area with a selection tool or choose Select > Deselect (Command/Ctrl-D).

Quick Mask mode

A semipermanent selection, whereby you can view a selection as a transparent colored mask overlay. Selection adjustments can be carried out with any of the fill or paint tools. To switch to Quick Mask mode, click on the Quick Mask icon in the toolbox or use the keyboard shortcut 'Q' to toggle between selection and Quick Mask mode. A Quick Mask is more permanent than a selection – you cannot accidentally deselect it as you can in selection mode.

Alpha channels

A selection can be stored as a saved selection, converting it to a new channel (Select > Save Selection). A selection can be reactivated by loading a selection from the saved channel (Select > Load Selection). Alpha channels like the color channels contain 256 shades of gray, 8-bit information. An anti-aliased selection or one that has been modified in Quick Mask mode with the fill and paint tools will contain graduated tonal information. An active (click on the channel to highlight it) mask channel can be manipulated any way you want in Photoshop. A saved channel can be viewed as a colored transparent mask, overlaying the composite channel image, identical in appearance to a Quick Mask. To view, highlight the chosen mask channel to select it and click on the eye icon of the composite channel (Command/Ctrl-~).

Paths

Paths are used in Photoshop among other things as an alternative method for defining an image outline. A path (closed or not) can be converted to a foreground Fill, Stroke or Selection. In the Paths palette, drag the Path icon down to one of the buttons like the Make Selection button. An active selection can be saved as a path – choose Make Path from the Paths palette sub-menu. Saving a

selection as a path, which occupies just a few kilobytes of file space is more economical than saving as an alpha channel in a TIFF file. Paths cannot save graduated tone selections though. A saved path can only generate a non-anti-aliased, anti-aliased or feathered selection, but we'll come on to that later in the chapter.

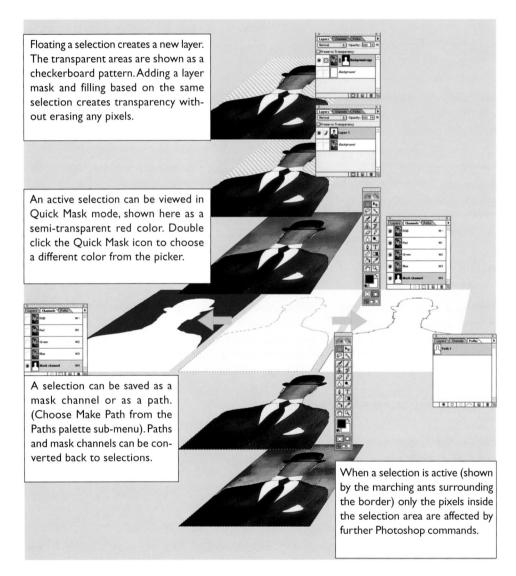

Figure 11.2 The above diagram shows the relationship between selections, channels, paths and layers.

Modifying selections

When Adobe upgraded Photoshop to version 4.0, one of the objectives was to unify the keystroke commands and palette designs between the different Adobe graphics programs. Like everyone else, I found this took some adjustment at first after using Photoshop 3.0 for two years, but everyone agreed it made more sense in the long run and the interface in 5.0 has remained unchanged in this respect.

As was mentioned in Chapter Seven, to modify the content of a selection you need to learn how to coordinate the mouse with the keys at the bottom left of the keyboard. To add to a selection, hold down the Shift key as you drag. To subtract from a selection, hold down the Option/Alt key as you drag. To intersect a selection, hold down the Shift+Option/Alt keys as you drag. The magic wand is a selection tool too. Just click with the wand, holding down the appropriate key(s) to add to or subtract from a selection.

Placing the cursor inside the selection and dragging moves the selection boundary position, but not the selection contents.

To expand or shrink the selection border, choose Select > Border > Expand/Contract. Select the number of pixels to modify by up to a maximum of 16 pixels. From the same menu the other options include Border and Smooth. To see how this works, make a selection and choose Select > Modify > Border. Enter various pixel amounts and inspect the results by switching from selection to Quick Mask mode. I think the border modification feature is rather crude as it is and can be improved by applying feathering or saving the selection as a channel and filtering with Gaussian Blur.

Smoothing and enlarging a selection

Selections made on the basis of color value, i.e. when you use the magic wand or Color Range method, are not very pretty to look at on close inspection. The Smooth option in the Select > Modify sub-menu addresses this by averaging out the pixels selected or not selected to the level of tolerance you set in the dialog box.

The Grow and Similar options enlarge the selection using the same criteria as with the magic wand tool, regardless of whether the original selection was created with the Wand or not. To determine the range of color levels to expand the selection by, enter a Tolerance value in the Options palette. A higher Tolerance value means a greater range of color levels will be included in the enlarged selection.

The Select > Grow option selects more pixels immediately surrounding the original selection of the same color values within the specified tolerance. The Select > Similar option selects more pixels from anywhere in the image of the same color values within the specified tolerance.

Anti-aliasing and feathering

All selections and converted selections are by default anti-aliased. A bitmapped image consists of a grid of square pixels. Without anti-aliasing, a diagonal line would be represented by a saw-tooth of jagged pixels. Photoshop gets round this problem by anti-aliasing the edges – filling the gaps with in between tonal values. All non-vertical/horizontal lines are rendered smoother by this process. Therefore anti-aliasing is chosen by default. There are only a few occasions when you may wish to turn it off.

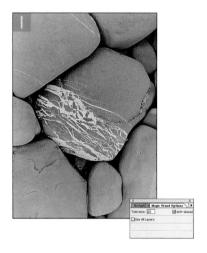

I The objective here is to make a simple soft edged selection based on tonal values and colorize one of the stones. Use the magic wand tool to make the initial selection. The Tolerance setting used was 25.

Photograph: Davis Cairns.

2 Enlarge the selection locally by choosing Select > Grow. Note that the amount of growth is governed by the Tolerance values linked to the magic wand tool options. Switch the display from Selection to Quick Mask mode. Notice how there are a few stray pixels not selected and the edges are a bit rough.

3 Return to Selection mode and apply Select > Modify > Smooth, entering a value between 5 and 10. Now inspect the difference in Quick Mask mode again. The selection is now a lot smoother.

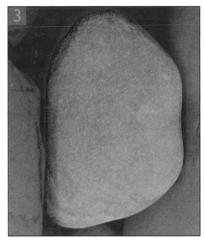

4 With the selection satisfactorily complete, hide the selection edges (View > Hide Edges) and open the Hue/Saturation dialog box. Click on Colorize and adjust the Hue and Saturation sliders to color in the selected area.

Sometimes you have an 8-bit image which resembles a 1-bit data file (say an alpha channel after you have applied the Threshold command) that needs to be anti-aliased. If it is just a small portion that requires correction, use the blur tool to lightly soften the edge, otherwise follow this technique:

I Apply I pixel Gaussian Blur to the image.

2 Apply a Levels adjustment using the following settings: set the shadow point to 65, the gamma setting 1.0 and highlight point at 190.

Anti-aliasing sorts out the problem of jagged edges. Selections usually need to be softened more than this. It is obvious when a photograph has been montaged if the edges of a picture element are too sharply defined – the result looks unnatural. The secret of good compositing lies in keeping the edges of your picture elements soft. Study a scanned image in close-up and even the sharpest of images display smooth tonal gradation across image edges.

With a selection active, go to the Select menu, choose Feather and enter the pixel radius. A value between 1.0 and 2.0 is enough to dampen the sharpness of a selection outline, but you can select a much higher radius. For example, if you want to create a custom vignette effect, use the lasso tool to define the outline, feather the selection heavily (50–100 pixels or more depending on file size), invert the selection and apply the Levels command. This will enable you to lighten or darken the outside edges with a smooth vignette.

Layers

Layers are very different to channels. As the name might suggest, they are like image layers on acetate overlaying the base background image – remember all those Walt Disney cartoon animations built up of multilayered celluloid elements? As shown in Figure 11.2, when a selection is floated it becomes a new layer. You can add as many new layers as you like up to a limit of 99. Every time you drag and drop a new image into an open document, it becomes a new layer. Empty new layers can be created by clicking the New Layer button in the Layers palette.

Layers are individually controllable image elements. In a multilayered document, you can selectively choose which ones to view (selecting and deselecting the eye icons), link layers together in groups, merge linked layers or merge just those which are visible. If you don't like one of the image layers, they are easy to discard – just drag the layer icon to the Layers palette Wastebasket button. Or to duplicate a layer, drag the layer icon to the New layer button.

Layer image content can be modified by applying a layer mask to an individual layer. Just as applying a selection to the background layer (or any other layer) and floating creates a masked layer, applying the mask instead of the selection to a channel, masks out the unwanted areas. Make a layer active and choose Add Layer Mask from the layers menu, or drag the layer icon down to the Layer Mask button in the layers palette. Either load a channel mask as a selection or create a new mask by modifying the active layer mask using the selection, fill or paint tools. A layer mask is active when a thick black border appears around the Layer Mask icon.

The great thing about layers are all the different blending modes available. As is often pointed out, aimless tweaking of the opacity and blending mode settings can seriously restrict your productivity. It helps if you understand and can anticipate the effect an overlay mode change will have upon the final image.

Blending modes

Normal

This is the default mode. Changing opacity simply fades the intensity of overlaying pixels by averaging the color pixels of the blend layer with the values of the composite pixels below.

Dissolve

Combines the blend layer with the base using a randomized pattern of pixels. At 100% opacity, the blend layer is unaltered. As opacity is reduced, the diffusion becomes more apparent.

Multiply

Multiplies the base by the blend pixel values, always producing a darker color, except where the blend color is white. The effect is similar to viewing two transparency slides sandwiched together on a lightbox.

Screen

Multiplies the inverse of the blend and base pixel values together, always making a lighter color, except where the blend color is black. The effect is similar to printing with two negatives sandwiched together in the enlarger.

Overlay

This plus the two blend modes – Soft Light and Hard Light – should be grouped together as variations on the theme of projecting one image on top of another. The Overlay blending mode is usually the most effective, superimposing the blend image on the base (Multiplying or screening the colors depending on the base color) while preserving the highlights and shadows of the base color.

Soft Light

Darkens or lightens the colors depending on the base color. Soft Light produces a more gentle effect than the Overlay mode.

Hard Light

Multiplies or screens the colors depending on the base color. Hard Light produces a more pronounced effect than the Overlay mode.

Color Dodge

Brightens the image using the blend color. The brighter the color, the more pronounced the effect. Blending with black has no effect.

Color Burn

Darkens the image using the blend color. The darker the color, the more pronounced the effect. Blending with white has no effect.

Darken

Looks at the base and blending colors and selects whichever is darker and makes that the result color.

Lighten

Looks at the base and blending colors and selects whichever is lighter and makes that the result color.

Difference

Subtracts either the base color from the blending color or the blending color from the base, depending on whichever has the highest brightness value. In visual terms, a 100% white blend value will invert (i.e. turn negative) the base layer completely, a black value will have no effect and values in between will partially invert the base layer. Duplicating a background layer and applying Difference at 100% will produce a black image. Dramatic changes can be gained by experimenting with different opacities. An analytical application of difference is to do a pin register sandwich of two near identical images to detect any image changes – like a comparison of RGB color space modes, for example.

Exclusion

A slightly muted variant of the Difference blending mode. Blending with pure white will invert the base image.

Hue

Preserves the luminance and saturation of the base image replacing with the hue of the blending pixels.

Saturation

Preserves the luminance and hue of the base image replacing with the saturation of the blending pixels.

Color

Preserves the luminance values of the base image replacing the hue and saturation values of the blending pixels. Color mode is particularly suited for hand coloring photographs.

Luminosity

Preserves the hue and saturation of the base image replacing with the luminance of the blending pixels.

Layer masks

I will return to using paths again in later chapters, but for now let's return to combining mask channels with layers. In the illustration at the beginning of this chapter, I showed two ways of making a new layer from a selected image area. The quick method is to make a selection and float it (Layer > New Layer Via Copy – the shortcut is Command/Ctrl-J), duplicating the selected contents to make a new layer. The alternative is to duplicate the whole layer or import a new layer element and in either case apply a layer mask to the image.

Adding a layer mask based on a selection

To add a layer mask to a layer with the area within the selection remaining visible, click the Layer Mask button in the Layers palette. Alternatively, choose Layer > Add Layer Mask > Reveal Selection.

To add a layer mask to a layer with the area within the selection hidden, Option/Alt click the Layer Mask button in the Layers palette. Alternatively, choose Layer > Add Layer Mask > Hide Selection.

Choosing 'Add Layer Mask > Reveal Selection' was how I created the top layer in Figure 11.2. As was pointed out, the end result is the same. Though in using a layer mask to hide rather than erase unwanted image areas, there is provision to go back and change the mask at a later date. Or if you make a mistake editing the layer mask, it is easy to correct mistakes – you are not limited to a single level of undo.

Adding an empty layer mask

To add a layer mask to a layer with all the layer remaining visible, click the Layer Mask button in the Layers palette. Alternatively, choose Layer > Add Layer Mask > Reveal All.

To add a layer mask to a layer with all the layer hidden, Option/Alt click the Layer Mask button in the Layers palette. Alternatively, choose Layer > Add Layer Mask > Hide All.

It is fairly common to want to create either an empty or completely obscuring layer mask on a layer, then to paint in or out the detail to be shown using either the fill or paint tools. The following example uses a combination of selection and fill modifications applied to a layer mask.

Viewing a Layer Mask in Mask or rubylith mode

Normally the layer mask is hidden from view and the result of editing the mask is seen directly in the layer image. The small layer mask icon shows roughly how the mask looks. You can if you wish view the mask as a full screen image.

Option/Alt click the layer mask icon to view the layer mask as a full mask. Option/Alt+Shift click to display the layer mask as a transparent overlay (rubylith). Both these actions are toggled.

I The idea here is to add a scanned 5×4 film rebate to the above photograph. Both images happen to be near enough the exact same size. Start by selecting the move tool and dragging the border image across to the wire image window. This automatically places the border rebate as a new layer.

3 There are some unwanted sticky tape marks inside the border that must be removed. With the new layer still selected, click the Layer Mask button. Ensure the layer mask is active (there should be a solid border around the icon). Select the marquee tool and draw a rectangle inside the border. Fill the marquee selection with black as the default foreground color (Option/ Alt+Delete). If that does not do the job properly, draw another marquee and repeat the process. To undo masking, fill or paint with white.

Photograph: Davis Cairns.

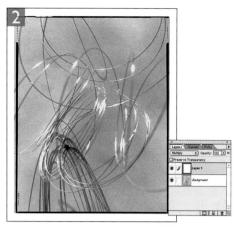

2 All the image adjustments will now take place on this layer. The 5×4 border needs to appear transparent. We can make this happen by changing the blending mode to Multiply, while leaving the opacity at 100%. The move tool is still selected, adjust the position of Layer I to align the two images as desired.

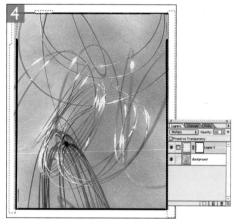

4 Lastly before flattening the image check to see where there are overlaps outside the 5 x 4 border. Make the background layer active and carefully marquee these areas to just inside the border and fill with white. Press Delete with white as the background color.

Applying and removing Layer Masks

When work is complete there are several ways to remove a layer mask.

From the Layers menu, choose Layers > Remove Layer Mask. A dialog box asks do you want to Apply or Discard the layer mask? Select either option and click OK.

With the Layer selected in the Layers palette, click on the palette Wastebasket icon or drag the active layer mask icon to the palette Wastebasket. Again the same dialog box appears asking do you want to Apply or Discard the layer mask?

To temporarily disable a layer mask, choose Layer > Disable Layer Mask. To reverse this, choose Layer > Enable Layer Mask. Another shortcut is to Shift click the layer mask icon to toggle between these two modes.

Working with multiple layers

How did we ever manage without layers? They have become an essential part of the Photoshop process. It was not always so – in the early days of digital imaging, even high-end work stations were limited to one layer at a time working. Layers are costly in terms of memory consumption, so it is wise to boost the system RAM memory as much as possible. Remember too that Photoshop's adjustment layers act just like real layers. If, for example, you need an image to interact with itself (i.e. apply a Multiply blend), rather than make a copy layer as before, create an adjustment layer (any type will do) and apply the required blending mode, saving extra drain on precious RAM memory.

When working with more than one layer you can choose to link particular layers together by creating links in the Layers palette. To do this, click in the column space between the eye icon and the layer name – you will see a chain icon appear. When two or more layers are linked, movement or transform operations affect all the linked layers as if they were one, but they still remain as separate layers, retaining their opacity and blending modes. To unlink a layer, click on the link icon to switch it off.

layer masks are by default linked to the layer content. If you move a masked layer, the mask moves with it, as long as no selection is active – then the movement or transformation will be carried out without the associated mask. Switch off the link between mask and layer and they then become independent. Depending on whether the image or mask icon is selected, the move tool will operate on that part of the layer only.

Preserve Transparency

Another much overlooked feature of layers is that little check box entitled Preserve Transparency. It does what it says – it preserves the transparent areas of a layer. Layers are mostly bits of image data lying above the main picture, they are made up of some pixel information and the rest is empty transparent space. With the Preserve Transparency switched on, any painting you do to that layer only affects the opaque portion of the layer and where the image is semitransparent, retains that level of transparency.

So why is it such a useful feature? Well, when you have a layer of type, for example, and want to change the color of the font, you could load the layer selection by Command/Ctrl clicking the Layer name and filling the selection with color. The shortcut method is to leave Preserve Transparency on and fill – choose Edit > Fill. This does the same thing. It is also a neat way of adding with a paint tool to a layer without painting beyond the edges of the layer image.

Transform commands

All the scaling, rotating, skew and perspective controls can now be applied either singly or combined in one process. Formerly stored in the Image menu, these commands are now to be found under the Layers and Contextual menus.

The Transform command works on layers, grouped layers and selections only. Select a layer or make a selection and choose Edit > Transform or Edit > Free Transform. The Free Transform options as demonstrated here permit you to apply any

number of adjustments. A low resolution preview quickly shows you the changed image shape. At any time you can use the Undo command (Command/Ctrl-Z) to revert to the last defined Transform preview setting.

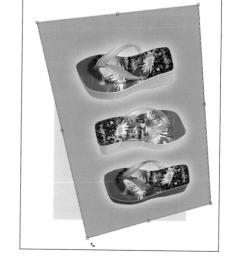

Figure 11.3 Rotating and distorting an image in one go using an Edit > Free Transform command.

Photograph by Davis Cairns. Client: Red or Dead Ltd.

Layer rotation and flips

The Edit menu Transform commands include rotate and flip. These function exactly the same way as the Image menu commands of the same name. The distinction between the two is that these layer commands affect the layer or grouped layers only whereas the Image menu commands rotate or flip the whole image.

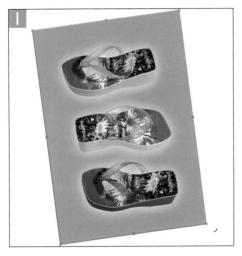

I Place the cursor outside the bounding border and drag in any direction to rotate the image. Holding down the shift key as you drag constrains the rotation in 15 degree increments.

2 Hold down the Command/Ctrl key as you click any of the handles of the bounding border to perform a free distortion.

3 If you want to constrain the distortion symmetrically around the center of the image, hold down the Option/Alt key as you drag a handle.

4 To skew an image, hold down the Command/ Ctrl+Shift key and drag one of the side handles.

5 To carry out a perspective distortion, hold down the Command/Ctrl+Option/Alt+Shift keys together and drag a corner handle. When you are happy with the new shape, press Enter to carry out the Transform. Press esc to cancel. The Transform uses the default interpolation method selected in Preferences to calculate the new image shape.

Numeric Transforms

Choose Edit > Transform > Numeric. In the dialog box, select or deselect any of the Transform options and enter numeric values for a precise Transform. For example, a common use of the numeric transform is to change the percentage scale of a selection or layer. Enter the required percentage with the Constrain Proportions on or off. Furthermore, if you first select Edit > Transform and make an adjustment, you can then select Numeric Transform, make further numeric adjustments and click OK to accept. This does not take you outside the Transform, you will still be able to make further manual adjustments.

Repeat Transform

This is a feature familiar to users of Adobe Illustrator. After applying a transform to the image data, you can instruct Photoshop to repeat that transform again. The shortcut is Shift+Command/Ctrl-T. The image transform will take place again on whatever layer is selected and regardless of other steps occurring in between. Therefore you can apply the transform to the same layer again or transform another existing layer.

Transforming selections and paths

You can now apply transforms to selections and paths. Make a selection and choose Transform Selection from the Select menu. The same key combinations apply to altering the selection shape as with the Edit Transform. To call up a menu list, hold

down the Ctrl key/right mouse click as you mouse down on one of the border handles. If you refer back to Chapter Seven, you will remember that there were already the Option/ Alt, Shift and Spacebar keys which could be used to modify the selection scale and positioning on the fly. Now you can modify the selection shape after releasing the mouse. Another tip to remember is the reselect function. Selections are memorized in Photoshop beyond the single undo. Choose Select > Reselect to bring back the last used selection. With paths, the transform options are located back in the Edit menu again. Paths can be transformed and repeat transformed just like image data and selections. Maybe this does not sound like something of immediate benefit, but perfect for image makers who are drawing and creating objects in perspective.

Figure 11.4 One way of transforming a selection was to activate and view the mask as a rubylith and apply a transform. Now when a selection is loaded, go to the Select menu and choose Transform Selection. The selection shape can be altered following the instructions decribed on the previous page.

Client: Clipso. Model: Melanie at Storm.

Drawing paths with the pen tool

Unless you have had previous experience working with a vector based drawing program like Freehand or Adobe Illustrator, the concept of drawing with paths will be unfamiliar. It is difficult at first to get the hang of, but I promise you it is well worth mastering the art of drawing with the pen tool. Hard as it may seem at first, it is like riding a bike, once learned – never forgotten. Paths are useful in several ways: either applying a stroke with one of the paint tools, for saving as a clipping path or defining a complex selection shape, which can be converted to a selection. For the purposes of this chapter, we will concentrate on the latter.

I am sure there are still those of you who remain to be convinced that paths are important. In the first few pages I have discussed working with the selection tools. how to feather selections, convert them to masks and modify them using the paint tools. What more do you need? I believe the answer is related to size of images being manipulated. When Adobe first released Photoshop, the first customers were exclusively Macintosh users. The Apple computers in those days could only be expanded in a limited fashion and at great cost. Consequently, Photoshop was in practice a veritable tortoise compared with the high-end systems used to retouch large digital files. The Photoshop selection tools like the lasso and magic wand were suited to operating efficiently with small sized files, which was all the program was likely to deal with back then. In a typical design studio, most of the images handled were less than 10 MB in size. That was then and today Photoshop is able to handle poster sized images with ease, when configured on a top of the range desktop computer. The pen tool is the professional's selection tool, so if you are planning to work on large sized files, you will mostly find it quicker to draw a path and convert this to a selection rather than any other method relying on the selection and paint tools alone. The magic wand may do a grand job on the tutorial sized images, but is not a working method which translates well to working on bigger files. The magnetic tools fall half way between. They are cleverly designed to automate the selection process, but there is often still no alternative available but to manually define the outline with a path.

Guidelines for drawing pen paths

At this stage you might be scratching your head saying 'I still don't get it yet', so let's start with the task of following simple contours as shown in figure 11.5. You will find a copy of this image in a layered Photoshop format on the CD-ROM. It contains saved path outlines of each of the shapes. The background layer contains the basic image and above it the same image plus the pen path outlines with all the points and handles showing. Make this layer visible and fade the opacity if necessary to follow the handle positions when trying to match drawing the path yourself. The shapes used by the way were created from a font called Populist – Control from the Fuse collection. Start at kindergarten level with the letter 'd'. If you mastered the polygon lasso tool, you can do this – click on the corner points one after another till you reach the beginning point and click to close the path.

This is better than the polygon lasso, because you can now zoom in if required and precisely reposition each and every point. As before, hold down the Command/Ctrl key to switch to the pointer and drag any point to realign it precisely. To emphasize the importance and usefulness of paths, after closing the path, hit the Enter key to convert to a selection. Now can you see why drawing with paths offers unparalleled flexibility?

Figure 11.5 Path tutorial file from the CD-ROM.

Moving down to the 'h', this will help you to concentrate on the art of drawing curved segments. Observe that the beginning of any curved segment starts by dragging the handle outward from the direction of the intended curve. To understand the reasoning behind this, it is like trying to define a circle by drawing a square perimeter. To continue a curved segment, click, hold the mouse down and drag to fine tune the end of the last curve and predict the next one. This assumes the next curve will be a smooth continuation of the last. Whenever there is a sharp change in direction, make a corner point. Convert the curved segment, holding down the Option/Alt key and click. Click to place another point, creating another straight segment as before.

Hold down the Spacebar to access the hand tool to scroll the image, then hold down the Command/Ctrl key to access the pointer to reposition points. When you use the pointer to activate a point, the handles are displayed. Adjust these to refine the curve shape. Finally with the 'v', this will help you further practice making corner points. A corner point can be placed when drawing a series of curved segments and you are not continuing to follow a smooth flowing outline. In the niches of the 'v/&' symbol, after dragging to define the curve, hold down the Option/Alt key and drag to define the predictor handle for the next curve shape.

Pen tool in action

This tutorial shows how to use the pen tool to draw a closed path outline around a portion of the shoe pictured here, how to duplicate a path and go back and readjust the path outline shape. To show the results clearly, the images here are printed as viewed on the monitor, working at a 200% scale view. Because the path outlines are hard to see sometimes, I have added a thin blue stroke to make them a little more visible. By the way, it is essential to work with at least a 32 000 color display in order to see the path outlines clearly.

I Select the pen tool and check that in the pen tool Options you have the Rubber Band option checked. This will make it easier for you to see the path segments taking shape as you move the mouse. Click on the image to create a starting point for your path. As you click, hold down the mouse and drag away from the point. You are now dragging a handle which will act as a predictor for the beginning arc of the curved segment you will create after placing the second point in the path.

2 If you simply click to create the second point, the path will have all the curvature at the starting point and flatten off towards the second point. To follow the line of the shoe strap, click and drag the mouse following the flow of the image curve shape. You notice now that there are two equidistant handles in line with each other leading off from the second path point. You have just completed drawing a curved segment.

3 Now add a corner point at the apex. Hold down the Option/Alt key and click with the mouse while continuing to drag the handle upward and outward to the right. The Option/Alt key action defines it as a corner point and the dragging concludes the curvature of the segment just drawn.

- 4 After making a corner point, hold down the Option/Alt key again and drag the handle out downwards to the right to begin drawing a series of curved segments.
- **5** Drawing a straight segment is the easy part. End the curved segment by Option/Alt clicking the last point and simply click to draw a straight or series of straight lines.
- **6** Continue to draw the shape of the path as before. When you reach the end of the path and place the cursor on top of the original starting point a tiny circle appears to the bottom right of the pen tool icon. Clicking now will complete the path and create a closed path. Drag the mouse as you complete this operation to adjust the final curve shape.

Photograph by Davis Cairns. Client: Red or Dead Ltd.

These are the basic techniques for drawing straight line and curved segment paths. Try practicing with the supplied tutorial image to get the hang of using the pen tool. Your first attempts probably won't be spot on. Don't worry too much, the following tutorial shows you how to refine the path outline.

I Activate the work path in the Paths palette. A work path, like a selection, is only temporary. If you activate the path icon and draw a new path, it is added to the work path. If you don't activate the work path, the original is lost and a new work path created. Drag the icon down to the Make New Path icon. Photoshop renames it Path I. It will now be savable as part of the image just like an alpha channel.

3 Replace the points and redraw the curved segment by Option/Alt dragging the handles until the curves more neatly follows the contours of the ribbon. Points can be added or deleted using the add point or delete point tools, but also when the pen tool is selected clicking on a segment or clicking on an existing point is a very convenient and easy to remember shortcut

2 Use the direct selection tool (from the pen tool fly-out menu) to select one or more points on a path. Marquee points to select them and click on any of the selected points and drag to reposition them. The path points all move in relation to each other. In the last tutorial, I introduced the use of the Option/Alt key to change a smooth point to a corner point. You can temporarily convert the pen tool to the direct selection by holding down the Command/Ctrl key.

Montages

Now to put all these techniques into practice. The aim of the following sequence is to merge two photographs together seamlessly. The main problem here is the hair – how do you get a good outline? The shortcut to creating such a selection is to copy an existing color channel and modify it to make a mask.

I The first stage is all about making a good quality alpha channel mask. To save time, first check to see if there is already information in the image that can easily be adapted, instead of having to spend a lengthy time drawing and painting a mask from scratch. Inspect the color channels independently – see which has the most useful contrast already present. Most often this will be the green or blue channel. Either click on the channels in the Channels palette or use the shortcut Command/Ctrl channel number. Select the channel and make a copy, dragging down to the New Channel button in the Channels palette.

Client: Clipso. Model: Gillian at Bookings.

2 Use the Curves command (Image > Adjust > Curves) to increase the contrast, concentrating on the hair outline. The mask channel at the edges does not have to be completely black or white, in between shades are adequate. Leave the mask for now and click on the composite channel (Command/Ctrl-~) to prepare for the next stage.

The most efficient method of defining the remaining outline is to draw a pen path. Enlarge the screen display to 200% and follow the instructions in the early part of the chapter to draw around the body. Close the work path (joining the last point to the first) and save as a new path.

Return to the mask copy channel. The mask channel is now active. Convert the path to a selection – drag the path down to the Make Selection button in the Paths palette. Fill the selection with black as the foreground color – press Option/Alt+Delete on the keyboard. Deselect the selection.

Finish making the mask. Paint in the gaps with the brush tool. Sometimes you may find it useful to apply the burn tool set to Shadows. Providing the outline is completely closed, a quick tip for filling the interior is to use the bucket tool set to a high tolerance setting (approx. 200) and click inside the masked area, filling with black.

6 Reduce the image display to fit the screen (double click the hand tool). Choose the rectangular marquee tool and select the background area – Shift drag with the marquee, adding to the selection. Fill the selection with white. Check the mask image border and paint out remaining specks.

7 Apply a Levels adjustment to the mask. Clip the shadows and highlights by setting the shadow and highlight sliders as shown. The mask is now complete, so save the image.

One cannot stress enough just how important it is making a good mask when compositing with any image editing program. Once you have a good mask prepared, the remaining work is made far simpler for you. There are alternative masking methods, including Magic Mask, a Photoshop plug-in available from Chromagraphics, which takes the hard work out of mask making. Mask Pro from Extensis generates

alpha channel masks and path outlines. I remind you again that photographic objects rarely have neat crisp outlines. Softer masks usually make for a more natural looking finish. Therefore experiment by softening your masks before applying them. A mask derived from a path conversion may be too crisp, so either feather the selection or if saving as a mask, apply a little Gaussian Blur filtration.

8 The background image is roughly the size of the model image. The model will eventually appear to be in front of this backdrop, but to create the illusion the backdrop will in fact be on a layer residing above the model image. Select the move tool and drag and drop the backdrop to the model image window.

10 The backdrop obscures the image. To reveal the correct portions of the Background layer, add a layer mask to the new layer. Before creating the layer mask, go Select > Load Selection and choose the alpha channel mask made in stages I–7. With the new layer active, Option/Alt click the Layer Mask button in the Layers palette. This creates a layer mask based on the loaded selection, with the selected areas masking out the layer and revealing the image below.

II Check up close the smoothness of the transition between the two elements. Minor problems can easily be corrected by brush on the layer mask with an unlimited number of redos. Where the subject was shot against a light or white background, I like to try changing the blending mode to either Multiply, Soft Light or Hard Light. The two images combine together even more smoothly – every single strand of hair in the original shines through. (I applied a color correction at this point to make the skin tones blend in with the backdrop.)

9 The backdrop is slightly too small, so needs to be scaled up slightly. Activate the backdrop layer and select Edit > Free Transform and drag the handles to enlarge the layer image. Press Enter on the keyboard to OK the Transform.

Clipping groups

Another Layers feature is the ability to create Clipping Groups within layers. The lowest layer in a clipping group acts as a Layer Mask for all the grouped layers above it. To create a Clipping Group, you can either link layers together and choose Layer > Group Linked, Option/Alt click the border line between the two layers or

use Command/Ctrl-G to make the selected layer group with the one below. When a layer is grouped, the upper layers become indented and the solid line between the layers is dotted. All layers in a clipping group assume the opacity and blending mode of the bottom layer. To ungroup the layers, Option/Alt click between the layers, the layers ungroup and the dotted line becomes solid again. To demonstrate Clipping Groups in action, I am going to continue the tutorial, showing how to add a duplicate layer of the model and make it appear as a blurred ghost image.

- **12** Activate the Background layer and load the mask channel as a selection. Float the selected area to make a new layer: Command/Ctrl-J. Drag the duplicate layer above the backdrop layer.
- 13 The next objective is to blur the image. Preserve Transparency should be on by default. This will constrain the filter effect to modifying the non-transparent pixels only, so uncheck the Preserve Transparency box, allowing the pixels to blur outwards. Apply Filter > Blur > Motion Blur and set a large amount (20–50 pixels) at an angle of 0 degrees.

14 Change the image layer opacity to 15%–25% using the Normal blending mode. Now Option/ Alt click the blurred layer to make it part of a clipping group with the backdrop layer. The backdrop layer now masks the blurred layer.

Exporting Clipping Paths

Not to be confused with layer clipping groups, Clipping Paths are vector paths used to mask the outline of an image when exported to be used in a DTP layout program such as Illustrator, Freehand, PageMaker or Quark.

Do you remember me saying earlier that a selection can be converted to and from a path? If an image document contains a closed path, when you save it as an EPS format file, there is an option for selecting that path as a Clipping Path. In Illustrator, for example, you can use the saved clipping path as a masking object.

Imagine a catalog brochure shoot with lots of products shot against white ready for cutting out. Still life photographers normally mask off the areas surrounding the object with black card to prevent unnecessary light flare from softening the image contrast. Whoever is preparing the digital files for export to DTP will produce an outline mask and convert this to a path in Photoshop or simply draw a path from scratch. This is saved with the EPS file and used by the DTP designer to mask the object.

Clipping paths are an efficient and effective tool for lots of projects, but not in every case. I had a recent design job to do for photographer Peter Hince, who asked me to design a brochure showing a collection of his underwater photographs, Ocean Images. I assembled the twelve B/W pictures in PageMaker. They all had rough edged rebates which Peter wanted preserved. I could have made a path outline of each image and placed these on top of the background image. What I did instead was to prepare the design in PageMaker, scaling the individual images and working out their position. After that I reproduced a similar guideline layout in Photoshop and created a multilayered image, positioning the individual images and merged them all into one to make a single CMYK, EPS file. The following steps demonstrate how I retained the subtlety of the borders, which may otherwise have become lost.

Another good reason for doing things this way is that it saves on the RIP time for proofing and imposition and reduces the chances of file errors. On the other hand, clients might ask you to alter one of the images after seeing the proof, so save that multilayered Photoshop original for backup!

I The background layer consists of a water reflection pattern. All the individual photographs are aligned to guides, as they will appear in the final design and grouped on the one layer. Before proceeding to the next stage, copy this layer by dragging down to the New Layer button.

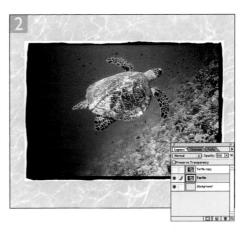

2 To demonstrate clearly what is going on, the following stages are carried out on a separate, close-up image. Switch off the eye icon for the copy layer and activate the original layer. There are two methods of blending the black border edges with the background. One is to select the Multiply blending mode from the layer menu. A more general purpose method is to adjust the Layer Options.

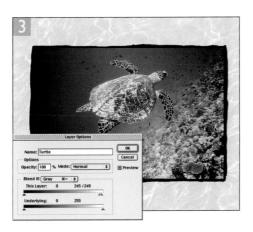

3 Double click the layer to open the Layer Options dialog box. Hold down the Option/Alt key to split and drag the highlight sliders for This Layer, as shown here. What this does is to remove the pure white tones from blending with the underlying layers. It also makes some of the inner highlight areas transparent. These will be covered up with the copy layer.

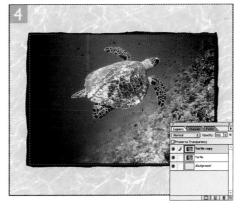

4 Activate the copy layer again and marquee inside the image border. When finished, invert the selection – Select > Invert Selection and delete or cut the selected area (Edit > Cut). Flatten the image before saving to export to the DTP program, but also save a layered copy of the image in case further adjustments are required.

Photographs: Peter Hince/Ocean Images.

Chapter Twelve

Retouching

ime now to explore more ways of digitally retouching your pictures and effecting repairs to an image. Some of these techniques demand at least some basic drawing skills and ideally you should be working with a graphic drawing tablet as your input device rather than a mouse. Mistakes can easily be made – in other words, before proceeding, always remind yourself: 'now would be a good time to save a backup version to revert to'.

I have chosen here a mixture of extra Photoshop techniques which would be useful for photographers. This has been done using examples of problems which demand a special approach, like how to retouch areas where there is not enough information to clone from. The good old rubber stamp tool serves us well when repairing an image provided there are enough of the right color pixels to sample. When there is not, you have no choice but to paint the information in. If you are not careful, the problem here is that the brush strokes don't look like they are part of the camera image (excessive cloning, especially at low opacities, creates the same type of mushy result). The reason brush work tends to stand out is because the underlying film grain texture is missing. This can easily be remedied by introducing the Add Noise filter selectively to the paint stroke pixels. The following steps show how lettering was removed from the cyclist's headband.

I Here is the problem – remove the thick black lettering and convincingly replace the removed areas so that they match the green fabric texture. Commence by drawing a path to define the outline of the headband or if you prefer, use the freehand lasso tool.

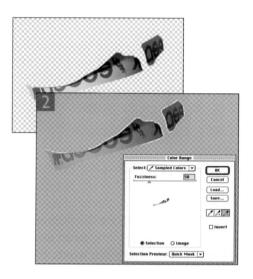

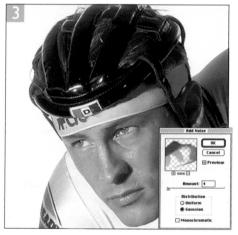

4 Select the brush tool, using a small soft edged brush. In the Brush Options palette, set the brush to Lighten blending mode. Begin by sampling colors from the green portion of the headband (hold down the Option/Alt key) and paint over the letters. Keep resampling different shades of green to achieve realistic tonal gradation.

- 2 Having drawn a closed path, convert it to a selection (drag to the palette Make Selection button). Feather the selection by I pixel (Select > Feather) and float as a new layer (Command/ Ctrl-J). The new layer should by default have Preserve Transparency switched on, which is important if you want the following retouching to be constrained to within the non-transparent areas. Because I am going to use the saved selection later to do the constraining it does not matter too much in this instance.
- 3 Before removing the black bits, we need to make and save a mask for future reference. Choose Select > Color Range and create a mask based on samples from the black lettering. Save as a new mask (Select > Save Selection).

5 Now blend the retouched headband with the background layer. Load the saved selection – Select > Load Selection, choose Channel 4 and create a layer mask – click on the Layer Mask button in the Layers palette. Only the areas which were once black are allowed to blend with the background layer. Add grain to the layered image: Choose Filter > Noise > Add Noise. Select Gaussian Noise and experiment with an amount setting of 5. Judge for yourself whether the retouched layer matches convincingly with the background. If not, undo the filter and repeat with less or more noise. Also try removing portions by painting them out on the Layer Mask.

Brush blending modes

In the last example the blending was changed to Lighten mode and it is good practice to remember always to reset the options back to Normal. A number of the painting and editing tools operate in a variety of blending modes which are identical to those you come across in layers and channel operations. In this instance, Lighten mode was chosen in preference to Normal because I wanted to selectively paint over the black areas while minimally affecting the existing green. Just try getting your head round the total of 133 different tool blending mode combinations, or rather don't, as it is unlikely you will ever want to use them all. For example, will you ever want to use the rubber stamp tool in Difference mode? To narrow down this list, I reckon the following modes are probably the most useful: Screen, Multiply, Lighten, Darken and Color combined with the paint brush, airbrush, blur and gradient tools.

Suppose you want to selectively add some misty soft focus to a specular highlight – use the blur tool in Lighten mode. If you want to create a diffuse glow around the edge of something, draw an outline path and stroke the path using the blur tool set to Darken. I photograph and clean up a lot of hair and beauty type photographs and sometimes get requested to tidy up the hair color where perhaps the roots are showing. I will first marquee the area and float it to a new layer so that if I don't like the result I can ditch the new layer. I sample a color from the area with the right hair color, then set the brush to Color mode and paint over the roots. Painting in Color mode, the lightness values which define the hair texture and shape are unaffected – only the color values are replaced. The saturation values remain unaffected, so it may be necessary to run over the area to be colored beforehand, desaturating the area and then coloring it in. Painting in Color mode has many uses – try it yourself and experiment away. Artists who use Photoshop to color in line art will regularly use the Color and other blending modes in their work. Another good example is hand coloring a B/W photograph.

Retouching with the paintbrush

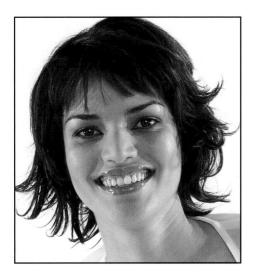

2 I made a rough selection around the face and floated this as a new layer. Mostly I used the paint-brush in Lighten mode, sampling the lighter, adjacent skin tone colors and lightly brushing over the shaded portions with the pressure sensitive stylus. When done, I reduced the layer opacity in order to retain some of the original shading.

Image courtesy of Conexions. Model: Carolyn at Nevs. Photograph: Chris Bishop.

I In this before shot we see that the lighting is creating distracting shadows on the face. It would help to add the impression of the presence of a frontal fill light to soften the shadows. When I was supplied with this picture to retouch, I decided it would be better to use the paintbrush.

For the type of retouching I normally do, which usually means retouching skin tones, the paintbrush is indispensable. The accompanying example shows how the paintbrush was used in Lighten and Darken mode to paint out shadows and unwanted highlights without destroying too much of the tonal information one wants to keep preserved.

My personal preference is to carry out the retouching on a separate layer because this enables me to reduce the layer opacity and blend the work I have done with the background layer. The end result is smoother and less noticeable. With beauty shots I often lighten up the whites of the eyes too, but only a little. In my opinion, too many magazines make the mistake of bleaching out the eyes to an unnatural degree at which the press cannot register any ink dot whatsoever.

Softening the focus

Here are a few variations where a Gaussian blur filter was applied to a duplicate background layer and the layer blending mode was then changed.

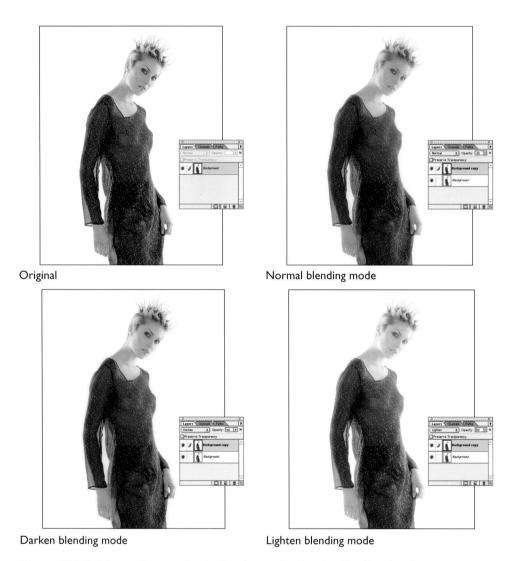

Figure 12.1 Soft focus effects can be simulated using the Gaussian blur filter. I prefer to sometimes duplicate the background layer, apply the filter to the new layer, fade out the effect and apply a layer mask to further modify the soft focus. Alternatively, filter the whole image and apply a Fade Filter command (and changing the blending mode), which has the same basic effect but with less room for further modification.

Client: Clippers. Model: Agnes at Profile.

Rescuing shadow detail

Sometimes no amount of Curves contortion can successfully lift up the shadow tones without causing the rest of the image to become degraded. Curves adjustments must be done carefully. The curve shape should be smooth, otherwise gentle tonal transitions will become lost and may appear solarized. There are similarities here with the problems faced when trying to get the best full tone print from a contrasty negative. The invention of multigrade black and white paper was a godsend to photographic printers who were then able to print using a combination of paper grades with one or more enlarger exposures. If you have ever printed in the darkroom yourself, you'll know what I mean. If not, don't worry – all you need to know is that the Photoshop method I am about to describe can achieve the same end results in black and white or color.

Shadow tones can appear compressed or lost for a variety of reasons. It may not be the image but the monitor display which is at fault, so check the monitor has been properly calibrated and that the viewing conditions are not so bright as to cause flare on the screen. You must also realize that monitors are not able to represent a full range of tones displayed in evenly balanced steps. As was mentioned before, all monitors compensate for their limited dynamic range by applying a small amount of tonal compression in the highlights and more tonal compression in the shadow areas, leaving room for the midtones to display proportionally, as they are. If there really is a problem with the shadow detail, the true way to find out is to check the histogram and rely on that for guidance. If there are a bunched-up group of bars at the left of the histogram - then yes, you have compressed shadow tones. Knowing a little about the picture's history helps. I once had to correct some transparency scans where the film had been underexposed and push processed by at least two stops. The image was contrasty, yet there was information in the shadows which could be dug out. Or maybe you can see from the original photograph that the lighting was not quite good enough to capture all the shadow detail. You will be amazed how much information is contained in a high quality scan and therefore rescuable.

The following tutorial is a recognized method of exploiting the adjustment layers feature in Photoshop. I have tried to show a number of ways to fine tune adjustment layers. If it all looks too complex, filling the adjustment layer mask with black and painting back in the layer with white will usually suffice for localized lifting of lost shadow detail.

2 Keep the selection active and choose New Adjustment Layer from the Layers palette sub-menu and select Curves from the pop-up menu in the dialog box. A curves adjustment layer appears in the Layers palette with the luminance mask loaded as a layer mask, visible in the adjustment layer preview icon. Adjust the curve shape to raise the shadow tones. The curve does not have to be perfect just yet.

3 Inspect the result – there is room for plenty of fine tuning. Try lowering the layer opacity, or double click the adjustment layer and change the curve shape. For greater control, keep the adjustment layer highlighted and select Image > Adjust > Curves from the main menu. The curves adjustment you make now will apply to the layer mask only. As can be seen, having made a more contrasty mask, the adjustment layer is restricted in its impact to the shadows. To preview the mask as you do this, Option/Alt click the mask icon. Option/Alt click to return to the normal display. If that was not enough, you can Control - click (Macintosh), right mouse click (PC) and drag down the context menu to select Layer Options. Option/Alt drag the half of the highlight This Layer slider down to the left. Layer Options are discussed more fully in Chapter Fifteen.

Client: Hair UK. Model: Maria at Nevs.

I Stage one – prepare a luminance mask representing the shadow detail. You might know this already, but if you want to load a selection based on a color or alpha channel, you Command/Ctrl+Option/Alt click the channel in the Channels palette. So if you want to make a selection based on luminance, Command/Ctrl+Option/Alt click on the composite channel (represented by the tilde sign ~). The selection loaded now is for the midtones to highlights. Inverse the selection – Select > Inverse before proceeding. It helps if at this stage you choose to hide the selection 'marching ant' edges (View > Hide Edges). One is then able to work much quicker and judge what is happening more clearly.

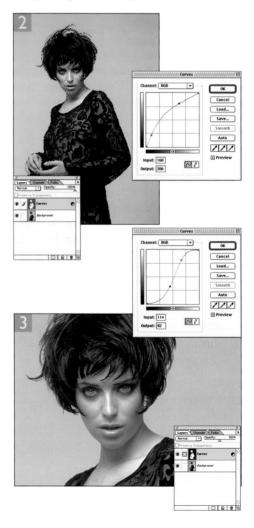

Scanning halftone images

One of the most common queries I come across concerns how best to scan halftone images and eliminate the resulting moiré patterns. Photographs that appear in publications are reproduced on the page using a regularly repeating rosette pattern of ink dots. The severity of the moiré depends on the coarseness of the printed screen, the angle the page is scanned at, the scanning resolution used and the viewing resolution on the monitor (inspect at either 50%, 100% or multiples thereof). Rotating the page a few degrees can make a big difference as it is easy to rotate the page back into alignment once captured in Photoshop. Try scanning at the higher resolutions and work downwards in gradual increments to find the optimal resolution.

The big question though is the legality of copying pictures from a publication. Fine if it is your own work, but do make sure that permission of the copyright holder is always sought. Be warned that steps are being taken to inhibit infringement of copyright and protect the rights of authors. First of all images can be invisibly encrypted using either the SureSign or Digimarc systems which are available as third party plug-ins for Photoshop. (The Digimarc plug-in is included with Photoshop 4.0.) You won't always be aware that a published picture has this tagging embedded and the process of removing the moiré plus smoothing away the halftone dots may actually enhance the encrypted signature instead of destroying it.

With regard to pirated photographs being used on the web, I do know that Digimarc have a web crawler scouring the web with the aim of enabling Digimarc to detect encrypted images. It has to be said that at the smaller file sizes used to publish on the Internet, the robustness of any fingerprint is much weaker. See also Chapter Five for more information about image protection.

Moiré patterns can be eliminated by softening the image detail in the worst affected channels followed by resharpening. You can soften an image using the Gaussian Blur, Median Noise filter or a combination of the two. Some scanner software programs have their own descreening filters. These may or may not do a good job. The advantage of the method outlined here is that with a manual correction, you only soften as much detail as is absolutely necessary.

Tool applications and characteristics

Some tools in the Photoshop toolbox are more suitable than others. The blur tool is very useful for localized blurring – use it to soften edges that appear unnaturally sharp. Its neighbor, the sharpen tool, I urge you use with caution. In my experience the sharpen tool has a tendency to produce unpleasant artifacts. If you want to apply

2 The green and blue channels require more softening. Work on each channel individually and apply the Median filter (Filter > Noise > Median). Use a small amount of Median noise, if you cannot remove all traces of the moiré, try applying a Gaussian blur first followed by the Median.

I The moiré pattern is mostly found in the green and blue channels, there is a slight amount in the red channel. To minimize image degradation, apply just a small amount of Gaussian blur or Noise > Median to the red channel. Start with as large a scan as possible with the intention of reducing the image size later.

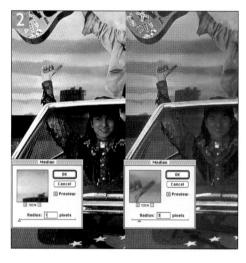

3 Any remaining traces of moiré should disappear after reducing the file size down. Finally apply Unsharp masking to restore some crispness to the image.

localized sharpening, select an area with the lasso tool, feather the edge by 5 pixels or so and apply an unsharp mask to the selected area. If you have a selection saved, this can be converted to a path (load the selection, go to the Paths palette and choose Make Work Path). Use paths as a guideline for stroking with Photoshop tools. For example, I said the blur tool can be used to selectively soften an edge. If you want to soften the outline of an image element and have a matching selection saved, convert this to a path, select the blur tool and choose Stroke (Sub) Path from the Paths palette. And of course in the History palette you can always plan to take a snapshot of the image state before blurring and afterwards selectively paint back in the non-blurred images data using the history brush.

The smudge tool hasn't been covered fully yet. It is important to recognize the difference between this and the blur tool which is best suited for merging pixels. The smudge tool is more of a painting tool, either used for blending in a foreground color

or 'finger painting', smearing pixels across an image. Smudge strokes look odd on a photographic image unless you are trying to recreate the effect of Instant Polaroid smearing. A better smudge tool is the super putty plug-in which is part of the Pen tools suite distributed by Wacom. Some retouchers like to use the smudge tool to refine mask channels, working in Quick Mask mode, and with the smudge tool set to Finger Painting drag out mask pixels to follow the outline of hair strands, for example. I tend to stick with the brush tool nearly all the time, making use of the different pressure sensitivity options (available only if you have a pressure sensitive graphic tablet device installed). The standard pressure setting is Opacity but you can choose Brush Size as well. Low stylus pressure produces fine faint brush strokes; heavy pressure produces thicker and darker brush strokes.

Dodge and Burn

The dodge and burn tools require little explanation, but like the sharpen tool need to be used with care. The great thing about these tools is that you can set them to affect either the Highlights, Midtones or Shadows only. My only criticism or warning is that these tools cannot always modify the hue, saturation and brightness values together in a convincing manner. This is not a huge problem, just something to watch out for. If you try to dodge an area of a picture too much, you might discover it removes too much of the saturation as well, so use them carefully. To dodge a large area of a picture, you are better off making a heavily feathered selection and applying a combination of Levels and Hue/Saturation image adjustments. The results will be a lot smoother. The other difficulty Photoshop users face is the slowness of the large brushes, though this is not a fault of the program, rather a limitation of the desktop computers used to run Photoshop. The associated sponge tool is great for tweaking color. Again be careful when applying saturation not to cause clipping or artifacts to appear. Use in desaturate mode to correct for oversaturated areas and smooth color transitions which look wrong.

When you first discover and learn about the rubber stamp tool, it is natural to think that it should be used for all blemish removals. Not so, cloning out facial wrinkles and such like are best removed with the dodge tool set to Midtones and applied with a smallish soft edged brush at low opacity (1%–2%). After gently brushing with the dodge tool, you will notice how the lines start to disappear. As was demonstrated earlier, I also like to paint color in using the brush tool set to Lighten mode. Keep in mind the ability to restrict the application of the dodge and burn tools and its usefulness will become apparent in all sorts of situations. To improve the definition of hair silhouetted against a light background, use a small low opacity brush burn tool set to Shadows to build up the fine hair detail without darkening the background.

Chapter Thirteen

Shortcuts

etting to know the basics of Photoshop takes a few months, learning how to become fluent takes a little longer. There are a great many keyboard shortcuts and not all of them are listed in the manual. In this chapter I have grouped together a list of tips and keyboard shortcuts to help expand your knowledge of Photoshop. These are a reminder of some of the suggestions covered elsewhere in the book – use it as a reference for productive and efficient Photoshopping. Learn the keyboard shortcuts a few at a time. Don't try to absorb everything at once.

I would start by saying that the key to efficient working is to plan your projects in advance. Rather than dive straight in, think through first about what you want to achieve – either write down or make a mental note of what it is you want to do and work out the best order to do everything in. An obvious example would be to avoid preparing your work at high resolution when the final and only use was just a few megabytes. You would want to reduce the file size at the beginning of the process to save on computer processing time rather than at the end. Another reason is that there is often more than one way of doing something and a little time spent thinking through things at the beginning will save much in the long run. This is particularly true if working on an underpowered computer or pushing your machine to its limits.

Where a project requires experimentation to see which effects work best, it may be wise to start with a low resolution version first. This will enable you to edit quickly without waiting for the dreaded wristwatch or egg timer. Make a note of the settings which looked best and repeat these at higher resolution. This is a particularly handy way of exploring the different blending modes and filters but remember that the filter effects may work slightly differently at higher resolutions and the settings will need to be scaled up.

Instead of making notes you could try recording the steps used as an Action. This can then be replayed on subsequent images. Process an image once, recording each step used, stop the recording and play the action on single or batches of images. You will find several Actions ready supplied when you install Photoshop and discover many more which are freely available on the Internet. One such site is Actions X Change maintained by Joe Cheng and can be found at: http://www.actionxchange.com. Another is the Elated site: http://www.elated.com/freebies/actionkits/. Both these sites have ready prepared actions or sets of actions with examples of the types of effects achieved with them for you to freely download for use in Photoshop. To find out more about Actions, see the section towards the end of this chapter — Working with Actions. Macintosh/Windows key equivalents are used everywhere else in this book, but due to lack of space, only the Macintosh keys are listed in the tables. Remember, the PC equivalent for the Command key is Ctrl and the Option key is Alt. To start with, here are the single key shortcuts for accessing tools and commands in the Toolbox:

Toolbox	
Α	Direct Select tool
В	Paintbrush tool
C	Crop tool
D	Reset to default Foreground/Background colors
Employed the state of the	Eraser tool
F 100 100 100 100 100 100 100 100 100 10	Toggle the three screen display modes
Shift+F (after first F)	Toggles menu bar on/off
G	Gradient tool
H	Hand tool
Spacebar	Access hand tool while any other tool is active
	Eyedropper
J_{1},\ldots,J_{n	Airbrush tool
K	Paint Bucket tool

To cycle through the hidden tools, either hold down the Option/Alt key and click again on the tool icon in the Toolbox or hold down the Shift key and press the key shortcut again. For example, if the blur tool is currently selected, Option/Alt click the blur tool icon or press Shift-R, to select the sharpen tool. This rule applies to all the tools except the eraser tool, which changes its operating mode, not the toolbox icon.

Toolbox continued	
	Lasso tool
М	Rectangular marquee
N	Pencil tool
0	Dodge tool
P	Pen (path) tool
+ (plus)	Add Anchor Point tool
- (minus)	Delete Anchor Point tool
Q	Quick Mask mode/Selection mode
Option+click on Quick Mask button	Invert Quick Mask mode
R	Blur tool
S	Rubber Stamp tool
	Type tool
U	Measure tool
V	Move tool
Arrow keys	Nudge selection border only, by I pixel
Arrow keys	While move tool selected: nudge selection by I pixel
Shift+Arrow keys	Nudge selection border only, by 10 pixels
Shift+Arrow keys	While move tool selected: nudge selection by 10 pixels
Command key	Access move tool while any tool is active, bar pen tool
W	Magic Wand tool
X	Exchange Foreground/Background colors
Y	History Brush
Z	Zoom tool
Command+Spacebar-click	Zoom in
Option+Spacebar-click	Zoom out

Toolbox continued	
Shift+I	Cycle through eyedropper tools
Shift+L	Cycle through lasso tools
Shift+M	Cycle through marquee tools
Shift+N	Toggle between pencil and line tools
Shift+O	Cycle through toning tools
Shift+P	Cycle through pen tools
Shift+R	Cycle through focus and smudge tools
Shift+S	Toggle between rubber stamp and pattern stamp tools
Shift+T	Cycle through type tools

Efficient running

Load Photoshop first, allocating as much RAM memory as possible (see Chapter Seven) and run Photoshop on its own. If you have lots of RAM and are working with small sized files, you can work smoothly swapping between Photoshop and a page layout program. In most cases it is more efficient to work exclusively in Photoshop, quit and load up Quark or PageMaker. There needs to be plenty of free hard disk space available and this must at least match the amount of available RAM. Regularly clear the clipboard memory (use the Edit > Purge command). If you happen to be using an older version of Photoshop, then do the following: select the marquee tool and make a tiny selection of pixels anywhere in the image. Copy the selection once – this copies the selected pixels to the clipboard but with the last undo still stored. Copy again and this will clear the clipboard memory completely replacing it with the small selection. Deselect the selection and carry on working.

Keep the minimum number of image files open at any one time. Check the scratch disk size by having the status box at the bottom of the window set to show Scratch Disk memory usage. Once the left hand value starts to exceed the right, you know Photoshop is running out of RAM memory and employing the scratch disk as virtual memory. If a single file is too big, save in TIFF format and use Quick Edit. To copy selections and layers between documents, use the move tool. Save either in the Native Photoshop format or as an uncompressed TIFF to the desktop. Save to the hard disk not to removable media, except perhaps in the case of Jaz drives which have reasonably fast read/write speeds.

File Menu	
Keyboard shortcut	Function
Command-K	File > Preferences > General
Command+Option-K	File > Preferences > General (last used dialog box)
Command-N	File > New File
Command+Option-N	File > New File using previously selected settings
Command-O	File > Open File
Command-P	File > Print File
Command+Shift-P	File > Page Setup
Command-Q	File > Quit
Command-S	File > Save
Command+Shift-S	File > Save As
Command+Option-S	File > Save As a Copy
FI2	File > Revert to last saved version
Command-W	File > Close
Esc or D	Activate Don't Save after File > Close (System command)
Esc or Command-Period (.)	Cancel or abort function (System command)

Contextual menus

More shortcuts are available just a mouse click away. On the Macintosh, hold down the Control key and mouse down in the image window or on a palette (Windows users should click with the right mouse button). Contextual menus are available when clicking in the Brushes, Layers, Channels or Paths palette or anywhere in the image window area. For example, click in the image area – Control click (Macintosh) or right mouse click (Windows) to access a list of menu options associated with the tool currently selected. The only exception is to be found in Photoshop 4.0 when the pen tool is being used, as this conflicts with specific pen path modifier functions.

Edit Menu	
Keyboard shortcut	Function
Command-C	Edit > Copy
F3	Edit > Copy
Command-V	Edit > Paste
F4	Edit > Paste
Command+Shift-V	Edit > Paste Into
Command-X	Edit > Cut
F2	Edit > Cut
Command-Z	Edit > Undo last operation
FI	Edit > Undo last operation
Command+Shift-C	Edit > Copy Merged
Option+Delete	Edit > Fill Foreground color
Command+Delete	Edit > Fill Background color
Option+Shift+Delete	Fill layer with Foreground color whilst preserving transparency
Command+Shift+Delete	Fill layer with Background color whilst preserving transparency
Shift+Delete	Open Edit > Fill dialog box
Command+Option+Delete	Fill from history
Command-T	Free Transform
Command+Shift-T	Repeat Transform
Command+Option-T	Free Transform with Duplication
Command+Option+Shift-T	Transform again with Duplication

Selections

Holding down the Shift key when drawing a marquee selection constrains the selection being drawn to a square or circle.

Holding down the Option/Alt key when drawing a marquee selection centers the selection around the point from where you first dragged.

Holding down the Shift+Option/Alt keys when drawing a marquee selection constrains the selection to a square or circle and centers the selection around the point where you first clicked.

If you hold down the Spacebar at any point, you can reposition the center of the selection. Release the Spacebar and continue to drag using any of the above combination of modifier keys to finish defining the selection.

After drawing a selection and releasing the mouse: hold down the Shift key to add to the selection with the lasso, marquee or magic wand tool.

Hold down the Option/Alt key to subtract from the existing selection with the lasso, marquee or magic wand tool.

Hold down the Shift+Option/Alt key to intersect with the existing selection using the lasso, marquee or magic wand tool.

Filters

If you can't run a filter, try filtering each color channel individually. Or, select half the image, filter, inverse the selection and filter again. These suggestions are only appropriate as a last resort and even then for certain filters only – some filter actions are affected by the boundary or extend beyond it, like Motion blur. If memory is running low, purge the clipboard memory or try quitting Photoshop and reloading.

Windows Options (PC only)

Choose Window > Cascade to display windows stacked one on top of the other going from top left to bottom right of the screen. Choose Window > Tile to display windows edge to edge.

Image Menu	
Keyboard shortcut	Function
Command-B	Image > Adjust > Color Balance
Command-I	Image > Adjust > Invert Image
Command-L	Image > Adjust > Levels
Command+Shift-L	Image > Adjust > Auto Levels
Command-M	Image > Adjust > Curves
Command-U	Image > Adjust > Hue/Saturation
Command+Shift-U	Image > Adjust > Desaturate
Option Image > Duplicate	Holding down the Option key whilst choosing Image > Duplicate bypasses the Duplicate dialog box
Command+Shift-F	Filter > Fade Image Adjustment

The Option/Alt key can be used in combination with any of the above image adjustment commands (just as you can with Filters) to open up the relevant dialog box with the last used settings in place. This is a generic Photoshop interface convention. The Fade command belongs to the Filter menu, but operates for the Image adjustment controls too. If you have a version of Photoshop later than the 4.01 upgrade, the Fade command works on brush strokes as well.

Select Menu		
Keyboard shortcut	Function	
Command-A	Select > Select All	
Command-D	Select > Select None	
Command+Shift-D	Select > Reselect	
Command+Option-D	Select > Feather	
Command+Shift-I	Select > Invert Selection	

Keyboard shortcutFunctionCommand+Shift-NLayer > New LayerCommand+Option+Shift - NLayer > New Layer (without dialog box)Command-ELayer > Merge DownCommand+Option-EClone layer contents to the layer directly belowCommand-GLayer > Group With Previous LayerCommand+Shift-GLayer > UngroupCommand-Layer > New > Layer Via Copy (float to new layer)Command+Shift-JLayer > New > Layer Via CutCommand+Shift-ELayer > Merge VisibleCommand+Shift+]Arrange > Bring to frontCommand+JArrange > Bring forwardCommand+Shift+[Arrange > Send to back	Layer Menu	
Command+Option+Shift - N Layer > New Layer (without dialog box) Layer > Merge Down Command+Option-E Clone layer contents to the layer directly below Command-G Layer > Group With Previous Layer Command+Shift-G Layer > Ungroup Command- Layer > New > Layer Via Copy (float to new layer) Command+Shift-J Layer > New > Layer Via Cut Layer > Merge Visible Command+Shift-E Command+Shift-I Arrange > Bring to front Command+] Arrange > Bring forward	Keyboard shortcut	Function
Command-E Layer > Merge Down Command+Option-E Clone layer contents to the layer directly below Layer > Group With Previous Layer Command+Shift-G Layer > Ungroup Layer > New > Layer Via Copy (float to new layer) Command+Shift-J Layer > New > Layer Via Cut Layer > Merge Visible Command+Shift-E Command+Shift-I Arrange > Bring to front Command+] Arrange > Bring forward	Command+Shift-N	Layer > New Layer
Command+Option-E Clone layer contents to the layer directly below Layer > Group With Previous Layer Command+Shift-G Layer > Ungroup Layer > New > Layer Via Copy (float to new layer) Command+Shift-J Layer > New > Layer Via Cut Layer > Merge Visible Command+Shift-E Command+Shift-J Arrange > Bring to front Command+] Arrange > Bring forward	Command+Option+Shift - N	Layer > New Layer (without dialog box)
Command-G Layer > Group With Previous Layer Command+Shift-G Layer > Ungroup Layer > New > Layer Via Copy (float to new layer) Command+Shift-J Layer > New > Layer Via Cut Layer > Merge Visible Command+Shift-E Command+Shift-J Arrange > Bring to front Command+] Arrange > Bring forward	Command-E	Layer > Merge Down
Command+Shift-G Layer > Ungroup Layer > New > Layer Via Copy (float to new layer) Command+Shift-J Layer > New > Layer Via Cut Layer > Merge Visible Command+Shift-E Arrange > Bring to front Command+] Arrange > Bring forward	Command+Option-E	Clone layer contents to the layer directly below
Command- Layer > New > Layer Via Copy (float to new layer) Layer > New > Layer Via Cut Layer > Merge Visible Command+Shift-E Arrange > Bring to front Command+] Arrange > Bring forward	Command-G	Layer > Group With Previous Layer
Command+Shift-J Layer > New > Layer Via Cut Layer > Merge Visible Command+Shift+] Arrange > Bring to front Command+] Arrange > Bring forward	Command+Shift-G	Layer > Ungroup
Command+Shift-E Layer > Merge Visible Command+Shift+] Arrange > Bring to front Command+] Arrange > Bring forward	Command-	Layer > New > Layer Via Copy (float to new layer)
Command+Shift+] Arrange > Bring to front Command+] Arrange > Bring forward	Command+Shift-J	Layer > New > Layer Via Cut
Command+] Arrange > Bring forward	Command+Shift-E	Layer > Merge Visible
에 선생님들이 있다. 그는 사람이 되었다고 있는 것이 되었다. 그는 사람이 되었습니다. 그는 사람 그리고 한 사람들이 살았습니다. 그는 사람들이 있는 사람들이 보면 보고 있습니다. 그는 사람들이 되었습니다.	Command+Shift+]	Arrange > Bring to front
Command+Shift+[Arrange > Send to back	Command+]	Arrange > Bring forward
	Command+Shift+[Arrange > Send to back
Command+[Arrange > Send backward	Command+[Arrange > Send backward

Filter Menu	
Keyboard shortcut	Function
Command-F	Filter > Apply last filter used (with same settings)
Command+Shift-F	Filter > Fade filter
Command+Option-F	Open dialog with last used filter settings

Moving and cloning selections

To move the border outline only, place the cursor inside the selection border and drag. To move the selection contents, the move tool must be selected. The Command/Ctrl key shortcut saves you from having to select the Move Tool each time – just hold down the Command/Ctrl key and drag inside the selection. To clone a selection, hold down the Option/Alt key+Command/Ctrl key and drag.

View Menu	
Keyboard shortcut	Function
Command-H	View > Show/Hide Edges (selections)
Command+Shift-H	View > Hide Path
Command-R	View > Show/Hide Rulers
Command-Y	View > CMYK Preview
Shift+Command-Y	View > Gamut Warning
Command-;	View > Show/Hide Guides
Command+Shift-;	View > Snap To Guides (toggle)
Command+Option-;	View > Lock Guides
Double click guide with move tool	Edit Guides & Grid settings: color and increments
Command-"	View > Show/Hide Grid
Command+Shift-"	View > Snap To Grid (toggle)
Command-plus	View > Zoom in with window resizing
Command+Option-plus	View > Zoom in without resizing window size
Command-minus	View > Zoom out with window resizing
Command+Option-minus	View > Zoom out without resizing window size
Command-0	View > Fit To Screen
Double click hand tool	View > Fit To Screen
Option+Command-0	View > Actual Pixels at 100%
Double-click zoom tool	View > Actual Pixels at 100%

Navigator, Info and Options Palette

Double click any toolbox tool icon to display tool options or use the associated key-board shortcut and press Enter to open the Options palette. Click on the eyedropper or crosshair icons in the Info palette to display a menu of color mode/measurement options. Double click ruler margins to open unit measurement Preferences.

Window Menu	
Keyboard shortcut	Function
Tab key	Hide/show palettes and toolbox
Shift+Tab key	Hide/show all palettes except toolbox
F5	Hide/show Brushes palette
F6	Hide/show Color palette
F7	Hide/show Layers palette
F8	Hide/show Info palette
F9	Hide/show Actions palette

Keyboard numbers set Tool opacity whilst any paint or fill tool is selected (1 = 10%, 9 = 90%, 0 = 100%). For more precise settings, enter on the keyboard any double number values in quick succession (i.e. 04, 23, 75 etc.). Use the up arrow to increase values in the box by 1% and use the down arrow to decrease values in box by 1%. The Navigator palette provides one of the swiftest ways of scrolling across the image. The bottom left box indicates the current viewing percentage scale. As with the identical box in the window display, any value can be entered between 0.19% and 1600.00%. To zoom to a specified percentage and keep the box highlighted, hold down the Shift key whilst pressing Enter. Use the slider control to zoom in and out or mouse down on the left button to zoom out incrementally and the right button to zoom in.

The dialog palette preview display indicates by a red rectangle which portion of the image is visible in relation to the whole – the rectangle border color can be altered by going to the palette options. To scroll quickly, drag the rectangle across the Navigator palette screen. Hold down the Command/Ctrl key and marquee within the thumbnail area to specify an area to zoom to. The Navigator palette can also be resized to make the preview window larger.

Working with Actions

The introduction of Actions in version 4.0 replaced the old Commands palette. In Button mode, Actions can be made to display very much like the old Commands – it is in effect a super Commands palette. Except the major difference is that whereas Commands performed single keystroke macros, Actions can be configured to define a string of Photoshop Commands and process not just a single file but batches of

images. The Batch... command has been transferred to the File menu in 5.0 under File > Automate. There is an example shown later of a batch action set up to convert RGB files to CMYK from one folder to another. There is unfortunately not enough room to go into too much detail over Actions, except to say there are now fewer limitations on what can be done compared with version 4.0. Batch opening of Photo CDs is possible and many more Photoshop steps including use of the Paths and History palettes, Lighting Effects, most of the Photoshop tools in fact almost everything is 'Actions savvy'. The tool actions are recorded based on the currently set ruler unit coordinates. Where relative positioning is required, choose from the new percent measuring option. Where a particular command cannot be recorded for some reason, or you may wish to alter the input settings to suit each individual image, a break can be included plus a little memo to yourself. This will remind you what needs to be done. Best of all, with Actions you *can* be productive whilst reading the paper at the same time.

Playing an Action

A number of prerecorded Actions were included when you installed Photoshop 5.0. To test them out, have an image open, select an Action from the menu and press the Play button. Like a pianola, Photoshop automatically snaps into action, running through the recorded sequence of commands. What you must remember is that with complex Actions there is no way of completely undoing all the commands at the end of an Action, if the number of steps in the Action exceed the number of available histories. As a precaution, either take a Snapshot in the History palette or save before executing an action and if not happy with the result, fill with the Snapshot or revert to the last saved version.

Recording Actions

In essence, it is as easy as clicking the Record button and proceeding with a few Photoshop commands on a dummy image. When finished, click the Stop button. The thing to watch out for is: using commands which as yet are not recognized in Actions. This is less of a problem now, as Photoshop 5.0 features improved scriptability which was missing in 4.0. Layer, Paths and History palette operations are now available as are Apply Image and many of the tools. If you want to include tools in an action and for this Action to be scalable on another image, first set the ruler measurements to 'Percent'. The other thing to watch out for is commands that rely on the use of named layers or channels (which exist in your dummy file, but will not be recognized when the Action is applied to another). If recording a complex Action, the

Navigation	
Keyboard shortcut	Function
Page up	Scroll up by one screen
Page down	Scroll down by one screen
Shift+Page up	Scroll up in smaller steps
Shift+Page down	Scroll down in smaller steps
Shift+Page up/Page down	Scroll up or down a single frame of a Filmstrip file
Command+Page up	Scroll left one screen
Command+Page down	Scroll right one screen
Command+Shift+Page up	Scroll left one screen in smaller steps
Command+Shift+Page down	Scroll right one screen in smaller steps
Home key	Display top left corner of image
End key	Display bottom right corner of image

answer is to plan your sequence carefully (though an Action can be edited and I will come on to this shortly). The following example demonstrates how to record a basic Action.

Troubleshooting Actions

Check you are operating in RGB mode. Most Actions are written to operate in this color mode only. Color adjustment commands will not work properly if the starting image is in Grayscale or Indexed Color. Some pre-written Actions require the image you start with to fit certain criteria. For instance, text effect Actions may require you begin with an image containing text on a separate layer. If it is an Action you have just recorded which is causing the problem, you can inspect it command by command. Open a test image and expand the Action to display all the items. Hold down the Command/Ctrl key and click on the Play button. This will play the first command only. If there is a problem, double click the command item in the list to rerecord it. Hold down the Command/Ctrl key again and click on the Play button to play the next command item. If now you want to replace this item completely, press Record and perform a new step, click Stop. Delete the old command, leaving the new one in its place.

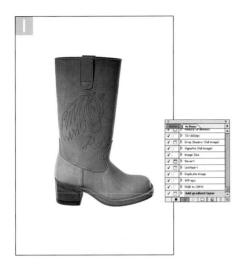

2 This Action is designed to instruct Photoshop to add an extra layer fill with a color (any will do, we just need to fill it with pixels in order for the following step to work) and apply a custom gradient fill. As was mentioned before, layer palette commands will not record, so always use the Layer menu when recording an Action which includes layering steps.

4 When the recording is complete, hit the Stop button in the Actions palette. Expand the Action items to inspect the recording. Just before the Filter step, I inserted a 'Stop' with a message reminding me that the next step requires me to select a KPT gradient. The Stop allows the Action to continue playing after pressing Enter.

Photograph: Davis Cairns. Client: Red or Dead Ltd.

I The normal procedure when recording an Action is to start with a dummy image, record all your steps and then test the action to make sure it is running correctly. The Action can easily be edited later where there are gaps or extra steps that need to be included.

3 In this Action, a new layer is created and filled with a KPT Gradient. The Action requires that a mask channel is present in the starting image to be loaded as a layer mask to reveal the object on the background layer.

Automation plug-ins

This, another new feature to Photoshop 5.0, will enable third party developers to build plug-ins for Photoshop which will be able to perform complex Photoshop operations and can also provide more feedback information for the user. This will be of special interest to everyone, including those who only use Photoshop occasionally and wish to carry out skilled tasks like resizing an image without constantly having to refer to the manual. They can operate like 'wizards'. An on-screen interface will lead you through the various steps or else provide a one step process which can save you time or be built into a recorded Action.

Batch processing

One of the great advantages of Actions is the ability to record one Action and then apply it to a batch of files. Batch actions are now set via the Automate menu and one can record an Action for opening a Photo Image and then instruct Photoshop to open all the remaining images on the disc and save then to a folder on the desktop. The Batch processing and next few Auotmation plug-ins are all accessed from the File > Automate menu.

Figure 13.1 An example of a Batch Action dialog and accompanying Action. Choose File > Automate > Batch. This opens up the dialog. Select the Action to apply from the pop-up menu. Next choose the source folder containing the images to process, followed by the destination folder where the processed files are to be saved to. If you include an Open command in the recorded Action, then don't override this command, though you will want to override the save file operation as the recorded command may be to a different named destination to the one selected.

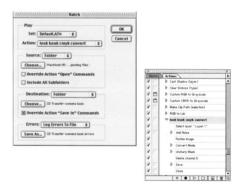

Conditional Mode Change...

This is a good example of how an Automation plug-in can accomplish sometimes a two step process, quickly in a single stage. You select the mode the active file is in (or choose to check all modes.

Contact Sheet...

Choose a source folder and all the images will be opened up and assembled to form a single document contact sheet file. The Contact Sheet layout and save destination are specified in the opening dialog box.

Fit Image...

A very simple utility which bypasses the Image > Image Size menu item. Well suited for screen design work. Enter the pixel dimensions you want the image to fit to by specifying the maximum pixel height or width.

Multi-Page PDF to PSD...

You can open multiple pages of a PDF document as individual Photoshop image files. The opening dialog offers a choice of source file, which pages you want to select, what resolution to open to and the location of the folder to save to.

Export Transparent Image and Resize Image

These last two Automation plug-ins are located in the Help menu. They are very nicely designed and illustrate just what we might come to expect in the future. The Export Transparent Image interface starts by asking you whether the purpose of the final image is for print or on-line use. For example, if you want to make a transparent GIF and there is no selection currently active, it will tell you to cancel and make a selection first. From there on it will duplicate the current image and ask clearly put ques-

Figure 13.2 Two dialog boxes from Actions plug-ins found in the Help menu. On the left: the Export Transparent Image, which is asking if the image is already on a transparent background or a selection is currently active. On the right: Resize Image where the user can select the ratio of image resolution to screen resolution selected, plus a warning that the image may need to be re-scanned if this size is selected.

tions about the intended final output and guide you towards that desired goal. The Resize Image Automation plug-in also has a clearly designed interface and takes the user step by step through the process of sizing an image for reprographic or on-line use (see Figure 13.2).

Brushes	Palette shortcuts
Keyboard shortcut	Function
F5	Display/Hide Brushes palette
Bracket: [Select brush one size smaller
Bracket:]	Select brush one size larger
Shift+[Select first brush in palette
Shift+]	Select last brush in palette
Command+Shift-F	Filter > Fade last brush stroke (4.01 or later only)
Double click brush	Edit brush
Click in empty palette slot	Create a new brush
Command click on brush	Delete brush from palette
Caps lock	Display crosshair cursor
Shift key	Having started using the brush, then pressing and holding the shift key will use this brush in a straight line to the next click

Swatches	Palette shortcuts	
Keyboard shortcut	Function	
Click on swatch	Choose swatch as Foreground color	
Option click on swatch	Choose swatch as Background color	
Click in empty slot	Add the Foreground color as a swatch	
Shift click swatch colour	Replace Foreground color as a swatch	
Command click on swatch	Remove swatch from palette	
Shift+Option click in palette	Insert Foreground color as a swatch	

Color	Palette shortcuts
Keyboard shortcut	Function
F6	Display/Hide Color palette
Command click Color bar	Toggle between different color spectrums
Shift click Color bar	Cycle between all the options
Control click Color bar	Specify Color bar to use

History	Palette shortcuts
Keyboard shortcut	Function
Command-Z	Toggle moving back and forward one step (undo/redo)
Command+Option-Z	Move one step back through History
Command+Shift-Z	Move one step forward through History
Click New Snapshot button	Create a new Snapshot
Click New Document button	Create a new document from current image state
Option click on History state	Duplicate any <i>previous</i> history state

Layers and Channels

How did we ever manage without layers? The temptation is to get completely carried away and before you know it there are umpteen of them and your computer will really feel the strain. Extra layers and channels add to the file size and RAM memory requirements. Get rid of unwanted mask channels as you work and consider converting some mask channels to paths, then deleting the channel mask. Paths occupy only a few kilobytes of disk space.

Adjustment layers may only occupy a few kilobytes of file space, but whilst open do put a strain on the screen redraw speed. To create a new adjustment layer: hold down the Command/Ctrl key as you click the New Layer button in the Layers palette. If you have three or four adjustment layers active every refresh and scroll action will be accompanied by a fresh calculation of the pixel value taking into account the cumulative settings in each of these layers. There are two things that can be done to remedy this – either temporarily switch off the eye icons on these layers or merge them, fixing the image.

Layers	Palette shortcuts
Keyboard shortcut	Function
F7	Display/Hide Layers palette
Click New Layer button	Create new empty layer
Option click New Layer button	Create new empty layer, showing Layer Options dialog
Option click New Layer button	Open New Layer dialog box before making new layer
Command click New Layer button	Make a new adjustment layer
Drag layer to New Layer button	Duplicate layer
Click palette Delete button	Delete selected layer (or drag layer to delete icon)
Option click palette Delete button	Delete selected layer (bypassing alert warning)
Option+[Select next layer down
Option+]	Select next layer up
Shift+Option+[Select bottom layer
Shift+Option+]	Select top layer
Double click Layer name	Open Layer Options dialog box
Double click adjustment layer name	Edit adjustment layer options
Double click Layer Effect icon	Edit Layer Effect options
Option+double click Layer Effect icon	Clear each Layer Effect in sequence
Double click Type icon	Edit Type options
Keyboard numbers	Set layer opacity whilst a non-painting tool is selected
(1=10%, 9=90%, 0=100%)	(Enter any double number values in quick succession)
Up arrow	Increase value setting in box by 1%
Down arrow	Decrease value setting in box by 1%
Click in Link icon area	Link/Unlink a layer to currently selected layer
Click Layer Eye icon	Show or hide layer
Option click Layer Eye icon	View layer on its own/View all layers (toggle)

Layers	Palette shortcuts continued
Keyboard shortcut	Function
Option click Layer mask thumbnail	View Layer mask as a mask on its own
Command click layer thumbnail	Load Layer transparency as a selection
Command+Shift-click Layer thumbnail	Add Layer transparency to selection
Command+Option click Layer thumbnail	Subtract Layer transparency from selection
Command+Option+Shift click Layer thumbnail	Intersect Layer transparency with selection
Click Mask button	Create Layer mask with reveal all/reveal selection
Option click Mask button	Create Layer mask with hide all/hide selection
Command click Layer mask icon	Load Layer mask as a selection
Click Lock Layer Mask thumbnail	Lock/unlock Layer and Layer mask
Shift click Layer Mask thumbnail	Disable/enable Layer mask
Shift+Option click Layer Mask thumbnail	View Layer mask as an alpha channel (rubylith)
	Switch on/switch off Preserve Transparency
Option click Layer icon	Hide all Layers except that one (toggle)
Option+Merge Visible	Merge visible Layers to selected Layer
Option+Merge Down	Merge down and leave a copy of the selected Layer
Option+Merge Linked	Merge a copy of linked Layers into layer below
Option click line between Layers	Toggle Group with Previous Layer/Ungroup
Return	Commits edit in pop-up slider in mouse up mode
Escape	Exits out of slider edit in mouse up mode

Channels	Palette shortcuts
Keyboard shortcut	Function
Command click channel	Load channel as a selection
Command+Shift click channel	Add channel to current selection
Command+Option click channel	Subtract channel from current selection
Command+Option+Shift click channel	Intersect channel with current selection
Shift click channel	Activate and add to selected channels
Command-I	Activate channel-I, e.g. red or cyan channel and so on
Command- ~	Activate composite channel, e.g. RGB or CMYK
Option+Command-I	Load channel I as a selection and so on to channel 9
Click New channel button	Create a new channel
Option click New channel button	Create a new channel whilst opening the Options dialog
Command click New channel button	Create a new Spot color channel
Click on Save Selection button	Create a new channel from current selection
Option click on Save Selection button	Create a new channel from current selection with channel options dialog
Click Load Selection button	Load active channel as a selection
Shift click Load Selection button	Add selected channel to current selection
Option click Load Selection button	Subtract selected channel from current selection
Option+Shift click Load Selection button	Intersect selected channel with current selection
Click Delete button	Delete selected channel (or drag channel to wastebasket)
Option click Delete button	Delete selected channel (without alert warning)

Paths	Palette shortcuts
Keyboard shortcut	Function
Click New Path Button	Create a new path
Option click New Path Button	Create a new path showing New Path dialog
Drag path to New Path button	Duplicate path
Click Delete Path button	Delete path
Option click Delete Path button	Delete path, bypassing the alert warning
Double click Path name	Edit path name
Click Make Work Path button	Convert a selection to make a Work Path
Option click Make Work Path button	Convert a selection to make a Work Path via Work Path dialog (choose pixel tolerance setting)
Double-click Work Path icon	Convert Work Path in palette to a new path
Drag Work path to New Path button	Convert Work Path in palette to a new path
Command click Path thumbnail	Load path as a selection
Click Load Selection button	Convert active closed path to a selection
Option click Load Selection button	Convert active closed path to a selection via Make Selection dialog
Enter key (selection or path tool active)	Convert active closed path to a selection
Click Stroke Path button	Stroke perimeter of path with Foreground color
Option-click Stroke Path button	Stroke perimeter of path via the Stroke Path dialog
Enter key (paint or edit tool active)	Stroke perimeter of path with Foreground color
Click Fill path button	Fill path with Foreground color
Option click Fill Path button	Fill path via Fill Path dialog
Click empty Paths palette area	Deactivate path

With layers, it is a combination of calculating the image redraws and the extra image size which slows down Photoshop. Merging layers helps but the order of the layers in a stack and their respective blending modes are crucial to the final effect. If you have several layers, each applied with a different blending mode, only flattening the image entirely will achieve the same effect as when they are in separate layers. Merging down one layer whilst keeping one or more of the others separate will alter the look of the image.

Blending modes	
Keyboard shortcut	Function
Shift-plus	Set layer to next blend mode in list
Shift-minus	Set layer to previous blend mode in list
Option+Shift-N	Normal mode
Option+Shift-I	Dissolve mode
Option+Shift-M	Multiply mode
Option+Shift-S	Screen mode
Option+Shift-O	Overlay mode
Option+Shift-F	Soft Light mode
Option+Shift-H	Hard Light mode
Option+Shift-D	Color Dodge mode
Option+Shift-B	Color Burn mode
Option+Shift-K	Darken mode
Option+Shift-G	Lighten mode
Option+Shift-E	Difference mode
Option+Shift-X	Exclusion mode
Option+Shift-U	Hue mode
Option+Shift-T	Saturation mode
Option+Shift-C	Color mode
Option+Shift-Y	Luminosity mode

Pen tool	
Keyboard shortcut with pen tool selected	Function
Command key	Direct selection tool (whilst key is held down)
Option key	Convert direction tool (whilst key is held down)
Click on anchor point/path	Remove/add anchor point (toggle)
Shift key	Constrains the path drawing horizontally, vertically and at 45 degrees
Command click Path	Activate all control points without selecting them
Command+Shift click	Select multiple path points
Command+Option click path in image	Select entire path or uppermost subpath
Command+Option+Shift drag path	Clone selected path (Shift key constrains movement to 45 degree increments, let go after first dragging)

General	
Keyboard shortcut	Function
Command-Period (.)	Cancel or abort operation
Esc	Cancel operation (Crop/Transform/Save)
Delete key	Remove selected area to reveal transparency (on layer)
	or background color (on background layer)
Option key	When a painting tool is active, use the Option key to sample in window area to make Foreground color
Tab key	Toggle show/hide palettes (see Window menu)
Tab key	Jump to next setting in any active dialog box
Option click Cancel button	Change Cancel button in dialog boxes to Reset

Without the resources of unlimited processing power and RAM memory, there is no alternative but to periodically merge layers before introducing new ones. Save different versions of the file with open layers as you progress, before merging and moving to the next stage.

Chapter Fourteen

Black and White Effects

f particular interest to photographers, are those methods of duplicating B/W darkroom techniques with the computer. The main problem with digital B/W work is getting a good quality scan from a B/W negative or print. At the beginning of the book in Chapter One, I said that digital capture from a B/W original is a real test of scanner quality. Scanning in a color image records a different range of grayscale tones in each of the three color (RGB) channels. When you change from RGB to Grayscale Mode in Photoshop, the tonal values of these three channels are averaged out, usually producing a smooth continuous tone grayscale. If the original scanned image is monochromatic, there is little or no deviation between the color channels and the averaging out process emphasizes the deficiencies contained in the weaker channels.

An 8-bit grayscale image has a maximum of 256 brightness levels. A decent gray-scale image will look all right on the monitor and may even look good in print (the B/W images in this book are all 8-bit grayscale Tiffs). The practical consequence of using 8-bit grayscale files is that as many as a third of the tonal shades will get lost during the reproduction process. The fine quality B/W printing you see in some magazines and books is achieved through using a duotone or conventional CMYK printing process. Adding just a second printing plate dramatically increases the range of tones printable on the page.

Duotone mode

You need to start with an image in Grayscale Mode first before converting to a duotone: Image > Mode > Duotone. A duotone is made using two printing plates, a tritone has three and a quadtone, four. The Ink Color boxes display a Photoshop preview of the ink color with the name of the color (i.e. process color name) appearing in the box to the right. The graph icon to the left is the transfer function box. In here you specify the proportions of ink used to print at the different brightness levels of the grayscale image. Double click the graph icon and transfer function box opens, change the shape of the curve to represent the proportion of ink used to print in the highlights/midtones/shadows. Normally the inks are ordered with the darkest at the top and the lightest inks at the bottom of the list. There are a number of duotone presets (plus tritones and quadtones) to be found in the Photoshop Goodies folder. Experiment with these by clicking the Load... button in the Duotone dialog box and locating the different preset settings.

Printing duotones

To prepare an image for placing in either PageMaker or Quark, the only file formats (other than Photoshop) to support duotone are EPS and DCS. Remember though that if the ink colors used in the duotone are custom colors, these need to be specified to the printer and will add to the cost of making the separations if CMYK inks are already being used in the publication. Duotones which are converted to Multichannel mode are converted as spot color channels. Alternatively you can take a duotone image and convert it to CMYK mode in Photoshop.

'So,' I hear you say, 'in that case why not use the CMYK mode instead of duotone, what difference will an extra plate make between a tritone and CMYK?' Well, a designer's job is to make the best use of his or her skills within the allocated budget. It is common for a color print job to include extra plates beyond the four employed in CMYK. Yes, you can construct many flat colors using a mix of these four inks, but designers have to be wary of misregistration problems. It is all right to specify large headline text in a process color, but not smaller body text. For this reason, designers specify one or more process colors for the accurate printing of colors other than black or a pure C, M or Y (which is unlikely). A typical custom brochure print job with full color images might require a total of 6 color plates, whereas a brochure featuring black plus one or two process colors requires fewer printing plates to make sumptuous duotones or tritones. You find designers working within the limitations of black plus two custom inks are still able to pull off some remarkable illusions of full color printing. If you are interested, the TAGS web site http://www.sni.net/ ~tptags/> contains an interesting article by Tim Piazza showing just how this is done.

Duotone: 506 burgundy (75%) bl 3

Tritone: BMC blue 2 (Process)

Normal – Grayscale Mode

Tritone: bl 313 aqua 127 gold (Pantone)

Quadtone: bl 541 513 5773 (Pantone)

Quadtone: Custom (Process)

Quadtone: Extra Warm (Process)

Figure 14.1 Examples of preset duotones (see Goodies folder) applied to a Grayscale image. Process color duotones are formed using the standard CMYK process inks. Pantone (or any custom process color ink) duotones can be made from specified color inks other than these process colors.

2 With the Preview switched on, any changes you make to the duotone settings will be immediately reflected in the on-screen image appearance. In this example a custom color tritone was selected – the darkest color is at the top and at present the middle orange graph icon double clicked and the transform curve is being modified. The transform curve is similar to the image adjustment curves, except a little more restrictive in setting the points. You specify the ink percentage variance at set points along the horizontal axis. The color ramp in the duotone dialog reflects the tonal transformation across an evenly stepped grayscale ramp.

I To preview a grayscale image on screen for printing, go first to the Grayscale setup option image and choose to preview Black Ink in the Color settings. The Dot Gain settings entered in the Separation Setup will affect the darkness of the grayscale image appearance on screen. Any conversion made to Grayscale mode will take the current dot gain settings (see CMYK setup) into account. If you do not require to preview how a monochrome, grayscale image will print, then leave the Grayscale Setup checked against RGB.

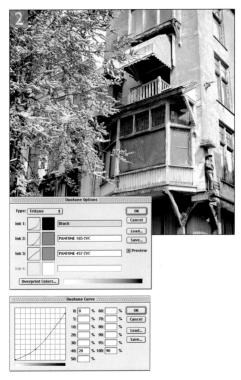

Full color toning

The lack of an image preview before was a serious handicap. Duotones now do feature a preview and this opens up many possibilities for the creative use of working in duotone mode to simulate all types of print toning effects. I now use Duotone mode much more and will maybe afterwards convert the image to either RGB or CMYK color. The alternative is to start with the image in a color mode and desaturate or convert a grayscale image to a color mode and use some of the other techniques demonstrated here which also simulate traditional darkroom toning techniques. The simplest method of toning an image is to use the Color Balance adjustment.

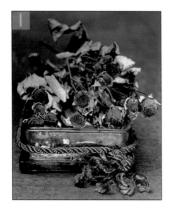

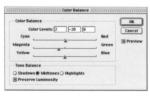

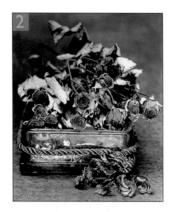

I Start with a grayscale image or convert an RGB image to Grayscale mode (Image > Adjust > Desaturate, or convert to Lab mode and copy the Lightness channel) and choose Image > Adjust > Color Balance. Click on 'Shadows' and move the sliders to change the shadow tone color balance.

2 Repeat the same thing with the Midtones and Highlights. Return to the Shadows and readjust if necessary. Instead of using the Image > Adjust route, create an adjustment layer. This way you can return again to alter the color settings.

3 The Fade Filter Command (Filter > Fade Filter) works on Image toning adjustments too. The Desaturate command and all other image adjustments can be faded out. Fading the Desaturate adjustment is identical to reducing the Saturation in the Hue/Saturation dialog box.

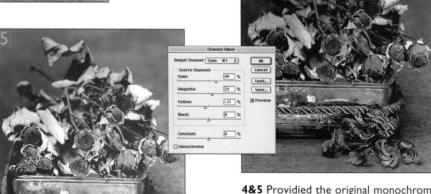

4&5 Providied the original monochrome image is in RGB or CMYK color mode, the Channel Mixer is an effective tool for coloring an image. For more instructions on Channel Mixer use, see the latter part of this chapter and cross processing techniques in Chapter Fifteen.

Split toning

A split tone, for those who have not come across this printing method, is a B/W image that has only been partly toned or a mix of toning effects are applied. For example, the print is placed in a bleach bath to remove all the silver image, then thoroughly washed and placed in a bath of toner solution, which replaces the bleached silver with the sepia or other dye image. If the print is only partially bleached, you get an interesting split tone effect in the transition between the base and toned colors. The following steps demonstrate the use of Layer Options in conjunction with adjustment layers.

I A color image in RGB mode is first desaturated (Image > Adjust > Desaturate).

4 Layer Options are reached via the Layers menu or Layers palette sub-menu. Hold down the Option/Alt key and drag one half of the shadow triangle slider as shown here. Note the wide spacing of the slider halves which gives the gentle tonal transition shown here.

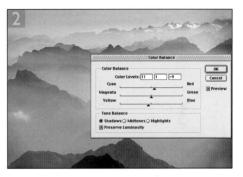

- **2** Tone the desaturated image using the Color Balance Image adjustment. This sets the base color. Click on the Midtone and Shadow buttons and move the sliders to suit.
- **3** Make an Adjustment layer. Command/Ctrl click the New Layer button in the Layers palette. This opens the adjustment layer dialog box choose Color Balance again. Now click on the Midtone and Highlight buttons to set the highlight color.

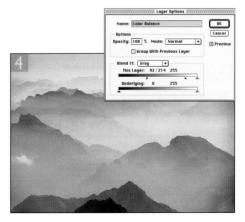

Solarization

Some people dismiss the Photoshop Solarize filter as being too basic and of limited use. I am inclined to agree. It is better to generate your own custom solarizations using the Adjust Curves command from the Image menu. The original photographic technique is associated with the artist Man Ray and is achieved by briefly fogging the print paper towards the end of its development. Working in the darkroom, you can get nice effects by selectively solarizing the print image: place the partially developed print under a white light source, dodging the print during second exposure. Needless to say, this is a very hit and miss business. The digital method provides more control, because you can precisely select the level of solarization and the areas of the image to be affected.

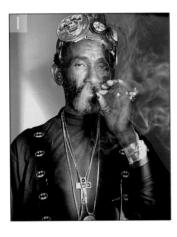

I Start with an image in Grayscale Mode. Go to the Layers palette and make a Curves adjustment layer (you will want to apply solarization on this layer and later remove parts of it to reveal the unaffected background layer).

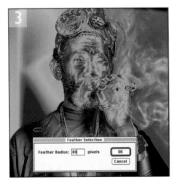

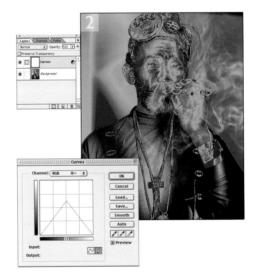

- 2 Select the arbitrary map tool and draw an inverted V. The easiest way to do this is to draw by Shift clicking which will create straight lines, or use the point curve tool to draw a series of wavy curves.
- 3 Add a mask to the adjustment layer. Activate the layer and start defining the areas of this layer you wish to erase using the lasso tool. Apply a heavy feathering to the selection: Select > Feather and enter a high value. I used 80 pixels, but you could use more or less.

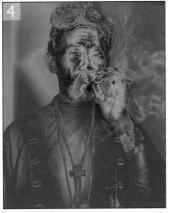

- **5** Switch back to Selection mode and fill the adjustment layer mask with black. In Layer Mask mode, the default Foreground/Background colors are black and white: choose Edit > Fill > Foreground Color. Deselect the selection, choose a large brush set to a low opacity and paint in or paint out the unsolarized background layer.
- **6** Finally, I merged the layers, converted the image to RGB color mode and toned the picture using the previously described split tone technique.

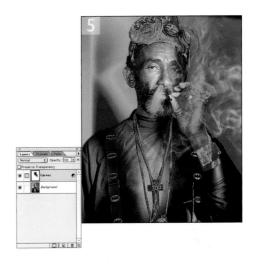

Black and white from color

A black and white image can be obtained from a color original (in CMYK or RGB mode, for example) and converted to Grayscale mode easily enough. In fact as was explained much earlier, this may be a better way of obtaining Grayscale scans from mid range scanning equipment or Photo CD scans. The distinction between shooting black and white or color is lost on many of the clients I have worked with. How you light and color compose a shot is determined by whether it is intended for color or monochrome. Ideally you would want to shoot one or the other using the most suitable medium for the capture and if that medium is a black and white negative, I recommend nothing less than a high quality professional scan for the job.

1&2 The conversion from RGB to Grayscale mode yields a rather flat monochrome interpretation. The original contains vibrant color contrast, but this is lost without adding tonal contrast to one or more of the color channels.

3 The Channel Mixer comes to the rescue and offers a simple, easy form of image adjustment which simulates the effect of photographing through colored lens filters. Choose Image > Adjust > Channel Mixer and check the Monochrome box at the bottom of the dialog. This coverts the colored image preview to monochrome, whilst retaining the color channel information. As you adjust the channel sliders, you mix the balance of the color channel content used to define the monochrome version of the image. So in this case a balance of the red and green channels only is used to output a grayscale image. Ideally the percentage values of the three RGB channels should equal 100%, although you can modify the matrix by adjusting the Constant slider. There are no hard and fast rules here, use whichever looks best.

If on the other hand you want to convert from a color file, you do have the latitude of being able to make creative decisions at the pre-press stage which will simulate the effect of filtering the lens at the time of shooting on black and white film. A straightforward conversion from RGB to Grayscale mode translates all the color data evenly to monochrome. This is what a panchromatic black and white film does or should be doing rather, because there are slight variations in the evenness of emulsion sensitivity to the visual and nonvisual color spectrum. It can be argued that these variations give films their own unique, special character. You are also probably familiar with the concept of attaching strong colored filters over the lens to bring out improved tonal contrast in a monochrome image. The same principles apply to converting from color to black and white in Photoshop.

The two examples shown here, again demonstrate uses of the Channel Mixer, which is a Color adjustment tool that is new to Photoshop 5.0. It is a perfect means for filtering a colour scan to produce a monochrome image. The following chapter also shows you how to use the Channel mixer to achieve colouring effects.

- I Another example of the Channel Mixer in action. This is a more familiar example where you would know to choose a red lens filter to strengthen the cloud contrast in the sky.
- **2** The standard conversion to grayscale mixes each color channel with equal prominence and the resulting monochrome image has an acceptable amount of tonal contrast.
- **3** Now compare what happens when we mimic the effect of a red filter over the camera lens. The red channel is being blended with a small amount of the green and the cloud contrast is now quite strong.

Chapter Fifteen

Coloring Effects

t a recent exhibition of digital photography, a visitor was heard to remark: 'It's all cheating isn't it?' A fair comment I suppose, though one should realise that photographers and printers were manipulating their images (or cheating) in darkrooms long before computers came along. The quest for new photographic styles has always inspired image makers to seek out and develop fresh techniques like processing films in the wrong chemistry.

It's all a matter of using any means at your disposal to achieve your ends, which is why computer manipulation should be seen as just another aspect of the image making process. The following techniques begin by emulating the results achieved with chemicals, but as will be seen, there is ample room for exploration to go further and create many types of color shifted results. Use the basic formula as a springboard for new ideas and variations beyond the scope of a wet darkroom.

There are two types of cross-processing, both of which gained popularity towards the late eighties. There was the E-6 transparency film processed in C-41 color negative chemicals technique and C-41 film processed in E-6. For the latter effect, you used Kodak VHC film, overexposed by 2 stops and overprocessed by 1 stop. The highlights became compressed in the yellow and magenta layers, so pure whites appeared pinky orange and shadow tones contained a strong cyan/blue cast. Most of the midtone to highlight detail (like skin tones) got compressed or lost. It was a very popular technique with fashion and portrait photographers who were fond of bleaching out skin tones anyway. In actual fact, Kodak designed this emulsion specifically for wedding photographers. This was in order to cope with the high contrast subject

tones of black morning suits and white bridal gowns. The sales of VHC rocketed. Kodak must have assumed the new demand was coming from their traditional wedding market base, so set about improving the VHC emulsion after which VHC did not cross-process so effectively unfortunately.

From a technical standpoint, the manipulation of silver images in this unnatural way is destructive. I have had to scan in cross-processed originals and typically there are large missing chunks of data on the histogram. The digital method of manipulating images to these extremes carries its own risks too. It is all too easy to distort the color in such a way that image data slips off the end of the scale and is irrevocably lost. Having said that, the digital method has the benefit that you can be working on a copy file and so therefore the original data is never completely thrown away. Second, you are in precise control of which data is to be discarded, taking the element of gambling out of the equation.

Photoshop is especially able to handle wild distortions with ease thanks to extended 16-bit channel support, improved color adjustments, not to mention the excellent new Channel Mixer. Support for 16-bits per channel is only available for a limited range of Photoshop functions, but it covers all the areas for which 16-bit provides a vital advantage over 8-bit channels. Extreme or repeated color changes multiply the data loss in each color channel – you may not necessarily notice this unless you later inspect the color channels individually. A histogram readout will certainly show where gaps in the levels occur. Data gets lost when working at 16-bit too, but crucially when you revert or compress to 8-bit color there is more than enough data to fill in the gaps. Close analysis will show the difference between a series of color adjustments made in 16-bit and 8-bit. An 8-bit image may result in some signs of posterization at certain delicate parts of the image. More usually you will see better preserved image detail in the 16-bit color manipulated image.

As the Photoshop software improves, so one adapts one's way of working. Certainly the new and revised color adjustments provide a remarkably versatile set of color tools. Take, for example, the Channel Mixer, in color operation and combined with curves, I can achieve the sort of coloring effects which could be done mainly with the Apply Image command, but more easily. Channel Mixer is an excellent tool for crossing the curves and producing subtle color changes which match the characteristics of almost any print process you care to mention.

2 Select first the blue channel and adjust the curve as shown – lower the Highlight point on the graph and add a mid control point to make a gentle curve. This will introduce a yellow cast into the image highlights.

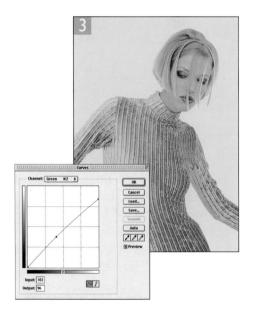

3 Now visit the green channel. Here too the highlight point is lowered as well (though not quite so much) and the mid point balanced to create a peachy cast.

I Before commencing, the image should be in RGB color mode with the Levels fully corrected. In the case of portraits, the skin tones should ideally be nice and light as shown. Go to the Layers palette and create a new Curves adjustment layer.

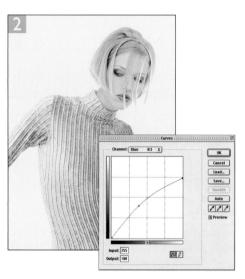

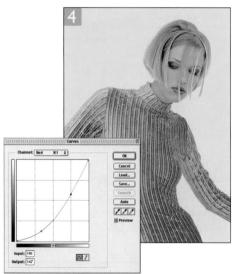

4 Next, the red channel is adjusted to introduce a cast in the shadow tones. Keep the highlight point pegged where it is, but increase the ink density in the shadow/quarter tones.

5 Lastly, return to the composite channel and finalize the overall curve to set the tonal contrast and lightness. The beauty of the new enhanced Curves interface is the ability to accurately manoeuvre individual control points (or shift select two or more) via the arrow keys on the keyboard, whilst anchoring the previously set points. It is now possible to go for wild curves effects and have super fine control over the curve shape.

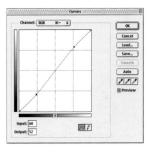

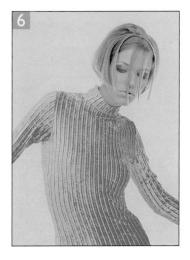

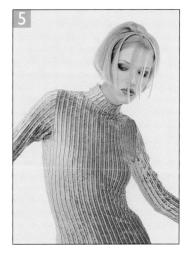

6 You can combine adjustment effects and introduce more color distortions. Here, for example, I added a Channel Mixer adjustment layer and experimented with the settings shown below to mix the colors up even more. By using adjustment layers to carry out these effects, the original pixels are always left unaltered. If you pound the color adjustments too much, there is a danger of making the colors posterize. If this occurs, you can lower the adjustment layer opacity.

I use Channel Mixer mostly in RGB. If you mix in CMYK mode, be aware that you are changing the ink values and this will conflict with the way the CMYK image was originally setup to print on the designated press. You can achieve interesting alternative color distortions as shown here, but do check that the total ink values are within limits.

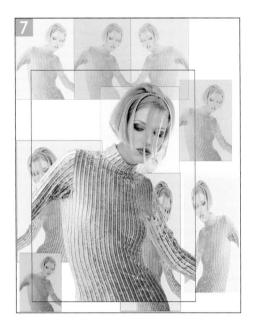

7 Here is the final image. I used this technique with a few variations on copies of the same original image. Some were taken to stage 2 only and further adjusted using the Hue/Saturation image adjustments. I also experimented with making a selection based on the model's outline, inverting it and filling the background area with different colors. The individual pictures were assembled on separate layers to make the final composite as shown here.

The Channel Mixer on its own is an excellent tool to use for both wild and subtle color control. The Channel Mixer affords just the sort of control you always dreamed of having in the darkroom. It is possible with a little patience to discover a whole host of new color distortions. Any setting you discover can be saved as you progress, to add to your collection of favorite color effects. The four examples shown here are all Channel Mixer variations which were applied to the original image without the Curves adjustment.

Figure 14.1 In the above illustration, four identical RGB images are colored by an overlaying layer filled with a color set to 'Color' and 'Hue' blending mode at 50% and 100%. Model: Clair at Boss Models.

Color overlays

An easy way to fade image colors is to add a blending layer consisting of a single color, set to either the Hue or Color blending modes. This produces an effective faded look (see Figure 14.1).

The Color blending mode is grouped with Luminosity, Hue and Saturation. Each of these blending modes operates along a similar principle: an HSB component of the pixel values of the blend layer replace those of the underlying pixels. HSB refers to Hue, Saturation and Brightness (luminosity).

Color mode: The hue and saturation values of the blend layer are combined with the luminosity of the underlying layers. The effect is to colorize the layers below.

Hue mode: Only the hue values of the blend layer are combined with the underlying saturation and luminosity values. The layers beneath are colorized, but the saturation of the base image is retained.

Saturation mode: The saturation values of the blend layer replace those of the underlying layer. A pastel colored overlay layer will cause the underlying layers to become desaturated, but not alter the hue or luminosity values.

Luminosity mode: The brightness values of the blend layer replace those of the underlying, but do not effect the hue and saturation.

Retouching with overlays

Whilst the above information is sinking in, let's look at more ways these and other overlay modes can be applied when working with the brush and fill tools. Suppose you have a landscape picture and are looking for a simple method to remove the clouds from the sky. Cloning with the rubber stamp tool or cutting and pasting feathered selections could work, but you would have to be very careful to prevent your repairs from showing – how will you clone in around the leaves, for example?

The sky is gradated from dark blue at the top to a light blue at the horizon. The easiest way to approach this task is to fill the sky using the gradient tool and Darken blending mode, with the Foreground and Background colors sampled from the sky in the image. Darken mode checks the pixel densities in each color channel. If the pixel value is lighter than the blend color it gets replaced with the blend color. In the accompanying example, the clouds (which are lighter than the fill colors) are filled in with a smooth gradient. The trees, which are darker than the fill colors are left almost completely unaltered. To maintain fine control, I applied the gradient fill in Normal mode to a new layer and changed the layer blending mode to Darken. Then a layer mask was added and the tree highlight areas were masked out. This can be done with the brush tool or you might want to load an existing color channel such as the red channel into the layer mask, which features strong contrast between the leaves and the blue sky.

NB: For a reminder on how to use these and other blending modes, refer back to Chapter Eleven.

2 Select the gradient tool and drag across the picture as shown. Set the copy layer to Darken blending mode. Apply a layer mask and retouch out any overlapping gradient areas. A layer mask based on one of the color channels (such as red) will be suited for this purpose.

I The before picture incudes a cloudy sky. Duplicate the background layer and sample foreground and background colors from the top of the sky and horizon.

The second example features a view of Piccadilly Circus in London. This is actually a composite image of several views joined together to make a panoramic picture. This technique is a reverse of the last one. Instead of removing the light colored clouds, a gradient is set up – sampling the sky colors, but this time the blending mode is set to Lighten. This has the effect of replacing any of the darker dust marks and hairs with the lighter sky colors.

I Another landscape, but this time there are a lot of dust marks on the scan which need to be removed. One can eradicate these by applying the same technique as before, but this time set the gradient tool to Lighten. Lighten mode checks the pixel densities of the color channels and if the pixel value is darker than the blend color it gets replaced with the blend color. Hence the dark scratches and marks are removed in one simple step and without affecting the clouds. This technique works fine on a scene where there are no trees in the sky as there was before.

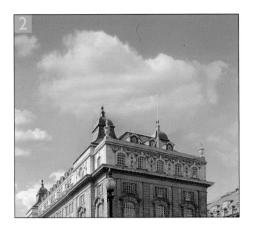

2 Before close-up view of sky showing the black dust marks which need to be removed. Sample the horizon color with the eyedropper tool. Invert the foreground and background colors (press 'X') and then sample the top of the sky.

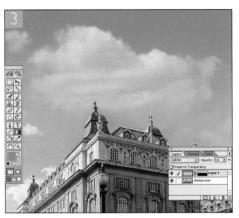

3 Create a new layer and drag the gradient tool from the top of the sky down to the horizon. Add a layer mask to the layer. Activate the layer mask. With the gradient tool, fill the mask as shown using the default Foreground/Background colors. Brush out on the layer mask unwanted overlaps and Merge Layers.

Hand coloring a B/W photo

I once used to assist a photographer who was very skilled at making hand colored pictures on black and white prints for advertising and fashion clients. I remember his work drew a lot of interest, whenever there was an exhibition or a fashion spread out, including one call from a businessman who asked to buy some original prints, but they'd have to be tinted purple (to match the interior decor of his penthouse flat of course). Enough said.

Hand coloring is a skilled craft. Photoshop makes things a little easier in as much as you can do all the painting work on a separate layer without risk of damaging the original. That was always the problem – one slip of the brush and you might have to start work on the print all over again. To reproduce some types of coloring, you are only as good as your brush skills allow. As always, Photoshop permits you to make life a little easier, like creating mask outlines to restrict the extent of your coloring. The following tutorial by Adam Woolfitt demonstrates the use of some of the selection and color adjustment methods described in previous chapters to create a colored image from a B/W original.

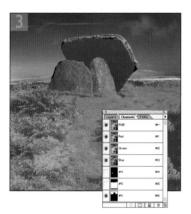

- Duplicate the last saved mask channel in the Channels palette, invert the contents Image > Adjust > Invert and add to it, painting in around the skyline and stones.
- Make a new selection, using the magic wand to select the middle distance areas. Feather and apply the Hue/Saturation command.

I The original is an RGB scan from a B/W negative of Mulfra Quoit in Cornwall, UK, which had been shot on Konica Infra Red 120 film.

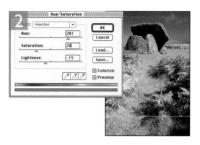

Make a feathered selection of the lower part of image and use the Hue/Saturation command (with Colorize clicked on) to color this area green. Colorize always defaults to 25% primary red on startup. Move the Hue and Saturation sliders to make fine adjustments. Save the selection before proceeding.

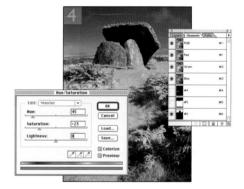

Convert the new channel to a feathered selection and use this to color the sky, again using the Hue/Saturation command.

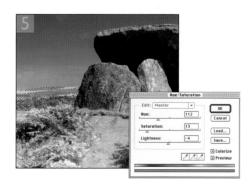

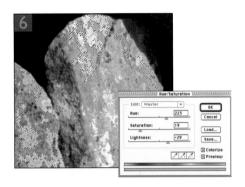

6 Use the magic wand again to isolate small areas of the stone. Repeat the selection, feathering and coloring process, setting the magic wand with higher or lower tolerances.

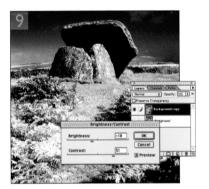

98.10 Crank up the contrast on the Background copy using the Brightness/Contrast command. Then choose Image > Adjust > Desaturate, but gradually reintroduce the original color saturation with the Fade control (Filter > Fade Desaturate).

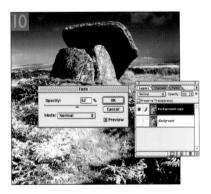

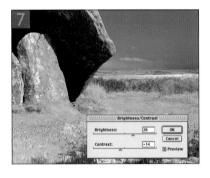

7 If necessary, load the previously saved selections and apply the Brightness/Contrast command to modify over bright or saturated areas that distract from the main emphasis.

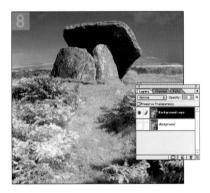

8 Duplicate the Background layer – the following modifications will be used to soften the focus.

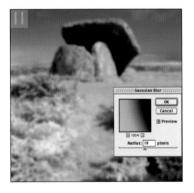

II Apply a heavy Gaussian blur to the background copy and with the Background copy selected, adjust the opacity slider to control the degree of blur overlaying the background.

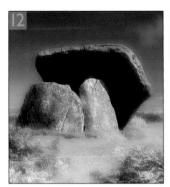

12 Add a layer mask to the background copy and brush away with a large brush to reveal more or less of the original sharp background image below.

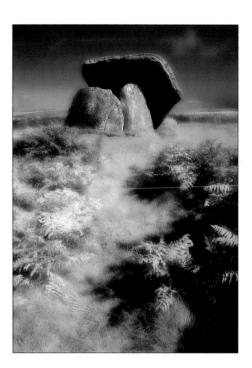

Chapter Sixteen

Layer Effects

orthy of special mention are the new things you can now do in layers and how these features will be of use to image makers as well as designers working in graphics or web design. The layer effects feature has achieved a new first, in enabling multiple (and reversible) Photoshop layer actions. This is a wonderful tool with which to automate the application of various Photoshop effects like embossing or making drop shadows within an easy to use interface. There are three main applications: applying layer effects to an image element on a layer; applying layer effects on a type layer and special paint effects where an empty layer can have the Layer Effect active and anything painted in that layer will have the effect applied as you add image data to it.

Layer effects controls

The layer effects control dialogs are to be found naturally enough in the Layer menu. On offer at present is a choice of five different effects. These may get added to in later versions, but for now there are plenty enough combinations to be experimenting with. Each effect can be applied individually or cumulatively. The live preview shows what the outcome will be after flattening the file. Remember what you are seeing is just a preview. The Layer Effect, whether applied to an image or type layer, is fully editable until then. When you select a Layer Effect, you will notice an italicised 'f' symbol appears in the layer caption area. Double click this symbol as a shortcut for reopening the layer effects dialog.

Drop Shadow

As you can see, there are quite a range of options associated with each of the layer effects. The drop shadow uses the Multiply blending mode to make the shadow with the default color set to black. Now obviously you can change these parameters, so the effect can become something like a drop glow, using any color you want and with varying opacities. Below this is the angle setting, where you can either enter a numeric value or use the rotary slider control to manually set the shadow angle. The Use Global Angle comes into play when you want to link the angle set here with those used in the Inner Shadow and the Bevel and Emboss layer effects and that of any other layer effects layers. If you want to set these angles independently, then deselect this option. Below this are the shadow distance and blur controls – these are self-explanatory. The Intensity setting intensifies the effect in much the same way as if you were to duplicate a real drop shadow layer and have it set to Multiply mode on top of the Multiply mode beneath it.

Figure 16.1 The layer effects dialogs, from top left: Drop Shadow, Inner Shadow, Inner Glow, Outer Glow plus Bevel and Emboss.

Inner Shadow

The Inner Shadow features identical controls to the Drop Shadow effect. The only difference being that this applies a shadow within the layered type or object area. The result may appear to be either that of a recessed shadow or will give a convex 3-D appearance to the layer object. It all depends on the angle you choose.

Outer Glow & Inner Glow

These both have similar controls. The Outer Glow is very much like the drop shadow, but defaulted to the Screen blending mode and spreading evenly outwards from the center. In which case you could say the Inner Glow corresponds with the Inner Shadow effect. The Inner Glow contains two options – for edge and center. Used in conjunction with the Inner Shadow, you can achieve a very smooth 3-D 'contoured type' appearance with the centered Inner Glow.

Bevel & Emboss

This double effect adds a highlight and shadow 180 degrees apart from each other. When you adjust the angle the two move in sync, creating an illusion of depth, with light cast from an angled source. Again, you can alter any of the settings as outlined above.

Layer effects sub-menu

The accompanying illustrations show layer effects being applied to image data layers. As I said at the beginning, the Effects layers operate in the same way adjustment layers do – they create a live preview of the final effect and only when you flatten down the layer are the pixels modified and does the effect become fixed (although this can be reversed using History maybe). You will therefore find that layer effects are not scalable in the same way as image data is. If you resize the image the layer effects settings will not compensate for this change. In the sub-menu, you can temporarily switch off or on the layer effects in one go and also select the Global angle, which will then be applied to all the layer effects layers. The Create Layers option will deconstruct a Layer Effect into it's separate components. You can use this to edit individual layer elements if so desired, layer effects can be shared with other files or other layers. Go to the layer effects sub-menu and choose Copy Effects, then select another layer in the same or another image and choose Paste Effects from the same sub-menu.

Painting effects

You can take a look at the illustrations to see how this works. Basically the potential is there for Photoshop to have three dimensional painting brushes. For example, if you have an empty layer with the drop shadow effect active, anywhere you paint in the layer will automatically appear on screen with a drop shadow. I quite like the

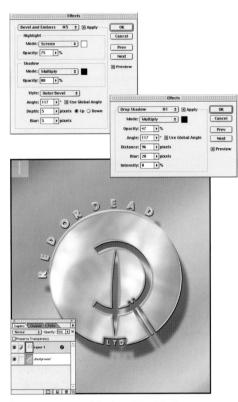

Logo courtesy of Red or Dead Ltd.

2 If you paint on the layer mask in white you will reveal the hidden layer. If a Layer Effect is also active the brush strokes will take on the characteristic of the layer effects. The effects can be edited as you paint. This doodle example shows some of the interesting possibilities.

- I A series of layer effects was applied to an image layer. In this example a combination of Bevel & Emboss plus Drop Shadow were used. The Drop Shadow settings were modified to make a deep heavily offset shadow.
- 2 In this next step, the eraser tool was selected and the image layer brushed away, creating the etched effect shown here. The layer effects generate a new preview showing the effect of modifying the layer image data.
- I I used this weathered stone texture for the next demonstration, which is really the same as the above example but in reverse. First add the texture as a layer and hide it with a layer mask fill.

effects which can be achieved with the Drop Shadow, Bevel & Emboss and Inner Glow effects. They work both by adding paint or texture to an image and erasing away at a layer. So on the one hand you can create an effect which is like painting with mercury or you can etch away at an image, leaving a contoured edge as you do so.

Transforms and alignment

There are still a few more layer tricks to discover. You will see that Photoshop 5.0 has gained Adobe Illustrator type features. Any transform you carry out can be repeated using the Edit > Transform > Again command (Command/Ctrl+Shift-T). The transform coordinate change is memorised in Photoshop, so even if other image edits are carried out in between, the Transform > Again command will remember the last used transform.

When more than one layer is present, the layer order can be changed via the Layer > Arrange menu, to bring a layer forward or back in the layer stack. The full Layer menu and Layer palette shortcuts are listed back in Chapter Thirteen. In addition, two or more linked layers can now be aligned in various ways via the Layer > Align Linked menu. The latter is a desirable feature for design based work when you want to precisely align image or text layer objects in a design, although as can be seen the combination of repeat transforms and align layers affords interesting possibilities for making image patterns.

Photograph: Laurie Evans.

I-3 To demonstrate the repeat transform feature, I took this still life picture and made a mask selection of the cheeses. I loaded the selection and floated a copy of the cheeses (Layer > New > Layer Via Copy) or used the shortcut Command/Ctrl-J. The first single transform combined a scaling down, a diagonal movement and an anticlockwise rotation.

To repeat the effect and make use of the repeat transform, I kept duplicating the last transformed layer by dragging the layer name down to the New Layer button in the Layers palette and chose Edit > Transform > Again, or the shortcut Command/Ctrl+Shift-T. I ended up with six repeating transformed layers as shown in picture 3. To make the layers nestle one behind the other, I reversed the layer order above the background layer.

4 To complete the arrangement of the neatly stacked images falling behind each other, I merged all the linked layers (see the Layers palette in picture 3) and applied a layer mask to the merged layer based on the original mask selection.

Photographs: Laurie Evans.

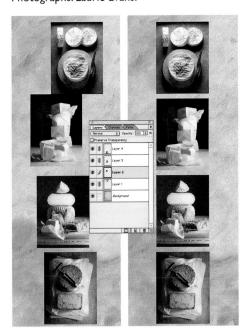

Figure 16.2 Keeping on the cheese theme – these layered images were tidied up using the Layer Alignment feature. I chose Layer > Distribute Linked > Vertical Center to evenly balance out the spacing and followed this with the Layer > Align Linked > Horizontal Center. The align command brought all the individual images horizontally centered around their common axis as shown in the right hand example.

The alignment commands allow you to both distribute and align linked layers according to a number of different rules in the sub-menu list. To use this feature, first make sure the layers are all linked. The distribute command evenly distributes the linked layers based on either the top, vertical central, bottom, left, horizontal central or right axis. So if you have several linked layer elements and you want them to be evenly spread apart horizontally and you want the distance between the mid points of each layer element to be equidistant, then choose Layer > Distribute Linked > Horizontal Center. If you next want the layer elements to align, then go to the Layer > Align Linked menu. How the align command centers or aligns the layers will be based on whichever of the linked layers is selected. The other layer elements will always reposition themselves around the active layer.

Type layers

Type is now fully editable in Photoshop, it is no longer permanently fixed as a rasterized layer at inception. You can still choose to place type as a selection or import EPS artwork as before, but you only have to rasterize (convert to pixels) the type added as a layer at the very last stage. Besides the fact that type remains editable up till then and the overall file space is reduced, you can apply Layer effects just as if the type were already rasterized. This is a very neat feature indeed and quite amazing the first time you experiment to see what happens when a Layer effect is active on a type layer and you then proceed to alter the type settings in the Type dialog. The layer effects change too of course and in real time as you change font and type size. Now reflect on how long it would take to set up an equivalent 'Layer Effect' type Photoshop Action and repeat that process over and over again to see which font or combination of font plus effect worked best.

Spot color channels

This is not a Layer Effect as such, I know, but previously one would have used Layers to perhaps simulate the effect of what a spot color channel would do and determine how a special color overlay would interplay with the underlying image. Spot colors include a wide range of industry standard colors. You use the manufacturer's printed book color guides as a reference for how a color will print and not judge this from the screen. The colors available can include those found in the CMYK gamut, but also a whole lot more that are not, including metallic 'specials'. Spot colors are used where it is important that the printed color conforms to a known standard and for the printing of small point size type and graphics in color. A four-color process mix can be used when printing larger non-serif point sizes, but not for fine type and lines as the slightest misregistration will make the edges appear fuzzy. Spot colors can be added to images as part of the graphic design or as a means of accomplishing a color not available in the CMYK gamut.

A colleague of mine once won the dubious honor of 'most out of gamut color of the month' award from his repro company, after presenting them with a vivid green backdrop in his RGB transparency. The image was being printed as an advert to promote his work, so they made a masked color plate, adding a spot color to the background, simulating the green in the original. Here then is an example of a spot color channel and type tool in action.

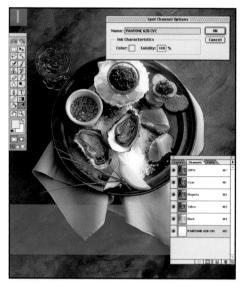

Photograph: Laurie Evans.

2 Now if the spot color channel remains active and the type tool is selected, any type entered will be rasterized directly into the spot color channel. So when 'Oyster Bar' was input it appeared as a floating selection and as part of the spot channel. The type can then be repositioned using the move tool until dropped in place.

More type is added, this time using a process color mix on an editable type layer. Select the composite channel (the spot color channel is therefore now deselected) and choose a foreground color from the color picker dialog. In the type dialog, a new font can be chosen, or combination of fonts applied in the body of text. And as type is entered, a live preview appears in the image. So with a type layer we are entering vector type, which will not become fixed as rasterized pixels until the image is flattened and saved as a TIFF or whatever non-Photoshop file format is going to be used for output.

I Choose New Spot Channel... from the Channels palette fly-out menu. You will see a dialog as shown here. When you click on the Color box. this calls up the custom color dialog and you can choose from any of the installed custom colors including the Pantone color selected here. Choose a solidity percentage which matches the solidity of the custom color specified. When you change the solidity of the custom color, the effect is simulated in the image preview, matching the ink characteristics. Most custom colors are opaque (100%), whilst varnish colors are translucent. To produce a faint tint, you lower the opacity in the spot channel. The block shown here was created by filling a marquee selection with a light gray.

Chapter Seventeen

Filters

ne important factor which separates Photoshop from other image editors and gives it an edge over the competition is its widespread support for third party plug-ins and filters. John Knoll, brother of Thomas Knoll who originally wrote the Photoshop program, was responsible for writing many of the plug-ins which shipped with the earlier versions of Photoshop (and still survive today). The open door development policy has enabled many independent software companies to add creative tools and functionality to the Photoshop program. In turn this ongoing development has boosted the status of Photoshop as a professional image manipulation program. Even high-end retouching systems cannot match this versatility and will rely on accessing Photoshop for its plug-in rich features.

Some filters are simple one step actions like the Noise > Despeckle filter for example. If you are brave enough to venture experimenting with the Custom filter, you too can create similar types of plug-in filter effects of your own. Some sophisticated plug-ins are more like applications in their own right, operating within Photoshop (there are demo samples available on the CD-ROM to try out). With so many filters to choose from, it is easy to get lost amongst the Filter menu options. The inclusion of revised Gallery Effects filters in Photoshop 4.0 and later versions should be enough to keep everyone happy.

In this chapter and the next, we shall be looking at ways filters can enhance an image. There is not enough room for me to describe every filter present, though some you will be familiar with already – like the Unsharp Mask filter. Instead I shall highlight some of the more useful ones plus a few personal favorites.

Blur filters

The Radial blur does a very good job of creating blurred spinning motion effects. This is anything but a gimmicky filter – it has many uses, like adding movement to car wheels shot stationary in the studio. Similarly when switched to the zoom blur setting, it does a neat impression of a zooming camera lens. The filter dialog box offers a choice of render quality settings. This may appear quite a sluggish plug-in, but is after all carrying out a major distortion of the image. So either be very patient or opt for a lesser quality setting. The Motion blur filter is not nearly so slow as the above and again it creates really effective sensations of blurred movement. Both the blurring angle and length of blur (defined in pixels) can be set. The blurring spreads evenly in both directions along the axis of the angle set, but that need not be a problem – the tutorial on the Adobe CD-ROM demonstrates how to create what are described as 'front flash' and 'rear flash' camera sync motion effects. Basically, if the blur is applied to a duplicate of a layer element and then positioned on the layer beneath, the blur can be shifted with the move tool as desired either side.

Fade filter

Filter effects are enhanced by applying the Fade Filter command. The accompanying examples in Figure 16.1 demonstrate modification with the Fade Filter command used in conjunction with the Radial blur filter. Apply the Radial blur in the normal way and afterwards choose Filter > Fade Filter and experiment with different blending modes. The Fade Filter command is almost like an adjustment layer feature, but without the versatility and ability to undo later. It makes use of the fact that the previous Undo version of the image is stored in the Undo buffer and allows you to calculate many different blends but without the time consuming expense of having to duplicate the layer first. Having said all that, History offers an alternative approach whereby you can do just that. If you filter an image, or make several filtrations, you can return to the original state and then paint in the later (filtered) state using the history brush or make a fill using the filtered history state.

Smart blur

This was a new addition in Photoshop 4.0, to the blur range of filters: it blurs the image whilst at the same time identifying the sharp edges and preserving them. Used to extremes the effect becomes very graphic and can look rather ugly. In some ways its function mimics the Median noise filter and is another useful tool for cleaning up noisy color channels or artificially softening skin tones to create an airbrushed look.

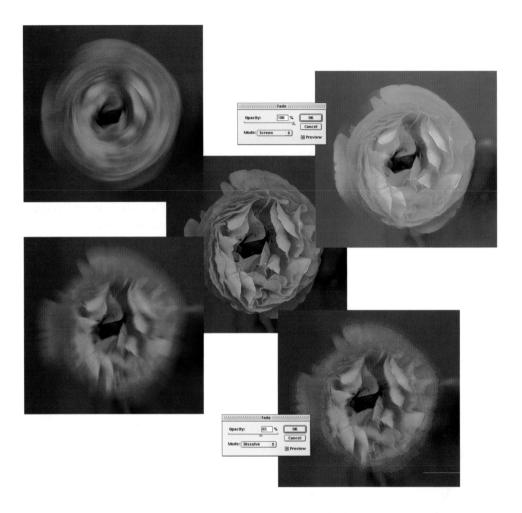

Figure 16.1 A few examples of the Filter > Fade Filter command used in conjunction with the Radial blur. The centre image is the before image. Top left a Radial Spin blur with a Screen Fade version top right. The bottom left image is a Radial Zoom blur and bottom right a Diffusion Fade version.

Noise filters

Other than the Add Noise filter, the other three filters – Despeckle, Dust & Scratches and Median – are in fact all types of noise reduction filters. The Despeckle filter is intended to remove scanning noise and artifacts which are present with all scanners to a greater or lesser degree – I have occasionally come across bad examples where the fault is more due to a poorly skilled operator. The Median filter averages out the color values of adjacent pixels, smoothing the differences between them. The mini-

mum radius setting of 1 pixel will have quite a noticeable effect. Despeckle is like a 'gentler than 1 pixel radius' Median filter. It might get rid of the worst of the noise. I would recommend inspecting the individual color channels and applying to just those which are badly damaged. The Dust & Scratches filter is a sort of Median filter combined with a Threshold control. The higher the radius, the more spread or smoother the effect and the higher Threshold levels setting, the less effective the filter is. Dust & Scratches is not, repeat not a filter you want to apply globally to the whole image as part of the scan preparation. Where there is an area of flat tone in a picture with lots of marks on it, make a selection of that area and apply the filter to the selection only. It is a handy alternative to spending several minutes cloning with the rubber stamp tool, though don't forget there is also Russell Brown's technique which uses the Dust & Scratches filter in an intelligent way, as described in Chapter Ten.

Filters for alpha channel effects

I Here in the final stages of adding a color overlay to an image on a white background, I have the color fill on a layer above the background, using a layer mask based on an alpha channel mask prepared earlier. As masks go, it's not bad but as you can see there is still a slight halo around the object where the white background shows through.

Photograph: Davis Cairns. Client: Paul Smith.

2 To get round this, activate/highlight the Layer Mask icon and apply the Other > Maximum filter, at a setting of I pixel. Notice the filter effectively makes the layer mask shrink very slightly and now the halo has almost completely disappeared in one easy step. You can refine the layer mask with a brush to fill in or remove any sections which are still showing.

The Other Filter sub-menu contains a collection of filters, some of which I find essential for alpha channel work. The Offset filter offsets the active layer or channel. You would use this filter as part of a series of steps where, for example, you wanted to create a displaced drop shadow or maybe build a wrap around texture.

The Maximum and Minimum filters I use to either choke or expand an alpha channel mask and the High Pass filter is useful as a tool for detecting and emphasizing image areas of high contrast in preparation for converting a duplicated color channel to a mask.

Creative filtering

If I have a problem with filters, it is this: like many things that are supposed to expand our horizons – television, multimedia CD-ROM, the Internet etc. – the reality is if you supply people with easy to use, easily digestible information, instead of exploring more, they use it to work less.

I was talking to an art teacher from my old school about this and he mentioned what he liked to call the 'Encarta' effect: if a teacher instructs the students to write an essay on Van Gogh, for example, half the kids will lazily reach for their CD-ROM encyclopedia and all end up quoting from identical references. Now they could discover a broader if not mind boggling range of alternative primary sources via the Internet, but just as with going down the library, that would require too much effort sifting through the data. These are the views of a teacher who is all in favor of students using computers, but not in a way that leads to homogeneity of thought and expression.

The same thing can be said about the misuse of filters. Photoshop should be seen as more than a glorified electronic 'paint by numbers' kit. Even the esteemed Kai Krause (the man who gave us Kai's Power Tools) was heard to offer a tongue in cheek apology for inflicting the ubiquitous Page Curl filter upon the world. With a little imagination one can cumulatively combine filters and create all sorts of interesting new textures and image effects.

Distort filters

I produced the following tutorial, which demonstrates how to produce an emulsion lift-off type technique. I use this as an exercise to illustrate the range of Distort filters. Photoshop may currently lack the freeform distortion tools found in Live

Picture or Kai's Goo, but the power is there to create interesting effects when you use a combination of distortion filters like Shear, Displace and Wave. The latter has one of the most complex and bewildering dialogue boxes to be found in Photoshop. The settings used here will have a very different effect on images that are not the exact same size; if these don't work at first, try varying the scale sliders.

3 The Shear filter distorts the vertical plane only, so you'll have to rotate the image 90 degrees (Image > Rotate Canvas > 90 degrees) and repeat the process with a different shear if you like and then rotate the image back again.

- I Open the image, set the background color to white and enlarge the canvas size to allow enough room for the following distortions.
- 2 Apply the Distort > Shear filter. Add points to the shear line in the dialog box and drag to define the curve distortion along the vertical axis.

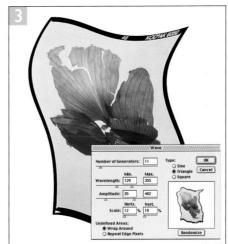

4 Now enhance the distortion with the Distort > Wave filter. You can use the Triangle or Sine wave with the settings shown here, but as I said earlier, more than likely you'll have to experiment with the various controls, though I would recommend a low number of generators. The scale settings magnify the effect, so if you create a trial image at a small size, increase the scale setting when repeating at higher resolutions.

5 I created a texture channel which could also double as a displacement map. I made a new channel and filled: Filter > Render > Texture Fill. I selected a texture like 'Driven Snow' from the Textures for Lighting Effects folder on the Adobe Photoshop CD-ROM, then manipulated this texture with a combination of an Image > Scale enlargement, Gaussian blur, Threshold, Motion blur, Levels, Image > Adjust > Invert, more Gaussian blur and a gentle Wave Distort filter. I selected the white surround of the RGB channel and filled the border of the new mask channel with black. If you would like to see an expanded demonstration of how this was done, refer to the tutorial movie on the CD-ROM.

6 Load the texture channel as a selection and adjust Levels, darkening the selected areas — adding a rippled texture. This is optional, but if you want, convert the new channel mask into a separate Grayscale Photoshop image and use this as a displacement map. Have the main image open only, choose Filter > Distort > Displace (keep the displacements to around 5 pixels) and proceed by opening the saved map.

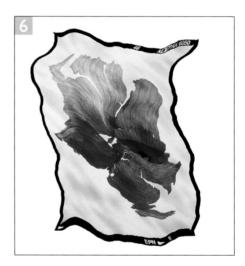

Figure 16.2 Another image partly modified this time using the Square Wave setting. If you are confused about the dialog box settings and are looking for inspiration, try clicking the Randomize button to see different random options.

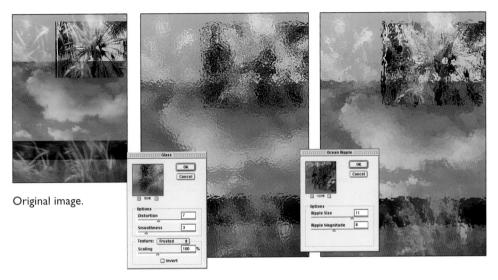

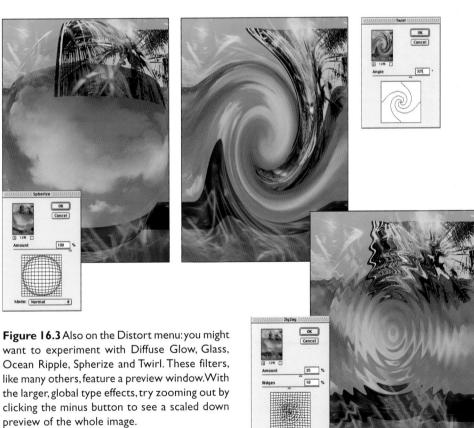

Pushing the envelope

This still leaves another fifty or so filters supplied as standard with Photoshop 4.0 to discover. There is not enough room for me to examine each and every one and to be honest half of them I have not even got round to using myself yet. Nor have I fully mentioned all the third party filters available and what they can do. I used to wonder why it was not possible to access every filter in CMYK mode. The answer is that most special effects filters can only work in RGB mode as these can have a dramatic effect on the pixel values, easily sending colors way out of the CMYK gamut. So to unleash the full creative power of Photoshop plug-ins, this is a good argument for having to work in RGB mode and convert to CMYK later.

As I said before, there are more ways of using filters creatively apart from single filtrations. Are you looking for a background texture image? Here's how to render your own. The following filters will be used: KPT Power Tools, Distort > Wave, Render > Lighting Effects, Sketch > Plaster and Brush Strokes > Spatter.

I Create a new document. For this example, the pixel dimensions were 1200×800 . It is important to note that the following effects settings would need to be adjusted for other document sizes. To begin with, I filled with a 'Dean Ice Scape' texture from Kai's Power Tools Texture Explorer, set to 512×512 tiling.

2 In my opinion, KPT filters are fine as a starting point. With so many extra filters at your disposal, why not take things further? Here a KPT Noise f/x filter was added to mix things up a bit.

3 The Distort > Wave filter is a favorite of mine. Remember the above settings worked on a 1200 x 800 pixel sized image. Here are a few tips: for larger pictures, increase the scale settings. For example, if you were testing an effect at 50%, repeat everything on an image 4 times bigger at 100%. The number of generators setting instructs the filter to electronically throw more stones in the water. Experiment with the Wavelength and Amplitude settings – try keeping the sliders close together and also far apart to see the full range of possibilities.

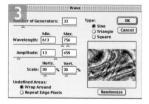

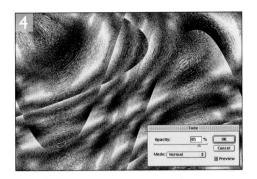

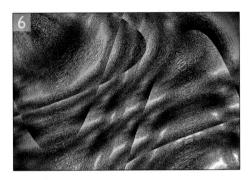

6 With the lighting effects applied, I faded the filter to 85% opacity, keeping to the Normal blending mode.

7 To complete the picture, add more detailed textures. With the Foreground color set to black, I applied the Plaster filter from the Sketch submenu with the Darken blending mode at 15% (Image balance 15, Smoothness 2, Lighting – Top). Then I added a Spatter filter from the Brush Strokes submenu with a Spray radius of 10 and Smoothness of 5 at 80% and made a few adjustments to the color via the Hue/Saturation dialog box.

4 Here is the result I got after applying the Wave filter. So far so good, one can keep adding more variations, it's just a case of knowing when to stop.

5 A cool feature of the Lighting Effects filter is the Texture Channel bump map facility. I selected the blue channel as the texture map, with White set as high. In fact, one could use any of the other color channels or an alpha channel.

Adobe packaged the Gallery Effects collection beginning with Photoshop 4.0 and later versions. With the standard Easy Install you will find these included in the Filter menu. I have another example which follows, demonstrating how subtle use of these filters in combination work well on some images.

I This was a shot I took a few years ago to illustrate the theme of what it would be like as a fish starved of oxygen in river water polluted by acid rain. The black and white print was chemically toned and scanned in as an RGB image (these creative filter effects will not work in CMYK or Indexed Color modes).

2 Begin by applying the Sketch > Graphic Pen filter. The Sketch range of filters (with the exception of Water Paper) will always produce a monotone image, as shown here. These filters often work well if you follow the filtration with a Fade > Filter command, in this case reducing the opacity to 30% with the blending mode remaining on Normal.

3 Next apply the Artistic > Cutout filter.

4 Afterwards, I faded the filter again. The opacity was reduced to 35% and the blending mode set to Difference. The image is darker and the highlights are lost, but this actually suits the mood of the image quite well. It is not always necessary that the levels be expanded to fit the full tonal print range.

Displacements

This last demonstration shows how to import a vector graphic from Illustrator and make a displacement map with which to apply the Displace filter.

I I borrowed this sparkling sea shot as it was likely to show the displacement effect quite clearly. To displace an image, one needs to have a separate 'map' source image which can be any type of image (except Index color).

4 Back at the original image, I selected Filter > Distort > Displace. The options were set to Stretch to fit and Repeat edge pixels. After clicking OK, a dialog box asks you to find and select the map to be used. The lightest parts of the map produce no pixel movement, whilst the darker areas shift according to the parameters set.

- **2** I created the basis for the displacement map as a new channel in the destination water image it would be used later to enhance the effect. I placed an Illustrator file (File > Place...) and duplicated the channel.
- **3** Gaussian blur was applied to the copy channel, which was inverted, then copied and saved as a new separate 'map' image (Select > All; Edit > Copy; File > New; Edit > Paste; Layer > Flatten Image).

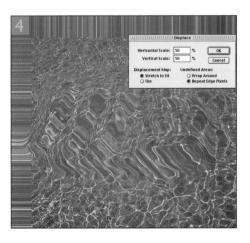

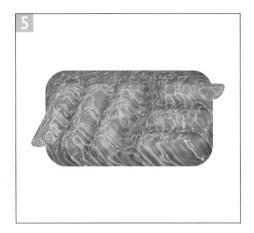

5 Some extra finishing work was done to add emphasis to the displacement. The border was cut away and a couple of layers added based on the original logo placed and stored in the new channel. The blending modes were set to Screen at low opacity and Hard Light at 49% above.

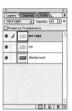

The displacement filter is capable of producing strong image distortions like the classic Parabola shape described in the Adobe manual. Intuitive it is not. The effect works well with text effects and where the displacement map has been softened beforehand. Displacement maps are useful for generating texture patterns. You will find a large number of displacement maps contained on the Adobe Photoshop CD and these can be loaded to generate all types of surface texture patterns.

Comparisons of all the Photoshop filters

With so many more filters to experiment with, there is not enough room to show them all here, but there is on the CD-ROM though. I have taken a single image and applied nearly every one of the Photoshop filters. You can quickly click on the filter name and see how the filtered image compares.

Chapter Eighteen

Lighting and Rendering

omitted mentioning the Render filters from the last chapter, the most interesting of which is Lighting Effects. Photographers are sure to find this a really useful addition to the plug-ins arsenal. Rendering processes are normally associated with 3-D design programs, yet Photoshop has hidden powers itself when it comes to rendering 3-D shapes and textures. Let's look at the other Rendering filters, though, first.

Clouds and Difference Clouds

This filter generates a cloud pattern which fills the whole image or selected area based on the Foreground and Background colors. The cloud pattern alters each time the filter is applied, so repeated filtering (Command/Ctrl-F), for example, will produce a fresh cloudscape every time. If you hold down the Option/Alt key whilst applying the Cloud filter, the effect is magnified. The Difference Cloud filter has a cumulative effect on the image. Applying it once creates a cloud pattern which appears based on the inverse color values. Repeating the filter produces clouds based on the original colors and so on... though after each filtration the clouds become more pronounced and contrasty.

Lens Flare

This is another one of the Render filters and a little overused perhaps, but nevertheless quite realistic when it comes to adding the effect of light shining into the lens along with the ghosting type of patterns normally associated with camera lens flare. For

the purposes of illustration or adding realism to computer rendered landscapes, it is ideal. An alternative method of applying Lens Flare is to make a new layer above the background, fill with black and apply the filter to this layer only. Then you can set the blending mode to Screen and have the option of repositioning the flare after filtering. Here is a picture I took of Battersea power station with Lens Flare added.

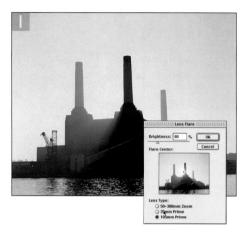

Figure 17.1 The position of the Lens Flare center point can be positioned in the dialog preview. One can also experiment with the effect of using three different lens types: 35 mm–500 mm, 35 mm Prime or 105 mm.

Lighting Effects and Texture Fill

To back up the assertion that Photoshop has the power to render 3-D objects, here follows an exercise in which an image is created entirely within Photoshop utilizing the Texture Fill and Lighting Effects filter.

I To prepare the image, I made this grayscale bump map of a computer mouse in a mask channel. The dark tones represent the lower relief levels and lighter tones the peaks (though this arrangement can be reversed if you wish). To work at its best, the bump map must have really smooth tonal gradations to represent the curved surfaces. Save an extra channel representing the outline of the mouse (channel 5).

2 The texture/3-D modeling feature is to be found at the bottom of the Lighting Effects dialog box. Select an alpha or color channel as the texture or 'bump' map for the lighting. In this case, select the bump map, channel 4 and click the White is High checkbox. The slider control determines how mountainous the render should be – the 50% value worked best. Position the light, in this case a single spotlight and adjust the lighting attributes. The settings shown here were for a shiny plastic surface with a raised ambient light level.

3 The resulting render as shown here takes effect in the selected area only. The image is a bit too dark, so fade out the effect with the Fade > Filter command to around 50%.

5 Now activate the RGB channel (channel ~) select the Mouse outline channel: channel 5, inverse and apply the Lighting Effects filter. This time go down to the Texture channel and select the channel 6 which was just made and as shown here use a single directional light.

4 After this create another texture map – click the New Channel button in the Channels palette, select all and choose Texture Fill from the Render menu. Any texture image can be used, but it must be a grayscale image. You will find a whole host of textures provided on the Photoshop program CD in the Textures for Lighting Effects folder inside the Goodies folder. Selected here is the Burlap texture map.

6 To finish of the image, the background and mouse were colored separately using the channel 5 selection and its inverse. To add a shadow, make a new layer, load the channel 5 selection and fill with black. With the Preserve Transparency option switched off, apply Gaussian Blur.

7 Apply the Offset filter: Filter > Other > Offset and nudge the shadow down and to the right, with repeat edge pixels selected. Lastly, load the channel 5 selection again and delete the overlapping areas and change the blending mode to Darken. You now have an offset shadow layer and completed render.

This last tutorial demonstrates that whilst Photoshop is no replacement for professional 3-D design packages, there is more to the Lighting Effects filter than first meets the eye. I thought I would begin by introducing an over the top use of the filter that does not use photography at all, just to demonstrate its potential before showing a more typical, photographic use. The following example shows how lighting can be added to an existing studio photograph – either to add emphasis or to introduce a spotlight effect in the background. I should mention that Lighting Effects is a memory hungry plug-in. You will not always be able to use it on large files unless your computer is well equipped with RAM memory.

I This is a photograph taken for a Gucci window display manual. The Lighting Effects filter works well as a means of adding lighting afterwards to a photographic scene. A little careful control will help you achieve a more realistic effect. Here I duplicated the background layer and made a rectangular selection of the panel before applying the filter.

 ${\it Client: John Field/Gucci. Photograph: Alex Howe.}$

- 3 Continue working on the background copy layer and apply the Lighting Effects filter again. This time we'll look at ways to combine light sources. The Omni light source is like a round diffuse light, which when positioned above the mannequin creates a hot spot and centres the attention on this part of the picture.
- 4 Now I will introduce another spot light on the right hand side of the image. To make this effect look more natural I emulated the light on the top right, which has a slight color tinge to it. If you double click the swatch to the right of the lighting controls, one can choose a color from the picker, which will in effect 'gel' the light.
- **5** Lastly, double check with the layer mask and opacity to see if anything else should be altered. Remember that Lighting Effects is a very powerful imaging tool. The combinations of light sources, light coloring and texture map facility offer many more opportunities than can be explained in a single chapter.

2 The Lighting Effects dialog box displays the selection area only in the Preview window. I positioned a spotlight, dragged the handles and adjusted the settings in order to apply a highlight on the shoes in keeping with the shadows already present. After applying the filter, I reduced the layer opacity slightly and added a layer mask and removed areas where I felt the rendering had not worked as I wanted.

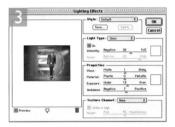

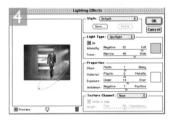

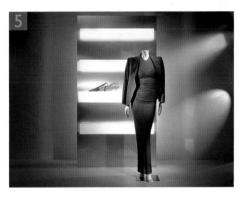

3D Transform

This is a new filter effect introduced in Photoshop 5.0. In fact it is the only new filter. It bears some resemblance to one of the Andromeda series of plug-in effects. The filter can be used to take an object and effectively change the perspective view relative to the remaining image. It is not an easy filter tool to master and there are restrictions on how far round you can rotate what is a '2-D captured' object. The following example was done with the cine camera on a background copy layer, with the camera carefully cut out. You'll notice that after the transform was applied part of the underlying image appeared, which was easily erased afterwards.

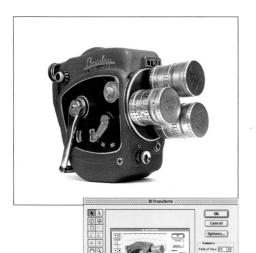

I Take an object and isolate it from the back-drop by defining an outline selection and floating to make a new layer. The 3D Transform filter is then chosen from the filter menu to affect this layer only. The dialog box displays a monochrome preview. Select one of the object drawing tools to surround the selected area and match its perspective. Next select the view angle tool to twist the perspective.

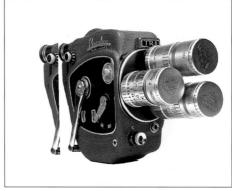

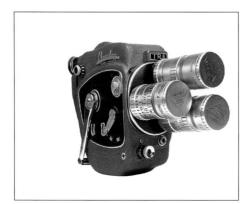

2 When the 3D Transform has finished processing, the before image may show through from below. Here I went to the background layer and deleted them, filling with white.

3 The cleaned up after shot appears to show the camera as if it had been rotated toward the lens axis. Excessive 3D transforms will not work so convincingly. After all, not even Photoshop can reproduce the back of an object!

I The original shot was made against a light gray background and the colors modified using Curves and Hue/Saturation adjustments to produce the colored shadows.

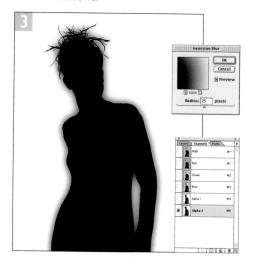

4 Load the duplicate channel as a selection (drag the channel down to the Make Selection button) and then choose New Adjustment Layer from the Layers palette sub-menu and select Hue/Saturation. This operation will create the adjustment layer and mask it at the same time. In the Hue/Saturation Dialog box, tweak the settings to darken or saturate/desaturate the background areas as shown. Of course, a Levels adjustment or color fill would work too.

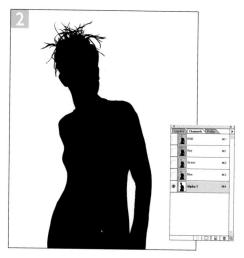

2 A mask was prepared based on information existing in one or more of the color channels (see chapter on montage techniques) the alpha channel is shown here.

3 Duplicate the mask by dragging to the New Mask button and apply a Gaussian Blur of between 20 and 50 pixels. Follow this by adding the original mask to the duplicate. There are several ways of doing this, you could try going Image > Apply Image, select channel 4 as the source and set the blending mode to Multiply at 100%.

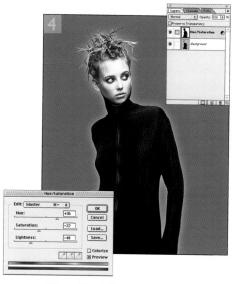

Client: Hair UK. Model: Emily at Storm.

Halo effect

To finish off with, the last example shows how to create a glowing halo effect. You need to prepare a precise outline selection first. Once that is made, the rest is fairly simple to accomplish. The amount of blurring applied to the first copy mask determines the extent of the glow. Try making a few attempts with different settings to judge which is the right one to use. The opposite effect of adding a border shadow (like a ring flash) is also fairly easy to achieve, but again the original mask used for the technique must be quite precise.

Practical applications

People either overuse these filters and techniques or dismiss them as pure fakery and having nothing to do with photography. There is a middle line where I believe there is nothing wrong with experimenting, mixing illustration techniques and photography. I would suggest that at times, when used properly, the Lighting Effects filter is an exceptional Photoshop tool for generating textures, objects or lighting fills. I once saw a good example of a floodlit hotel exterior where some of the outside lights were missing. This is a situation you are probably familiar with – the client couldn't get it together to organise replacement bulbs and the photographer had to shoot the scene as it was. Because it wasn't completely pitch black, there was plenty of shadow detail recorded and the Photoshop artist was able to apply the Lighting Effects filter to replicate the missing lights. He followed the same steps as outlined here, but also used one of the image color channels as a texture map to make the floodlighting appear more realistic.

So is it real or is it Photoshopped? Where the integrity of an image matters, such as in photo journalism, I would prefer photographers not to mess around with the subject matter. On a commercial shoot I think one weighs up the pros and cons and makes a decision based on whichever method is going to produce the best end result. If Photoshop can do something quickly and effectively, it makes sense to do it on the computer rather than waste time in the studio when you could be more productive and creative attending to other important things.

Chapter Nineteen

Synthesis

o round off this book, I invited a couple colleagues and friends who are professional photographers to contribute their favorite Photoshop techniques combining many of the things you will have learned from the previous chapters. The above title for me has connotations of the time spent studying chemistry at school. Synthesis described those practical experiments where elements and simpler compounds were mixed together to make a more complex compound. It seems therefore an appropriate way of concluding the book. Someone I know who once assisted a well-known photographer was given a book as a leaving present, it carried the simple inscription: 'Learn the tricks of the trade first and art will take its course'. A less prosaic interpretation of those sentiments might be: 'If at first you don't succeed, try reading the manual'. Or RTFM as they say on the Internet.

Disco Inferno

Rex Boyd is a comedy performer and juggler whom I met a while back at a cabaret show in London. I shot a photographic session based on the beginning part of his act where he dances to the Bee Gees 'Disco Inferno' (a great seventies disco classic by the way) in a style which can best be described as an eight year old overdosed on blue Smarties. There were lots of shots to choose from and to be honest I hadn't really thought through how I was going to present the session. The idea came later as I was experimenting with a storyboard type layout in Photoshop.

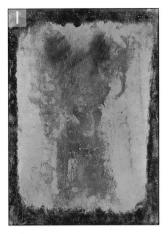

2 I then duplicated Layer I to make the Layer I copy layer and reverted the blending mode back to Normal. I wanted to then remove everything with a layer mask and paint detail back in. To do this, I Option/Alt clicked on the Layer Mask button. A layer mask was created which hid all the layer information. I then selected white as the foreground color and a soft edged brush with which to paint in the highlight areas.

3 Each element was treated the same way. Finally they were all combined as a single image (some of the images were flipped horizontally) and the joins repaired using the rubber stamp tool in Clone (aligned) mode. I didn't choose to paint in all the highlight areas – I mainly wanted to paint in the face. Other parts of the image worked well using just the Darken layer.

I Each of the nine sections were worked on individually and joined together at the end. Here you see the background image and the subject combined as a layer, but with the subject layer set to Darken blending mode. When applying this blending mode, the darker tones only merge and blend with the base layer and the white background disappears. I also retain the shadow detail and keep the sense of depth.

Paris Metro by Ed Horwich

Ed shoots many of his images with a good deal of in-camera manipulation. The following technique works well with this sort of picture. Working with images that are crisp and sharp will reveal completely different results or may not work at all.

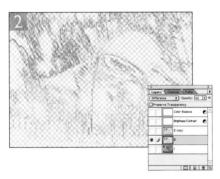

2 Ed used the third party Find Edges and Invert filter from Kai's Power Tools (v2.1) on the Background copy layer.

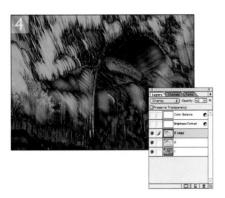

4 Now the Background copy layer is itself duplicated but this time the blending mode is changed to Overlay. The blending opacity is left at 42% though.

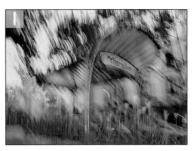

I Having opened the image, the background layer was first duplicated.

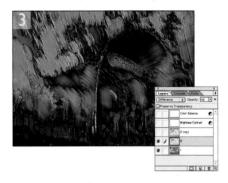

3 The copy layer blending mode was changed from Normal to Difference and the blending opacity adjusted until a rough visual balance was achieved when viewed with the underlying Background layer. In this example it was set at 42%.

5 The image is now looking rather dark so adjustment layers were added: one for Brightness & Contrast and another for Color Balance.

6 Finally, a flattened copy was made and further fine tuning Image adjustments were made to selected areas of the image only, changing the color, contrast and sharpness.

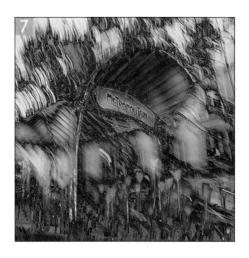

Red Dwarf Radio Times cover by Ian McKinnell

The picture was originally created for the cover of the BBC *Radio Times* magazine, with its logo worked into the image. The whole image took three or four days: one day for the photography and two or three long days carrying out the manipulation. Since then, however, this image has become almost an icon of the Red Dwarf series and has been resold extensively for use as posters, calendars, advertising, books and video covers etc. So the work did pay off.

Because the characters have been greatly distorted more than once it inevitably leads to some degradation of the image. To counter this I did all the work at a very high resolution: over twice the resolution that the image would finally be used, only resizing it down after all the work had been com-

pleted.

Ian writes: 'Much of my most useful Photoshop work is carried out in the bath before I start the day's work: thinking the image through, working out how to do it, and then working backwards a stage at a time to plan the images that are needed. It was this thinking that made me to conclude that the actors had to be shot separately: the image could not have been realized if I had taken the most obvious step and shot them together.'

I The actors were shot in the studio using a large format camera with perspective control to ensure that the actors were sharp from head to foot. They were shot individually for a number of reasons: to allow more flexibility when the final image was assembled; so that I could concentrate on each characters expression and that none of the actors would be in another's shadow. If one of the characters couldn't make it, I could shoot them later. The stand was there to make sure that the actors didn't move out of the narrow zone of focus. The bodies were cut out using paths and the hair cut out using a density mask combined with illustration to clean the edge up.

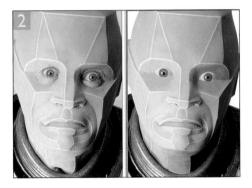

2 The actors are from a BBC series 'Red Dwarf', and whilst the makeup is adequate for the low resolution medium of TV, high resolution stills photography shows up a great number of shortcomings, so much work had to be done with the cloning tool and paintbrush.

3 The characters were 'whizzed' by duplicating the image, erasing the top half with a very soft edge so that their faces and shoulders would not be obscured, and then using the Motion blur filter. This was repeated a number of times, using Curves to increase the contrast. These layers were then merged to form two: one 'whizz' behind the character and one in front. These were then distorted into perspective using the Free Transform tool. This was done for each of the characters in turn. The star background is there to check how the transparency of the 'whizzes' is working.

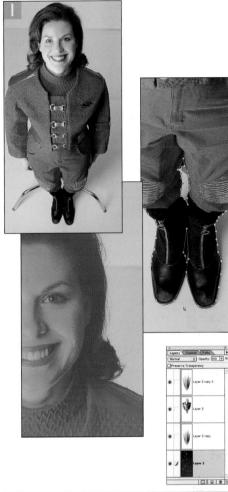

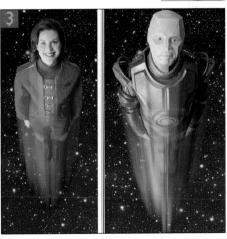

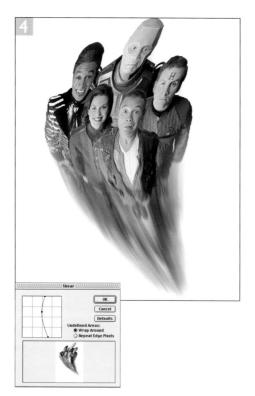

5 The star background is an illustration, using the gradient tool for the black and blue, and the stars created using the airbrush tool in a variety of sizes. The clouds are from a shot of real clouds taken during the day. This was then used as an alpha channel, and the image within the clouds altered using Curves.

6 The image was finally assembled by rotating the image, further distorting the characters using the Transform tool to achieve the final shape. The glow behind the characters was added by selecting their shape, creating a new layer and filling the shape with white and then applying Gaussian blur. This was repeated using cyan color, and the two combined using various layer blending options, such as Lighten, Darken, Hard Light etc.

4 The whizzed versions of the actors were then merged down to one layer, and combined with the other actors each on a separate layer. This way, their individual positions could be altered ad infinitum. When the composition was finalized the Free Transform tool was used so that the perspective of the characters was increased and made narrower at the bottom. All the layers were then merged into one, and bent using the Shear distort filter. One of the most frustrating aspects of Photoshop is that the Shear filter only works vertically, so images have to be rotated to the only usable axis.

Coloring in Lab color mode and using History

Any description of working in Lab color mode will mention the dangers of making image adjustments directly in the a and b channels, so naturally it is always interesting to see what happens when you do play around with the levels in these channels. The client wanted an android type image for his music promotional material and for this I exploited the unique way one can distort colors when working in Lab color mode.

I Open the image up in Lab color mode and carry out all the basic cleaning up, Levels and Curves adjustments on the composite channel to arrive at a bright looking image with a good balance of tones in the shadows and midtones.

2 One does not usually adjust the color of an image in Lab mode using Levels or Curves. Normally you would convert first to either CMYK or RGB mode. The *a* and *b* channels are unusual to look at and if you do adjust the levels in these channels, very odd color changes take place, which go beyond the level of color adjustment one is accustomed to (like with Hue/Saturation, for example). Operating on the *a* channel first, I raised the shadow slider up to the start of the shadow levels and brought the highlight slider in from the right and lowered the gamma slider setting. On any image the color change will be quite dramatic.

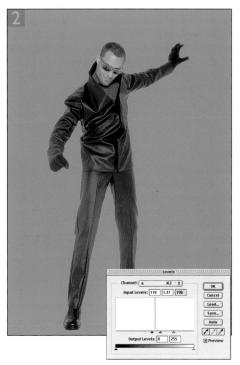

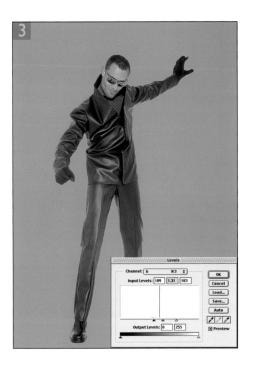

4 Non-linear history is switched on at this point (it does not necessarily matter for what follows). Activate the previous history state, but select the levels state as the history source. Click on the New layer button in the layers palette and choose Edit > Fill > History. The new layer is filled with the Levels history state. Double clicking the colored layer opened the Layer Options dialog box. I Option/Alt dragged the highlight slider as shown to drop out the blue background. The final image contains the coloring effect on the figure only.

3 I did a similar thing with the *b* channel. This made the background go blue and introduced an interesting metallic blue sheen to the suit. At this point in the proceedings we have the original opened image plus the next history stage with the levels applied.

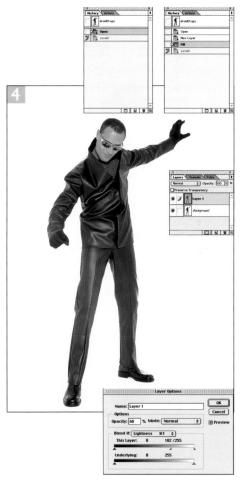

Anatomy of a layered image

So long as your computer has enough RAM memory installed and allocated to Photoshop, you can construct complex multilayered images with each object residing on a separate layer. This approach provides the utmost flexibility when it comes to making later revisions – not only the positioning, but layer order, opacity and blending mode can be altered too.

This last example is from a shoot I did for Rapid Pictures, a London broadcast video post production company. I took lots of pictures including the rooms, the various bits of kit and other close-up details to make a series of banner strip images.

The master document contains nine layers, one of which is an adjustment layer. The enlarged icon view (set in Palette Options) shown here, gives a clearer view of the individual elements. All layers are visible – the Sony camera layers are linked together and the adjustment layer is grouped with the room shot so the color adjustment affects that layer only. Now take a look at the image as it is built up in stages

3 The stripe was another blurred image - actually a long hand held-time exposure taken in one of the suites and stretched out across the length of the picture.

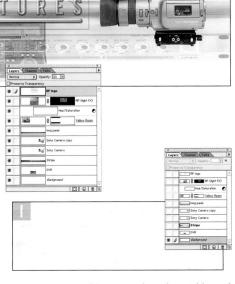

I The background layer was based on a blurred image which was partly blended with the Clouds filter, flattened and etched away with repeated rectangular and single pixel marquee selections. The faint soft colored tones make up the basic canvas.

2 The first object to be added was blended at 50% using the Difference blending mode. At 50% on an almost white background this near enough produces a negative image.

4 The Sony camera is duplicated and when the lower layer is highlighted, you can see the two are linked together. This layer is set to Darken mode at 100% and the one above it is on Normal at 50%.

6 Moving on up to the Yellow room layer, the shot has been temporarily cropped using a masking layer. If the client wanted a taller or narrower picture, this can be adjusted to suit. The adjustment layer affects this image only, because they are grouped. The Hue/Saturation adjustment softened the tones to make them warmer and less saturated.

5 Now the long panel is shown, which like the DVR layer is set to Difference mode, but at 35%.

7 The last thing to do was add the company logo. I took the Illustrator file and placed it in the image (File > Place...). This created a new Layer. I made a copy layer and named it 'RP logo', then reverted to the lower layer and applied a Lighting Effects filter. The layer mask is temporarily disabled, so you can see the filtration more clearly.

The RP logo layer was blended at 35% using the Normal blending mode and offset slightly with the move tool to add a slightly embossed look, which could also have been achieved using a layer effect.

Last word

This is now the end of the book. I hope the tips and techniques demonstrated throughout have helped you understand more about the power of Photoshop as a professional quality image editor. Don't forget that the CD-ROM features some of the tutorials as movies. There is also a web site http://www.bh.com/focalpress/evening used to promote this book where you'll find late breaking information and active links to all the sites I have mentioned. I hope too that you find using Photoshop to be a fascinating and rewarding experience. It literally changed my life and opened up many new avenues to explore!

Appendix

ost of the photographs you see in this book were taken by myself. Some were from commissioned assignments, others are personal shots. The last thing one needs is another computer graphics book filled with examples carried out on the author's holiday snaps (all right, I confess to using a few) – I wanted to keep the standard of image examples high and appropriate to the demonstrated techniques. I also roped in friends and colleagues to include their work too, all of whom are professional photographers. Here then is some biographical information on the other contributors whose work has been featured.

Photographer contributors

Davis Cairns

A partnership specializing in fashion accessory still life photography with clients who include: Red or Dead Ltd and Paul Smith. I have work on all the Davis Cairns computer retouching work and a number of these commissioned and personal images were used in this book.

E-mail: mail@daviscairns.demon.co.uk

Laurie Evans

Laurie Evans was born in Scotland in 1955. Having studied photography at Art School he spent two or three years as a rock and roll photographer before coming to London to seek his fortune. Transferring his interests to still life, and always a passionate cook, he quickly found that he could combine work with pleasure as he discovered the joys of food photography. He works extensively in the advertising and design industry and contributes to a broad range of magazines in the UK and abroad, and has also illustrated more than 40 cookbooks. He is married, has two sons and lives and works in London.

Tel: +44 (0)171 284 2140. Fax: +44 (0)171 284 2130

E-mail: Laurie@evansphoto.demon.co.uk

Jon Gibson-Skinner

Jon Gibson-Skinner is a young professional photographer who lives and works in London. Jon became involved with image manipulation as he studied for a degree in Photography at Farnham. After graduation he moved to London where he started working for Mouse in the House digital photography studios, with his work being showcased by Adobe amongst others.

Now established in Covent Garden Jon is at the forefront of the new digital photographic medium. Teamed with Quicksilver digital printers Jon has a client base of design agencies who are starting to acknowledge the full potential of the digital technology available.

Tel: +44 (0)181 995 5839 E-mail: jgs@dircon.co.uk

Peter Hince

Peter Hince is an advertising photographer specialising in people/lifestyle. He works mainly on location throughout the world and is very experienced with big productions and 'round the globe' projects. He also has a unique style of underwater work and produces toned and textured black and white shots for his 'Ocean Images' collection. His work has won many advertising and photographic awards.

Tel: +44 (0)171 386 0244

E-mail: 106255.2474@compuserve.com

Ed Horwich

Ed Horwich began his career as a photo lecturer and color printer, producing all the color prints for Martin Parr's book *The Last Resort*. He now works for advertising and design clients and is list-owner of the ProDIG discussion list http://image.merseyworld.com/prodig. The majority of his clients now commission him to do digital work – his first digital commissions came back in 1992 for the London Festival Orchestra and British Gas.

Tel: +44 (0)1704 507160

E-mail: ed@wiz-ed.demon.co.uk

Bob Marchant

Bob Marchant is an advertising photographer and commercials director based in London. He first became involved with digital imaging when working on special effects for a television commercial at a post production session. His studio now has its own in-house digital facilities running alongside conventional photography and film production. This in turn has led to an increasing involvement with multimedia.

Tel: +44 (0)171 381 3337

E-mail: bobphoto@dircon.co.uk

Ian McKinnell

One of the first Macintosh owners in the UK. Ian began incorporating computer graphics for his illustration work back in the mid eighties. He photographs mainly for editorial and design clients like the *Radio Times* and *The Observer magazine*. Ian uses Photoshop and 3-D package programs for nearly all his work.

Tel: +44 (0)171 631 3017

E-mail: 100671.615@compuserve.com

David Whiting Photography

DWP are based in Luton, and were established in 1969. Their team of photographers are able to photograph a diverse range of subjects, often travelling afar, to serve industrial/commercial clients and advertising/design agencies. Their move into digital imaging has enabled them to keep pace with rapid changes in the industry. Their photo library, ProVISIONS from DWP includes local scenes.

E-mail: dwp.imaging@btinternet.com

Adam Woolfitt

Adam Woolfitt has been a photographer all his life. For twenty six years he contributed to *National Geographic* and other equally famous magazines. Seven years ago he realized that photography was being reinvented and immersed himself in computers and digital cameras.

Last year he decided that silver was still lovely and made a partial return to traditional shooting both refreshed and invigorated – and with a large new armory of specialized knowledge and equipment including QTVR and VR skills. Adam is a founding member and past chairman of the UK Digital Imaging Group.

Tel: +44 (0)181 444 6516 E-mail: adampix@dircon.co.uk

Rod Wynne-Powell

Rod Wynne-Powell, who helped with the checking into some of the technical aspects of this book, set up SOLUTIONS photographic in 1986, and bought his first Mac in 1987.

Solutions Photographic came about because, after a period as a commercial/industrial photographer, and later as sales manager of a London color laboratory, many calls he received began with the words: 'Rod, I've got a problem...'

His attention to detail and dogged determination led some Developers to accept his offers to beta test their graphics products. This gave him the opportunity to fashion products to meet the requirements of retouchers and manipulators, which naturally gave his clients an edge against their competitors. It allowed him to offer in-depth training very early in the product life-cycle, and gain insights into the Developers' future direction.

Speaking the same language as Photographers, has enabled him to guide others past the pitfalls when introducing them to the digital world. He offers help from the basics of Mac housekeeping, its interface, and fault diagnostics, through to the far more enjoyable aspects of teaching techniques for the productive and creative use of Photoshop as a montaging and retouching tool. His help has been valued and respected amongst his peers in the digital arena.

SOLUTIONS photographic is now in its twelfth year. His work is rarely credited, but lies behind many images for book jackets, report and accounts brochures, advertisements and packaging designs. His clients tend to have completely individual understandings of

his services, and so he relies on most of his work by personal recommendation; the consultancy offered varies from the ad hoc to the retained, and he is particularly pleased with his 'flying doctor' service over the telephone, as this allows him to utilize time which might otherwise have been a tedious waste, spent inhaling exhaust fumes on the M1 or M25 car parks! His training sessions tend to be offered on a half-day basis to avoid 'information overload' effects, but if the student can take the pace, he will continue to provide answers!

SOLUTIONS photographic can be contacted by the following means: Mobile: 0836-248126 (24 hrs/7 days a week plus messaging service). Tel: 01582-725065 most mornings till 10.00 a.m. (no answer service).

E-mail: solphoto@dircon.co.uk

Glossary of terms

Term	Description
Anti-aliasing	Anti-aliasing removes the jagged effect of stepped pixels on non-horizontal/vertical edges by adding averaged pixel values.
ASCII	American Standard Code for Information Interchange.
ATM	Adobe Type Manager.
Binary coding	Two digit numbering code system.
Bit depth	Number of bits assigned to each pixel. The more bits, the greater the color depth.
Bitmap	Binary image data comprised of on or off pixels. (Adobe meaning)
ВМР	Standard Windows/DOS bitmapped file format.
Bump map	Grayscale mode image used as a texture map (see lighting FX).
CCD	Charged Coupled Device.
CDR	Recordable (once only) CD disc.
CLUT	Color Look Up Table.
CMS	Color Management System.
CPU	Central Processing Unit: the microprocessor at the heart of the computer.
CRT	Cathode Ray Tube.
DCS	Desktop Color Separations (EPS option for Quark).
DIMM	Dual Inline Memory Module (RAM).
DPI	Dots Per Inch. A definition of printer resolution that is now also used (inaccurately) to define scanning resolution.
EDO DRAM	Extended Data Out Dynamic Random Access Memory.
EGO	Edit Graphic Object AppleEvent. A Macintosh only facility for embedding images in a word processing application.
EPS	Encapsulated PostScript.
IFF	Amiga Interchange File Format.
Gamma	A measurement of the contrast affecting the midlevel grays.

Term	Description
Gamut	The range or confines of a color space, often determined by the limits of the input/output device in question.
GIF	Graphics Interchange Format – files can be saved as CompuServe GIF or exported in the GIF89a format.
GCR	Grey Component Replacement.
GUI	Graphical User Interface – first introduced on the Apple Macintosh operating system.
HSB	Hue Saturation Brightness $-$ an intuitive color space model.
HTML	HyperText Markup Language, code used to write web pages.
ICC	International Color Consortium.
Interpolation	A process used to increase the pixel dimensions of an image by interspacing them with new pixels (see Chapter Two).
ISDN	Integrated Services Digital Network.
JPEG	Joint Photographic Experts Group – JPEG file format.
Lossless compression	Image data compression which does not degrade image data. PICT, TIFF and Photoshop formats use lossless compression.
Lossy compression	Compression method, e.g. JPEG, in which image data is degraded.
LZW	Lempel Ziv Welch lossless compression method available with TIFF fomats.
Nubus	Port interface found in older Apple Macintosh computers.
OCR	Optical Character Recognition.
OLE	Object Linking and Embedding.
PCD	Kodak Photo CD format.
PCI	Peripheral Computer Interconnect. Macintosh Power PC and Intel PC common standard port interface.
Pixel	Picture element.
PDF	Portable Document Format (Adobe Acrobat).
PIW	Photo CD Imaging Workstation.

Term	Description
Plug-in	Compatible software which adds functionality to the program.
PostScript	Industry standard Adobe print description language.
PMT	Photo Multiplier Tube – sensor used in drum scanners.
PT	Precision Transform (Kodak Photo CD)
QuickTime	Apple developed technology for time-based multimedia.
RAM	Random Access Memory – see DIMM, SIMM, VRAM.
RDRAM (RIMM)	Rambus Dynamic Random Access memory. The newest standard in RAM memory, promising even faster speed.
RISC	Reduced Instruction Set Computing.
SCSI	Small Computer System Interface.
SDRAM	Synchronous Dynamic Random Access Memory.
SIMM	Single Inline Memory Module (RAM).
Soft proofing	Carrying out color proof approval directly on the monitor.
TIFF	Tagged Image File Format.
TWAIN	DOS Windows type interface for importing from input devices like scanners or other similar devices.
UCA	Undercolor Addition.
UCR	Undercolor Removal.
Vector based artwork	Image data comprised of mathematical expressions which unlike bitmapped data can be scaled to any size. Illustrator and Freehand are programs which produce Vector art.
Video LUT	Video Look Up Table.
VRAM	Video Random Access Memory.
YCC	Kodak Photo CD color model basde on the CIE LAB color model.

World Wide Web contacts list

4-Sight	www.four-sight.co.uk
Action Xchange	www.actionxchange.com
Adaptec	www.adaptec.com
Adobe	www.adobe.com
Adobe Photoshop Information page	www.adobe.com/prodindex/photoshop/main.html
Adobe Photoshop discussion list	www.sc.edu/deis/PHOTOSHP/
Agfa	www.agfa.com
Alien Skin	www.alienskin.com
Andromeda	www.andromeda.com
Apple	www.apple.com
Association of Photographers	www.aophoto.co.uk
Binuscan	www.binuscan.com
British Journal of Photography	www.bjphoto.co.uk
Chromagraphics	www.chromagraphics.com
Compaq	www.compaq.co.uk
Connectix	www.connectix.com
Contact Images	www.contact-uk.com
Daystar	www.daystar.com
Exabyte	www.exabyte.com
Extensis	www.extensis.com
Elated Action Kits	www.elated.com/freebies/actionkits/
Fargo	www.fargo.com
Formac	www.formac.com
Fractal	www.fractal.com
Fuji	www.fujifilm.com
Fujitsu	www.fujitsu-europe.com
Hermstedt Ltd	www.hermstedt.co.uk
Hitachi	www.hitachi-consumer-eu.com
Hewlett-Packard	www.hp.com
lomega	www.iomega.com
Kensington	www.kensington.com
Kingston	www.kingston.com
Kodak	www.kodak.com
Kodak Photo CD	. www.kodak.com/daiHome/products/photoCD.shtml
Lexmark	www.lexmark.co.uk
Linotype	www.linocolor.com
Live Picture	www.livepicture.com
Martin Evening Photography	www.evening.demon.co.uk
MetaTools	www.metatools.com

Minolta	www.minolta.de/europe.html
Mitsubishi	www.mitsubishi.com
Microsoft	www.microsoft.com
New Mexico Software	www.image-assets.com/index.html
Nikon	www.klt.co.jp/nikon/eid/
Olympus	www.olympusamerica.com/digital/
Panasonic	www.panasonic.co.uk
Pantone	www.pantone.com
Philips	www.philips.com
Polaroid	www.polaroid.com
ProDIG digital imaging discussion list	http://image.merseyworld.com/prodig
ProRental discussion list (users of IOMB plus digital came	eras)www.prorental.com/pr_digf.htm
Quantum	www.quantum.com
Quark	www.quark.com
Radius	www.radius.com
RasterOps	www.rasterops.com
Ricoh	www.ricoh-europe.com
Samsung	www.samsung.com/product.html
Sanyo	www.sanyo.co.jp/index_e.html
Scitex	www.scitex.com
Seagate	www.seagate.com
Sharp	www.sharp-uk.co.uk
Signum Technologies	www.signumtech.com
Sony	www.sony.co.jp
Sun Microsystems	www.sun.com
SuperMac	www.supermac.com/index.html
Symantec	www.symantec.com
Syquest	www.syquest.com
Taxan	www.taxan.co.uk
TDK	www.tdk-europe.com
Tektronix	www.tek.com
Texas Instruments	www.ti.com
Toshiba	www.toshiba.com/home/work.shtml
Umax	www.umax.com
Verbatim	www.verbatimcorp.com
Vivitar	www.vivitarcorp.com
Wacom	
Rod Wynne-Powell	·
Xerox	
Xaos Tools	www.xaostools.com
Yamaha	www.yamaha.com

Index

16 bits per channel	Bus 67
uses of 150	Byte order 59
3D Transform 278	
Acrobat format (PDF) 49	Calibration 37
Actions 74, 129, 216–218	Canon
troubleshooting 218	EFI Fiery RIP 55
Actions X Change 207	CCD 4
Adjustment layers 129, 136, 145, 154, 164-	CCD chip cameras 17
165, 180, 202, 223, 279, 283, 290	CD-ROM 57, 65
slow speed problems 154	Channel Mixer 234, 239, 241, 243-244
Adobe Gamma 37, 78, 86, 96	Channels 167, 223
Agfa 3	Channels palette 130
Airbrush 112, 286	Chromagraphics 191
Aliases (Mac) 58	Chromapress 57
Alpha channels 130, 169	CIE RGB 81
Analyzing an image 133	Clear clipboard memory 209
Anti-aliasing 169, 172	Clear guides 104
Apple RGB 81	Clipboard 98
Arbitrary Map 140	memory 70
Archiving images 57–58	Clipping groups 192, 193
Arrow heads 119	Clipping paths 42, 60, 194
Artifacts	Cloning 113
unsharp masking 25	Cloning alternatives
ASCII encoding 43	dodge tool 159
Assumed profiles 86, 87	Cloning selections 162
Auto erase (pencil) 119	Closed color loops 60, 96
Automation plug-ins 220	CMYK
AV hard drives 69	all CMYK route 33
	conversions 31, 39, 93
Barco 77	gamut 34
Batch processing 220	monitor display 35
Bevel and Emboss 254	Photoshop conversions 34
Bicubic 25	proofing 53-54
Binuscan 3	selective color 156
Bitmapped images 2	CMYK gamut 128
Black generation 95	CMYK Preview 38
Blending modes 175-176, 192, 245	CMYK setup 94
Color 198, 245	Color bit depth 3
Darken 246-247, 282, 290	Color blending mode 177
Difference 283, 289–290	Color Burn 176
Hue 245	Color Dodge 176
Lighten 198, 247	Color management 36-38, 80-87
Overlay 283	ColorSync 38
Bletchley Park 71	Kodak CMS 38
Blur tool 120, 198, 203	Color modes
Boyd, Rex 281	CMYK 31–32
Brown, Russell 161	device dependent 35
Brush size 99	device independent 36
Brush tool 112	Lab 10, 36
Brushes palette 128	RGB 31-32, 33-34
Bucket tool 123, 190	Color neg retouching 159
Built-in conversions 38	Color palette 128
Bureau output	Color Range 197
checklist 59	Colorize
Burn tool 120, 205	hue/saturation 145
	Colombia DCD 02

ColorShop 25	Dot gain 39, 93-94
ColorSync 38, 86	Drop Shadow 253
Commission Internationale de l'Eclairage 3	
Compositing 191	Duotones 232
Compression	Duplicate image
lossless 9	History palette 114
LZW 42	Duplicate layer 193
Computer	Durst Lambda 53
acceleration 67	DVD 57
choosing a system 63-64	Dynamic range 77
expansion 64	
mail order 65	Easter eggs 107
monitor display 64	Edit menu
multiprocessor 66	purge 209
system maintenance 72–73	EDO RAM 67
Conditional Mode Change 220	Efficiency 102
Contact Sheet 221	EFI Fiery RIP 55
Contextual menus 107, 210	Electronic publishing 49
Cromalin proofing 40	Embedding profiles 93
Crop tool 112	Enigma code 71
fixed size 132	EPS 42
fixed target size 132	halftone/screen options 43
Cropping 131	Transfer functions 43
Cross-processing 240	Epson
CSI Lightjet 53	inkjet printers 56
CTP (Computer to Plate) 57	Eraser 118
Curves 201, 202	Evans, Laurie 150
Custom ink colors 94	Exclusion 177
	Export Transparent Image 221
Darken mode 176	Extensions (system) 66
Databases 58	Extensis 191
Daystar	Mask Pro 42
Genesis 66	Eyedropper 124, 136, 160
DCS format 43	
Despeckle filter 260	Fargo FotoFun 56
Difference mode 176	File extensions 98
Diffusion dither 99	File formats
Digimarc 61–62, 203	Acrobat (PDF) 49
Digital cameras 15–20	Duotones 231
benefits over film 15–16	EPS 42
Canon 600 21	Flashpix 49
CCD chip cameras 17	for the Internet 45
converting CMYK 32	GIF 47, 98
Dicomed Bigshot 20	JPEG 43, 98
image quality 17–19	multimedia use 51
Leaf DCB 20	Photoshop 41
lighting 16–17	PICT 41
scanning backs 16	PNG 51
striped chips 19, 19–20	Raw Binary 98
Digital image	TIFF 41
structure of 2–3	File menu
Digitizing pad 65 DIMMs 67	file Info 59
Disk cache 73	import 3
Dissolve mode 175	place 271, 290
Distribute layers 258	preferences 98
Document size 101	plug-ins 100
Dodge tool 120, 205	restore palettes 127
Douge 1001 120, 203	scratch disk 100 File size 25–28
	File 3126 Z3-Z6

Filter menu	
Artistic	Gamma control panel 37, 81
cutout 270	Gamut 99
Blur	GCR 95
gaussian blur 200, 203, 286	GIF format 47
motion blur 193, 261, 285	Gradient tool 122, 246, 248, 286
radial blur 261	Graphic tablet 112
smart blur 261	Grayscale mode 2
Brush strokes	Grayscale setup 94
spatter 268–269	Grids 100, 103–104
Distort	Guides 100, 103, 195
diffuse glow 267	
displace 265, 266, 271	Halo effect 280
displace map 272	Hand coloring 248
glass 267	Hand tool 124
ocean ripple 267	Hard light 176
shear 265, 286	HDTV 82
spherize 267	Hex-wrench 34
square wave 266	Hexachrome 34
twirl 267	Hince, Peter 194
wave 265, 268	History 74–75, 287
Fade adjustments 250	memory usage 115
Fade filter 200, 234, 261	History brush 75, 114 HK printer 53
Gallery effects 260 Gaussian blur 250, 276, 279	HSB color model 145, 150
	Hue blending mode 177
Lighting effects bump map 274	Hue/Saturation
texture map 269	colorize 249–250
textures 266	COIOTIZE 247-250
Noise	ICC 38. See also Color management: ColorSync
add noise 196, 262	ICC conversions
despeckle 262	Perceptual rendering 39
dust & scratches 262	ICC profiles 81–83, 86
median 203, 261	Illegal colours 128
noise f/x 268	Imacon
Other	CCD scanner 4
high pass 264	Image AXS 59
maximum 263, 264	Image cache 101
minimum 264	Image menu
offset 264, 276	Adjust
Render	arbitrary map/curves 236
clouds 273, 289	auto levels 133, 161
difference clouds 273	brightness & contrast 131, 144, 250, 283
lens flare 273	color balance 144, 233, 283
lighting effects 268-269, 276, 290	curves 137, 138, 152
texture fill 266, 274–276	desaturate 234, 235, 250
Sketch	gray balance/levels 136
graphic pen 270	hue/saturation 145-148,
plaster 268-269	152, 161, 234, 244, 279,
Solarize 236	invert 160, 249
Finger painting 61, 120, 205	levels 133-136
Fit image 221	replace color 153
Flatten image 195	selective color 155, 156
Foreground/background 125	variations 144
Fraser, Bruce 82	canvas size 132, 133
Free transform 285-286	histogram display 133
Fuji	rotate canvas 265
Pictrography 53	Image security 60–62
Thermal Autochrome 56	Image size 25, 140
Fuzziness control 153	Image window 101

Import from Illustrator 271	Linotype Saphir Ultra 4
Indigo 57	Linotype-Hell 3
Info palette 96, 128	Live Picture 264
Inner Glow 254	Flashpix 49
Inner Shadow 253	IVUE 51
Interpolation 25, 60	Lock guides 104
Iris printer 54	Lossy compression 43
ISDN 19, 44	Luminance mask 202
Iteration 96	Luminosity blend mode 177, 246
Jaz 58	LZW compression 42
Jaz drive 209	
JPEG format 43–44	Macros. See Actions
	Magic eraser 74, 114
Kai's Goo 265	Magic wand 106, 250
Kai's Power Tools 264	Magnetic lasso & pen 106, 109
find edges & invert 283	Magneto optical drives 59
texture explorer 268	Marquee tool 106, 167
Knoll brothers 260	Marrutt 57
Kodak	Mask channels 168
Photo CD 7-II	Memory management 101
acquire module 14	Modifier keys 107, 108
cost 9	Moire patterns 203
image pac 9, 10	Monitor calibration 77
precision transforms 11	tonal compression 201
scene balance algorithm 10	Monitors
sharpening 141	non-linear compression 77
universal terms 10	Move tool 111
YCC 12	Mulfra Quoit 249
YCC/LAB mode 36	Multi-Page PDF to PSD 221
Premier 4	Multiple layers 180
Shoebox 59	Multiple undos 74, 114
XLS 8600 dye-sub 54	
Konica	Multiply mode 175
infra red 249	Navigator palette 124, 127, 215–216 New channel button 189
Lab color	
	New Mexico software 62
CIELab history 36	Nikon 4, 5
Lab color mode 287	Noise & scratches filter 161
Lambda (Durst) 53	Non-linear history 75, 117
Lasso 106, 108	Norton utilities 72
Layer alignment 256	Now utilities 73
Layer Effects 121, 252–253	NTSC RGB 82
Layers 174–175, 223	Nubus cards 71
add layer mask 164, 178	Numeric transforms 183
layer via copy 164	
layer mask 177, 192, 251, 282	Ocean images 194
Quick Mask mode 178	Options palette 128
removing 180	Outer Glow 254
linking 180	Output
merge layers 286	guidelines 59
Layer options 195, 202, 235, 288	guidelines on supplying 54
Layers palette 129	preferred file formats 59
Leaf DCB 25	Overlay mode 175
Legacy files 84-85	Overlays
Levels 133–136	retouching with 246
in Lab color mode 287	-
Lighten 176, 247	Painter program 112
Line tool 119	PAL/SECAM RGB 82
Linotype 3	Palette Options
• •	icon view 289
	Paths

direct-selection 189	(Measure tool) 122
Paths palette 130	Purge History 117
Pattern Stamp 113	,
PCI card 65, 70, 71	Quadtones 231
PDF (Acrobat) 49	Quick edit 75, 209
Pen paths 169, 184, 285	Quick Mask 125, 163, 167-168
drawing 185	Quick Mask mode 172
stroking 198, 204	
Pen tool 121, 184	Radial Blur filter 261
corner point 188	Radio Times 284
curved segment 186–187	Radius 71, 77
pointer 185	RAID hard drives 70
rubber band 187	RAM doubler 69
straight segment 188	RAM memory 67
Pencil 119	configuring 71
Photoengine 71	Rapid Pictures 289
Photomultipliers 4	Recording Actions 217
Photoshop	Red Dwarf 284
improving performance 66	Repeat Transform 183
memory management 69	Repeat transform 256
Photoshop LE 4	Replace color 153
Piazza, Tim 95, 231	Resize image 221
PICT 42	Resolut 25
JPEG compression 42	Resolution
Pictrograph prints. See Fuji	film 22
Pixel doubling 111	image size 140
Pixels 2, 22	output resolution 24
Plug-ins	pixels 22
third party 260. See also Filters	reciprocal formula 23
PNG format 51	terminology 23–24
Polaroid 4	RGB
Polygon lasso tool 106	printing from 52
PostScript 55	RGB color 36–37
Preserve transparency 181, 276	RGB setup 80, 81, 82, 94
Preview box 101	RGB work space 80
Primary scratch disk 72, 100	Rosettes (halftone) 24
Printers	Rotate image 133 Rubber stamp 113, 158–159, 196, 282
budget priced 56	Ruler units 100
Chromapress 57	Rulers 103
dye-sublimation 53 Epson 56	Ruleis 105
Fujix Pictrography 53	Saturation blending mode 177
gravure 95	Saturation mode 246
Indigo 57	Saving 41
inkjet 54	previews 98
inkjet plotters 55	Scanning
laser 55	bit depth 5
Marrutt 57	drum scanners 3
packaging 95	dynamic range 5
PostScript 55	flatbed 4
silk screen 95	halftone images 203
Xericon 57	noise 7
Printing dots. See Resolution: film	resolution 5, 24
Profile mismatch handling 86	scanners 3-5
Profile setup 86-87	scans from films 2
Profile to Profile 85	speed 6
Progressive JPEG 44	weaknesses 7
Protractor mode	Scitex Iris 54
	Scratch disk memory 209
	Scratch disks 67, 102

Screen blending mode 175	Transform
Screen display modes 125	scale 192
Scripting Photoshop 129	Transforming selections 183-184
SCSI 65	Transforms 181-183, 256
standards 70	flip 182
Select	rotate 182
Modify Border 171	Transparency 99
Select menu	Transparency writers 53
color range 153, 155	Tritones 231
deselect 169	Type layer effects 258
feather 163, 174	Type mask tool 121
grow 172	Type tool 121, 258
invert selection 195	Type (001 121, 230
Selections 167	UCA 95
	UCR 95
feathering 197	
modifying 171	Umax 3, 4
smoothing 171	Unsharp masking 25
Sharpen tool 120, 203	amount 143
Sharpening 141	incremental 141
Shortcuts 166	radius 142
Show grid 104	radius and threshold 143
Signum Technologies 61–62	selective channels 142
SIMMs 67	
Smoothing options 106	Vector Effects 121
SMPTE-240M 82	Video display 72
SMPTE-C 82	Video LUT animation 99, 134
Smudge tool 120, 204	Video RAM (VRAM) 64
Snap to grid 104	View menu
Snap to guides 104	fit to window 131
Snapshot 74	gamut warning 99, 156
Snapshot button 114	hide edges 157
Soft Light 176	new view 103
Soft proofing 35	show rulers 103
Solarization	Virtual memory 69
curves 236	,
Spectrophotometer 37	Wacom 65
Split toning 235	Wet edge painting 113
Sponge tool 120, 157, 205	Whiting, David 159
Spot color channels 258	Wide Gamut RGB 81
sRGB 81–84	Window
SureSign 61–62, 203	cascade 212
Swatches palette 128	tile 212
Syquest 57	
syquest 37	Wynne-Powell, Rod 159
Threshold mode 136	V
	Xericon 57
TIFF 41–42	7
Timing 102	Zoom tool 124
Tolerance settings 106, 172	
Tonal adjustments 133	
Tonal range 2	
Tool selection 102	
Toolbox 104–106	
color sampler tool 124	
Freeform pen tool 121	
Measure tool 122	
selection tools 106	
Type Mask 121	
Total ink coverage 95	
Transfer function	
(duotones) 231	